A NEW GUIDE TO CREATING GREAT PICTURES WITH CAMERA AND COMPUTER

For more than thirty years, *The Basic Book of Photography* by Tom Grimm and Michele Grimm has been the classic guide to film photography. Now these veteran photographers and authors have compiled the definitive handbook about digital imaging, which offers fresh vistas to all photographers. The Grimms give you practical advice about choosing and using digital cameras, including methods for composing outstanding photographs. They also explain the many ways to use image-editing software to improve and even create pictures with your computer. In addition, you'll learn about making prints from your digital images, sending pictures in e-mails, displaying photos on the Internet, and even creating slideshows to watch on television. This comprehensive guidebook will help you become the digital photographer you always wanted to be.

THE BASIC BOOK OF DIGITAL PHOTOGRAPHY

TOM GRIMM and MICHELE GRIMM are a husband-and-wife photojournalism team who have spent nearly four decades traveling the globe; the couple has visited every continent and more than 130 countries in search of the perfect photographic image. Their photographs and articles have been published worldwide in magazines and newspapers and on the Internet. The Grimms are authors and illustrators of thirteen adult and children's books.

ABOUT THE COVER PHOTOGRAPHS BY
MICHELE GRIMM AND TOM GRIMM

Unique to digital cameras, the LCD monitor allows photographers to review pictures that have been recorded on the camera's memory card, such as that of the scarlet macaw on the front cover photographed in Hawaii.

The macro mode on a digital camera was used to make a close-up of the parrot's feather, which appears on the spine and back cover of the book.

Also on the back cover, the multicolored versions of a blue-and-yellow macaw were created in the "digital darkroom" with a computer and an image-editing software program, Adobe Photoshop Elements. After cropping the image to feature only the bird's head and shoulders, the Eraser tool was used to eliminate the background where the parrot was photographed in Brazil. Five separate images of the bird were then created with different colors by simply adjusting the Hue setting. Afterward, three images of the bird were flipped horizontally to change their direction. Finally, a white Background layer was created so the six bird images could be assembled in a row (as additional layers) for the final picture. Experimenting with image-editing software can add much to the enjoyment of digital photography, as you'll discover in chapter 14.

The authors wish to thank their friends—Buddy Mays, Nancy Erickson, Glenn Bozarth, and Sherilyn Mentes—for a few of the images appearing in this book. Thanks also to Charles Engel for his digital imaging expertise and assistance.

THE BASIC BOOK
OF DIGITAL
PHOTOGRAPHY

HOW TO SHOOT, ENHANCE,
AND SHARE YOUR DIGITAL PICTURES

Tom Grimm
and
Michele Grimm

Photographs by
Michele Grimm and Tom Grimm

A PLUME BOOK

PLUME
Published by the Penguin Group
Penguin Group (USA) Inc., 375 Hudson Street, New York, New York 10014, U.S.A. • Penguin
Group (Canada), 90 Eglinton Avenue East, Suite 700, Toronto, Ontario, Canada M4P 2Y3
(a division of Pearson Penguin Canada Inc.) • Penguin Books Ltd., 80 Strand, London
WC2R 0RL, England • Penguin Ireland, 25 St. Stephen's Green, Dublin 2, Ireland (a division
of Penguin Books Ltd.) • Penguin Group (Australia), 250 Camberwell Road, Camberwell,
Victoria 3124, Australia (a division of Pearson Australia Group Pty. Ltd.) • Penguin Books India
Pvt. Ltd., 11 Community Centre, Panchsheel Park, New Delhi–110 017, India • Penguin Group
(NZ), 67 Apollo Drive, Rosedale, North Shore 0632, New Zealand (a division of Pearson
New Zealand Ltd.) • Penguin Books (South Africa) (Pty.) Ltd., 24 Sturdee Avenue, Rosebank,
Johannesburg 2196, South Africa

Penguin Books Ltd., Registered Offices: 80 Strand, London WC2R 0RL, England

First published by Plume, a member of Penguin Group (USA) Inc.

First Printing, November 2009
10 9 8 7 6 5 4 3 2 1

Ⓟ REGISTERED TRADEMARK—MARCA REGISTRADA

LIBRARY OF CONGRESS CATALOGING-IN-PUBLICATION DATA
Grimm, Tom.
The basic book of digital photography : how to shoot, enhance, and share your digital pictures /
Tom Grimm and Michele Grimm ; photographs by Michele Grimm and Tom Grimm.
 p. cm.
Includes index.
ISBN 978-0-452-28955-0 (alk. paper)
1. Photography—Digital techniques—Handbooks, manuals, etc. 2. Photography—
Handbooks, manuals, etc. I. Grimm, Michele. II. Title.
TR267.G756 2009
775—dc22 2009011946

Printed in the United States of America
Set in Bembo with Gill Sans
Designed by Daniel Lagin

Dedicated to Laura Southwick, 1965–2002
"She Leaves Echoes of Joy, Love, and Compassion"

Contents

Read This First

Digital photography is fascinating, fulfilling, and just plain fun.

Little wonder that in relatively few years it has become far more popular than film photography. (It was 1994 when the first consumer digital camera appeared.) In our fast-paced times, we all want instant gratification—and that's what you get with digital photography. There's no more waiting for the film to be processed to see how your pictures came out. These days you can literally point and shoot a camera—and immediately see the results.

For those of us who grew up shooting with film and making photo prints in a darkroom, it is a challenge to learn about things called pixels and image-editing programs in order to produce pictures in today's world. But once you press a digital camera's shutter button a time or two, and soon watch beautiful full-color photos appear on your computer screen or desktop printer, you're hooked.

There are two big steps to making great digital photographs: understanding how to use your camera, including the ways to compose good pictures, and knowing how to improve the results

with your computer. In this book we provide many stepping-stones to help you along the path to outstanding images.

The chapters are necessarily filled with technical stuff so you'll understand all the lingo digital photographers are using these days. (Our glossary at the back of the book is very helpful, too.) But mostly we give practical hands-on advice about choosing and using digital cameras, perfecting your pictures with image-editing software, and then sharing and showing off your best digital images.

As our book title indicates, this guide is all about digital photography. Of course, because of similarities in equipment and techniques, there will be references to film photography, which might pique your interest in that time-honored approach to photographic imagery. If so, you should read our all-inclusive volume, *The Basic Book of Photography*, now in its fifth edition and also published by Plume.

—Michele and Tom Grimm
San Clemente, California
January 2009

Quick Start Guide
to Digital Photography

D igital camera manufacturers realize that few people want to read a thick instruction manual before they start taking pictures. So many cameras come with a QUICK START GUIDE, which is a foldout chart or a booklet with a few pages of simple instructions and illustrations to get you going. We do the same thing in this first chapter—give you a basic understanding of how to make your first digital photos.

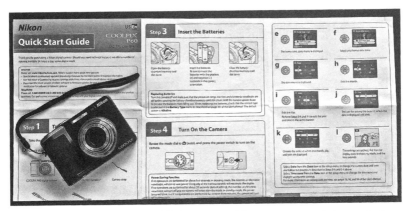

1.1. Much like the "quick start guide" that comes with new cameras to help you start shooting pictures almost immediately, this chapter introduces you to the special features of digital cameras and digital photography.

Anyone who has shot pictures with a film camera may wonder what's the difference when using a DIGICAM (the word that has been coined for "digital camera")? Not much, except that digital cameras have some great advantages. We summarize them here, and then give more details in the chapters that follow.

DIGITAL CAMERA BENEFITS

Perhaps the greatest thing about digital photography is that you no longer have to bother with the effort and expense of buying, loading, and then processing film. That's because the film has been replaced by a MEMORY CARD. A digital camera electronically records images on a tiny cardlike device, which can be quickly erased and used again and again—literally thousands of times.

1.2. A removable memory card is the "film" in a digital camera. These small reusable cards vary in name, size, shape, and capacity. This Secure Digital (SD) card is shown at its actual size. Read more about memory cards in chapter 3.

An even bigger bonus for many people, and the main reason for shooting with a digital camera, is that you get to see the results right away—there's no waiting, as in the past, for film to be developed. Instead, the electronically created images appear instantly in color on a small TV-like screen called an LCD MONI-TOR at the back of your digital camera.

Another significant difference in shooting with a digital camera rather than a film camera is that your creativity doesn't have to stop once you press the shutter release button and make

1.3. A hallmark of digital cameras is the LCD monitor, which allows you to review pictures immediately after shooting them. The LCD screen also is used to compose pictures, especially if your camera has no viewfinder. Read more about LCD monitors in chapter 2.

an exposure. Digital images can be changed in countless ways by using a computer with IMAGE-EDITING SOFTWARE. Are some of your pictures underexposed or do they seem off-color? Don't worry. You can sit down at a computer keyboard and fix them.

To display the results of your digital photography, there's no

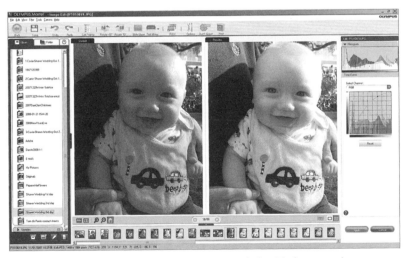

1.4. Digital photographers can "fix" their pictures with the aid of a personal computer and image-editing software, such as the Olympus Master program shown here. "Before" and "after" pictures show the change being made as the Tone Curve setting is adjusted to lighten the image of this baby. Read more about improving your digital pictures with computer software in chapter 14.

1.5. Making photo prints is easy with a desktop printer. Like this portable Sony Picture Station, many models feature slots for memory cards and do not need to be connected to your camera or computer. An LCD screen shows a preview of each image, which can be edited and improved before printing. Read more about making your own digital prints at home in chapter 15.

need for a photographic darkroom. You can make photo-quality prints or enlargements at home with a DESKTOP PRINTER. If you'd rather not do it yourself, just take your memory card to a local digital photo center where prints are professionally made on-site. And prints can be easily ordered online via the Internet.

By the way, have you wondered why digital cameras are smaller in size and lighter in weight than film cameras? A main reason is that no space is needed to hold a roll of film and its take-up spool. Also, the mechanized autowinder or motor drive that advances the film and recocks the shutter is not necessary. So let's praise microchips for making digicams more electronic than mechanical and very convenient to carry around.

OPENING THE CAMERA BOX

When you buy a digital camera and open the packaging, there is more than a camera inside. You'll usually find a memory card,

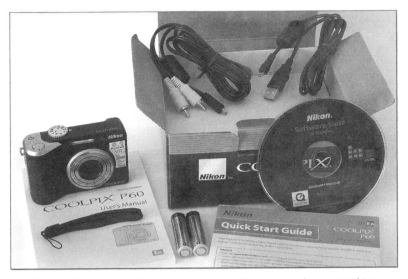

1.6. The box with your new digital camera has everything you need to start making pictures immediately and to download the images to your computer for printing or electronic display.

batteries or a battery pack, a wrist strap or neck strap, connecting cables, a compact disc (CD) or two, an instruction manual and the quick start guide. Some models also come with a camera docking station or cradle. In addition, there will be a battery charger if a rechargeable battery pack is provided.

Digital cameras are crammed with tiny electronics that may malfunction if you drop or bang the camera around. Some point-and-shoot models are so small that they easily slip out of your hand, and SLR (single lens reflex) models with interchangeable lenses can be heavy to hold. Use the wrist strap or neck strap, and always remember to treat your camera with care.

We suggest the first thing you do is attach the WRIST STRAP or NECK STRAP to your new camera. Don't wait until you've dropped the camera, and then wish you had installed its safety strap.

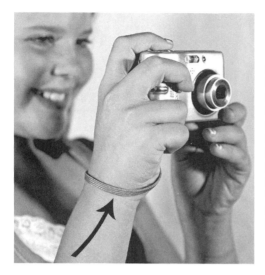

1.7. Whenever you're going to use your camera, be sure to slip its wrist strap (see arrow) around your wrist or its neck strap around your neck. Accidentally dropping a camera may ruin that little electronic marvel, and your day. Be safe instead of sorry—always remember to wear the camera strap. Read about other ways to protect your camera in chapter 5.

The MEMORY CARD stores the images captured by your camera; some digicams also will record sound on the card. There are several types of these small cards, but only one type (and sometimes two) will fit your particular model. If a memory card comes with your camera, consider it a "starter" card because of its limited capacity. Soon you'll want to buy another card or two with larger capacities so you won't have to stop taking pictures when the card gets full.

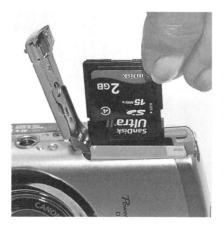

1.8. To record digital images, you must first insert a memory card into your camera. A flap on the bottom of this point-and-shoot model covers compartments that hold the card and the camera battery pack. Read more about memory cards in chapter 3.

The memory card slips into a slot in your camera that is accessed by a small door or flap. The card goes into the camera only one way; orient it according to the camera's instructions and don't force it. Handle the card carefully (it's holding your pictures!) and keep your fingers off its gold metal contact area. When out of the camera, always store the card in its little plastic case for safety. Memory card types and capacities are described in detail beginning on page 59.

Your camera needs BATTERIES to operate. It may require a single battery pack or two to four AA or AAA batteries. The batteries supplied will be either the replaceable type or the rechargeable type. Rechargeable batteries must be charged before their initial use; use the battery charger or camera dock that may be supplied with your camera, or buy a battery charger specifically designed for your batteries.

Batteries are installed in your camera behind a small door or flap; they may be in the same compartment with the memory

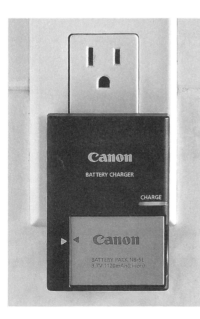

1.9. Some cameras are supplied with a battery pack and a battery charger. The battery pack must be charged by electrical power before its first use; look in the camera instruction manual for the charging time required. Read more about camera batteries in chapter 3.

card. Always make certain the camera is turned off before install-ing or removing batteries. Take care to insert batteries according to the camera's instructions so they make proper contact to sup-ply power. Test that they work by turning the camera on. Battery types and usage are described in detail beginning on page 66.

The CONNECTING CABLES that come with your camera serve two purposes. The most important is a USB (UNIVERSAL SERIAL BUS) CABLE that connects the camera to a computer so you can download your photos from the memory card. A few SLR mod-els use a FIREWIRE (IEEE 1394) CABLE that transmits images faster than a USB cable.

A protective flap on the camera opens so the small end of the USB or FireWire cable can be plugged in. Once the photos (more correctly called IMAGE FILES) are transferred to your com-puter's hard drive, you can erase (reformat) the memory card in your camera for future shots.

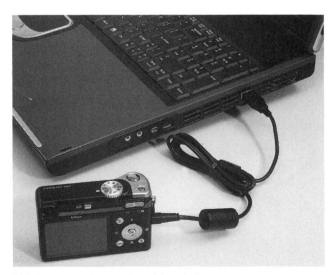

1.10. Pictures can be transferred directly from your camera to a computer via a connecting cable that plugs into USB ports on both devices, as shown here.

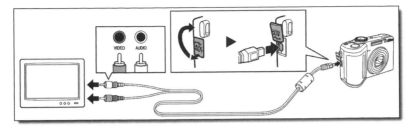

I.II. Most cameras (except SLR models) are supplied with an audio/video (A/V) cable so you can show your still pictures and video clips (movies) on a TV screen. One end of the cable plugs into a flap-covered socket on the camera, and the other two color-coded ends plug into video (yellow) and audio (white) sockets on the television set. Read more about displaying your photos on TV in chapter 17. (Illustration courtesy of Nikon Corporation.)

The other connecting cord supplied is an AUDIO/VIDEO (A/V) CABLE or VIDEO CABLE that will connect your camera with a television set so pictures on the memory card can be viewed on the TV screen and any sound recorded by your camera can be heard on the TV speakers. (Some cameras only transmit the pictures, not the sound.) A protective flap on the camera opens so the audio/visual or video cable can be plugged into the output socket. At the TV end, the video input socket is yellow and the audio input socket is white.

If a CAMERA DOCKING STATION or cradle is provided (or available as an optional accessory), the audio/video and USB cables are connected to the dock instead of to the camera. The camera is then placed in the dock to easily make various connections: to a TV set to view your photos, to a computer to transfer the image files (photos) to its hard drive, and even to a desktop printer to print your pictures. If your camera uses rechargeable batteries, the docking station also serves as a battery charger when its AC adapter is plugged into an electrical outlet.

Some cameras include an AC ADAPTER that you plug into an electrical outlet, or often one is available as an optional accessory. When connected by a cord to your camera, the AC adapter

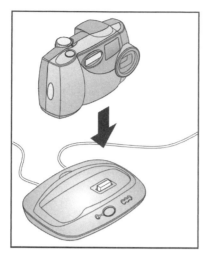

1.12. Some cameras are designed with electrical contacts on the base so they can be put onto a compatible camera dock that is connected by cables to your computer, printer, and/or TV set. This provides easy downloading or viewing of all the images on the camera's memory card. Read more about camera dock connections in chapters 11 and 17. (Illustration courtesy of Eastman Kodak Company.)

instead of the batteries powers the camera. Although it will not recharge the batteries, an AC adapter prevents battery drain. Be sure to attach only the AC adapter designated for your camera because one with a higher voltage could damage the camera permanently.

An AC adapter is worth using when you download images from the memory card to your computer via a USB cable, which can take considerable time. Also, an AC adapter will spare the camera batteries whenever you settle down to review photos on the LCD monitor and take time to erase (delete) some of them. It's also worthwhile to use the AC adapter when taking pictures if your camera is near an electrical outlet and stationary for some time, as when doing tabletop photography or making portraits indoors.

One or two important CDs will be found in your camera box. Included on a compact disc is software to download the image files from your camera to your computer. Install that software on your computer first before connecting your camera to the computer with the USB or FireWire cable. With the image-editing software that's on the CD, you can improve and resize

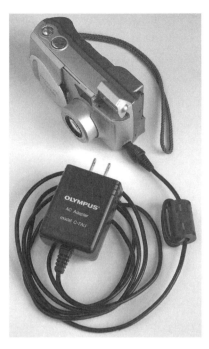

1.13. To save your camera batteries when reviewing many pictures on the LCD monitor or downloading the images via a connecting cord to your computer, an accessory AC adapter can be plugged into the camera (as shown here) and then into an electrical outlet in order to provide power.

the photos before you e-mail or print them. The CD may also include the instruction manual and quick start guide, in case you misplace the printed copies packed with your camera.

1.14. A CD packed with your new camera includes software for transferring pictures from the camera to your computer as well as an image-editing program for organizing, improving, and printing them. The CD may also include an electronic version of the printed instruction book that comes with the camera.

By the way, a few camera makers, including Nikon, incorporate a HELP FEATURE in some of their models. When a menu appears with a question mark (?) icon on the LCD monitor, you can press a button that displays a brief explanation of the option you've selected on the menu. Consult your camera manual for specific information about the "Help" feature, if available.

Here's a tip: If you lose your printed instruction manual or the CD that may have an electronic copy, go to the camera manufacturer's Web site. You'll discover that instruction manuals for most models are available online and can be viewed or downloaded on any computer. Look for "support," or enter your camera's model name and number in "search." Be sure to remember this if you have camera problems or questions while traveling and have left the instructions at home.

MAKING YOUR FIRST DIGITAL PICTURES

Okay, you've attached the wrist strap or neck strap, inserted the memory card, and loaded fresh or recharged batteries into your camera. Turn the camera on, follow the next steps in the quick start guide, and then shoot your first pictures.

The good thing about digital cameras is that they can be fully automatic. Just point and shoot. Of course, there are dozens of camera settings you can choose (which we describe in upcoming chapters), but the factory default settings let you take some initial shots without much thought.

Better yet, you can see the results immediately. And best of all, it doesn't cost anything if you don't like the photos. Just erase them. If you're used to shooting film, being able to snap away without paying for your mistakes will be a relief. Once you leap into digital photography, there is no need to think about the number of times you press the shutter button.

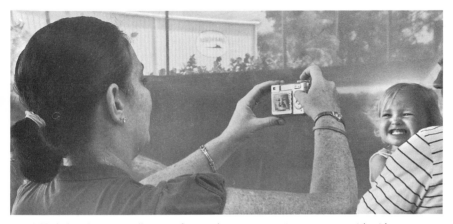

1.15. A digital camera will set you free to shoot as many pictures as you wish without worrying about wasting money. If you don't like the results, erase those images and keep shooting some more. Read about the best way to delete pictures from a memory card in chapter 3.

After explaining how to load batteries and the memory card in your camera, quick start guides cover how to make an exposure and then review the photo you've just taken. (Often the basic steps for downloading the photos from the camera to your computer are also described.)

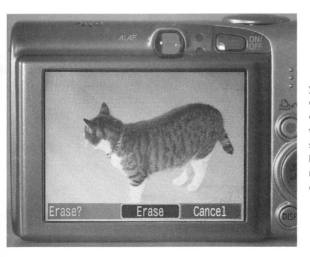

1.16. If you don't like a picture you're reviewing on the camera's LCD monitor, you can instantly erase the image with a menu command, as shown here; some cameras have an erase button. Read more about erasing images in chapter 3.

Being carefree instead of cautious is one of the joys of learning to use your digital camera. Shoot away. Try different settings, and instantly see the results. Don't like it? Erase the shot and try something else. Rather than worry about the outcome, become familiar with your camera by shooting and shooting and shooting.

Every camera has buttons and/or sliding switches and/or rotating knobs, most often located on its top and/or back. The first to find is the one that turns the camera on and off; some models turn on when you slide open the lens cover.

Next, you may need to use the button that activates the camera's "taking" or SHOOTING MODE, as opposed to its "reviewing" or PLAYBACK MODE that shows the picture on the LCD monitor after an exposure is made. (Some camera makers call the shooting mode the RECORDING MODE or PHOTOGRAPHY MODE.)

Activating the shooting mode may turn on the LCD monitor with a live view of your subject. However, we strongly recommend using only the camera's viewfinder (if available) for easier and better composition of your picture and to avoid significant battery drain whenever the LCD is on.

Next, with your finger on the topside shutter release button, press fully down to activate the autofocus and auto-exposure settings and to make the exposure. Hey! There's a problem— you pressed the button all the way down, but it took a second or two before the shutter opened. And your subject moved or changed expressions before the picture was made.

You've just experienced the greatest frustration with most lower-cost digital cameras: SHUTTER DELAY. Sadly, point-and-shoot and other compact models commonly suffer from this malady; the more expensive SLR cameras do not. You'll read more about shutter delay, and how to overcome it, beginning on page 186.

1.17. Composing pictures on the LCD screen with the camera held away from your face is a common reason for blurred photos caused by camera shake. To keep the camera steadier, we recommend you use its viewfinder (if available) instead of the LCD monitor. Composing pictures will be quicker, too. Read more about viewfinders, LCDs, and camera shake in chapter 2 and composition in chapter 10.

Once an exposure is made, it usually appears briefly on the LCD monitor. Most often you have to push the playback button or switch to keep the picture visible on the LCD screen. Even if the monitor is large, it may be difficult to see the details of your image. But usually you can tell if the composition is poor or your subject moved or the picture is overexposed or under-exposed. If you don't like what you see, shoot again.

Remember that your quick start guide is only the beginning. It makes you feel good to shoot and see pictures soon after you've

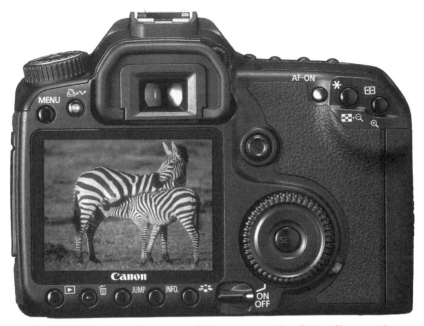

1.18. Whether shooting with a point-and-shoot, prosumer (professional/consumer), or single lens reflex camera (like this Canon SLR), it is worthwhile checking your results on its LCD monitor. Using the playback mode gives you time to study the image and decide if you want to shoot the picture again. Read more about LCD monitors in chapter 2.

opened the camera box for the first time. But don't be satisfied with your initial digital camera experience. There is much, much more to learn to fully enjoy your digicam and enhance your creative photographic abilities.

Among the many subjects to understand are pixels, resolution, file formats, ISO settings, white balance, optical and digital zoom, interpolation, flash range, exposure modes, parallax error, spot metering, image stabilization, focal length, index mode, histograms, artifacts, burst rate, recycle time, depth of field, and more. So take a deep breath, and read on.

Thumbing through a digital camera instruction manual is likely to overwhelm you. Thanks to today's incredible computer

1.19. You'll be surprised by all the things your camera can do, even if it is a point-and-shoot model. Only by studying the instruction manual will you learn how to successfully operate the camera and take advantage of the many features that make digital photography so enjoyable.

chip technology, even the least-expensive point-and-shoot models have dozens of features and settings. You may utilize only a few of them for the types of photography you do, but it is worthwhile to learn about every feature and setting so you know the potential of your particular camera and can become a better photographer.

Knowledge is power, especially if you want to go beyond the snapshot stage and become a real photographer. That means you should have your camera in one hand and its instruction manual in the other, and learn all the camera's features step-by-step. This will take time. Please don't think you can conquer the camera and get beautiful pictures by intuition alone.

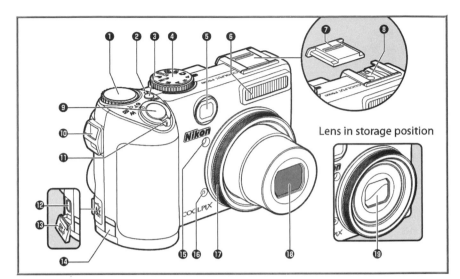

Lens in storage position

1 Command dial	**11** Zoom control
2 Power-on lamp	▦ (thumbnail playback)
3 Power switch	Q (playback zoom)
4 Mode dial	❷ (help)
5 Viewfinder	**12** Cable connector
6 Built-in flash	**13** Connector cover
7 Accessory shoe cover	**14** Power connector cover for
8 Accessory shoe	optional AC adapter kit
(for optional flash unit)	**15** Self-timer lamp
9 Shutter-release button	AF-assist illuminator
10 Eyelet for camera strap (×2)	**16** Microphone
	17 Lens ring
	18 Lens
	19 Lens cover

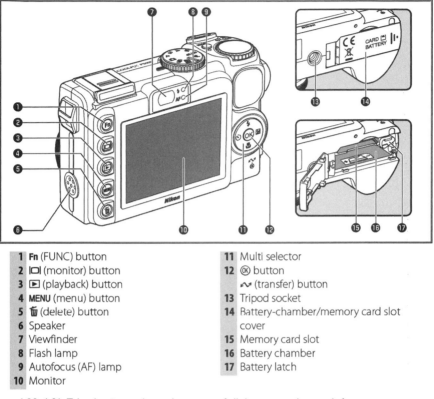

1	**Fn** (FUNC) button	11	Multi selector
2	▢ (monitor) button	12	⊛ button
3	▶ (playback) button		⁀ (transfer) button
4	**MENU** (menu) button	13	Tripod socket
5	🗑 (delete) button	14	Battery-chamber/memory card slot
6	Speaker		cover
7	Viewfinder	15	Memory card slot
8	Flash lamp	16	Battery chamber
9	Autofocus (AF) lamp	17	Battery latch
10	Monitor		

1.20–1.21. Take the time to learn the names of all the parts and controls for your camera. Study the instruction manual's diagrams, like these for a Nikon COOLPIX model, and then become familiar with everything on your actual camera. (Illustrations courtesy of Nikon Corporation.)

In the next few chapters, we discuss digital cameras in detail— the different types, their unique features, and their peculiarities. Then we follow with descriptions of the various camera settings you should understand in order to get the most of out of your camera and really enjoy digital photography.

2

Choosing a Digital Camera

THREE TYPES OF DIGICAMS

How do you decide which digital camera is best for you? It depends on the kinds of photographs you intend to make. Are they just record shots of birthdays and vacations? Or perhaps images for the Web site of your business? Or will they be works of art worthy of framing?

There are three basic types of digital cameras. DIGICAMS, as digital cameras are also known, are most often categorized as POINT-AND-SHOOT, PROSUMER, and SINGLE LENS REFLEX (SLR) models. Those labels generally reflect their relative physical sizes (small, medium, and large) as well as their relative price levels (low cost, midrange, and high end).

POINT-AND-SHOOT (P&S) CAMERAS are just that. They are the Kodak Brownie cameras of our computer age. P&S models are generally associated with amateur photographers who like no-thought picture taking and are content with so-called snap-shots. These small cameras are also known as COMPACT CAMERAS and CONSUMER CAMERAS. The built-in zoom lens on many P&S models retracts into the camera body when the camera is turned off.

2.1. The most popular type of digital cameras are point-and-shoot (P&S) models, which come in many shapes and sizes. They are convenient to carry and can produce some very pleasing pictures.

PROSUMER CAMERAS are digital cameras designed for more advanced photographers who fall between amateurs and professionals in regard to their photographic interests and abilities. These digicams are also known as PRO-AM CAMERAS. They include ZOOM LENS REFLEX (ZLR) CAMERAS, which resemble SLR cameras but feature a built-in zoom lens instead of allowing lenses to be interchanged.

2.2. Prosumer cameras offer more features and controls than point-and-shoot models but are less versatile than single lens reflex (SLR) cameras. They have an optical or electronic viewfinder that helps you compose pictures by looking directly through the built-in zoom lens.

SLR CAMERAS are designed for those who make their living as professional photographers and for serious photo enthusiasts. A significant advantage is that the lenses on these versatile cameras can be removed and interchanged with other types of lenses, like when you go from a wide-angle lens to a telephoto lens. SLR cameras produce the highest-quality images, are better made than the other types of digital cameras, have all the bells and whistles, and usually are the most expensive.

These also are known as DSLR (DIGITAL SINGLE LENS REFLEX) CAMERAS to distinguish them from SLR cameras that use film. However, because this book is all about digital photography, we refer to digital single lens reflex cameras simply as SLRs.

In addition to the three basic types of digital cameras described above, there are increasingly common CAMERA PHONES, which are mobile (cell) phones with built-in digital cameras. And there are expensive DIGITAL CAMERA BACKS with image sensors that attach to MEDIUM-FORMAT and LARGE-FORMAT CAMERAS for professional work in the studio or on location.

2.3. Single lens reflex (SLR) cameras are the choice of professional photographers and other photo enthusiasts who want to get the most from digital photography. Interchangeable lenses are a major feature of these cameras. See also illustration 2.10.

BUYING YOUR CAMERA

The most important thing you should do before purchasing a digital camera is try it out. Go to a store where they allow hands-on inspection of cameras. As you handle any camera model for the first time, here are a few questions to consider:

1. Does it feel comfortable in your hands?
2. Is it too heavy or too light, or too large or too small?
3. Are the camera controls easy to reach and to operate?
4. Can you see your subjects clearly in the viewfinder?
5. How do images look on the LCD monitor?

Once you've found a model or two you like, get on the Internet to research those cameras and compare them with others. Type the brand name and model of each camera into a search engine. Don't only trust salespeople for advice. There are hundreds of camera models with so many different features that you can't expect a salesperson to know about all of them. Find out for yourself.

Web sites like www.dpreview.com, www.steves-digicams .com, www.imaging-resource.com, and www.cnet.com feature detailed camera reviews and list all the specifications so you can get professional evaluations as well as check camera features and technical details. Also visit camera manufacturers' Web sites to make comparisons of specific models that interest you. (See page 475 for a list of camera makers and their Web addresses.)

In the United States, digital cameras normally include a one-year manufacturer's LIMITED WARRANTY for repairs due to defects in materials or workmanship. We advise you to save money by not buying an in-house extended warranty for repairs to be made by the store *after* the regular manufacturer's warranty

2.4. The Internet makes it easy to research and compare digital cameras before you buy one. Among the popular Web sites with camera and equipment reviews is dpreview .com; see text for others.

expires. Digital cameras rarely break unless you drop them or get them wet (and an extended warranty wouldn't cover those types of damage anyway). If your online research reveals that a certain model has had chronic troubles, such as an LCD monitor screen that cracks after a brief time, don't buy that camera in the first place.

Searching the Internet is an excellent way to compare camera prices. Whether you buy online or at a local store, ask about the return policy in case you don't like the camera after you've actually used it. Beware of restocking fees that may be charged for returned merchandise.

THINGS TO KNOW ABOUT DIGITAL CAMERAS

Digital cameras are manufactured by the traditional film camera makers, such as Canon, Kodak, Olympus, Nikon, Fujifilm, Pentax, Ricoh, and Leica, but also by consumer electronics firms that have entered the game, including Sony, Samsung, Panasonic, HP, Sanyo, and Casio. Among the other brands of digital cameras are Vivitar, Polaroid, and Argus. (Two long-standing brands, Minolta and Konica, were merged into one company but got out of the camera business in 2006.)

Advertisements for digital cameras often highlight a few key aspects that you need to be familiar with. For instance, you might read a camera ad listing features like these:

8 Megapixels (MP)
3× Optical Zoom (35mm equivalent: 35–105 mm)
4× Digital Zoom
2.5-inch LCD Monitor
Optical Viewfinder

What do the names and numbers mean? Following are explanations of the important features you'll encounter when buying any digital camera: megapixels, optical zoom, digital zoom, LCD monitors, and optical or electronic viewfinders.

SOLVING THE PIXEL PUZZLE

Newcomers to digital photography will find that cameras are commonly judged by the number of megapixels (MP) they have, such as 8 MP. This is referred to as a camera's MEGAPIXEL RATING. Megapixel ratings, which currently range from 5 to 24 MP, appear in advertisements, on camera boxes, and sometimes on

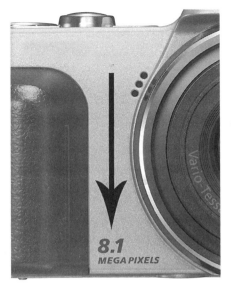

2.5. The megapixel (MP) rating of a camera is an indication of the potential quality of its pictures. As shown here (see arrow), the MP number often is inscribed on the camera body itself.

the cameras themselves. In general, the higher the MP number, the better the quality of the pictures produced by the camera.

What does the megapixel (MP) rating actually mean? Technically, a megapixel equals 1 million pixels, so a 5 MP camera will have 5 million pixels. A 10 MP camera will have twice as many pixels, or 10 million. Okay, so what is a PIXEL? The word was created from two words that give pixel its literal meaning: "picture element." As such, and most important to remember, *pixels are the tiny building blocks of all digital images.*

In a camera, pixels refer to light-sensitive diodes called PHOTOSITES, which are the minuscule receptors that receive the light focused through the camera lens to make an image. The pixels are lined up in a rectangular grid on what is called an IMAGE SENSOR, a small solid-state device that is a silicon computer chip.

An IMAGE SENSOR takes the place of photographic film in digital cameras. Like film, the sensor reacts to light coming through

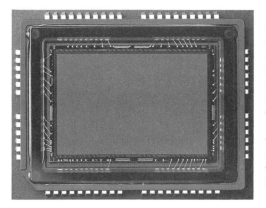

2.6. This uninstalled image sensor from a single lens reflex (SLR) camera is surrounded by electronic contacts that make it function. Although its longest dimension is less than one inch, the tiny sensor has 10.8 million pixels (unseen on the gray screen). Those pixels react to light passing through the lens to create a digital image.

the lens to record an image that must be processed in order to be seen. Instead of being processed with chemicals like images on film, digital images are processed electronically in the camera and then recorded on the camera's memory card as IMAGE FILES. The electronic data in those files produce your digital pictures.

Over the years, camera makers have consistently increased the number of pixels on image sensors. The first digital camera we owned was a point-and-shoot model with 1.3 MP (1.3 million pixels); the minimum number of megapixels in many P&S cameras nowadays is 5 MP (5 million pixels). At the top end is an SLR camera that boasts 24.6 MP (24.6 million pixels)!

The manufacturers' megapixel mantra has always been "more is better." But increasing the number of pixels on an image sensor has some limitations. Initially, adding more pixels meant increasing the size of the image sensor, which in turn meant increasing the size of the camera (as in the SLR models). However, many photographers would rather not carry big cameras.

So camera makers found an alternative. They reduced the size of the pixels themselves so that more pixels would fit on smaller image sensors. That way they could increase the megapixel number and still keep cameras small. As a result, 7 and 8 MP cameras have

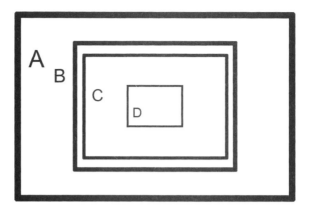

2.7. Image sensors vary considerably in their megapixel ratings (see text) as well as in their relative physical sizes (shown here). Largest is the full-frame sensor (A) found in a few single lens reflex (SLR) cameras; it measures 36 × 24 mm, which is equal to the size of a frame of 35mm film. Other SLR models have somewhat smaller sensors (B and C), while those in compact point-and-shoot cameras are quite minuscule, including one (D) that measures only 7.2 × 5.3 mm.

become common, and there are increasing numbers of cameras with 10 to 12 MP.

When comparing cameras to buy, you're likely to find moderately priced compact point-and-shoot models with the same number of megapixels as larger prosumer and SLR models that are more expensive. The big difference is IMAGE QUALITY. Because the pixels themselves are bigger in size on the image sensors in larger-size cameras, they collect light com-

Keep in mind that all SLR cameras are not created equal. Those with the largest 36 × 24 mm image sensors are called "full-frame" models (see illustration 2.7 above). Nikon uses FX and DX to indicate the relative sizes of image sensors in its SLRs: "FX format" identifies cameras with full-frame image sensors, while "DX format" denotes models with smaller sensors. (Nikon lenses labeled "DX" are designed especially for Nikon DX format SLRs.)

ing through the lens more effectively, which produces higher-quality images.

Does that mean you must buy an SLR camera in order to make the best digital pictures? Of course not. It all depends on what is best for your photographic purposes. If you are only going to send your photos as e-mails or post them on the Internet for viewing on computer screens, even an early model camera with as few as 1.3 MP will produce acceptable images.

And if you just plan to make 4 × 6 inch snapshot prints to share with family and friends, any digital camera currently on the market will do, as will older models with as few as 2 MP. To make nice 8 × 10 inch enlargements to frame and display, you should have at least a 5 MP camera. Anyone who is going to shoot photos for advertisements in magazines will need a professional SLR camera with 10 MP or more.

You'll note that the technical specifications for a camera will sometimes list its EFFECTIVE PIXELS. For example, a 7.4 MP camera might be noted to have 7.1 million effective pixels. That's because not all the pixels on the camera's image sensor are represented as pixels in the digital image that results when you make an exposure. The pixels that actually record the image are called effective pixels, and their number is a more accurate indication of the picture quality that is possible with that camera.

As stated earlier, the accepted rule of thumb when buying a camera is that the greater the number of megapixels (or effective pixels, if indicated), the better the picture quality will be. However, when judging cameras by the number of megapixels, be certain the cameras you compare are all of the same type: point-and-shoot, prosumer, or single lens reflex.

If you've never used a digital camera before, the truth is that any model will produce remarkable photographs, especially

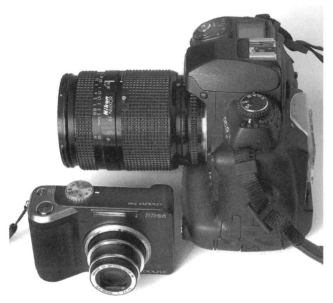

2.8. Many photographers prefer point-and-shoot (P&S) cameras (bottom) because they are smaller in size, lighter in weight, and less costly than other types of digital cameras, especially professional single lens reflex (SLR) models (right).

when compared to snapshots made with film cameras. So don't worry about the megapixel rating of your first digital camera.

ZOOM, ZOOM, ZOOM

All digital cameras have something in common: ZOOM LENSES. They make it easy to compose a picture. A zoom lens lets you increase or decrease the image size of your subjects without physically moving closer to or farther from them.

All point-and-shoot and prosumer models have their zoom lenses permanently attached to the camera. On the other hand, SLR cameras feature INTERCHANGEABLE LENSES, which means the lens can be removed from the camera and replaced with a different lens.

Zoom lenses are adjusted electronically by simply pressing the camera's zoom control switch toward the wide-angle or

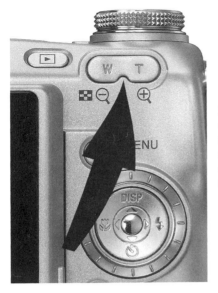

2.9. You press or move the zoom lens control (see arrow) on point-and-shoot and prosumer cameras to adjust the lens to wide-angle (W) or telephoto (T) in order to make the image size of your subjects smaller or larger.

telephoto setting, which is represented by W or T or an appropriate icon, such as three trees (for wide-angle) and one tree (for telephoto). For zoom lenses on SLR models, you twist or push/pull a ring on the lens itself to adjust your subject's image size.

Interchangeable lenses were a revolution in the early days of film cameras because photographers could then mount lenses of different fixed focal lengths—wide-angle, normal, or telephoto—in order to change the image size of their subjects. Zoom lenses that incorporated a range of focal lengths into a single lens were developed later and now are the dominant lenses in photography.

What is LENS FOCAL LENGTH? It is a measure that tells you the relative subject image size that a lens produces. Focal length is commonly measured in millimeters (mm). The larger the number of millimeters, the greater the focal length of the lens. But most important to remember: *The greater the focal length, the larger the subject image size will be.*

2.10. All digital cameras except single lens reflex (SLR) models have *built-in* zoom lenses. SLRs are more versatile because their lenses can be removed and replaced with other lenses of different zoom or fixed focal lengths (see text).

Just in case you'd like to know the technical definition of lens focal length, it is the distance from the optical center of a lens to a point behind the lens where the light rays from an object are brought into focus. That distance usually is indicated in millimeters (mm).

THE RANGE OF ZOOM LENSES

Exactly how much a particular zoom lens can increase the image size of a subject is indicated with a number and a "times" sign, such as 5×. This will be written as "5× Optical Zoom" in camera ads, sales brochures, technical specifications, and sometimes on the lens itself. And 5× means that your subject can be increased up to five times in size when the zoom lens is adjusted from its shortest focal length (wide-angle setting) to its longest focal length (telephoto setting).

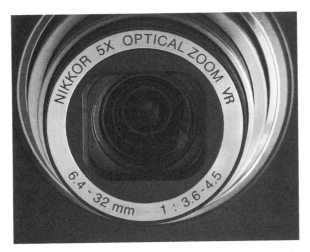

2.11. The focal length range of a built-in zoom lens is often inscribed on the lens ring, as it is here: 5×. This means the image size of your subject can be increased up to five times as you adjust the zoom from wide-angle to telephoto. The specific range is also inscribed: 6.4–32 mm.

How else can you easily tell the optical zoom lens range of any digital camera? First, look at the front of the lens for a pair of numbers separated by a dash and followed by "mm" (for millimeter). Then divide the larger number by the smaller one. For example, if the camera with an attached zoom lens shows a focal length range of 5.8–17.4 mm, divide 17.4 by 5.8 to discover that it is a 3× zoom lens.

The same is true for interchangeable lenses on SLR cameras. However, because SLR cameras and their lenses are physically larger, so are the focal length measurements. Thus an SLR zoom lens marked 35–105 mm will also be a 3× zoom (105 divided by 35 equals 3).

The majority of zoom lenses have a focal length range of 3× or 4×. Some are 5× or 6×. A few are called SUPERZOOMS because they have an extreme range from wide-angle to telephoto, such as 10×, 12×, or even 18×.

OPTICAL ZOOM VERSUS DIGITAL ZOOM

It is important to remember that OPTICAL ZOOM refers to the actual zoom lens on your camera. Be careful not to confuse it with DIGITAL ZOOM, which also is cited in camera ads and literature and is preceded by a magnification factor, such as 4× or 8×. A camera's digital zoom feature is a way to increase the image size of your subject after you've reached the telephoto limit of the camera's optical zoom lens.

However, instead of increasing the image size *optically* as the zoom lens does, digital zoom increases the image size *electronically* by enlarging the center portion of pixels on the camera's image sensor. The result is inferior in picture quality when compared with using only the optical zoom lens to increase a subject's image size.

Many photographers will tell you to avoid using the digital zoom feature, but you should at least try it and see how you like the results with your particular camera. However, you should also be aware that you can later use IMAGE-EDITING SOFTWARE

2.12. A camera's "digital zoom" increases the size of your subject electronically (rather than optically), which can degrade the image. You can avoid using the digital zoom by turning it off; a menu on the camera's LCD monitor should offer that option.

Take note that digital zoom is only found on cameras with permanently attached lenses; there is no such feature on digital SLR models that use interchangeable lenses.

on your computer to enlarge your subject to equal any size that could be created by the digital zoom feature. That's the option we favor if we want a greater image size than is possible with the camera's optical zoom lens.

What is most important is not to be misled by ads listing a camera's TOTAL ZOOM or COMBINED ZOOM. Camera manufacturers simply multiply the optical zoom (say 3×) and digital zoom (say 8×) together in order to tout a larger number (such as 24×). They figure the greater the zoom range they advertise, the greater the camera's sales. But "total zoom" is more of a marketing ploy than an honest indication of the camera's true zoom range.

Our advice: when considering what camera to buy, compare only the optical zoom range of various models, not the digital zoom range or the total zoom range.

WHAT'S THIS "35MM EQUIVALENT"?

You'll notice when advertisements list a camera's optical zoom range, such as 3×, it is often accompanied by a pair of numbers identified as the 35MM EQUIVALENT. Camera makers figure that many people have used 35mm film cameras, so they relate the optical zoom range to lens focal lengths that might be familiar from the past. (Lens focal length was described on page 31.)

For example, an ad for a point-and-shoot camera with a

5.8–17.4 mm zoom lens might state: "3× Optical Zoom (35mm equivalent: 35–105 mm)." To former 35mm film camera users, that signifies that the digital camera will produce images ranging from a minimal wide-angle, 35mm, to a moderate telephoto, 105mm, ANGLE OF VIEW.

The angle of view, also called FIELD OF VIEW in some camera manuals, is an indication of the subject area a lens will cover, as measured in degrees (°). In this case, the lens equivalent to 35–105 mm will cover angles that narrow from 63° at the wide-angle setting to 23° at the telephoto setting. It is important to remember that *the smaller the angle of view the larger your subjects will appear* in the camera's viewfinder or on the LCD monitor.

You'll soon discover a frustrating drawback with digital cameras: the wide-angle range is quite limited (unless you are using a full-frame SLR). This is especially bothersome to photographers who like to shoot landscapes and architectural images.

The 35mm equivalent of the widest angle you can cover with most digital cameras is 35mm, which has a 63° angle of view. Only a few models will cover the 35mm equivalent of a 28mm wide-angle lens, which has a 75° angle of view. By comparison, extreme 14mm wide-angle lenses for full-frame digital SLR cameras have an angle of view as great as 114°. See the chart on the opposite page for angles of view for other lens focal lengths.

SPECIAL CONCERNS FOR SLR CAMERA LENSES

First, some good news for photographers who have a single lens reflex 35mm *film* camera with an assortment of lenses. You may be able to use those same lenses on a digital SLR camera, particularly those models made by Canon and Nikon. That saves money because you only need to buy an SLR digital camera body.

ANGLES OF VIEW OF LENSES

The angle of view—how much area will be included in a picture—is given in degrees (°) and varies according to the focal length of the lens (or the focal length setting on a zoom lens), which is given in millimeters (mm). More area will be covered by wide-angle lenses or zoom settings, less area by telephoto lenses or zoom settings.

The following angles of view are given for the "35mm equivalent" focal length or focal length zoom range stated by manufacturers for some digital lenses, and they are the same for the focal lengths of lenses designed for *full-frame* single lens reflex (SLR) digital cameras or 35mm film cameras.

Lens Focal Length in millimeters (mm)	Angle of View in degrees (°)	Lens Focal Length in millimeters (mm)	Angle of View in degrees (°)
13 mm	118°	100mm	25°
14	114	105	23
15	110	135	18
16	115	150	16
17	104	180	14
18	100	200	12
19	96	210	11
20	94	250	10
21	90	280	8.5
24	84	300	8
28	75	350	7
35	63	400	6
50	45	500	5
60	39	600	4
75	32	800	3
80	30	1000	2.6
85	28	2000	1
90	27		

Also, if you are fortunate to shoot with one of the few *full-frame* digital camera models available, it will have an image sensor the same size as a frame of 35mm film, as we mentioned earlier. That means the subject image size recorded by the digital camera will be identical to the subject image size captured by a 35mm film camera when the same lens is used. In other words, a 20mm lens on a full-frame digital camera will act just like a 20mm lens on a 35mm SLR film camera.

However, that's *not* true for all the other digital cameras. Because their image sensors are smaller than a frame of 35mm film, the lenses won't produce the same subject image size. Only a portion of what the lens sees will be recorded by the smaller sensor, which increases the apparent size of the subject. As such,

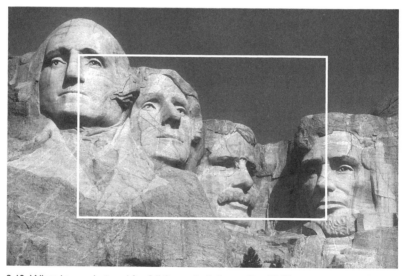

2.13. When lenses designed for *full-frame* single lens reflex (SLR) cameras are used on SLRs with smaller image sensors, only a center portion of the image from that lens is recorded, as shown here by the white frame. A crop factor (such as 1.3, 1.5, or 1.6, depending on the sensor size) is used to calculate the apparent increase in the effective focal length of the lens, which narrows the angle of view recorded by the image sensor (see text).

putting any SLR camera lens on a *non-full-frame* SLR increases the EFFECTIVE FOCAL LENGTH of the lens. (The actual focal length of the lens itself does not change.)

> The effective focal length of a lens on any SLR digital camera except full-frame models is determined by what is called the CROP FACTOR, which is a reference to "cropping" the digital image from the center of a 35mm film frame. Sometimes this is termed a FOCAL LENGTH MULTIPLIER or a MULTIPLIER FACTOR.

The crop factor is a number that varies according to the specific size of a camera's image sensor. The factor frequently is 1.5 or 1.6 but can range from 1.25 to 2.6. To determine the *effective* focal length of a lens, you multiply the *actual* focal length of the lens by the crop factor.

For example, a 28mm wide-angle lens used on a digital SLR camera with a crop factor of 1.5 would act like a 42mm lens (28 × 1.5 = 42). Likewise, a 200mm telephoto lens used on a camera with a 1.5 crop factor would effectively become a 300mm lens (200 × 1.5 = 300).

Actually, you don't have to do the math because camera and lens manufacturers and reviewers publish the EFFECTIVE FOCAL LENGTH (also called the EQUIVALENT 35MM CAMERA FOCAL LENGTH) to help experienced 35mm film photographers better relate to the actual coverage of the lens on digital SLRs. For example, a 24–120 mm zoom lens would act like a 36–180 mm lens on a digital SLR that has a crop factor of 1.5.

As you might expect, crop factors are welcomed by photographers who make telephoto pictures because their subjects will appear larger. But crop factors are disliked by photographers using wide-angle lenses because the angle of view is reduced.

Here's something else to keep in mind. While lenses made for

2.14. Be aware of vignetting—dark corners in your pictures—caused by any obstruction that keeps light from reaching the camera's image sensor. This can happen when some lenses for digital SLR cameras are used on *full-frame* models (see text). Also watch out for attachments in front of the lens, such as a lens converter (see chapter 4) like the one that caused the dark corners in this picture of a tour guide in historic Petaluma, California.

35mm film cameras might also work on digital cameras, lenses designed specifically for digital cameras will not work satisfactorily on full-frame digital (or 35mm film) models.

Because image sensors in most digital SLR cameras are smaller than 36 × 24 mm, which is the size of a frame of 35mm film, those lenses will not cover the entire image sensor in a full-frame digital SLR. The result is unwanted VIGNETTING, which is the effect of dark corners and edges around your photos.

Our advice: if you expect someday to splurge and step up to a full-frame digital SLR, don't buy any SLR lens that is designed only for digital cameras with image sensors smaller than full-frame; i.e., 36 × 24 mm. Otherwise, all the photos made with your new full-frame SLR will be vignetted.

BIGGER LCD MONITORS ARE BETTER

A familiar selling point for any digital camera is the size of its LCD monitor. As a rule, the bigger the better. This full-color miniature viewing screen has two basic purposes: to help you compose pictures and to enable you to review the results. It also displays electronic menus for many of the operational settings you make on a digital camera.

Be aware that the inherent design of SLR models does not allow you to preview images on the LCD monitor before making an exposure, unless the camera has what is called a LIVE VIEW feature (see page 50).

Known best by the abbreviation LCD, these LIQUID CRYSTAL DISPLAYS have improved considerably over the years. The most significant improvement is their size, which increased from little more than 1 inch (2.54 cm) in early models to as much as 3.8 inches (9.65 cm) currently.

2.15. A large LCD monitor on your camera makes it easier to compose pictures in the shooting mode and then review them in the playback mode. This Panasonic model has a 3-inch screen, measured diagonally.

Take note that LCD monitor screens are rectangular and their size is mea-
sured diagonally from corner to corner. You'll see the monitor's size listed
in camera ads and on camera boxes, such as "2.5-inch LCD."

Another improvement to LCD screens has been an ANTIRE-
FLECTIVE COATING to reduce glare and help make images easier
to see. Many photographers prefer matte LCD screens to glossy
screens. Some cameras allow you to adjust the brightness of the
LCD monitor so that images can be seen better in direct sun-
light and in low light.

In descriptions of a camera's LCD monitor, you'll often see
reference to its VIEWING ANGLE; the wider the angle (sometimes
expressed in degrees), the better for viewing the screen at an
angle from the side. Regardless, in order to see the picture in its
full brightness and color, your line of vision should be perpen-
dicular to the screen; the image may appear faded if you view it
at less than a right angle.

While most LCD monitors are mounted flat on the back of
the camera body, some are designed so they can be flipped out
and tilted up and down for easier viewing in awkward situations.
This ARTICULATING LCD SCREEN is commonly called a "twist-

2.16. An articulating LCD monitor is helpful because it can be pulled away from the
camera body and then tilted up and down so you can compose pictures with the camera
held below or above eye level.

and-tilt LCD," and it is especially useful when doing close-up (macro) photography.

An adjustable LCD screen also helps you compose pictures in difficult situations, as when shooting a parade by holding the camera high over the heads of the crowd. And it makes it easier to position the camera at low angles without crouching down or getting on your stomach, as when photographing children or pets at their own levels.

As digital camera LCD monitors have increased in size, some camera manufacturers have eliminated the traditional viewfinder from their point-and-shoot models. That's a shame. *In fact, we recommended you never buy a digital camera without a viewfinder.*

Here are some reasons why your camera should have a VIEW-FINDER. Even if the camera has a really big LCD screen, you'll soon discover you cannot see well enough—especially in bright sunshine or low-light conditions—to properly compose a picture.

2.17. Often it is easier to compose pictures through a viewfinder instead of looking at the LCD monitor. Also, you can hold the camera steadier when it is braced against your face. See the text for the other advantages of having a digital camera with a viewfinder.

Stray light and distractions in your peripheral vision make composition difficult when you are holding the camera out in front of you to view your subject on the LCD monitor. Also, your eyes will find it troublesome to keep shifting their focus between the subject and the LCD screen when trying to compose a picture.

Instead, put the viewfinder up to your eye, just as everyone used to do with film cameras. Like blinders on a horse, this concentrates your attention on the subject and makes it much easier and faster to compose the best picture.

Another good reason not to use the LCD monitor for composition is that it's difficult to keep a camera steady (and level) when held at arm's length. With your eye in the viewfinder, as we recommend, the camera is pressed to your face for support. That means there is less chance of CAMERA SHAKE, the major reason for blurred pictures. Some digital cameras have an anti-shake feature to offset inadvertent camera movement, but that technology isn't foolproof.

You should also be aware that using the LCD screen causes the biggest drain on your camera batteries; an optical viewfinder (see page 46) requires no power. By using the monitor mostly for reviewing your pictures after you press the shutter release, instead of composing your pictures on the LCD screen, you will greatly extend the life of the batteries in your camera.

After making an exposure, always keep in mind that the resulting picture may not be as sharp as it appears on your camera's LCD monitor. The relatively small screen—and poor viewing conditions in bright light—makes it difficult to see if the image is blurred because of camera shake, inaccurate autofocusing, or inadvertent movement of your subject.

When looking at a camera's LCD monitor, an LCD SHADE or HOOD can help block extraneous light so you can see the image better. The hood or shade is a built-in feature of a few digital cameras, and they are also sold as accessories. Some fold flat against the screen

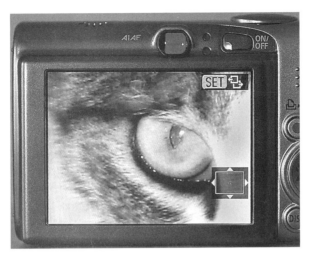

2.18. Although most cameras allow you to magnify a portion of a recorded image to check its sharpness, the LCD monitor is too small to make a critical assessment. (The eye of a cat has been enlarged here.) Only by viewing the image at full size (100 percent) on your computer monitor can you tell if it is truly sharp or not.

2.19. You can attach an accessory shade or hood to help prevent glare on your camera's LCD monitor, which makes it much easier to see your pictures when shooting or reviewing them. The type shown here folds down to cover and protect the screen when not in use.

to protect it when not in use, while others can be collapsed like a bellows. Many are attached with an adhesive and can be removed without damage to the screen. Others are fastened to the camera using its tripod socket, and some clip on. LCD shades or hoods are available for all sizes of screens and all types of cameras, including SLR models.

> Our advice: before buying a hood or shade for your LCD monitor, be certain to test it on the camera to see if it will really be helpful or, instead, become a hindrance when shooting or reviewing pictures.

CHOOSING A VIEWFINDER: OPTICAL, ELECTRONIC, OR SLR THROUGH-THE-LENS

When viewfinders are mentioned in camera ads and reviews, they are distinguished as either optical viewfinders or electronic viewfinders. We prefer OPTICAL VIEWFINDERS. As the name implies, you look through a little window with glass or plastic optics that mimic much of what the camera's image sensor will record when you press the shutter release button.

Optical viewfinders are easy to use in both bright and dim light, help you concentrate on composing a picture, and do not require battery power. The view will adjust whenever you move the zoom lens control switch toward the wide-angle or the telephoto settings. You should, however, know about two drawbacks.

Most disconcerting is that optical viewfinders in point-and-shoot and prosumer cameras show only about 75–90 percent of what the camera records. That means that more subject area will appear around the perimeter of your pictures than you expected. (A viewfinder's specific coverage is stated in the camera manual and often discussed in camera reviews.)

2.20. When using an optical viewfinder, be aware that a greater subject area than what you see will be recorded by the camera's image sensor, such as that outside the white lines in this picture. Your camera manual should indicate the exact percentage of coverage by the viewfinder.

It's frustrating when you carefully compose a picture in the viewfinder and end up recording parts of the scene that you wanted to eliminate. To combat the problem, zoom in or get physically closer until your subject appears right at the edges of your viewfinder. Make a variety of test shots to compensate for the reduced coverage of the optical viewfinder and see how you like the results. (Of course, you can always crop the picture later with image-editing software on your computer to produce the image you originally envisioned.)

Also be aware that optical viewfinders in point-and-shoot cameras cause what is termed PARALLAX ERROR. When making close-ups, what you see is often *not* what you get. That's because the viewfinder is in a different position than the camera lens, usually just above it and sometimes slightly to one side. For the

2.21. When making close-ups with a point-and-shoot camera, as of this rose, compose with the LCD monitor instead of an optical viewfinder in order to avoid parallax error (see text). Because the viewfinder is above and often to the left or right of the camera lens, the image sensor records a different part of the subject (white frame) than what you compose in the viewfinder (black frame).

most accuracy when composing close-up (macro) images, use the LCD monitor instead of an optical viewfinder.

As for an ELECTRONIC VIEWFINDER (EVF), be aware that it is not another name for your camera's LCD monitor. An EVF outwardly resembles the more traditional optical viewfinder until you look in its eyepiece and see a tiny LCD screen instead of a direct view of your subject.

The advantage of an electronic viewfinder is that it shows you the exact picture area the camera will record and helps make composition more precise. However, it usually presents an image that appears less sharp and off-color compared to that in an optical viewfinder. An EVF also can be difficult to view in low light.

Another distraction with an EVF is the brief blur of your subject that occurs on the viewfinder screen whenever you quickly reposition the camera. In addition, the electronic viewfinder must be turned on in order to work, which not only drains the camera's batteries but can cause delays in composing pictures. If you are unfamiliar with electronic viewfinders, be sure to try out any camera equipped with one before you buy the camera.

By the way, SLR cameras do not have an electronic viewfinder or a traditional optical viewfinder. They feature an entirely different THROUGH-THE-LENS (TTL) VIEWING SYSTEM that usually utilizes a mirror and an optical pentaprism to transmit what the camera lens sees to the photographer looking in the viewfinder.

This is the easiest and most accurate way to compose pictures because you look through the actual camera lens and the coverage is most often 100 percent; what you see is usually what you get. (When you press the shutter release, the mirror flips out of the way so the light can pass to the image sensor.)

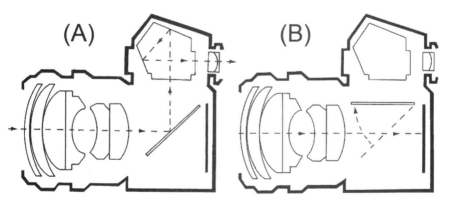

2.22. Single lens reflex (SLR) cameras feature a through-the-lens (TTL) viewing system, as illustrated here: (A) light coming through the lens reflects off a mirror into a pentaprism at the top of the camera that inverts the image so you see it correctly in the viewfinder; then (B) when you press the shutter release, the mirror flips up momentarily to allow the light to reach the image sensor that records the image. See also illustration 2.23.

Again, keep in mind that, unlike all other digital cameras, SLR models do not offer the option of viewing a subject on the LCD monitor prior to making an exposure—unless they have a feature called LIVE VIEW. Introduced by Olympus in 2005, live view has since been improved and adopted by other SLR manufacturers.

Because the mirror diverts the light from the camera lens to the SLR's viewfinder, the image sensor at the back of the camera cannot produce a live picture on the LCD screen. However, by installing a second sensor to receive that reflected light, a "live view" image can be seen on the LCD screen, just as it is on all P&S and prosumer digital cameras.

While most SLR photographers prefer to use the through-the-lens viewfinder for composing their pictures, there are situations where it is advantageous to choose live view (if available) in order to preview shots on the LCD monitor. This is particu-

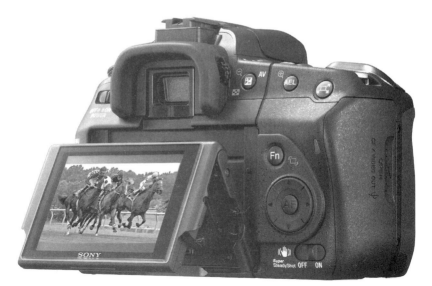

2.23. Some single lens reflex (SLR) cameras offer a feature called "live view" that allows you to compose pictures on the LCD monitor rather than using the through-the-lens (TTL) viewfinder. This Sony model has an articulating LCD screen that makes it easier to compose pictures in awkward camera positions.

2.24. Located near the viewfinder eyepiece on many cameras is a diopter adjustment, a small lever, slider, or dial (see inside white circle) for matching the eyepiece to your eyesight so that subjects appear sharp to you in the viewfinder.

larly true if the camera features an ARTICULATING LCD SCREEN that can be tilted or otherwise angled away from the camera body for composing in awkward positions, as when making over-your-head or ground-level photos.

Regardless of the type of viewfinder—optical, electronic, or through-the-lens—you'll be glad to know that many digital cameras have a DIOPTER ADJUSTMENT that will set the focus of the viewfinder's eyepiece for the photographer's particular vision. To correct for nearsightedness or farsightedness, you move a small knob or lever located next to the viewfinder until an autofocused subject appears sharply defined to your eye.

On some digital cameras, the LCD screen is automatically activated whenever you turn on the camera. This can be annoying (as well as a drain on the batteries) if you usually compose pictures using a viewfinder instead of the LCD. Check in the camera manual for a setting in the shooting mode that will keep the LCD turned off until you activate it yourself.

On the other hand, also look for another setting in the shooting mode that will automatically turn on the LCD for a few seconds immediately after an exposure is made so you can quickly check the picture before continuing to shoot.

3

More Things to Know about
Digital Cameras

Some basic features of digital cameras were discussed in the previous chapter to help you choose the camera that's best for your photographic pursuits. But there is much more to learn about image sensors, memory cards, batteries, and flashes for all three types of digital cameras.

MORE INSIGHT ABOUT IMAGE SENSORS

IMAGE SENSORS were described in some detail in chapter 2 (see page 26). Here is more information about those remarkable computer chips that have taken the place of film to digitally capture photographic images.

Don't be confused when you see image sensors described with different initials or names, such as CCD or Foveon X3. Camera makers have put image sensors with different engineering designs into their camera models.

The first digital cameras adapted CCD (charge-coupled device) microchips from videotape camcorders. Newer microchip technologies have brought CMOS (complementary metal-oxide semiconductor), LBCAST (lateral buried charge accumulator and sensing transistor array), Foveon X3, and other image sensors to the scene.

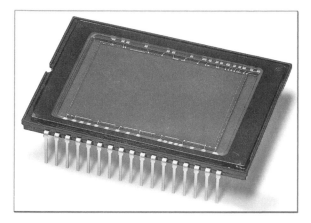

3.1. The heart of every digital camera is its image sensor, which is the electronic replacement for film. There are several types and sizes of sensors (see text). Shown here is an uninstalled CCD sensor that will be mounted in a 6.1 megapixel (MP) single lens reflex (SLR) camera.

Camera engineers like to debate the merits and shortcomings of the different sensor designs. What matters most is that the chip and camera makers continue to improve image sensors for better picture quality and faster camera operation. The actual type of sensor is unimportant to most photographers; our main concern is how well a camera performs and produces the pictures we want to make.

In that respect, you should at least be aware of two characteristics of image sensors: their physical size and their aspect ratio.

As discussed in chapter 2, IMAGE SENSOR SIZE matters, especially in relation to the number and size of the pixels (picture elements) the sensor holds. In general, the larger the camera (e.g., SLR models), the larger the size of its image sensor and its pixels. In contrast, palm-size point-and-shoot models have much smaller sensors and pixels.

As we explained, that's how a small digital camera can sometimes boast as many megapixels as found in a larger camera. It's simply that the pixels themselves are smaller in order to fit the same number of pixels on a small sensor as there are larger pixels on a large sensor.

Why should you care? Well, for the best technical picture

quality, a large sensor with its larger pixels will be able to capture more details in shadows and highlights. And when shooting in low light, those larger pixels gather the light more easily and more precisely than small sensors. Larger pixels also produce more accurate color renditions, and they cause less noise and fewer color artifacts in your images (see page 139).

In reality, only professional photographers and very serious photo enthusiasts pay any attention to the size of image sensors. However, you'll read about image sensors in camera articles and technical specifications, so we'll explain what the numbers mean.

The physical sizes of these rectangular image sensors vary from a tiny 3.2 × 2.4 mm (in camera phones) up to 36 × 24 mm. The latter size—which is the same size as a frame of 35mm film—is more than ten times larger than the smallest image sensor. The size of a camera's sensor may be indicated by its actual

3.2. Large cameras like this professional single lens reflex (SLR) model (right) have large image sensors with larger pixels. This can significantly increase a picture's image quality, which is especially important when very large prints are made.

dimensions given in millimeters, as above, or as a fraction, such as 1/2.5 (see illustration 2.7).

The fraction is not any measurement of the sensor itself, but simply a number you can use for comparison of the relative sizes of image sensors. Here are those numbers, ascending from the smallest-size image sensor to the largest: 1/4, 1/3.6, 1/3.2, 1/3, 1/2.7, 1/2.5, 1/2, 1/1.8, 1/1.76, 2/3, 1, 4/3, plus the largest sizes, designated APS-C, APS-H, and 35mm.

Something else you might see in the technical literature and articles about digital cameras is ASPECT RATIO. The aspect ratio is basically the ratio between the width and the height of the rectangular image that the image sensor records. (This assumes the camera is held horizontally, not vertically.)

Most digital cameras have a 4:3 aspect ratio. However, full-frame digital cameras have a 3:2 aspect ratio (as do all 35mm film cameras). A few digital cameras can be set to either of these aspect ratios and sometimes to a 16:9 aspect ratio to produce wider images.

What does all this mean in practical terms? Although most casual photographers are not concerned about aspect ratios, it does affect how your pictures are printed or are displayed on a computer or television screen. Unless the printing paper or the display screen has the same aspect ratio as your picture, you'll need to crop the image, or reduce its size, in order for it to fit fully on the paper or the screen.

This really is not a problem, because images can be cropped or downsized with image-editing software, if necessary, before you print them (see pages 323 and 338). For example, prints of the standard 6 × 4 inch snapshot size have a 3:2 aspect ratio, so images from most digital cameras (which have a 4:3 aspect ratio) will have to be cropped—or reduced proportionally in size—in order to fit on the paper. That is not the case with full-frame SLR models, which have the same 3:2 aspect ratio as the 6 × 4 inch paper.

Also, computer and television screens can be set to display

3.3. The usual aspect ratio of the image recorded by digital cameras is 4:3, except for *full-frame* SLR models, which have an aspect ratio of 3:2. When making prints, the image may not be proportional to the size of the photo paper you are using. This means there will be white margins, as shown here, when a 4:3 image from a point-and-shoot camera was printed on 6 × 4 inch snapshot-size paper. To get rid of the white margins, you can crop the image to fit the photo paper or trim off the margins after the picture is printed.

full uncropped images whatever the aspect ratio of your camera, although black borders may appear around the pictures.

Because wide-screen high-definition television (HDTV) sets have a 16:9 aspect ratio, in order for your photos to fill up the entire screen, you'll have to set your camera to the same 16:9 aspect ratio, if possible.

COMBATING THE DUST DILEMMA IN SLR CAMERAS

If dust or other minute debris gets on your camera's image sensor, it will show up on every picture you make. This is a problem for SLR models because their sensor is momentarily exposed when

interchangeable lenses are removed from the camera. Unwanted spots also will appear if raindrops, snowflakes, or other moisture reaches the image sensor. Actually, dust or moisture falls on a glass filter just in front of the sensor and is recorded as dark spots in the images. There are no such worries with point-and-shoot and prosumer cameras because their lenses are permanently attached and their sensors are never exposed to outside elements.

If spots appear in the pictures you make with an SLR camera, they are most easily seen in light areas of an image when the picture is displayed full size (i.e., viewed at 100 percent) on your computer screen. Fortunately, you can remove the spots by using retouching tools found in certain image-editing software, such as Adobe Photoshop or Apple's iPhoto. However, that procedure can be tedious and time-consuming. The better action is to try to keep dust or other elements from reaching the sensor in the first place.

3.4. Take precautions (see text) to avoid dust or debris on the image sensor of an SLR camera, which can show up as dark spots in the lighter areas of your photographs. Spots caused by dust, like these (see arrows), will be most evident when the picture is viewed at full size (i.e., 100 percent magnification) on your computer screen. Tools in some image-editing programs enable you to retouch the spots so they will no longer show in the picture.

You should follow these guidelines to help keep an SLR image sensor free of dust:

1. Avoid changing lenses in dusty environments, or cover your camera and lenses to keep the dust away.
2. *Turn off the SLR camera before changing lenses* so the sensor isn't charged with electricity that might attract dust.
3. Make sure the lens you are going to put on the camera is free of dust and debris on its rear lens element and mounting ring. (Use a microfiber cleaning cloth.)
4. Hold the camera facedown when changing lenses so any dust or moisture cannot fall into the opening.
5. Change lenses quickly.
6. Use a camera body cap to cover the opening if removing a lens but not replacing it with another lens.

Because the dust problem has long plagued digital SLRs, most camera makers have devised self-cleaning technologies for their image sensors. In general, the filter in front of the sensor briefly

3.5. Prior to putting lenses on SLR cameras, use a microfiber cleaning cloth on the lens elements and mounting ring to wipe away any dust that might fall into the camera body and onto the image sensor. This helps prevent dark spots that can mar your pictures (see illustration 3.4).

vibrates at ultrasonic speeds to dislodge any dust or debris, which is then collected by an adhesive strip in the camera. This self-cleaning action automatically occurs whenever you turn the camera on and again when you turn it off.

Sooner or later, foreign matter will collect on the image sensor that cannot be dislodged by the camera's self-cleaning feature. Your camera manual offers advice and/or directions for manually cleaning the sensor. However, we also recommend doing an Internet search for "cleaning SLR image sensors" to find detailed information that will be more helpful.

To clean the sensor yourself, you can first try hand squeezing an air bulb to blow away any dust—do not use compressed air from an aerosol can. Otherwise, there are special cleaning swabs, solutions, and methods for delicately wiping off the sensor, as you'll read on the Internet.

Because the effectiveness of self-cleaning varies with the camera model, and manual do-it-yourself cleaning requires time, skill, and special materials, you should always take all the precautions listed above to keep an SLR image sensor free of dust.

MORE DETAILS ABOUT MEMORY CARDS

MEMORY CARDS were mentioned briefly in the first chapter. These slim solid-state magnetic devices are inserted into cameras to record and store digital pictures after they are captured by the image sensor. Memory cards are also known as FLASH MEMORY CARDS, MEDIA CARDS, and STORAGE CARDS.

You should be aware that "flash memory" has nothing to do with a camera's flash unit that is used to illuminate subjects. Flash memory refers to data that remains stored in memory even after the electrical supply that transferred the data is turned off.

Although sometimes referred to as DIGITAL FILM, memory cards are unlike film in that they can be erased and then reused over and over and over.

Once images are electronically processed by microchips in the camera, they are written as DIGITAL IMAGE FILES to an INTERNAL MEMORY BUFFER before that data is written at a certain speed to the memory card. To use those image files now stored on the memory card, they are downloaded from the camera to your computer, where you review and can improve the pictures before making prints or displaying them on Web sites or sending them in e-mails.

The transfer of image files from camera to computer is done via a connecting cable, or the memory card is removed from the camera and inserted into an accessory CARD READER that is connected to a computer.

A memory card also can be put directly into a card slot that's built into some laptop computers and into the towers of some desktop computers. Some photo printers have built-in card slots

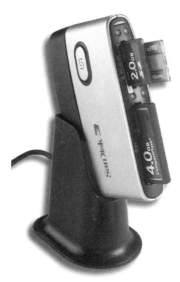

3.6. Accessory card readers transfer digital image files from a memory card to your computer faster than if you transfer the files directly from the camera via a connecting cable to your computer. A multi-card reader like this SanDisk model will accept all types of memory cards, but it can read only one card at a time. (Some computers have built-in card readers for more direct transfer of the image files.)

for direct printing from a memory card and for transferring image files from a card to a computer via a connecting cable.

Although more expensive, a few memory cards are designed to transfer image files without a connecting cable or a card reader. One features a built-in USB plug that can be inserted directly into a USB port on your computer. Another can transfer images files wirelessly to a Wi-Fi-enabled computer while the memory card remains in your camera.

It's important to know that there are five basic types of memory cards. Because camera makers have failed to adopt a universal memory card, *you must be certain to buy the type of card designed for your specific camera*. (Note that some cameras allow the use of different types of cards.) The cards vary in name, shape, size, and capacity.

The current memory cards are named CompactFlash (CF), Memory Stick (MS), Secure Digital (SD), xD-Picture Card (xD), and MultiMediaCard (MMC).

However, there are also variations within each type of card, which adds to the confusion. For example, you'll find Memory Stick, Memory Stick Pro, Memory Stick Duo, and Memory Stick Pro Duo cards. Likewise, in addition to the regular Secure Digital (SD) card, there is a Secure Digital High Capacity (SDHC) card and a miniSD card. Also, similar in size to the Compact-Flash card is a Microdrive, which is actually a miniature hard drive with a rotating disc and not a solid-state device like all the other cards. (Note that a card named SmartMedia [SM] lost favor with camera makers and is no longer manufactured; it was primarily used in early Olympus and Fujifilm models.)

The unique shape and size of each card usually reveals its type, but it's a good idea to look specifically at its label. The label also tells you its CAPACITY, which is indicated in megabytes (MB) or gigabytes (GB). The higher the number of bytes, the more pictures the card will hold.

3.7. Memory cards vary in type, brand, physical size, capacity, and speed. Four of the most popular types are shown here: CompactFlash (CF), Secure Digital (SD), xD-Picture Card (xD), and Memory Stick (MS). Cameras commonly use only one type of card; some SLR models accept two types.

Capacities have been standardized, and they double with each step up: 32, 64, 128, 256, and 512 megabytes (MB); and then 1, 2, 4, 8, 16, and 32 gigabytes (GB). A 1 GB card has twice the capacity of a 512 MB card. Keep in mind that not all the types of memory cards are available in all the megabyte (MB) and gigabyte (GB) capacities listed above.

What does memory card capacity mean in terms of the actual numbers of pictures a card will hold? That depends on the file format you select for shooting—JPEG, TIFF, or Raw (if available)—and the image quality (i.e., resolution and compression) you choose. These camera settings will be explained in chapter 6,

3.8. Memory cards are available in various capacities, such as these 4, 8, and 16 GB (gigabyte) SDHC (Secure Digital High Capacity) cards.

where you'll also find a chart (illustration 6.5) showing how the number of images recorded on a memory card will vary.

> When you buy a new digital camera, most manufacturers (Nikon is an exception) include a memory card with *minimal* capacity. Although this enables you to start shooting immediately, the card will only hold a small number of pictures. To avoid the frustration of having to stop photographing when that memory card is filled, we recommend you buy a high-capacity card at the same time you buy your camera.

Some photographers buy the highest-capacity memory card that they can afford. This enables them to keep shooting without worrying about running out of room on the card or bothering with changing cards (or erasing images) when a card fills up. Other photographers, however, prefer having two or more cards with smaller capacities because they are fearful of losing all their pictures if a single high-capacity card is damaged or lost before the images are downloaded to a computer.

Another aspect of a memory card is its SPEED, which affects the relative time it takes to record (write) an image onto the card. Card speed is especially a concern for photographers shooting a quick series of pictures, as at action-packed sports events; when the internal memory buffer fills up, the camera's operations slow down until image files are written to the card.

Card speeds, indicating the number of megabytes (MB) of data the card can record in one second, are designated by an *x* (e.g., 133x) on most cards and by "Class" (e.g., Class 6) on Secure Digital High Capacity (SDHC) cards. The higher the number, the faster the card's recording (or writing) speed.

To explain, because 1x equals 1.5 kilobytes (KB) per second, a 10x card writes 1.5 MB of data per second. Cards with the fastest speed, 300x, record 45 MB per second, which is thirty times faster than a 10x card. As you might expect, the faster the

3.9. The speed of a memory card—how fast it records image file data from the camera—can be important when you are rapidly shooting many pictures, as at a sports event (see text).

speed, the more costly the card. Regarding SDHC cards, Class 2 cards write a minimum of 2 MB of data per second, while Class 4 and Class 6 record 4 MB and 6 MB per second, respectively.

We advise you to read your camera manual carefully for any warnings in regard to memory cards. For instance, cards with very high capacities, or very high speeds, may not work in certain camera models, especially older ones.

Whenever you buy a new memory card, it needs to be formatted in your camera so it will work correctly with your specific model.

Carefully follow the directions in your camera manual for formatting a memory card. It will take several seconds to com-

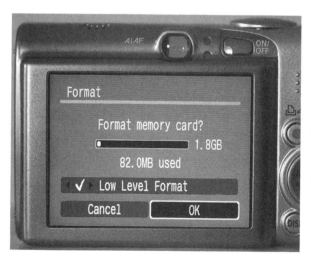

3.10. *Formatting* a memory card deletes all data from the card, which is a better choice than just *erasing* the card (see text). As shown here, the camera's LCD monitor will display the format procedure.

plete the process once you start it. During that time, do not press any buttons or change any camera modes; above all, do not turn the camera off.

Every time you transfer pictures from the memory card to your computer's hard drive and are ready to reuse the card, you need to remove the old image files so there is room on the card for new pictures. There are "erase" or "delete" commands in your camera and computer software to do this.

However, the better choice is to "format" the card again. This not only erases the old image files but gets rid of any other data that otherwise might corrupt the card and possibly ruin the pictures that your camera subsequently records on it.

Remember that image files remain on the memory card even after you've downloaded those files to your computer. As soon as possible after transferring the files (and checking on the computer that they have been downloaded successfully), it's smart to "clean up" the card by formatting it in your camera so it will be empty and ready to use again to its full capacity.

Play it safe and always "format" a memory card prior to reusing it in your camera. Choose that option to permanently eliminate old pictures on the card instead of using the "erase" or "delete" commands.

How should you handle memory cards? Carefully, of course. Most are quite durable despite their small size, but they can be damaged. That means any pictures they contain could be ruined if the image files become corrupted in some way. *To avoid destroying data on a memory card, always make sure your camera is turned off whenever you insert or remove a card.*

Don't bend or drop or get memory cards wet, which is possible when changing cards outdoors in rainy or snowy weather or at the beach. Handle the cards by their edges and don't touch

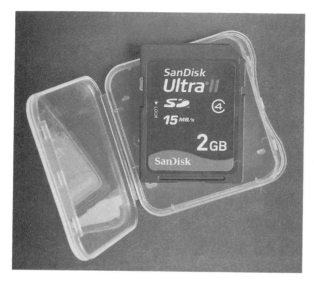

3.11. Protect your memory cards from damage by keeping them in a protective case when not being used in your camera. The SD card shown here came packaged in this plastic case.

their metal contacts. Always keep them in a protective MEMORY CARD CASE when not in the camera; you can use the small plastic case that many cards come packaged in.

Take note that when you pass through checkpoints at airports, cruise ports, and other high-security places, the X-ray and magnetic scanners that are used to inspect people and their belongings will *not* harm images on your memory cards. Remember to keep your camera and memory cards with you when traveling; do not pack them in your checked luggage, which might be lost or stolen.

MORE POWER TO YOUR BATTERIES

Batteries are especially important in a digital camera. They must power all the microchips and other electronics that create and record images digitally. Their energy is required to light up the LCD monitor screen, control motors for autofocusing the lens, operate the metering system for manual and auto-exposures,

charge the built-in flash system, and activate any camera or lens antishake feature.

As mentioned in the first chapter, the batteries supplied with a new camera are either the rechargeable type or the replaceable type. Some cameras can utilize both types.

Most photographers prefer RECHARGEABLE BATTERIES because you don't have to keep buying new batteries when the old ones become exhausted.

However, whether you use rechargeable or replaceable batteries, you should *always* carry a spare set. There is nothing more frustrating than having to quit shooting because your batteries have been drained of their power and your camera stops working. Never forget to have extra new or freshly charged batteries with you.

> Keep this in mind: if your camera fails to operate, first clean the batteries before you assume your batteries need to be replaced or recharged. Often an invisible chemical film builds up on the ends of the batteries and breaks the electrical contact. Wipe off the battery ends with a clean, dry cloth. Do the same for all battery contacts in the camera. Use the eraser on the end of a pencil for hard-to-reach contacts.

Some digital cameras only operate with a rechargeable LI-ION (LITHIUM-ION) BATTERY PACK, which varies in physical size according to the particular camera. It comes in the box with the camera and must be fully charged before using your camera for the first time.

A battery charger or a camera dock that plugs into an electrical outlet for charging the battery pack should also be included in the box. If it is not, buy the appropriate battery charger immediately. Remember to purchase a spare battery pack, too, and always keep it charged.

Some digital cameras operate with common AA-SIZE BATTERIES, usually two or four or more. This gives you the option

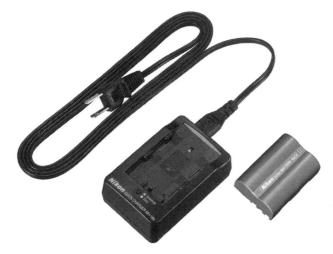

3.12. Power for some digital cameras is supplied by a proprietary Li-Ion battery pack that fits a specific camera brand and model. Included with the camera is a battery charger that plugs into electrical current in order to recharge the battery after it is removed from the camera.

of using rechargeable or replaceable batteries. The best and most popular rechargeable type is the NIMH (NICKEL–METAL HYDRIDE) BATTERY, which has superseded an earlier type, the NiCd (nickel-cadmium) battery.

Because the box with a new camera using AA batteries usually includes only replaceable alkaline batteries, you'll have to buy your own set of rechargeable batteries and a battery charger. There are dozens of different NiMH batteries on the market; some last more than four times longer than the common alkaline type.

For an idea of a battery's running time before recharging is necessary, check its MILLIAMPERE-HOUR (MAH) RATING, which can range from 1600 to 2700. The higher the number, the longer the battery charge will last. Actual running time depends on the power consumption of your camera, which is greatly affected by your use of the LCD screen and flash.

We prefer the newer generation of NiMH batteries that are described as "precharged" and "ready to use," such as Sanyo's eneloop brand, which is rated at 2000 mAh. Unlike earlier NiMH batteries, these hold their charge over a long period without use; after one year sitting on a store shelf, 85 percent of the

3.13. *Precharged* NiMH batteries are the recommended type of rechargeable AA batteries for cameras. That's because they hold their charge for a longer time between uses (see text). A compatible battery charger is packaged with this Sanyo eneloop brand of ready-to-use batteries.

initial full factory charge still remains. With such batteries, your camera should work even after it has been idle for a few days or weeks or even months.

BATTERY CHARGERS vary in their features, including the time required for charging. Some advertise quick one-hour charges, but more time is required for batteries with higher milliampere-hour (mAh) ratings. The life span of some batteries will be shortened if they are not fully discharged before recharging. Read the charger's instructions about proper procedures, and look for any warnings about overcharging that may cause damage to the batteries.

Our advice is to buy a charger that includes the batteries, because they will be compatible with the charger. Also, buy spare batteries of the same brand and type. That way all your rechargeable batteries can be interchanged in the camera and recharged successfully with the same charger.

As mentioned, some new cameras come with AA-size REPLACE-ABLE BATTERIES instead of the rechargeable type. Most are *alkaline*

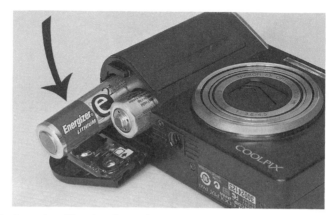

3.14. If using *replaceable* rather than rechargeable AA batteries in your camera, buy lithium batteries instead of the more common alkaline batteries that are supplied with new cameras. That's because lithium batteries will last three to seven times longer than alkaline batteries.

batteries, so we recommend you immediately buy new LITHIUM BATTERIES (unless you've decided to use rechargeable batteries). That's because lithium batteries will last three to seven times longer than the common alkaline type. Lithium batteries are lighter in weight and have a longer (ten-year) shelf life, too. They also will speed up the recycle time of the camera's built-in flash so you can shoot flash pictures in quicker succession.

Whether you use replaceable lithium or rechargeable NiMH or Li-Ion batteries, be aware that they slow down and become exhausted more quickly in cold weather. For that reason, keep spare batteries inside your warm clothing (not in a camera bag). Also note that cold camera batteries can recover when brought back to room temperature, unless they've had extensive use outside.

Most digital cameras feature a BATTERY ICON on the LCD screen to indicate whether the battery power is full, low, or exhausted. On some models, the icon or a colored light will blink to signal that the batteries will soon be out of power. Whenever you plan to make important pictures (or to download images

3.15. To check the condition of your camera batteries, look for a battery icon (see arrow) on the menu display on the LCD monitor. Here it shows full power; be ready to replace or recharge the batteries if the power is low.

from your camera to a computer via a connecting cable), always check the icon to be sure you have full battery power.

You'll be glad to know that most cameras have a BATTERY SAVE, POWER SAVE, or AUTO POWER OFF feature to help conserve their batteries. This will automatically turn off the camera if it has not been operated after a certain number of minutes or hours. Check your camera manual for the specific time, which varies widely from model to model, and can be anywhere from one minute to one hour. Fortunately, some models allow you to adjust that time to your personal preference.

Most cameras also have a battery-saving SLEEP MODE for the exposure metering system and the LCD and viewfinder displays, which turn off after a few seconds or a minute or so without use. On some models, you can change the length of time before the metering system and those displays go off. To reawaken them, slightly press the shutter release button.

Of course, the more you use your camera and its power-consuming features, especially the LCD monitor, the quicker the batteries will drain. So it is very important to buy extra batteries and always carry them with you.

ADD PUNCH TO YOUR PICTURES WITH FLASH

One of the most useful features of any digital camera is its BUILT-IN FLASH, which provides an instant bright source of light to illuminate your subject. It is also one of the most misused features.

We believe the true value of the camera's small built-in flash is to use it for FILL FLASH, especially to add a little extra light to a subject that is in shadow outdoors. For example, whenever you notice the face of your subject is in shadow, perhaps caused by a hat or the sun being behind them, turn on the flash so its light will "fill in" the shadow and show more detail in the face. It often adds a nice sparkle (known as a CATCH LIGHT) to a person's eyes.

Fill flash is also useful indoors when the natural light or artifi-

3.16–3.17. A simple way to eliminate shadows on the faces of your subjects is with Fill Flash (see text). This outdoor portrait of a member of the Royal Canadian Mounted Police, made in New Brunswick, became much more pleasing when the camera's flash unit was fired to offset the harsh sunlight exposure.

cial electric light is dim and the extra flash illumination will add more punch to the picture. Sometimes, however, the flash light overpowers the existing light and creates a harsh flash picture instead of just filling in where extra light is needed. This can be controlled with flash exposure compensation (see page 79). Of course, the great thing about a digital camera is that you can see the result immediately on the LCD screen, and then shoot again if you don't like the flash lighting of your picture.

When you want to use your camera's built-in flash, you have a choice of several FLASH MODES, which are indicated by icons on the LCD monitor. One mode is FILL FLASH, which was described on the previous page, although it may be called FILL-IN FLASH, FORCED FLASH, or just FLASH ON. A lightning bolt icon often identifies the "flash on" setting.

Whenever you turn on any camera with a built-in flash, it often activates the factory-set default flash mode, which is usually AUTO-FLASH. This means the flash will fire automatically every time the camera's exposure-metering system determines that the existing light level is low. The word "Auto" usually appears on the LCD screen, sometimes next to a lightning bolt icon, or it may not show at all.

3.18. If you don't want the camera's built-in flash to fire, you can turn it off. This menu on the LCD monitor shows the flash icon—a lightning bolt—surrounded by a circle with a diagonal line that indicates the autoflash is turned off.

If you don't want the flash to fire, you select the FLASH OFF or NO FLASH setting. The "flash off" icon is often a lighting bolt within a circle and a diagonal line through it. If the built-in flash pops up from the top of the camera, you push it down to close the flash and turn it off.

Remember to turn off the flash if making time exposures or shooting indoors when flash is not allowed or appropriate, as in art museums, theaters, and churches or other places of worship. Also turn it off when it won't be effective, as in a vast indoor or outdoor sports arena (see below).

Be sure to look for glass windows, mirrors, and other shiny surfaces that might cause unwanted flash reflections, like when shooting though a car or tour bus window. Turn the flash off, or change your camera angle so the flash light will not reflect back into the camera lens.

Another flash mode you can select is RED-EYE REDUCTION, which is usually indicated by an icon that resembles an eye. When red-eye reduction is selected and you press the shutter release button, it briefly triggers flashes or a steady light to cause the pupils of your subject's eyes to contract in size just prior to the actual flash exposure. This is supposed to prevent the camera from recording the red retinas at the back of the eyes.

However, we recommend you *do not* use the red-eye reduction setting for several reasons. First, the quick series of preflashes or steady light beam often ruins the picture by making people blink or close their eyes while the camera's shutter is open. Also, the extra flashes or light beam drains your camera batteries more quickly.

Best of all, some cameras feature red-eye detection and correction that automatically fixes the problem before you even notice it. And if you do see red-eye in a flash photo that you've downloaded to your computer, it can be easily eliminated with image-editing software (see page 326.)

3.19–3.20. There are several ways to eliminate red-eye, the undesired effect from flash that gives people a spooky look, like the girl on the left. Her boyfriend looked the same way until his red-eye was fixed with image-editing software (see text).

A flash mode available on many cameras is called SLOW SYNC, SLOW SYNCHRO, or NIGHTTIME FLASH. An "S" or the word "Slow" next to a lightning bolt often identifies this setting, which automatically slows the shutter speed when the flash fires. This extended exposure time allows the background to be recorded in addition to the foreground subjects that are illuminated by the flash.

For normal flash exposures, the shutter only opens for a very brief time, such as 1/125 second. Because slow-sync exposures are longer, sometimes 1 second or more, use a tripod or other support to avoid a blurred background caused by camera shake.

Some cameras have other flash modes, such as "Slow Sync with Red-eye Reduction"; check your camera manual. Our advice is to try out all the available flash modes so you'll know how effective each one is with your particular camera. And when a certain photo situation occurs, you'll be ready to choose and use the flash mode that will help make a better picture.

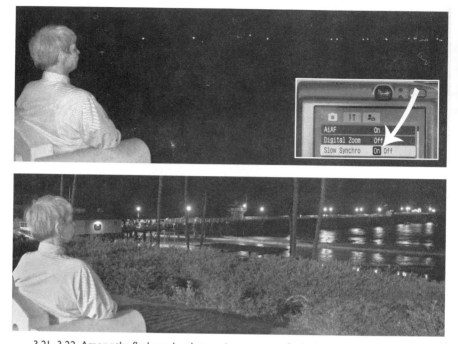

3.21–3.22. Among the flash modes that can improve your flash photography is Slow Synchro (also called Nighttime Flash). It slows down the shutter speed so that existing light as well as light from the flash will be recorded by the image sensor. In the top photo, the camera's built-in flash was set to Autoflash, which only illuminated the woman sitting on a park bench. When the Slow Synchro flash mode was turned on (see inset), the next exposure (bottom) was long enough to also record the park foliage and lights on the ocean pier in San Clemente, California. A tripod was used to hold the camera steady.

The misuse of built-in flash we mentioned earlier mostly occurs because the photographer does not know about the EFFEC-TIVE FLASH RANGE, which also is called the FLASH DISTANCE RANGE or the FLASH SHOOTING RANGE. This tells you how close and how far away your camera can be from a subject for the built-in flash to be effective, such as 1.5–11 feet (0.5–3.5 meters). Get too close and your subject will be washed out (overexposed). And if you are too distant, your subject will be too dark (underexposed).

The fact is that the light from those small built-in flash units doesn't reach very far. On some point-and-shoot models it is no

FLASH SHOOTING RANGE		
ISO	@ MAX. WIDE-ANGLE	@ MAX. TELEPHOTO
AUTO*	2-29.4 ft. (0.6-8.9 m)	1.7-24.4 ft. (0.5-7.4 m)
80	2-20.8 ft. (0.6-6.3 m)	1.7-17.2 ft. (0.5-5.2 m)
160	3-29.4 ft. (0.9-8.9 m)	2.3-24.4 ft. (0.7-7.4 m)
320	1.3-41.3 ft. (1.3-12.5 m)	3.3-34.3 ft. (1.0-10.4 m)

*When ISO is set on AUTO, it is automatically adjusted between the range of ISO 80-160.

3.23. To avoid disappointment with your flash pictures, check the instruction manual for the range of your camera's built-in flash. As this chart for an Olympus prosumer model shows, the flash distance range is greater at higher ISO settings and also when the zoom lens is set at its widest angle rather than at the maximum telephoto position.

more than 10 feet (3.04 meters). Imagine the waste of battery power when you see hundreds of cameras flashing from the stadium seats during a nighttime football game.

Check your camera manual for the specific built-in flash range, and memorize those minimum and maximum distances.

As the manual should note, the maximum flash distance will be reduced if your camera's zoom lens has a variable lens aperture (most do!) and you zoom from wide-angle to telephoto. For example, the flash might reach to 11 feet (3.5 meters) at the wide-angle setting but only to 7.2 feet (2.2 meters) at the telephoto setting. The flash distance range also will vary according

One caution when using a built-in flash: be certain your camera lens—or a lens attachment, such as a lens hood, lens converter, or lens adapter—does not block any of the flash light. Make some test shots to see if any shadows appear in your flash pictures. Your camera manual may give specific warnings about shadows from the built-in flash, such as when shooting close to your subject with the zoom lens at a wide-angle setting.

to the ISO setting; the higher the ISO, the greater the range (see page 138).

Whenever you use a built-in flash, it must be charged to a high voltage by the camera batteries before it will fire. A READY LIGHT will signal when the flash is charged. It is a small LED (light-emitting diode) in or near the viewfinder, or represented by an icon (most often a lightning bolt) on the LCD screen. The time it takes for your flash to be fully charged varies for each camera model and the condition of your batteries; you may have to wait several seconds.

If a flash mode has been turned on, the flash will recharge every time you slightly depress the shutter release button to automatically set the exposure and focus the lens. Even if you fully depress the shutter release to make an exposure, some cameras will not do so until the flash is charged and ready to fire. Other models will make the exposure but the flash will not fire, so you won't get the picture you expected. Or the camera will flash a weak amount of light because it was not fully charged, and the picture will be underexposed.

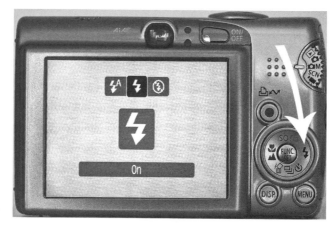

3.24. To use a camera's built-in flash whenever you wish, such as for fill light, you must turn it on manually. On many models, you select the stand-alone lightning bolt icon on the LCD menu after you press the flash control button on the camera body (white arrow).

Some SLR cameras offer FLASH EXPOSURE BRACKETING. This gives protection against underexposures and overexposures by making one or two extra flash pictures of the same subject at different exposure settings that you select. This is part of the camera's auto-exposure bracketing (AEB) feature, which is described in chapter 7 (see page 164.)

When a flash picture does not turn out as you envisioned it, try the FLASH EXPOSURE COMPENSATION MODE, if it is a feature of

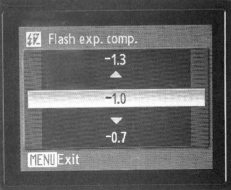

3.25–3.26. If the main subjects of a flash picture are overexposed (as seen above) or underexposed, some cameras have a feature called "flash exposure compensation" to decrease or increase the amount of light from the flash by a specific exposure value (see text). This LCD menu (right) shows that the camera has been set to decrease (–) the light output from the built-in flash by the equivalent of one f/stop.

your SLR or prosumer camera. This operates much the same as the camera's EXPOSURE COMPENSATION MODE, which is described in chapter 7, beginning on page 162. First read that description to understand the concept of EXPOSURE VALUES (EV) and the plus or minus (+/−) exposure increments you can set in order to increase or reduce exposure, then resume reading here.

Flash exposure compensation adjusts only the amount of light from the flash to help you balance the flash illumination of your picture without affecting the background exposure.

For example, after you review a flash picture on the LCD monitor, if your foreground subject appears washed out (overexposed) by the flash, you can reduce that light by setting the flash exposure compensation to a minus (−) EV, such as −1.0. Or, if your foreground subject looks too dark (underexposed) because there was not enough light from the flash, you can increase that light by setting a plus (+) EV, such as +1.5.

An icon of a lightning bolt with a plus/minus (+/−) sign usually appears in the viewfinder and/or on the LCD screen to indicate when the flash exposure compensation mode is turned on. After you are satisfied with your flash pictures, remember to set the exposure value (EV) back to zero (0) in order to cancel flash exposure compensation for subsequent shots.

By the way, if your built-in flash is located to either side of the camera lens and not just above it, whenever you turn the camera for a vertical picture, be sure the flash is positioned above the lens and not below it. Otherwise you may create disturbing shadows behind your subject (see photos 3.27 and 3.28). Also, when you are ready to shoot, always check that your fingers or camera strap are not inadvertently blocking the built-in flash.

As we mentioned, a built-in flash is convenient but not very powerful. When a stronger flash is needed, you can buy a DEDICATED EXTERNAL FLASH UNIT for SLRs and many prosumer models. These cameras have a HOT SHOE, which is a mount on

3.27–3.28. When shooting flash pictures in a vertical format, *make certain the built-in flash is not positioned under the camera lens*, as shown to the right (see arrow). Otherwise, distracting shadows may appear above and to the wrong side your subject, as below.

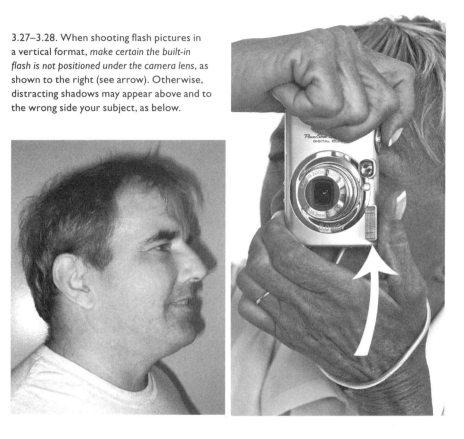

the top of the camera to hold the flash unit in place and also make direct camera-to-flash electrical connections so the flash will fire when you press the shutter release.

Many camera manufacturers—including Canon, Nikon, Olympus, Pentax, Sigma, and Sony—make dedicated external flash units that are designed to work with specific models of their cameras. Also, there are external flash units from independent makers—such as Metz, Sunpak, and Vivitar—that will work with specific camera models. To avoid electrical damage to your camera, do not attach or connect any flash unit unless

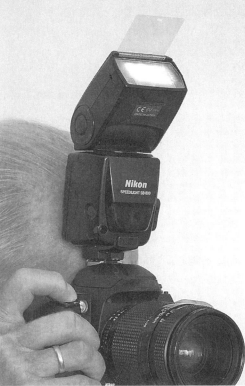

3.29–3.30. Bounce light from an external flash unit produces more uniform illumination for flash pictures, as of these passengers (above) enjoying lunch on a train traveling through Canada. The flash unit was mounted on the hot shoe of a single lens reflex (SLR), like the camera on the left. For bounce light, the flash head is set at an angle so the flash light reflects from the ceiling or from a small white reflector that is built in (as seen here) or can be attached to the flash unit as an accessory.

its instruction manual indicates the flash can be used with your digital camera model.

As with the built-in flash, the camera's flash modes will calculate exposures and then automatically set the correct shutter speed and lens opening (f/stop) for a dedicated external flash. Some flash units even have a ZOOM FLASH HEAD that automatically adjusts the flash coverage according to the focal length of the lens you are using.

Not only does an external flash unit enable you to illuminate subjects well beyond the flash range of your built-in flash, it allows you to aim the direction of the flash.

To reduce the harshness of direct camera-mounted flash, tilt the flash head up at a 45° or greater angle to the lens. In that position, it can be reflected off a ceiling to produce more diffused lighting, which is called BOUNCE LIGHT. Some external flash units feature a small white reflector you extend from the tilted flash head to create the bounce light, or you can buy an accessory reflector to attach to the flash head.

A dedicated external flash unit also can be removed from the camera to give more variety in flash lighting. If you position the flash unit away from the camera, which is called OFF-CAMERA FLASH, you can avoid the "flat" lighting effects of a camera-mounted flash. In order for the flash to fire when the shutter release is pressed, you attach a FLASH CONNECTING CORD between the external flash unit and the hot shoe or a flash socket on the camera.

Or you can go cordless. Some cameras come equipped or can be fitted with infrared or wireless transmitting devices that will trigger a compatible external flash unit that is used off camera. More commonly, the off-camera flash has a photocell sensor that receives light from the camera's built-in flash (or a hot-shoe-mounted flash) and both units fire at the same time when the shutter release is pressed.

As you'll discover when shopping for a dedicated external

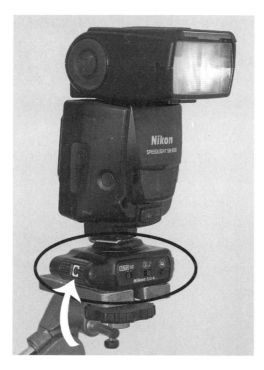

3.31. An off-camera flash can greatly improve pictures made with flash. This external flash unit is mounted on a small wireless receiver (see black oval) that is mounted on a tripod. The adjustable sensor (see white arrow) reacts to flash light from the camera's built-in or external flash unit to fire the off-camera flash at the same time. A connecting cord between the camera and an off-camera flash also can be used to fire the flash, but the wireless way is much more convenient.

flash unit, SLR manufacturers and independent companies offer a wide choice. The most versatile of these electronic marvels cost several hundred dollars, but it is well worth the investment if your photography becomes more satisfying with the use of flash. Just make sure that any flash unit you buy is specifically recommended for your camera brand and model, in order to enjoy all its benefits.

Newcomers to digital photography may not think this discussion about flash is necessary. That's because they discover that digital cameras do a wonderful job of making well-exposed pictures in low light, especially indoors *without* flash. Nevertheless, flash can be an important asset, if you know how to use it. There is much more to flash photography than just leaving your camera set on autoflash.

4

Learning All about Lenses

Without a lens, there would be no photograph. A lens focuses light on the camera's image sensor to create a picture. In addition to bringing light rays into focus, a lens has an adjustable aperture that helps control the intensity of the light in order to make a proper exposure—one that is not overexposed or underexposed.

Lenses will do their jobs *automatically*, thanks to the autofocus and auto-exposure features that are standard on all digital cameras. An advantage of SLR cameras and some prosumer cameras is that photographers also have the option of controlling focus and exposure *manually*.

All digital cameras, except SLR models, have BUILT-IN ZOOM LENSES that allow you to vary the size of the subjects you photograph by simply adjusting the zoom control of the lens. SLR cameras are more versatile because they feature INTERCHANGE-ABLE LENSES, which means you can use any type of lens, including zoom, telephoto, wide-angle, and macro (close-up).

There is much to learn about lenses for digital cameras. In this chapter, we discuss some of their features, such as anti-shake technology to prevent blurred pictures. In addition, you'll read about an important control, the lens aperture (f/stop),

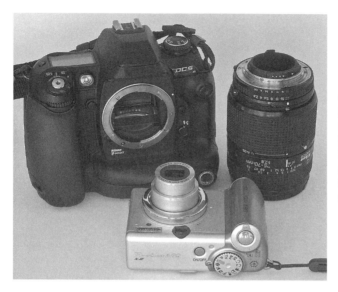

4.1. Zoom lenses are built into all digital cameras except single lens reflex (SLR) models, which have lenses that can removed and interchanged with others of different types and focal lengths.

which restricts the amount of light reaching the image sensor and also determines how much of your picture will be in sharp focus.

Also described are attachments that change the wide-angle or telephoto ranges of built-in zoom lenses and interchangeable SLR lenses. And you'll find out about macro lenses and attachments for making close-up photographs with SLR cameras.

Manufacturers of SLR cameras—including Canon, Nikon, Olympus, Pentax, Sigma, and Sony—make interchangeable lenses and lens attachments that are designed to work with specific models of their cameras. Also, there are interchangeable lenses from independent makers—such as Sigma, Tamron, and Tokina—that will work with specific camera models. To avoid damage to your camera, do not attach any lens unless its instruction booklet indicates that the lens can be used with your digital camera model.

Be certain when buying interchangeable lenses for an SLR that they are designed to mount on your specific model. Not only must the lens attach to your camera, but electronic contacts on the lens and the camera must match so that autofocusing, auto-exposure, and other controls will operate correctly.

ANTISHAKE FEATURES IN LENSES
AND DIGITAL CAMERAS

As you may recall from chapter 2, the zoom range of built-in zoom lenses varies considerably on P&S and prosumer cameras. Many zoom lenses will increase the size of your subject three or four times (3× or 4×) as you adjust them from the wide-angle to the telephoto setting. And there are others, called SUPERZOOM LENSES, that will enlarge your subject as much as ten (10×), twelve (12×), or even eighteen (18×) times.

Many photographers like the idea of having a camera equipped with a superzoom lens. But we have a special caution about such lenses: when set at an extreme telephoto focal length, there is a greater chance that the much-enlarged subject will appear a bit blurry in the picture you make, unless the camera is held rock steady, put on a tripod, or has an ANTISHAKE FEATURE.

Fortunately, antishake technology to prevent the unwanted blurring caused by inadvertent camera movement has become increasingly common in digital cameras. Although antishake features were initially built into SLR telephoto and zoom lenses, most are now built into all three types of cameras themselves.

Many manufacturers have their own proprietary antishake systems and give them special names. Among the first were Canon's Image Stabilization (IS) and Nikon's Vibration Reduction (VR) interchangeable lenses for their SLR cameras. Those IS and VR systems were later adapted to some of the companies' P&S and prosumer models that have built-in zoom lenses.

4.2. Camera makers have various names for the antishake feature that helps prevent blurred pictures when you don't hold your camera steady. Nikon calls it VR (for Vibration Reduction); Canon names it IS (for Image Stabilization). Many cameras, like this Nikon model, allow you to turn the antishake feature on (see arrow) and off.

So how does an antishake feature prevent the blurring of an image? Technically, it counteracts any movement of the camera and lens that shifts the point of focus of light rays on the image sensor. There are different ways to accomplish this.

The two best ways are both described as OPTICAL IMAGE STA-BILIZATION. They involve numerous thousandths-of-a-second movements by either an optical element in the lens or by the image sensor itself in order to maintain the point of focus in the same spot on the image sensor despite any movement of the camera.

Another way to offset camera shake is done electronically and is known as DIGITAL IMAGE STABILIZATION. In this case, during the time of exposure a microchip processor cancels any incoming light rays recorded by the image sensor that do not match each other and would thus record as a blur.

There is also a less-sophisticated technique called PICTURE STABILIZATION, which is a pseudo-antishake feature found in some point-and-shoot cameras. In low light, when the camera

would normally set a slow shutter speed, the sensitivity of the image sensor is increased so that a faster shutter speed is set to prevent any blurring caused by camera movement.

We realize that some serious photographers want to know all the technical details about their digital cameras and equipment, while many other casual shooters have little interest in such information. In keeping with the "basic" title of our book, we only summarize technical matters. If you would like detailed as well as understandable scientific explanations, read *How Digital Photography Works, Second Edition* (Indianapolis: Que Publishing, 2007), an exceptional book by Ron White, with enlightening illustrations by Timothy Downs.

How well does antishake work? It depends on what you expect it to do. Be sure to read the camera or lens manual to find out the manufacturer's specific directions on how, when, and where to use it. Pay attention to special advice regarding this feature. For instance, in order to save battery power (which is always a concern in digital photography), make sure the anti-shake feature is turned off when you do not intend to use it.

Activating your camera or lens antishake feature is especially useful when you are shooting in the telephoto range or photographing in low light with a slow shutter speed.

Long before antishake technology came along, photographers followed a rule of thumb to prevent blurred images caused by camera movement: set the shutter speed equal to—or faster than—the focal length setting of the zoom lens or the fixed focal length SLR lens. (Obviously, this can only be done on SLRs and other cameras where the shutter speed can be adjusted.)

As an example, if the lens focal length is the 35mm equivalent of a 250mm telephoto lens, you shoot at 1/250 second or faster ("35mm equivalent" was explained earlier; see page 35).

So what is the real advantage if you activate the antishake

4.3. Some lenses for SLR cameras have a built-in antishake feature to help prevent blurred pictures. Nikon calls this VR (Vibration Reduction); a switch (see circle) on VR-equipped lenses is used to turn the image stabilization feature on and off.

feature of a camera or lens? You should be able to shoot at least two and possibly three shutter speed steps slower than usual *without getting a blurred result.*

For instance, instead of using a shutter speed of 1/250 second, by turning on antishake you could shoot at 1/60 second (two steps slower) or possibly at 1/30 second (three steps slower) without seeing evidence of camera movement in the picture.

> When analyzing photographs, be certain you don't mistake the blurring of a fast-moving subject for camera movement. And don't confuse blur caused by camera movement with images that are simply out of focus.

4.4–4.6. Camera shake causes multiple images that are slightly offset, as in the picture of the blurry couple just below. However, the two other pictures on this page show that not all blurry subjects are the result of moving your camera during the exposure. The baby (right) is blurred because she is out of focus; the camera was too close for the lens to focus properly. The waterfall (lower right) was purposely blurred to show movement; the photographer used a slow shutter speed and held the camera steady on a tripod.

The important thing to do is put your antishake system through its paces so you'll know its possibilities, and its limitations, in various shooting situations.

LENS APERTURES AND DEPTH OF FIELD

As we mentioned earlier, automatic exposure is common to all digital cameras. On point-and-shoot and prosumer models, the shutter speed and the opening of the lens, which is called the LENS APERTURE or F/STOP, are adjusted automatically according to the EXPOSURE MODE you choose (see chapter 7).

Once an exposure mode is selected, in low-light situations the camera opens up the lens aperture and/or slows down the shutter speed to increase the amount of light reaching the image sensor. Or, in bright-light situations, the camera closes down the lens opening and/or increases the shutter speed to decrease the amount of light reaching the sensor.

An advantage of SLR cameras is that you can also control exposure *manually* by adjusting the shutter speed and/or changing the lens aperture yourself. And when you set a specific f/stop, you also control DEPTH OF FIELD, which determines how much of the picture's subject area will be in focus from foreground to background.

For example, opening up the lens aperture (such as to f/4) *decreases* the picture's depth of field so less of the overall subject area will be in focus. This is often desired in portraits when the person is meant to be in focus but the background out of focus. On the other hand, closing down the lens opening (such as to f/16) *increases* the depth of field so more of the overall subject area will be in focus, as is often desired in landscapes and scenic shots.

To precisely control depth of field and the amount of light passing through the lens, you turn a dial on the camera body to

4.7–4.8. A wide lens opening (f/stop) was used to limit the depth of field so that this snowy egret resting on a sailboat railing (right) would stand out in sharp detail from the background. For comparison, in the picture below, made at White Sands National Monument in New Mexico, a small lens opening was used for extreme depth of field so that everything would be in sharp focus— from the trail sign in the foreground to the near and distant hikers and the mountain range in the background.

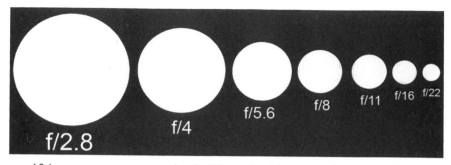

4.9. Lens apertures are commonly called "f/stops," and they are continuously variable from the largest lens opening to the smallest. They help control depth of field in your pictures. The larger the lens opening, such as f/2.8, less of the overall picture will be in sharp focus. Conversely, the smaller the opening, such as f/22, more of the overall picture will be in sharp focus. This diagram represents some of the standard f/stops: f/2.8, 4, 5.6, 8, 11, 16, and 22.

adjust the f/stop setting while in either the aperture-priority (A or Av) or the manual (M) exposure mode (see page 150).

F/stops are a series of numbers that commonly range from 1.4 to 32; the smaller the number, the larger the lens opening, and vice versa. That means a lens aperture set to f/1.4 (said to be "wide open") lets in the maximum amount of light, while the f/32 setting (said to be "stopped down all the way") lets in the least amount of light.

The usual f/stop numbers (from the widest to the smallest lens opening) are 1.2 or 1.4, 2, 2.8, 4, 5.6, 8, 11, 16, 22, 32, and (rarely) 45. However, take note that *most lenses do not have this complete range of f/stops.* For instance, the widest opening possible on a lens may be f/5.6, or the smallest opening may be f/16.

If you're curious, the f/stop number indicates what fraction the lens opening diameter represents in regard to the focal length of the lens. For example, the opening of a lens set at f/8 has a diameter of one-eighth its focal length (focal length was explained on page 31).

By the way, if you come across an f/stop number that is not in the range given above, such as f/3.5, it falls between the most logical pair of standard numbers, such as, in this case, f/2.8 and f/4.

All this background about lens apertures leads us to something that is important to know when buying a digital camera or an SLR lens: almost all zoom lenses have a VARIABLE MAXIMUM APERTURE, such as f/3.5–5.6. You'll find the aperture numbers engraved on the ring at the front of the lens barrel and listed in technical specifications about the camera or lens.

The first number indicates the widest lens opening that is possible when the zoom is at its minimum focal length (the wide-angle setting on some cameras). The second number indicates the widest lens opening that is possible when the lens is zoomed to its longest focal length (the telephoto setting on some cameras).

As the f/stop numbers (e.g., f/3.5–5.6) will show, more light can pass through the lens at its minimum focal length (wide-angle) setting than at its longest focal length (telephoto) setting. This matters because experienced photographers always want a lens that lets in the most light so they can shoot in low light at

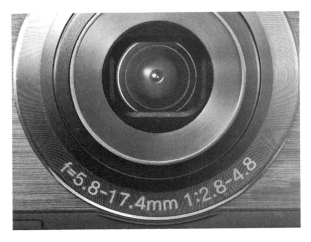

4.10. Zoom lenses have a variable focal length and often a variable maximum aperture, which are inscribed on the lens ring or camera body. This built-in zoom has focal length range (f=) from 5.8 to 17.4 mm, and its maximum aperture (1:) varies from f/2.8 to f/4.8 as the lens is zoomed from wide-angle to telephoto.

faster shutter speeds and thereby avoid blurred subjects or over-all blurred results from camera movement. They look for lenses with wide maximum apertures.

Some pros are even willing to pay extra for any zoom SLR lens that has a wide NONVARIABLE MAXIMUM APERTURE, notably f/2 or f/2.8. Unfortunately, to provide the same maximum aperture regardless of where you set the zoom focal length, such lenses have to be bigger because of larger optical elements. As a result, they are heavier, more cumbersome, and can be quite expensive compared to lenses with variable maximum apertures.

Ideally, you want a digital zoom camera or an SLR zoom lens that has a great focal length range and wide maximum aperture openings. In reality, prosumer and P&S zoom cameras offer greater zoom ranges (up to 18×) but smaller maximum apertures than do SLR cameras and lenses.

One advantage of an SLR camera is that you can buy two or three interchangeable zoom lenses that will offer an impres-

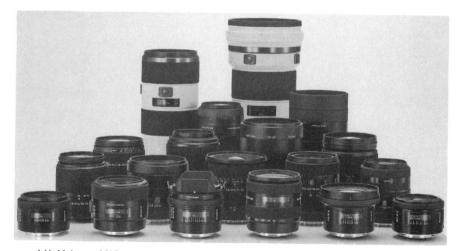

4.11. Makers of SLR cameras offer a variety of interchangeable lenses that fit their particular models. The lenses have a wide range of maximum apertures and fixed and zoom focal lengths. This display of nineteen lenses for Sony SLR cameras includes all types: normal, macro, wide-angle, telephoto, and zoom.

sive total range of focal lengths, along with wide maximum apertures. As an example, our favorite lenses when using a full-frame SLR camera include a 20–35 mm wide-angle, 35–70 mm normal range, and an 80–200 mm telephoto, all with wide f/2.8 nonvariable maximum apertures. With these three lenses, we can shoot at focal lengths ranging from 20 to 200 mm, which means we can increase the size of a subject up to ten times from the same camera position by changing from one lens to another.

WIDE-ANGLE AND TELEPHOTO LENS CONVERTERS FOR BUILT-IN ZOOM LENSES

What if you want to increase the wide-angle or telephoto range of the built-in zoom lens on your prosumer or point-and-shoot camera? Because the lens is permanently attached to the camera, you cannot physically change the lens as you can with an SLR. But you may be able to attach a wide-angle or telephoto LENS CONVERTER, an accessory that will change the effective focal length of your camera's built-in zoom lens. (Converters can be used on interchangeable lenses for SLRs as well.)

A wide-angle lens converter widens the wide-angle setting of your zoom so it will encompass more subject area. Similarly, a telephoto lens converter narrows the telephoto setting of your zoom so subjects will appear closer and therefore larger in size.

The amount of change these optical attachments will make is indicated on the specific lens converter by a number called a FOCAL LENGTH MULTIPLIER. For wide-angle lens converters, the number is less than one, often 0.7×, 0.75×, or 0.8×. For telephoto lens converters, the number is greater than one, often 1.5×, 1.75×, or 2×.

To determine the effective focal length of a lens fitted with a lens converter, multiply the actual focal length of the lens by the lens converter's focal length multiplier number.

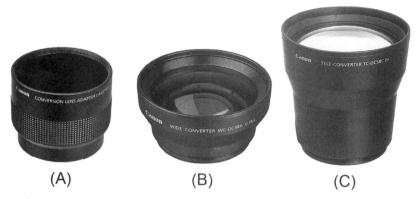

(A) (B) (C)

4.12. To change the effective focal length of your camera lens, optical accessories called lens converters can be attached to widen or narrow the angle of view in order to include more or less of your subject in the picture (see text). Many cameras require that a nonoptical lens adapter (A) first be attached to your camera in order to screw on a wide-angle (B) or telephoto lens converter (C). See also illustration 4.13.

For example, let's say the focal length range of your zoom lens is the 35mm equivalent of a 35–105 mm zoom lens. If you attached a 0.8× wide-angle lens converter, the lens would then have an effective focal length of 28mm at its wide-angle setting (35mm × 0.8 = 28mm). Likewise, if you attached a 2× telephoto lens converter, the lens would have an effective focal length of 210mm at its telephoto setting (105mm × 2 = 210mm).

When a lens converter is attached to the front of a built-in zoom lens, the camera's autofocus and auto-exposure systems will continue to operate normally.

Before buying a lens converter, be certain that it will fit your camera. Some converters screw on to the camera lens, so there must be screw threads at the end of the lens barrel. Other cameras have a covering ring around the lens that you have to remove in order to attach a converter, which usually has a bayonet mount that you twist on and twist off. Keep in mind that a number of cameras are not designed to accept lens converters; check your camera manual.

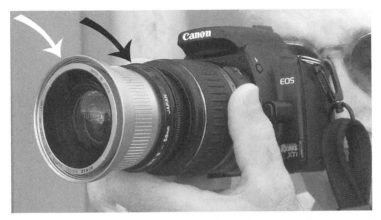

4.13. Attaching a lens converter (white arrow) in front of your camera lens may require a lens adapter (black arrow), which is a metal ring of a specified size that fits between the camera lens and the lens converter. See also illustration 4.12.

The size of a lens converter is given in millimeters (mm) and indicates the diameter of the opening where it attaches to the camera lens. Some converters are universal for several camera models and may require a LENS ADAPTER in order to attach to your particular lens.

If a lens adapter causes the lens converter to extend far from the camera lens, make sure it does not cause VIGNETTING of your pictures when the zoom lens is at its wide-angle setting. Also check to see if the camera's built-in flash will be blocked when a lens adapter or lens converter is attached.

LENS EXTENDERS FOR SLR LENSES

If you shoot with an SLR, you can always switch to a more powerful telephoto or zoom lens whenever a greater focal length is needed to make your subject appear larger. However, if none of the lenses you own has a focal length long enough to suit your purposes, you can use an accessory LENS EXTENDER instead of buying a new lens. Commonly called a TELE-EXTENDER or

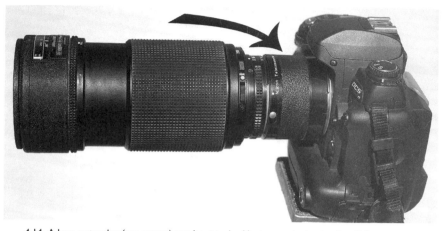

4.14. A lens extender (see arrow) can be attached between the body of an SLR camera and its lens in order to increase the effective focal length of that lens. Also called a tele-converter, the 2× optical attachment shown here extended the 80–200 mm zoom lens to an effective focal length range of 160–400 mm (see text).

a TELE-CONVERTER, these optical attachments increase the focal length of your existing lenses by a specific factor, either 1.4, 1.5, 1.7, or 2 times (×). Multiply the focal length of a lens by this factor to determine its effective focal length when the lens extender is attached.

For example, by using a 2× extender with the 35mm equivalent of a 200mm lens, you then have an effective focal length of 400mm (2 × 200mm = 400mm), which will double the original size of your subject.

Unlike the LENS CONVERTERS described earlier that attach to the front of built-in zoom lenses on P&S and prosumer cameras, lens extenders are mounted *between* the camera body and its lens. They are designed to fit specific SLR camera brands and models, and allow the auto-exposure and autofocusing features of the lens to operate as usual.

One important thing to keep in mind is that lens extenders require an increase in exposure. That's because light must travel

farther to reach the image sensor when a lens extender is placed between the camera body and its lens.

As an example, if using a 2× extender, you must increase the exposure by opening up the lens aperture two f/stops, as from f/11 to f/5.6, or by slowing down the shutter speed two steps, as from 1/500 to 1/125 second. Exposures will be adjusted automatically for most lens extenders unless you are using manual exposure control (see page 150).

If you only have occasional need for a camera lens with an extended focal length, a lens extender is a good option because it is far less costly than buying a new SLR camera lens itself, and it is more convenient to carry. However, a camera lens with the actual focal length you desire will produce images of better quality, and it will be easier to use than a camera lens with a lens extender attached.

MAKING IT BIG WITH SLR MACRO LENSES

When you want to do close-up photography, you can set the MACRO MODE on P&S and prosumer cameras or mount a MACRO LENS on an SLR camera. In both cases, this allows you to focus the camera lens closer to your subject than usual so it will appear larger and show greater detail in the picture.

Here are some things to know about macro lenses for SLR cameras. (The macro mode found on P&S and prosumer cameras will be discussed in chapter 9—see page 223.)

Most macro lenses for SLR cameras have a *fixed* focal length, such as 35mm, 50mm, 60mm, 70mm, 90mm, 100mm, 105mm, 150mm, or 180mm, and they can be used as regular lenses for general photography as well. A few zoom lenses are designed by their manufacturers to also serve as macro lenses.

A macro lens allows you to focus closer to subjects than any other type of lens; its *minimum focusing distance* is inches rather than feet (or centimeters rather than meters).

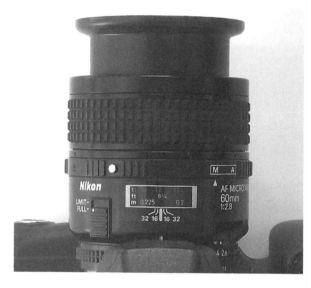

4.15. When shooting close-ups with an SLR camera, use a macro lens. Its front lens elements can be extended a considerable distance from the image sensor, which means you can focus closer to a subject and make it appear larger in the picture. Some macro lenses, like this one, can photograph small subjects at life size (see text and illustrations 4.16–4.17).

True macro lenses enable you to photograph a subject at LIFE SIZE. This means, for example, that your camera's image sensor would record the eye of a bug at the same size it is in real life, which is termed a one-to-one (1:1) REPRODUCTION RATIO. Not all macro lenses can achieve a 1:1 ratio; some will only be able to capture a subject at one-half (1:2), one-third (1:3), or one-fourth (1:4) of life size.

Before buying any macro lens, be sure you know its reproduction ratio (maximum magnification) so you won't be disappointed by its actual close-up capabilities. Also remember that

Every type of lens has a minimum focusing distance, which varies with the focal length of the lens. If you get any closer than that minimum distance, your subject will be out of focus. (At the other end of the lens focusing scale is INFINITY, the distance beyond which everything will be in focus.)

the focal length of the macro lens you choose determines the working distance (minimum focusing distance) between the lens and the subject.

You may prefer a midrange macro lens—such as a 90mm, 100mm, or 105mm—so you won't have to put the camera right on top of the subject for a close-up picture. That way you'll have more room to work with flash, which is an effective and popular way to illuminate close-up subjects (see page 72).

While many macro lenses have wide maximum apertures, such as f/2.8, that doesn't matter much when shooting close-ups. Why? Because it is best to use a narrow lens opening in order to increase depth of field so more of the subject will be in sharp focus at such a close range. Macro lenses have a minimum aperture setting of f/22 or f/32, and some even stop down to f/45.

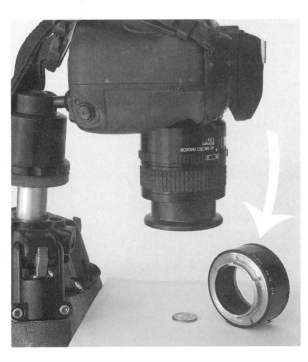

4.16–4.17. Held steady by a tripod, an SLR camera with a macro lens is focused on a coin that is only inches away. The result is a life-size image of the reverse of a U.S. nickel (below). To capture a close-up image that is even larger than life size, a nonoptical extension tube (see arrow) can be inserted between the camera body and the macro lens (see text).

CLOSE-UP LENSES AS A LESS-EXPENSIVE OPTION

Another way to increase the size of your subject is to screw a CLOSE-UP LENS to the front of an SLR camera lens. Sizes of close-up lenses are indicated in millimeters (mm) and must match the diameter of your specific camera lens. (Close-up lenses can also be fitted to the built-in zoom lenses on some pro-sumer and P&S models.)

Close-up lenses were common accessories for SLR camera lenses until the introduction of macro lenses, which are optically better and more versatile for close-up photography. As relatively inexpensive optical attachments, close-up lenses come in several strengths or powers. This power is measured in DIOPTERS and is indicated by a plus sign (+) with a number. Common diopters are +1, +2, +3, +4, +5, +8, and +10. The higher the number, the greater the magnification. You can combine two close-up lenses to create a stronger magnification, such as putting together a +3 and a +4 to make a +7 diopter.

You'll be glad to know that no increase in exposure is required when you attach a close-up lens, or two, to your camera lens.

4.18. Close-up lenses can be attached to the front of a camera lens to increase the size of the subject recorded by the image sensor. They are available in different strengths, which are called diopters (see text).

GETTING CLOSER WITH EXTENSION TUBES
OR AN EXTENSION BELLOWS

If you are going to do extensive close-up photography with an SLR camera, you probably will add EXTENSION TUBES or an EXTENSION BELLOWS to your camera gear. These *nonoptical* attachments are inserted between the camera body and the camera lens.

As their names imply, they extend the effective focal length of the lens, which magnifies the image of a subject on the image sensor. The amount of magnification depends on the distance your SLR lens is extended from the camera body by the extension tubes or bellows.

Extension tubes are made of metal or plastic and can be short, medium, or long. The exact length of the tube is indicated in millimeters, such as 13mm, 21mm and 31mm. Extension tubes can be used individually or in combination.

Much more versatile is an extension bellows, which has a flexible midsection. It can be easily adjusted to more extreme lengths that let you magnify a subject up to four times (4:1) life size, depending on the focal length of the camera lens.

As with lens extenders (see page 99), an increase in exposure is required when an extension tube or bellows is placed between the camera body and its lens because the light must travel farther to reach the image sensor.

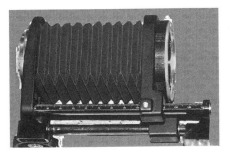

4.19. By mounting a flexible device known as an "extension bellows" between the camera body and the camera lens, you can vary the distance of the lens from the image sensor to make close-ups that are greater than life size (see text and also illustrations 4.16–4.17).

Regardless of whether you choose a macro lens, close-up lenses, extension tubes, or an extension bellows for close-up photography, most often you'll need a TRIPOD to keep your camera steady and precisely focused on your subject. A CABLE RELEASE also helps prevent blurred images by letting you trigger the shutter without jarring the camera. Read about these accessories in chapter 5.

COVERS AND HOODS FOR YOUR LENSES

This should go without saying, but we want to emphasize it: take care of your lenses! A dirty or scratched lens can degrade, if not ruin, your photographs.

Help keep lenses clean and free from dust and inadvertent damage by covering them when not in use. Point-and-shoot and prosumer cameras often have an irislike lens cover that closes automatically when you turn the camera off, or they have a sliding lens cover built into the camera. Otherwise, and especially for SLR lenses, you must use a round LENS CAP that slips or clips over the front of the lens to protect it.

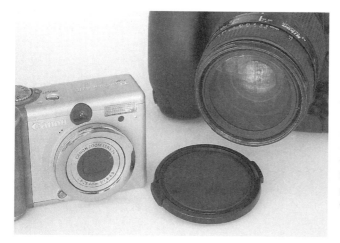

4.20. Keep your camera lens free of dust and finger smudges by making sure it is covered when not in use. Many point-and-shoot models have a cover that is self-closing when the camera turns off (left); with SLR cameras, you must physically put on a lens cap (right).

One caution: always make sure the *inside* of your lens cap is free of dust and debris, such as lint from a shirt pocket, so it won't be transferred to the camera lens when you cover it. The same is true for the additional REAR LENS CAP that you should always put on an SLR lens when it is not mounted on a camera.

As an alternative to lens caps, some photographers attach a clear SKYLIGHT or ULTRAVIOLET (UV) FILTER to protect the front optical element of the lens. This offers an advantage when a photo opportunity suddenly appears, because you won't waste any time uncapping the lens. Of course, a lens cap should be put over the attached filter whenever the camera or SLR lens is put away for the day.

You should be aware that many pros do not use UV or skylight filters for lens protection because they believe the added glass of any filter adversely affects the light rays passing through a digital camera lens to the image sensor. Read more about lens filters and their effects beginning on page 121.

By the way, when you need to clean the optics of your camera lens or SLR lenses (or filters), buy a rubber or soft plastic AIR BULB at a camera shop to first blow away any debris that might scratch the lens. (An ear syringe, sold at pharmacies, will work as well.) Then wipe the optics carefully with a MICROFIBER CLEANING CLOTH. These lintless and washable cloths are sold at camera shops and eyeglasses stores. Carry the cloth in a small plastic bag so it doesn't gather dust when not being used.

Very useful is a LENS HOOD, also called a LENS SHADE, which extends from the front end of the lens. Some are part of the lens barrel itself and slide out into position, while others are attachments that screw or clip on to the lens barrel.

Lens hoods are shorter on wide-angle lenses (to avoid vignetting) and longer on telephoto lenses. They offer some protection to the lens by helping to shield the front optical element from rain or snow and by blocking wayward objects that might scratch it.

4.21–4.22. To prevent sun flare from appearing in your pictures (below), use a lens hood (right) to keep sunlight from directly striking the glass elements of the camera lens or any filters in front of the lens. If you find yourself without a lens hood, block the sun with your hand or a hat.

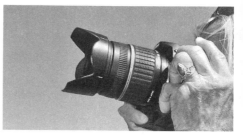

However, the main purpose of a lens hood is to shade the lens optics from direct sunlight or other bright lights that might create an unwanted flare in your photographs. Of course, if you don't have a lens hood, you can use your hand, a hat, an umbrella, or whatever is handy to shade the lens from any offending light, so it won't cause a flare.

5

Worthwhile Accessories
for Digital Cameras

One of the delights of digital photography is that many of the cameras are small and very convenient to carry wherever you go. Just slip an extra memory card and spare batteries in your pocket, and you're all set for casual shooting. More serious photographers using SLR cameras will also take along additional lenses. But will you need any other accessory equipment?

A few items might be helpful—and even necessary—depending on your photographic pursuits. Among them is an external flash unit that provides more flash power than the camera's built-in flash, which we described in chapter 3 (see page 80). Other gear to consider is a camera case or camera bag, a tripod, a cable release, and a few lens filters, all of which we discuss below.

CAMERA CASES AND BAGS PROTECT YOUR GEAR

When not in use, any small digital camera should be protected with a padded CAMERA CASE. It will help prevent damage due to careless handling and also keep the camera from getting dusty. Buy a case that is large enough to hold extra memory cards and spare batteries as well.

5.1. Whenever your camera is not in use, be certain to protect it with a padded camera case or bag. This small case for a pocket-size point-and-shoot model has room for spare memory cards and an extra battery pack.

Larger digital cameras, especially SLR models and their additional lenses, are best protected by a CAMERA BAG. There are many styles, including the popular soft-sided shoulder bags and photo backpacks. Other options are hip, waist, or chest packs that strap around your body. Photo vests or jackets are favorites for nature excursions. There are also hard-sided camera cases best suited for car and air travel. Another choice is a combination bag that holds camera gear and a laptop computer for editing images on location.

Not surprisingly, there are numerous camera bag and camera case manufacturers. Tenba, Domke, Lowepro, and Tamrac are some well-known brand names.

We recommend taking your camera and gear to the store to make sure everything fits in the bag you intend to buy. Don't be embarrassed about trying out various bags for their size, weight, comfort, and ease of access to your equipment.

Sturdy construction is especially important. The bag material should be durable and waterproof. Check for good cross-

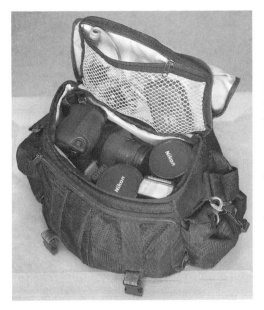

5.2. Make sure your camera bag is big enough to carry all your equipment, especially if you shoot with a single lens reflex (SLR) camera. This bag holds a full-frame SLR, four lenses, an external flash unit and extension cords, four battery packs, a case with six memory cards, a cable release, filters, an LED flashlight, and other miscellaneous items.

stitching and hefty rings and buckles for straps. Zippers should be easy to open and close, and covered with a flap to keep out moisture. Make sure the interior is well padded to serve as a shock absorber for your gear; add foam rubber if needed.

TRIPODS PROMISE BLUR-FREE PHOTOS

That familiar three-legged support called a TRIPOD is a vital accessory for every photographer. And if you're shooting architecture, landscapes, interiors, night exposures, close-ups, or time-lapse subjects, a tripod is a necessity.

The job of a tripod is simple: to hold your camera steady and in position, especially at slow shutter speeds. But it is no simple task to choose the tripod that is best for your purposes. You have to consider its extended height, weight, compactness when collapsed, materials, construction, leg locks, feet, center column (if any), head, and, of course, the cost.

There are dozens of tripods, and many have features unique to their brand. The major manufacturers include Manfrotto, Gitzo, Slik, Velbon, Cullmann, Benbo, and Sunpak. Tripod prices can reach as high as several hundred dollars. Shopping for a tripod is truly a case of "you get what you pay for." A bargain tripod will save you money but not the grief it can cause when you are using it.

Try out any tripod you intend to buy. The most important consideration is whether the tripod is sturdy. Always remember that a wiggly tripod is a worthless tripod.

As a test, extend the legs to reach the tripod's full height, and mount your camera; if it is an SLR camera, attach your longest and heaviest lens. The tripod must be strong enough to hold your camera rock steady, and tall enough so you don't have to

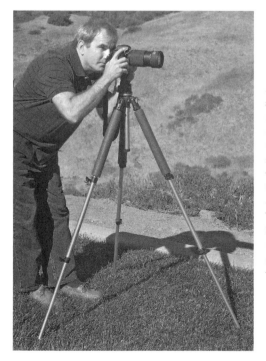

5.3. The first prerequisite for a tripod is that it be sturdy; it must be able to hold your largest camera and heaviest lens rock steady. For the best support and ease of use, the tripod's forward leg should be positioned in the same direction as the camera lens. This gives you room to stand between the two legs at the rear of the camera and helps prevent tripping over the tripod.

bend over to see through the camera's viewfinder or look at the LCD monitor.

Next, ask yourself if the tripod is light enough that you'll actually carry and use it. A tripod is no good if you just keep it in a closet. The tubular legs of many tripods are made of aluminum, sometimes in combination with magnesium and titanium alloys. However, the strongest and lightest are constructed of a much more expensive material, carbon fiber. The newest material for tripods is basalt fiber, which is made from lava rock; it is as strong as aluminum but lighter in weight.

To make a tripod collapsible and easier to carry, the legs are separated into three to five sections that slide into one another and lock into place. Check the LEG LOCKS carefully. They should be easy to open and close so the tripod can be quickly extended or collapsed. Be sure the locks do not lose their grip under the weight of your camera (and its heaviest lens).

Look at the FEET of the tripod; most have rubber tips but some feature interchangeable or retractable spikes that hold better to the ground when shooting outdoors. Accessory feet for some tripods include those with a wide base for use in sand, mud, and snow, and others with suction cups for more stability on smooth surfaces.

A CENTER COLUMN that extends from the top of the tripod is a worthwhile feature. It enables you to quickly make precise

5.4. Tripods have various types of leg locks, such as the twist ring, knob, and flip locks shown here. Be sure the type you choose is easy to use.

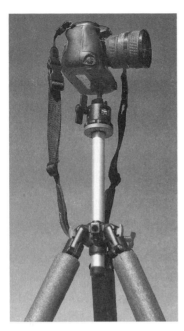

5.5. A tripod equipped with a center column allows you to raise and lower your camera easily and more precisely than by adjusting each of the tripod's three legs. Some center columns can be reversed so you can position the camera beneath the tripod base for close-up work directly below it without getting the legs in the picture. Some columns also can be pivoted and extended horizontally from the tripod base so you can shoot downward without including the legs in your photo.

adjustments to the height of your camera. Check the ease of raising and lowering the column, its locking device, and the overall sturdiness when your camera is in place on the extended column. For close-up work, look for a column that can also be removed and reversed so that it can be extended in the other direction (toward the ground) for low-level shooting and/or one that pivots 90° so it can be extended horizontally as well as vertically.

The type of TRIPOD HEAD to which you attach your camera is especially important. Regardless of its design, every head features a quarter-inch bolt that screws into the TRIPOD SOCKET on the bottom of your camera. Some tripods come equipped with a head, but many heads are sold separately.

Especially useful and very popular is a BALL HEAD, which lets you pivot the camera in any direction and then lock it securely into position with the twist of a knob. If you shoot many pan-

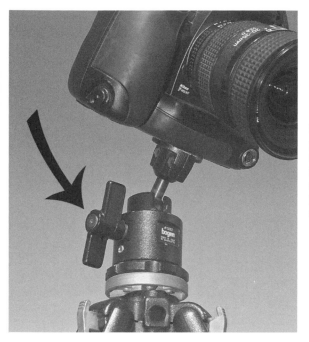

5.6. Many photographers prefer a ball head on top of their tripods. That's because the camera can be turned in any direction and then quickly locked into position with the twist of a knob (see arrow).

oramas, a PAN HEAD is preferred because it keeps the camera level while you move a handle to pivot the camera from side to side.

Photographers who make considerable use of a tripod often buy a QUICK-RELEASE DEVICE for fast attachment of the camera. Initially, you screw one plate of this two-piece device to the tripod head and screw its other plate to the camera's tripod socket. Whenever you want to mount your camera to the tripod, you simply align the two plates, flip a lock, and you're set to shoot. Removing the camera is just as easy.

Here are a few tips based on our long experience with tripods. If you plan to carry a tripod over your shoulder, it will be more comfortable if you slip some hollowed-out tubes of polyethylene foam around the tripod's uppermost leg sections for padding. It also helps insulate your hands from a cold tripod in

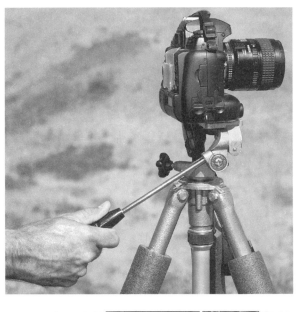

5.7. Because you can keep the camera level and easily pivot it left or right with a handle, a "pan head" on top of a tripod is ideal when creating panoramas or making video clips.

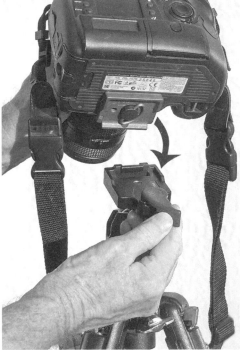

5.8. A two-piece device known as a "quick release" allows you to quickly and securely attach your camera to a tripod. With the flip of a lever, the base plate that screws into the tripod socket on the bottom of your camera is locked into the quick-release head plate that is attached to the tripod. A twist lock keeps the lever secure until you want to detach the camera.

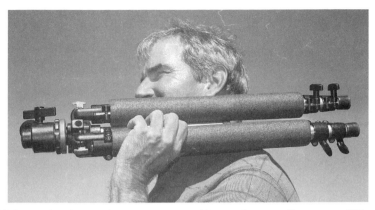

5.9. Foam tubes that can slip onto upper tripod legs are known as "leg warmers." They provide padding that makes it more comfortable to carry a tripod on your shoulder and to handle the tripod in cold weather.

winter. This foam tubing is sold in hardware stores as an insulator for water pipes; look for the kind that comes with a slit down the slide so you can easily snap it into place over the tripod legs. Camera stores sell similar padding as a tripod accessory known as LEG WARMERS.

To make your tripod-mounted camera more stable, especially in windy conditions or on uneven ground, hang your camera bag or some other counterweight from the tripod. Some tripods have a retractable BALLAST HOOK built into the center column for this very purpose.

To be certain your camera is level, especially when shooting panoramas, use a small BUBBLE (SPIRIT) LEVEL. This is a feature of some tripods, but you can also buy a bubble level that can be attached to the external flash mount, commonly called a HOT SHOE, on an SLR camera. Or you can hold the level against a flat surface on any camera.

If a tripod is too cumbersome to carry or use, try a MONO-POD. This one-legged, telescoping cousin of a tripod is popular with sports photographers, who must reposition their cameras

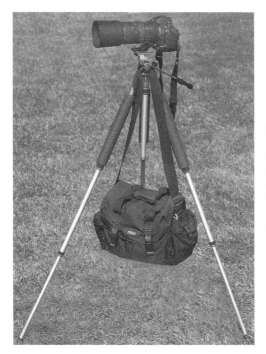

5.10. If your tripod seems unsteady, especially in windy conditions, hang your camera bag or some other counterweight from the tripod base (as here) or from the center column if it has a ballast hook.

quickly and use them to steady large telephoto and zoom lenses. A monopod can give support in places such as museums and busy tourist spots, where tripods may be banned or impractical because their legs might trip other visitors. The center column on some tripods can be pulled out to serve as a monopod.

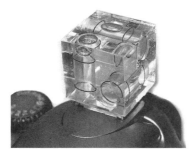

5.11. To check that your camera is level on a tripod, use a bubble (spirit) level device like this one that has been mounted in the hot shoe of an SLR camera. Its three-axis design shows when the camera is level from side to side and front to back whether in a horizontal or vertical format.

5.12. A monopod is two legs short of being a tripod, but it will provide support for your camera. With flip leg locks and a ball head, this lightweight model is very easy to use. Monopods are favored by sports photographers, who want to keep their cameras at eye level and ready for action.

Another option is a BEANBAG that you place on a solid surface to cradle your camera. Buy one at a camera store or make your own with Styrofoam pellets in a plastic or cloth bag.

All digital cameras have a SELF-TIMER feature that trips the shutter a few seconds after you press the shutter release button

5.13. When a tripod is not handy to support your camera, you can use a "beanbag" to hold the camera in any position for hands-off shooting (using the self-timer). This homemade bag is loosely filled with Styrofoam pellets.

Whenever you use a tripod (or beanbag), there is a simple way to help prevent camera movement that results in blurred pictures: don't touch the camera or tripod during exposures. You have a choice of hands-off methods for triggering the camera's shutter: use a cable release, a wireless remote control, or activate the camera's self-timer.

(see page 177 for details). That way your hands won't be touching (and possibly moving) the camera when the exposure is made.

Another option is to use a REMOTE RELEASE CABLE or CORD, more commonly known as a CABLE RELEASE. It plugs into an electronic socket or port that is found on all SLRs and some prosumer cameras. Instead of pressing the shutter release on the camera, you press a button at the end of the cable to trigger the shutter and make the exposure.

By the way, using a cable release is the recommended way to avoid camera movement while making TIME EXPOSURES. First, if available, set the shutter to B (B is the abbreviation for "bulb," a word from photography's early days when you had to squeeze

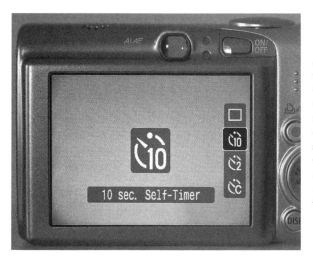

5.14. The camera's self-timer can be set to make an exposure after a specific time delay, such as 10 seconds. This menu on the LCD monitor offers other options: 2 seconds and custom (C) time settings that can delay the shutter release for different periods (up to 30 seconds) and trigger from two to nine more shots.

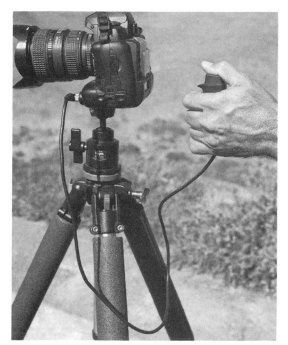

5.15. A cable release enables you to trigger the shutter release without touching the camera (see text). Using a cable release, especially for long exposures or macro (close-up) photography, helps prevent blurred images that result from camera shake.

a rubber bulb at the end of a rubber tube to open the shutter on vintage cameras). Next, open the shutter by pressing the button at the end of the cable release. Keep the button depressed for the number of seconds or minutes you desire for the time exposure, and, finally, release the button to close the shutter.

Some cameras have a built-in release feature that is controlled by a small handheld electronic device called a WIRELESS REMOTE or a CAMERA REMOTE. It will activate the shutter release from limited distances, much like the remote control for a television set. Check your camera's instruction manual for details.

LENS FILTERS OFFER SPECIAL EFFECTS

Placing a filter in front of a camera lens to enhance or otherwise alter the image has long been a practice in film photography. A

few of the same filters have carried over to digital photography, but others are no longer needed because the same effects can be created electronically in the camera or by using image-editing software after downloading the pictures to a computer.

For example, by setting your camera's WHITE BALANCE (WB) for the specific type of light illuminating your subject—such as Daylight, Fluorescent Light, or Flash—the colors in your pictures will look the same as they originally did to your eye (see page 141). (Film photographers use a variety of LIGHT-BALANCING, CONVERSION, or COLOR-COMPENSATING FILTERS to achieve the same results.)

Furthermore, the better image-editing software programs enable you to apply a variety of color-changing filters while viewing images on your computer screen, so most digital photographers find it unnecessary to use filters when they are shooting (see page 330).

However, if you want to emulate the pros, there are two filters to try on your digital camera lenses: a polarizing filter and a graduated neutral density filter. These are designed to fit SLR and prosumer cameras that have screw threads at the outer end of their lens barrels.

Most point-and-shoot cameras have no threads on their lenses and cannot accommodate screw-on filters. However, some models feature a covering ring around the lens that can be removed so a LENS ADAPTER can be mounted in its place to accept filters and/or wide-angle and telephoto lens converters (see page 97).

A POLARIZING FILTER polarizes the light reflected by your subjects, and it can be adjusted to reduce or eliminate those unwanted reflections. For example, this filter can cut the glare from a lake in order to show the water in more detail. Likewise, it can rid store window glass of reflections so you can better

5.16–5.17. Placing a polarizing filter in front of the camera lens is a popular and easy way to create more dramatic scenic shots by making clouds stand out in the sky. The filter also helps cut through atmospheric haze to make landscapes more distinct, as seen in these comparison views of the Organ Mountains above Las Cruces, New Mexico.

photograph the products on display inside. A polarizing filter also enhances a blue sky and will increase the contrast between clouds and the sky for more dramatic scenic shots.

The degree of these visual effects can be controlled by turning the outer ring of this circular filter. It is easiest to use with an SLR camera because you can see in the viewfinder (or on the LCD screen with live view) the actual change it will make to an image. Using a polarizing filter requires an increase in exposure of about one and a half f/stops; cameras will make that adjustment automatically unless set to the manual (M) exposure mode.

Especially useful for landscape photography is a GRADUATED NEUTRAL DENSITY (ND) FILTER. One-half of the filter has a neutral density that reduces the light passing through the lens but does not affect the colors or contrast in your pictures. This neutral density fades midway in the filter to clear glass that has no effect on exposure.

You position the graduated ND filter over the camera lens so that the filter's darker half covers the bright part of your picture, such as the sky, while the filter's clear glass area covers the darker part, such as the ground. The effect is to balance the overall exposure of the picture. Without this filter, the sky would be overexposed or the ground would be underexposed.

Some filters carry the brand names of camera makers, such as Nikon and Canon, but they also are available from well-known filter manufacturing companies. Among these are Tiffen, Hoya, B+W, Heliopan, and Cokin.

As mentioned in the previous chapter, some photographers use UV (ULTRAVIOLET) or SKYLIGHT FILTERS to protect the front element of their camera lenses from dust and scratches. However, many pros do not put these filters on their digital SLR camera lenses in the belief that this extra and unnecessary glass

5.18–5.20. Read the text to learn how a graduated filter can help you balance an exposure, as in this photo (right) of the Wright Brothers National Memorial at Kitty Hawk, North Carolina. Without the filter, if you expose for the pylon on the distant hill where the first glider flights were made (top left), the bronze plaque in the foreground is underexposed. And if you expose for the plaque, the pylon is overexposed (bottom left).

affects the light rays and can degrade their pictures. They protect their lenses with lens caps instead (see page 106).

By the way, the traditional way to give black-and-white pictures a surreal infrared look required special infrared film and filters. Nowadays, similar effects can be created with digital cameras, filters, and the help of image-editing software, as we describe in chapter 9 (see page 216).

LED FLASHLIGHT TO THE RESCUE

A final recommendation is that you buy a vital accessory, an LED flashlight. Compared with ordinary flashlights, an LED (light-emitting diode) flashlight offers very bright light and long-lasting battery power. Slip a small one into your camera bag so it's always handy.

A primary use is to help you find your way at night or in dimly lit interiors. It is especially helpful, too, if you need to see your camera controls or change a memory card or batteries in the dark. Also, in the dark or in dim light, you can shine it on your subject so there will be sufficient illumination for your camera's autofocus feature to work.

6

Key Operational Settings to
Make on Digital Cameras

No doubt about it—digital cameras are "smart" cameras preprogrammed for technical success. If you set the camera control to "Auto" and press the shutter release button, a well-exposed and focused photo is almost assured. However, whether point-and-shoot, prosumer, or single lens reflex models, digital cameras are not simple to operate to their *full potential*.

We urge you to study your CAMERA INSTRUCTION MANUAL until you are very familiar with the camera's operational settings, and therefore all of its picture possibilities. You won't be able to memorize all the technical information in the manual, so remember to have it handy for quick reference.

> What if you misplace or lose the printed instructions for your camera? A copy of the manual can be printed from the CD that came in the box with your camera. Or print a copy of the instructions after entering your model number on the "support" pages of your camera maker's Web site (see appendix B).

Every digital camera has an assortment of buttons, knobs, and switches that activate various operational features, which

will be discussed below. Some of these controls are named or marked by icons on the camera, but study the camera manual to learn their specific functions.

Keep in mind that some buttons control more than one feature. Common to most cameras is a FOUR-WAY SWITCH or CONTROLLER, sometimes called an ARROW SWITCH. It shows arrows at the top, bottom, left, and right that you press in order to switch to different settings.

6.1. Most digital cameras feature a round four-way switch (see arrow) that you press at different points to make selections on menus that appear on the LCD screen. This switch also shows icons that call up specific menus: erase mode (press top), flash mode (press right), self-timer mode (press bottom), and macro mode (press left).

Choices are often shown on the LCD monitor as a series of MENUS, some of which offer further choices on additional drop-down and fly-out menus. The LCD monitor on a few models also serves as a TOUCH SCREEN to make direct selections from the menus instead of pressing a button, knob, or switch to do so.

Note that the main menus change whenever you switch from the camera's SHOOTING MODE to its PLAYBACK MODE, or vice versa. (Your camera may have a different name for the shooting mode, such as RECORDING MODE or PHOTOGRAPHY MODE.)

Initially you should look at the SETUP MENUS to review the camera manufacturer's FACTORY DEFAULT SETTINGS, and to make any changes to suit your own shooting and viewing preferences. The instruction manual will list the default settings in the

shooting and playback modes and will show the options you can choose instead.

Be aware that most cameras will retain the settings you make unless you purposely reset them to the factory default settings. However, some models will automatically revert to the default settings *whenever you turn off the camera or remove the memory card*; avoid this problem by disabling the camera's RESET ALL feature.

With hundreds of different digital cameras on the market, obviously we cannot discuss every setting available on specific models. That's why we remind you throughout the book to refer to your own camera instruction manual. What we describe in this chapter are the settings you can make for KEY OPERATIONAL FEATURES, and the reasons for doing so. Those include image file formats, resolution and compression, ISO, and white balance, which are features of all P&S, prosumer, and SLR cameras.

SELECTING AN IMAGE FILE FORMAT

On the menu for your camera's shooting mode, the initial setting to make is the IMAGE FILE FORMAT. This determines how the images created by your camera will be recorded as digital files on the memory card. The format you choose affects the size and the quality of your image files and thus the pictures that result.

Take note that IMAGE FILE FORMATS have nothing to do with FORMATTING, which is the in-camera preparation of a memory card prior to its use (see page 64).

An image file format called JPEG is common to all digital cameras. Many cameras also offer a choice of one or two other

formats that are known as TIFF and Raw. The three formats vary in several ways.

Two of the formats, JPEG and TIFF, are "processed" in the camera. This means that various corrections—such as white balance, color saturation, contrast and sharpness—are automatically made to the image when it is shot. The other format, Raw, means just that: the file contains only raw image data that you must "process" later in your computer with image-editing software.

Casual photographers like shooting in the JPEG or TIFF format because they get a finished picture immediately. On the other hand, serious photographers often choose the Raw format because they have full control of the result by processing the picture themselves after it is downloaded to a computer. Raw allows you to make the best picture possible, but it takes considerably more time and experience with image-editing software to do so.

By the way, to satisfy professional photographers who want both a finished JPEG photo and a Raw image to work on, some

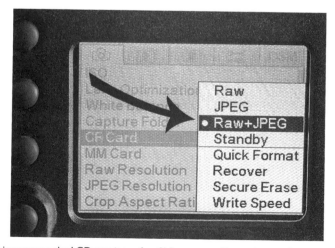

6.2. This menu on the LCD monitor of an SLR camera offers a choice of two image file formats: Raw and JPEG. The photographer has chosen the option of creating image files in *both* formats (see arrow) every time the shutter release is pressed.

SLR cameras can be set to shoot both JPEG and Raw images simultaneously with one press of the shutter release button.

JPEG is an acronym for Joint Photographic Experts Group, which created the format. TIFF stands for Tagged Image File Format. These formats are indicated by three-letter extensions that appear at the end of image file names: .jpg and .tif, respectively.

Unfortunately, almost every camera manufacturer has created its own Raw file program, so *there is no standard Raw format.* Because Raw files are proprietary, their three-letter file extensions are unique to the camera brand. For example, Nikon's Raw file format is designated .nef, Canon's is .crw or .cr2, Fujifilm's is .raf, Olympus's is .orf, Kodak's is .dcr, Sony's is .srf or .arw, and Pentax's is .pef. You will never see a Raw file format extension written as .raw.

Note that some publications capitalize the format name (i.e., RAW) even though it is not a specific file format like JPEG or TIFF; we capitalize only the first letter of Raw in order to emphasize that distinction.

Many photographers are hopeful there will someday be a universal Raw file format instead of the many proprietary Raw file formats created for specific brands of cameras. Their fear is that some of the numerous Raw file formats will go by the wayside in the coming years—as will the software programs to process those files. As a result, current Raw images may be unusable in the future.

Fortunately, the creators of Adobe Photoshop, the world's best-known image-editing software, have paved the way for Raw file archiving with long-term accessibility. They developed a *nonproprietary* Raw file format known as DNG, which is an abbreviation for DIGITAL NEGATIVE. Their idea is that your camera's proprietary Raw files should be converted and saved as DNG (.dng) files so the files can always be accessed (see page 304).

Adobe also has made publicly available all the technical specifications for the DNG file format in the hope that camera makers and software developers will adopt it as their standard Raw file format. Some have already done so. Several models of Samsung, Ricoh, Leica, Hasselblad, and other digital cameras produce Raw files that now carry the file extension .dng.

Meanwhile, camera companies have their own image-editing software programs to process their respective Raw images. The proprietary program is included on a CD that comes in the box with your camera.

Fortunately, there are also universal image-editing programs, such as Adobe Photoshop, that will convert proprietary Raw image files from the various brands and models of cameras. These programs allow you to process the Raw image as you like it best, and then save it as a JPEG or TIFF file for subsequent use in e-mails or on a Web site or to make photo prints.

Digital images are saved as JPEG or TIFF files because they are the two types of files recognized by most computer-graphics programs that are used for displaying or printing digital photos.

Whenever you're going to shoot some pictures, always consider what you plan to do with them and set the image file format accordingly in your camera. (Some point-and-shoot cameras are limited to only the JPEG format.)

A JPEG file is generally the best choice if you only expect to make small prints or display the pictures on a computer or TV screen. A TIFF file would be the better choice if you plan to make enlargements to frame and display in your home or office, or if the image is to be published, as in a magazine. Or shoot in Raw if you want full control of the result and have the time to process it with image-editing software, then save the image afterward as a JPEG or TIFF file or both.

How are JPEG and TIFF formats different? Mostly it is a

technical matter called COMPRESSION, which reduces the size of an image file. In general, a JPEG file is compressed when it is processed in the camera, while a TIFF image is not. One reason for compression is to speed up in-camera processing and later the downloading of the image file to your computer. But the major purpose of compression is to conserve space on the camera's memory card so that it can store more pictures. Compressed files also will save space on your computer's hard drive.

Compression was especially important in the earliest days of digital cameras because memory cards had very limited capacity. Today's memory cards are capable of faster processing and can hold hundreds of images, so choosing a file format just because it can significantly compress image files is of little concern for most photographers.

CHOOSING THE RESOLUTION (AND COMPRESSION) FOR IDEAL IMAGE QUALITY

While selecting the image file format—whether JPEG, TIFF, or Raw—you also need to choose the RESOLUTION, which directly affects the size and quality of the images. Menus on the camera's LCD screen will show you the choices, as will a chart in your camera manual.

Resolution is referred to in some camera manuals as IMAGE SIZE. Usually this is expressed by a pair of numbers that gives the image's dimensions in pixels (e.g., 3000 × 2000). The first number measures the count of pixels in one row across the *width* of the rectangular digital image, and the second number measures the count of pixels in one row along the *height* of the image.

The image size (resolution) may also be expressed as a single number that is the total of those two pixel counts multiplied

6.3. The resolution of an image is indicated by the number of pixels it contains; the more pixels, the higher the resolution. You can select a specific resolution, which often is referred to as "image size." As shown on the LCD screen of this 8 megapixel (MP) camera, the image size may be indicated by a single number and/or by a pair of numbers (see text). Here the photographer has selected an image size (i.e., resolution) of 5 MP (2592 × 1944 pixels).

together, such as 6 MP (3000 × 2000 = 6 million pixels, which is 6 megapixels). Just remember: the greater the number of pixels in a picture, the better the quality of the image.

When a digital picture is described as a high-resolution (hi-res) image, it means it has more pixels and therefore is of higher quality than a low-resolution (lo-res) picture. A lower resolution is okay for photos you shoot for e-mail or displaying on the Internet, but a higher resolution is required if you want to make large prints of the images.

Let's say that you shot a lo-res picture and sent it to friends via e-mail, and one of them liked the photo so much that he asked for an enlargement of it to frame. However, when you made

6.4. When an exposure is made at low resolution rather than high resolution, there are fewer pixels available to create the picture. If you greatly enlarge a low-resolution image, the blocky pixels will become evident, as seen here, and degrade the photographic quality of the picture.

the big print, the image visibly broke up into blocky pixels, and your picture lost its appeal. Unfortunately, the resolution was too low to produce a large, high-quality photograph.

Here's a guideline for shooting important pictures: set your camera at the highest resolution, just as professional photographers do. Why? Because a hi-res image can always be used to make a lo-res image, but not vice versa.

There is another setting to make if you choose the JPEG file format; this does not apply to TIFF or Raw file formats. You must set the COMPRESSION, which is referred to in some camera manuals as IMAGE QUALITY. JPEG files can be compressed in

order to reduce the number of pixels in the image and thus take up less space on the camera's memory card.

However, keep in mind the more the compression, the smaller the file size, and thus the lower the image quality. Conversely, the less the compression, the larger the file size, and thus the higher the image quality.

Depending on the camera, two or three choices of image quality (compression) may be offered, and their names also will vary with the camera brand. The image quality choices might be, for example, Good (most compression), Better, and Best (least compression); or Normal (most compression), Fine, and Superfine (least compression).

> We must mention that you can switch image file formats and change the resolution and/or compression anytime you wish. You don't have to fill up or empty a memory card before changing any of these settings.

A common question is, "How many pictures can I take with my camera?" A chart in your camera manual should indicate the number of images you can expect to shoot before the memory card fills up. The number depends on the card's capacity (see page 61), your selection from the available image file formats (such as JPEG, TIFF, or Raw), the resolution (image file size), and the compression (image quality) if you choose the JPEG format. As you'll find, the higher the resolution you select (and the better the image quality, if a JPEG), the fewer pictures you can shoot. Also see illustration 6.5.

You can shoot more pictures using the JPEG file format, which compresses the images, than if you use the TIFF file format, which generally does not. Images shot in a Raw file format usually take up more space on a memory card than JPEGs but less space than TIFFs.

Approximate Number of Recordable Images by Size and Quality*			
Quality Level / Recorded Pixels	★★★ Best	★★ Better	★ Good
12M (4000×3000)	201	291	404
10M (3648×2736)	242	350	486
7M (3072×2304)	342	495	685
5M (2592×1944)	481	695	963
3M (2048×1536)	728	1053	1458
1024 (1024×768)	1856	2682	3714
640 (640×480)	3405	4918	6811

*when using a 1 GB (gigabyte) Secure Digital (SD) memory card

6.5. This chart—from an instruction manual for a camera that only records in the JPEG image file format—shows the approximate number of pictures you can make on a 1 GB Secure Digital memory card. The number of exposures depends on the image file size (resolution) and the image quality (compression) you set. As shown in the left column, the camera offers a choice of seven resolution settings (recorded pixels) that expresses the file size in megabytes (M) and pixel dimensions (in parenthesis). The top row shows that the camera also offers three choices of JPEG image quality, as designated by one, two, and three stars and the corresponding names, Good, Better, and Best. Also see text.

Your camera will give you the most accurate count of the number of pictures you can shoot. Once you've inserted a memory card and set the file format, resolution, and compression, you can check the camera's LCD monitor to see the number of images that can be recorded. The number will decrease with each exposure you make.

Are you confused by all this discussion of image file formats, resolution, compression, and image quality? Here's a place to start: select the JPEG image file format, and choose its highest resolution and lowest compression settings. That way you'll have large, high-quality image files for whatever you want to do with the pictures.

SETTING THE ISO FOR IMAGE SENSOR SENSITIVITY

On the setup menu for your camera's shooting mode, another function you will find is ISO. This controls the sensitivity of the camera's image sensor to the light coming through the lens. You can set the ISO to "Auto" and let the camera adjust the sensor's sensitivity according to the light conditions. Or you can manually set the ISO yourself.

ISO is a carryover from film cameras, where it indicates to the camera's exposure metering system the speed (sensitivity) of the film being used. When light levels are low, film photographers have to switch to a roll of film with a higher ISO speed. With a digital camera, however, you just press appropriate buttons to set a higher ISO that increases the sensor's sensitivity. Technically, the image sensor doesn't really become more sensitive; rather, the electrical signals that represent the light recorded by the sensor are amplified at higher ISO settings. (This can cause a problem called NOISE, which we'll discuss shortly.)

Nonetheless, increasing the ISO number is normally described as increasing the image sensor's sensitivity. To do this, you choose from a menu of ISO numbers that appears on the LCD monitor. The image sensor's sensitivity is effectively doubled (or halved) by moving from one number to the next.

The ISO choices are fewest with P&S cameras, usually ISO 100, 200, and 400, which can increase the sensitivity up to four times. At the other extreme, one high-end SLR model offers ISO settings of 50, 100, 200, 400, 800, 1600, 3200, 6400, 12800, and even 25600, a range that can increase sensitivity more than fifty times. Some P&S models do not offer manual ISO control; the image sensor's sensitivity is always set automatically by the camera according to the light conditions.

By moving from one number to the next-highest number, say from ISO 100 to 200, the image sensor becomes more sensitive

6.6. To photograph when light levels are low, you can increase the sensitivity of the camera's image sensor by adjusting the ISO setting to a higher number. This menu on the LCD monitor indicates that the ISO has been set to 400. Some cameras have an "Auto" ISO setting, too (see text).

and you effectively increase the exposure by one f/stop or by one shutter speed step. Go from ISO 100 to 400 and you effectively add two f/stops or two shutter speed steps of exposure.

In practical terms, moving to higher ISO numbers means that you (or a camera on "Auto" ISO) can set smaller lens openings (f/stops) for increased depth of field, which puts more of your subject in sharp focus from foreground to background. You (or the camera) can also set faster shutter speeds for stop-action pictures or to avoid a blurred image caused by camera movement. In addition, setting a higher ISO extends the maximum distance that flash illumination will reach from a camera's built-in flash or an external flash unit.

We've mentioned some of the reasons for shooting at a higher ISO number, so why not keep your camera set at a high ISO all the time? There is a significant reason, and it is called NOISE.

The camera's lowest ISO setting is recommended for producing images of the best technical quality under normal light conditions. On many cameras that would be ISO 100.

With film cameras "noise" usually refers to the loud sound of a shutter or the autowinder or motor drive that advances the film after each shot. With digital cameras, noise relates not to equipment but to annoying effects in a picture that degrade the image. Noise shows up as random pixels that create multicolored blotches, called ARTIFACTS, and appears most often in uniform dark areas, such as shadows and blue skies.

Noise commonly occurs when the camera's ISO is set to a high number for making pictures in low light, especially with long exposures. Noise is less common in professional SLR cameras than in P&S and prosumer models.

Camera makers continue to work on the problem and some advertise models that feature NOISE REDUCTION. Close inspection of their noise-reduced images, especially when enlarged, shows

6.7. A problem called "noise" is inherent in digital cameras and can degrade your pictures. It is most noticeable when you shoot at a high ISO in low-light conditions, with a long exposure (see text). A blotchy image is one result, as seen in this after-dark shot of a costumed interpreter who was illuminated only by firelight at historic Colonial Williamsburg in Virginia.

that sharpness may suffer in the process. Fortunately, noise can be reduced and oftentimes eliminated with image-editing software, but loss of sharpness is always a concern.

To see how your particular camera may be affected by noise, make a series of test shots at different ISO numbers under low-light conditions (with the built-in flash turned off). An important reminder: whenever you set the ISO manually and shoot at a higher than normal ISO, be sure to reset the ISO to its usual lower and more ideal sensitivity, such as ISO 100, in order to avoid noise.

WONDERING WHAT WHITE BALANCE IS ALL ABOUT?

Another important setting in a digital camera is WHITE BAL-ANCE, which often is abbreviated WB. The reason for white balance is that you want colors to appear in your photographs just as you see them in real life. Unfortunately, when illuminated by different light sources, the colors of your subjects are recorded differently by your camera's image sensor. For example, under fluorescent lights, subjects might have a slight greenish hue. To compensate, you can set the white balance mode for the type of light in which you are shooting: daylight, cloudy, shade, flash, fluorescent tubes/bulbs, halogen bulbs, or incandescent bulbs (tungsten). These, or similar, choices are listed in your camera's white balance menu.

Fortunately, all digital cameras have an "Auto" or "AWB" setting for AUTOMATIC WHITE BALANCE. In many cases, this does the job well enough to create accurate color renditions in your photographs.

However, it is worthwhile experimenting to see the effects of different white balance settings. Make some test shots of the same subject under the same lighting conditions using the various WB settings on your camera. When you compare the results,

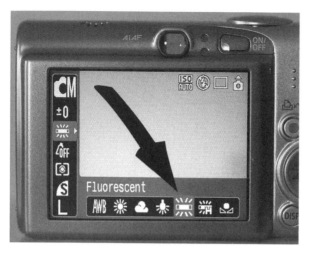

6.8. An important camera setting is white balance (WB), which helps make the colors in a digital photo appear as they do to your naked eye when shooting a picture. From a menu on the camera's LCD monitor, you select the type of light illuminating your subject; here it is set to fluorescent (see arrow). The choices (see text) are shown as icons representing different types of light, plus AWB for automatic white balance.

you'll undoubtedly see some significant shifts in the overall colors of the images.

The white balance menus in most cameras include the types of light listed above and have icons to represent each type. Some SLR and prosumer models also give corresponding COLOR TEMPERATURE numbers, based on what is called the KELVIN (K) SCALE. These numbers allow photographers to make more exacting WB settings that are particularly helpful under fluorescent light, which varies according to the bulb's specific type, such as "warm white," or "cool white."

The settings for white balance may also include a White Set or Custom setting that allows you to photograph a white-looking object (or a sheet of white paper) and use it as the basis for the best color balance under that specific lighting situation. The premise is that if an object looks white to your eyes and appears equally white in a picture, all the other colors in the picture will be accurate as well. That's how "white balance" gets its name, even though it pertains to achieving proper color balance.

If you're worried about whether colors will appear true in a

6.9. Because different light sources can change the colors in pictures, an important camera setting called white balance (WB) is used to correct the problem. Without it, fluorescent lights like the ones illuminating this display in a California sports museum would give everything in a color photo a greenish hue (see text).

picture, inspect the image closely on the camera's LCD monitor just after you make the exposure. If the result is disappointing, change the white balance setting, then shoot and review the image again.

In mixed lighting situations, as when you are indoors shooting under incandescent bulbs with sunlight coming through some windows, try both Daylight and Tungsten white balance settings and see which picture you like best.

What if you don't take such steps and later see some images that are off-color? Don't worry: you have an opportunity to alter the colors with image-editing software, which is one of the saving graces of digital photography. However, that is not a reason to be unconcerned about white balance settings before making an exposure. Why sit at a computer correcting avoidable mistakes when you can have a more enjoyable time shooting pictures?

MAKING SURE YOUR CAMERA'S FILE NUMBERING IS SET TO "CONTINUOUS"

One camera setting seems insignificant until you begin organizing your digital photo files: the FILE NAME. This is the title of each image file generated by the camera, such as *P6160019.jpg*, whenever you make an exposure. In some camera manuals it is called the FILE NUMBER or FRAME NUMBER.

By convention, regardless of what digital camera you use, the last four numbers show you the order in which the exposure was made on the camera's memory card.

You have a choice of two file name settings, CONTINUOUS and another that camera makers variously call RESTART, RESET, RENEW, or AUTO. We recommend you set the file name to "continuous" so all your images will be numbered in sequential order, such as 0019, 0020, 0021.

Otherwise, every time you put in a fresh memory card, your camera will restart the numbering at 0001. The result will be that different image files (pictures) end up with identical file numbers. And that can cause confusion and even software conflicts

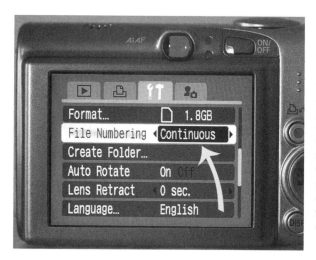

6.10. Set the camera's file numbering system to "continuous" (see arrow) so that all your pictures will be numbered sequentially as you shoot them. Otherwise, every time you use a newly formatted (or erased) memory card, the file number sequence will restart again at 0001. That can cause confusion because different pictures will have the same file numbers when downloaded to your computer.

when you are organizing those files after downloading them to your computer's hard drive. Note that some cameras also automatically restart file numbering at 0001 whenever you remove the camera batteries to recharge them or install new ones.

In chapter 12, we discuss how to organize your image files so you easily find any photo in the future. Meanwhile, make certain your camera's file name or file number setting specifies "continuous." A bonus is that this will also give you a running count of all the exposures made with your camera, up to a total of 9,999 images, when the numbering system will start over at 0001.

DO NOT FORGET THE DATE AND TIME SETTINGS

One of the primary instructions camera manufacturers give to new camera owners is SET THE DATE AND TIME. Do not ignore this important step, because the date and time of every exposure you make will be embedded in each image file as METADATA known as EXIF DATA (see page 285). This will help you identify and organize your image files.

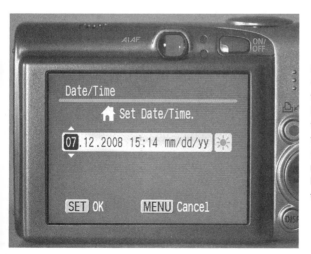

6.11. Be sure to set your camera for the correct time and date, because that information becomes part of the metadata that is recorded with every picture you shoot (see text). The settings are made on a date/time display like this one, which appears on the camera's LCD monitor.

Your camera manual will give step-by-step instructions for setting the date and time. And you may find some warnings. Most commonly, if the camera batteries become exhausted or if you remove the batteries from the camera for several hours to recharge them, the date and time settings could be canceled or become incorrect.

After replacing or recharging batteries, always remember to check the date and time for accuracy, and reset them if necessary. Some cameras have a separate clock battery to maintain the date and time for months or longer.

Understanding All the Exposure Settings

SELECTING EXPOSURE MODES ON YOUR CAMERA

Among all the operational settings that can be made on digital cameras, you should become especially familiar with the EXPO-SURE MODES. The selection of exposure modes is found on camera dials and on menus that appear on the LCD monitor.

On P&S models, the basic exposure mode is AUTOMATIC, which may be indicated by "A" or the word "Auto." Automatic exposure is just that: the camera determines and sets the SHUTTER SPEED and LENS APERTURE (f/stop opening). Together they control the amount of light reaching the image sensor that records the picture.

These auto-exposure settings are based on the camera's built-in exposure meter reading and the autofocused distance to your subject. In addition, when set to Auto (A), the camera automatically makes all the other decisions, such as the ISO and white balance settings, and turns on the built-in flash when needed in low light.

P&S and prosumer cameras, as well as some SLR models, also have a selection of preset modes called SCENE MODES, PIC-TURE MODES, or SHOOTING MODES. These modes, which have been given appropriate names like Landscape, Portrait, Night,

and Sunset (see more names below), automatically control exposure, focus, ISO, white balance, and other settings for specific subjects or situations.

> If you only have an all-automatic point-and-shoot camera, do you need to know about the other exposure modes? We think so, because you'll probably want a more versatile digital camera sometime in the future. By reading the information below, you'll know in advance about the wider choice of exposure settings that are features of advanced cameras.

On advanced cameras, including SLR and prosumer models, you'll find a greater choice of exposure modes than just the basic automatic mode. These modes are called "program," "shutter-priority," "aperture-priority," and "manual." And there may be a time exposure mode as well, indicated by "B" for "bulb" (see page 120).

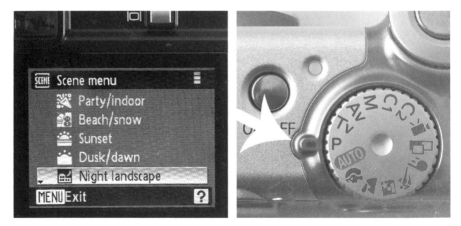

7.1–7.2. Although "Auto" is the most common exposure mode on digital cameras, most models offer a variety of other preset exposure modes known as scene, picture, or shooting modes. As shown above, these modes appear on camera dials or LCD menus and are indicated by an icon and/or a name. On advanced models, you'll also find other exposure modes indicated by letters (see text); the exposure mode dial seen here is set to "P" (program).

Just like P&S cameras, prosumer and SLR cameras provide automatic exposure. But these advanced cameras allow some choices to be made by the photographer. For instance, when set to PROGRAM mode, which is indicated by "P," the camera automatically sets the shutter speed and lens aperture, but you can make adjustments to ISO, white balance, and other settings. (Some models let you preset the shutter speed or the lens aperture as well.)

Another auto-exposure mode is specifically designed for SHUTTER-PRIORITY, indicated by "S" or "Tv" (time value). For

7.3. When you want to stop the action of a moving subject, use the shutter-priority (S or Tv) or manual (M) exposure mode in order to set a fast shutter speed. This bucking bronco at a rodeo was "frozen" in midair, with all four feet off the ground, by using a shutter speed of 1/500 second.

7.4. The camera's exposure mode should be set to aperture-priority (A or Av) or manual (M) when you want to use a large lens opening (f/stop) in order to limit a picture's depth of field. An aperture of f/4 made this handmade Native American bowl stand out in sharp focus from the natural surroundings of the Acoma Pueblo in New Mexico.

example, when you want to stop the action of a fast-moving subject, shutter speed is most important to your picture. In that case, you would select the shutter speed and the camera will automatically set the lens aperture for the correct exposure.

Likewise, there is an auto-exposure mode designed for APERTURE PRIORITY, indicated by "A" or "Av" (aperture value). For example, when you want to control depth of field for a specific range of sharp focus in a picture, the lens aperture is most important. In that case, you would choose the f/stop opening and the camera will automatically set the shutter speed for the correct exposure.

Whenever you don't trust an auto-exposure mode to make the best exposure, select the MANUAL exposure mode, indicated by "M." Then you have full control of exposure and get to set both the shutter speed and the lens aperture.

For instance, if a scene is very bright, such as sand dunes in the desert, the camera's metering system might underexpose the picture if set on an auto-exposure mode. Or if a scene has many dark shadows, such as in the middle of a forest, the metering system might set an auto-exposure that overexposes the picture.

By using the manual (M) exposure mode, you could open up the lens aperture or slow down the shutter speed to let more light reach the image sensor and prevent an underexposure of those bright sand dunes. And you could close down the lens aperture or increase the shutter speed to reduce the amount of light reaching the image sensor to prevent an overexposure inside the dark forest.

UNDERSTANDING LENS APERTURES
AND SHUTTER SPEEDS

If you select the manual, shutter-priority, or aperture-priority exposure mode, you need to know more about the interrelationship of lens apertures and shutter speeds. As mentioned above, the lens aperture and shutter speed together control the amount of light that reaches the image sensor to make an exposure.

LENS APERTURES, commonly known as f/stops, were described in some detail in chapter 4, during our discussion about depth of field. We listed the full range of standard f/stop numbers, from the largest to the smallest lens opening: 1.2 or 1.4, 2, 2.8, 4, 5.6, 8, 11, 16, 22, 32, and (rarely) 45.

To avoid being confused by f/stop numbers, just remember that the smaller the number, the larger the lens opening, and vice versa. This means, for example, that a setting of f/2 will let more light through the camera lens than f/22. Go to page 92 to review more important background information about lens apertures.

Like lens apertures, SHUTTER SPEEDS are represented by standardized numbers. They indicate the length of time the shutter stays open, which may be as long as 30 seconds or as brief as 1/8000 second. The full range of shutter speeds—from the longest to the shortest exposure time (given in seconds and fractions of a second)—is 30, 15, 8, 4, 2, 1, 1/2, 1/4, 1/8, 1/15,

7.5. Exposure is controlled by the shutter speed and the lens aperture. However, each setting also affects the impact of a picture. Always be aware of the specific settings, such as 1/125 second and f/8 shown here on the LCD panel of an SLR camera, and adjust them to suit your photographic purposes (see text).

1/30, 1/60, 1/125, 1/250, 1/500, 1/1000, 1/2000, 1/4000, and 1/8000.

This wide range will be available on many SLR models, but other cameras do not have the slowest or fastest speeds. For instance, a point-and-shoot camera might have an automatic shutter speed range only from 2 seconds to 1/1000 second (as will be noted in its technical specifications).

Most important to know is that when the shutter speed setting is changed to an adjacent number, the exposure time is either doubled or reduced by half, depending on whether that speed is slower or faster. This means either twice as much light or half as much light will reach the image sensor.

For example, switching from 1/250 to 1/125 second (a slower speed) doubles the amount of light reaching the image sensor. On the other hand, going from 1/250 to 1/500 second (a faster speed) cuts the amount of light in half.

The same is true for lens aperture numbers: change from one f/stop number to an adjacent number, and the amount of light reaching the image sensor is either doubled or reduced by half, depending on whether that lens opening is larger or smaller. For example, changing from f/11 to f/8 (a larger opening) doubles the amount of light, while switching from f/11 to f/16 (a smaller opening) cuts the amount of light in half.

7.6–7.7. Buckingham Fountain in Chicago's Grant Park looks almost the same in these twin photos, except the photographer used a slower shutter speed to intentionally blur the water more in the picture at the bottom. When using the camera's manual (M) exposure mode, whenever you change the shutter speed *or* the lens aperture (f/stop), you must also change the other in order to maintain a proper exposure. For example, if you slow down the shutter speed, you must use a smaller lens opening so that more light (from the longer exposure time) will not reach the image sensor. Otherwise, the picture will be overexposed. Read the text to understand the interrelationship of shutter speeds and f/stops.

What this means is that different combinations of f/stops and shutter speeds will produce the same exposure. For example, let's say you made an ideal exposure of a waterfall, but you decided to use a slower shutter speed in order to blur the falling water and make a more dramatic picture. The ideal manual exposure you had set for the first picture was 1/125 second at f/5.6. For the second picture, if you slow the shutter speed down from 1/125 second to the adjacent number, 1/60 second, you increase the amount of light reaching the image sensor by two times (2×).

To keep from overexposing the second picture, you must then reduce the size of the lens aperture from f/5.6 to the adjacent number, f/8, which decreases the amount of light by one-half (½×). This results in an equivalent amount of light reaching the image sensor as in the first picture. In other words, 1/60 second at f/8 produces the same exposure as 1/125 second at f/5.6, Study illustration 7.8 to see how other shutter speed and lens aperture (f/stop) settings are interrelated.

Please note that the f/stop and shutter speed numbers listed

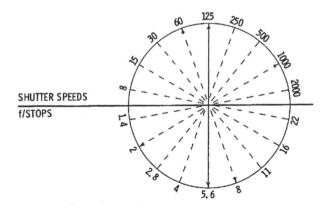

7.8. As this illustration shows, various shutter speed and f/stop combinations give the same exposure as 1/125 second at f/5.6. For example, 1/60 second at f/8 admits the same amount of light to the image sensor as 1/125 second at f/5.6. So does 1/250 second at f/4, and so forth.

above (see pages 151–52) are considered "standard" because they have long been common to film cameras and lenses. However, the advanced electronics in digital cameras allow shutter speeds to be set in half-step (and sometimes one-third-step) increments between those standard speeds, particularly on SLR and some prosumer models. For example, your camera might offer a shutter speed of 1/45 second between 1/30 and 1/60 seconds, and 1/180 second between 1/125 and 1/250 seconds.

If you can manually adjust the aperture of your lens, it is possible to make intermediate settings between the standard f/stop numbers as well. The aperture can be adjusted to any size opening by turning the aperture ring on the lens, but most apertures are controlled by a dial or knob on the SLR or prosumer camera itself.

This manual control allows the lens opening to be set in half-stop (and sometimes one-third-stop) increments between the standard f/stop numbers. As such, your camera might offer a lens aperture of f/4.8 between f/4 and f/5.6, and f/9.5 between f/8 and f/11.

In summary, automatic exposure modes are sophisticated and work very well on digital cameras. But whenever you are disappointed with a picture's exposure after reviewing it on the LCD monitor, consider using the manual (M) exposure mode (if available on your camera) so you can set the lens aperture and shutter speed and have full control of the results.

PICKING A PRESET SCENE, PICTURE, OR SHOOTING MODE

As mentioned earlier in this chapter, many cameras (except professional SLR models) include a variety of preset modes for specific shooting situations, such as Landscape, Portrait, and Night.

These are often called SCENE MODES, PICTURE MODES, or SHOOT-ING MODES. They combine automatic exposure with autofocus and other settings.

For example, if the Landscape mode is chosen, the camera turns off the autoflash, sets the exposure using a small lens opening (f/stop) for greater depth of field, and locks the lens focus at infinity to help put everything in the scene in sharp focus.

In the Portrait mode, the camera sets a large lens opening for less depth of field so the background will appear in softer focus to help your portrait subject stand out in sharper detail.

In the Night mode, the camera selects a slower shutter speed for a longer than normal exposure time to compensate for the limited light, and it sometimes fires the built-in flash to illuminate the foreground.

The specific f/stop, shutter speed, focus distance, and other

7.9. Be sure to try your camera's preset automatic exposure modes for various shooting situations. The "Night landscape" mode (see illustration 7.1) was selected for making shots of a night baseball game at Dodger Stadium in Los Angeles; a tripod held the camera steady.

settings for each scene, picture, or shooting mode are chosen by engineers who create an ALGORITHM that controls the camera operation once you press the shutter release button.

Such preprogrammed modes don't always make the best pictures, but some photographers prefer that the camera handles all the exposure, focus, and other decisions. Knowing this, camera manufacturers have attempted to incorporate scene, picture, or shooting modes for almost every situation.

In fact, one model offers thirty-four choices, including Portrait, Landscape, Landscape with Portrait, Night Scene, Night Scene with Portrait, Sports, Indoor, Candlelight, Self-portrait, Available Light Portrait, Sunset, Fireworks, Cuisine, Behind Glass, Documents, Action, Snow, Beach, Underwater Wide, and Underwater Macro.

Surveying various camera models, there seems to be no end to these specialized modes. Among others we've noted are Soft Skin, Party, Starry Sky, Aerial Photo, Baby, Pet, Museum, Flower Close-up, Aquarium, Foliage, Dawn, and Twilight. The

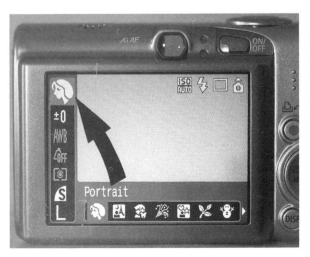

7.10. Most cameras (except professional SLR models) feature scene, picture, or shooting modes that are preprogrammed to make exposure, focus, and other settings for specific photo situations (see text). At the bottom of this menu on a camera's LCD monitor are icons representing (left to right) Portrait, Night Shot, Kids and Pets, Indoors, Creative Light Effect, Foliage, and Snow. The Portrait mode (see arrow) has been selected by the photographer.

important thing is to study your camera manual for a description of exactly what the camera will do when you choose a specific scene, picture, or shooting mode.

Our advice is to try all the scene, picture, or shooting modes available on your camera, and then decide which ones, if any, produce good pictures of your favorite subjects. Of course, don't just rely on these preset automatic modes if your digital camera also gives you more control of exposure and focus settings. Take advantage of the camera's program (P), aperture-priority (A or Av), shutter-priority (S or Tv), and manual (M) settings in order to make the best possible pictures.

CHOOSING AN EXPOSURE METERING MODE

Regardless of whether you prefer auto-exposure or like to manually set the lens aperture (f/stop) and shutter speed to personally control exposure, you must know how your camera's EXPOSURE METERING SYSTEM works. Most every digital camera offers two or more ways for its built-in exposure meter to read the light that will be recorded by the image sensor. The purpose is to make the most accurate readings under a variety of light conditions in order to avoid overexposed or underexposed pictures.

The choices for P&S cameras are often center-weighted metering and sometimes spot metering, while SLR and better prosumer cameras offer evaluative metering, center-weighted metering, and spot metering.

EVALUATIVE METERING, which is also called a number of names like multizone, multipattern, multisegment, or matrix metering, evaluates light readings from many parts (called zones) of the picture area to determine the best exposure. CENTER-WEIGHTED METERING reads the entire picture area but the center portion influences the reading to a greater degree. With SPOT METERING,

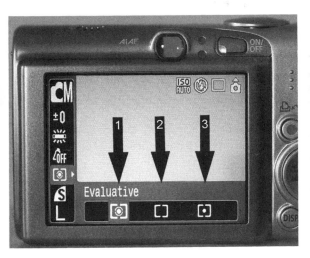

7.11. Many cameras offer a choice of three exposure metering modes: (1) evaluative, (2) center-weighted, and (3) spot (see text). The photographer selected evaluative metering from those options, which usually are shown as icons (see arrows) on a menu on the camera's LCD monitor.

a small area in the center of the viewfinder or LCD screen (often delineated by a circle or brackets) indicates the very limited portion of the picture area that is being read by the meter.

How do you choose one type of metering over another? First, you should "read" the picture area with your eyes to analyze the light sources and bright and dark areas. If the scene appears uniformly illuminated, without a patchwork of sunny spots and shadows, evaluative metering will work exceptionally well. It is the best choice for a majority of photos.

With point-and-shoot cameras, their default center-weighted metering systems are effective because most P&S users put their main subject in the center of the picture area.

Spot metering is ideal for reading a subject that is surrounded by bright light or dark areas that would adversely affect evaluative or center-weighted meter readings. For example, a child playing in the snow or on a white sand beach will be read most accurately with spot metering. (With the two other types of meter readings, your subject would probably be underexposed.)

7.12–7.13. Spot metering should have been used to keep this couple (above) from becoming silhouettes on the bright white slopes of a ski resort in Colorado (see text). For comparison, spot metering prevented the sunlit glare of a street in Texas from underexposing this ninety-year-old mother and her son (right) as they relaxed on the shaded porch of a restaurant.

After you position your main subject within the circle or pair of brackets that delineates the spot metering area, you press the shutter release button halfway to set and lock the auto-exposure. Then you compose the picture in the viewfinder or on the LCD monitor. Unless you release pressure on the shutter button, the auto-exposure setting stays locked until you fully press the shutter release button to shoot the picture.

Take note that SLR and some prosumer cameras feature a separate AUTO-EXPOSURE (AE) LOCK BUTTON that you can press (instead of the shutter release button) to lock in the exposure. On some models, this button also serves as a separate or simultaneous AUTOFOCUS (AF) LOCK BUTTON (see page 169).

A very nice thing about digital cameras is that immediately after tripping the shutter you can review a picture to see if it has

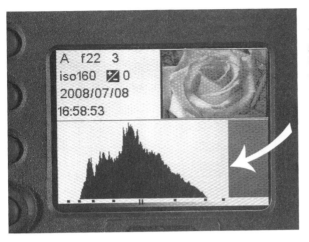

7.14. Cameras that show a graph called a histogram can help you analyze the exposure of a picture displayed on the LCD monitor in the playback mode. This histogram (see arrow) shows a proper exposure. A graph with black peaks that run against the right margin indicates overexposure; if the peaks run against the left margin, underexposure is indicated.

been properly exposed. If it appears too dark or too light on the LCD monitor, you can shoot again with a different exposure to get the result you want.

Helping to analyze exposure is a HISTOGRAM, which is a feature of better cameras that you can activate to appear on the LCD screen. A histogram is a horizontal graph that resembles a silhouette of mountain peaks or hills. If the right side ends abruptly (said to be "clipped") without sloping down to the bottom, it indicates that the picture is overexposed. If the left side ends abruptly without sloping down to the bottom, it indicates that the picture is underexposed.

On better cameras, you can activate another feature to help analyze exposure after a shot has been made. It's a HIGHLIGHT ALERT or OVEREXPOSURE INDICATOR that causes overexposed areas to flash repeatedly in the picture on the LCD screen. The effect is sometimes called the "blinkies." It's a visual signal that you should reduce the exposure if you think those very bright highlights that have no detail (said to be "blown out") will be detrimental to the picture.

7.15. When an area of a picture is overexposed, some cameras will give a "highlight alert" warning by flashing the very bright area(s) on and off when the image is viewed on the LCD monitor in the playback mode (see text). In this picture, the partial black circle was superimposed to indicate such an overexposed area (caused by shooting toward the sun); the circle would not appear on your LCD screen.

FINE-TUNING WITH EXPOSURE COMPENSATION

Many photographers, even the pros, let their SLR and prosumer cameras calculate and set the ideal exposure by using the auto, program, aperture-priority, or shutter-priority exposure modes instead of manual. However, if a picture appears to be under-exposed or overexposed when you review it on the camera's LCD monitor, you can make adjustments with the EXPOSURE COMPENSATION MODE and then shoot again.

This mode allows you to increase or decrease the amount of light that reaches the image sensor by selected amounts that are known as EXPOSURE VALUES (EV). Depending on the camera, you can do this by one-half or one-third increments up to ± 2 or 3 EV. As an example, the mode might offer you an EV choice of –2.0, –1.5, –1.0, –0.5, 0.0, +0.5, +1.0, +1.5, + 2.0.

Note that when you turn on exposure compensation, the starting point is zero, indicated as 0, 0.0, or ±0. At this default setting there is no effect on the exposure your camera makes. If a picture you review on the LCD screen appears overexposed, set

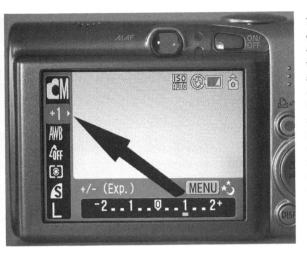

7.16. If your automatic exposures turn out too dark (underexposed) or too bright (overexposed), adjust the camera's exposure compensation mode. You can increase (+) or decrease (–) auto-exposures by increments (see text). The exposure compensation setting on this menu on the camera's LCD monitor indicates that auto-exposures will be increased by +1 (see arrow), the equivalent of one f/stop of additional exposure.

the exposure compensation to decrease (–) the exposure. Likewise, if a picture seems to be underexposed, adjust the exposure compensation to increase (+) the exposure.

How do you choose the amount of exposure compensation (the exposure value) to set? Whether you decrease (–) or increase (+) the exposure, you can think of the EV numbers as representing f/stops that control the amount of light passing through a lens.

For example, if you set the exposure compensation to –1, that's equivalent to decreasing the lens aperture by one f/stop, such as from f/5.6 to f/8, which cuts the amount of light reaching the image sensor in half. Or if you set the EV to +1, that's like increasing the lens opening by one f/stop, such as from f/5.6 to f/4, which doubles the amount of light reaching the sensor. The interrelationships of exposure settings were discussed earlier in this chapter (see page 151).

After you review the new exposures on your LCD screen and are satisfied with the results, *remember to reset exposure compensation back to zero* so that your next shots will not be accidentally overexposed or underexposed. Some cameras will revert to the 0, 0.0, or ±0 setting when you turn the camera off.

As we explained in chapter 3, SLRs and some prosumer cameras also feature a FLASH EXPOSURE COMPENSATION MODE. You can adjust it to reduce (–) the light from a flash unit to better balance the overall illumination for a picture. Or you can boost (+) the flash output to highlight a subject that's in the foreground (see page 79).

PLAYING IT SAFE WITH
AUTO-EXPOSURE BRACKETING

If you are disappointed with a picture's exposure when viewed on the camera's LCD monitor, you can try to improve subsequent shots by using exposure compensation (see above). However, if you are unsure about exposure *before* shooting a picture, activate the AUTO-EXPOSURE BRACKETING (AEB) MODE that is a feature of SLR cameras and some prosumer models. This mode quickly makes up to three different exposures of your subject so you can choose the exposure you like best. (Be aware that you must press the shutter release button to make each exposure, unless your camera is set for continuous shooting; see page 189).

The first exposure is what the camera's exposure metering system figures is ideal. Then one or two subsequent exposures are made according to the amount of overexposure and/or underexposure you choose. You preselect specific exposure values (EV), much like you do for exposure compensation.

For example, you might select EV –1.0, which makes a second exposure that underexposes by one f/stop. Or you might select EV –2.0 and +2.0, which makes a second exposure that underexposes by two f/stops, and then makes a third exposure that overexposes by two f/stops.

Auto-exposure bracketing (AEB) is especially helpful in difficult lighting situations, as when there are a number of bright

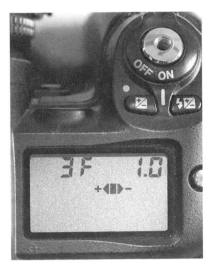

7.17. This LCD panel on an SLR camera shows that auto-exposure bracketing (AEB) has been set to automatically make three exposures, or frames (3F), with an exposure value (1.0) of one f/stop overexposure (+) and one f/stop underexposure (−) in addition to the normal exposure (see text). Depending on the camera, you can set bracketing by one-third or one-half stops in a range up to two stops of overexposure and/or underexposure.

and dark areas in the picture or the overall scene is very bright or very dark and might fool the camera's metering system.

Review the series of bracketed auto-exposures on the LCD screen to analyze the results. When satisfied that you have a well-exposed image, remember to turn off the auto-exposure bracketing mode to avoid multiple exposures the next time you press the shutter release.

Take note that if the camera's built-in flash or an external flash unit is being used, the auto-exposure bracketing settings you select should also control the flash exposure in an identical manner; check your camera manual.

Figuring Out Focusing Modes and Other Camera Settings

FOCUSING MODES: AUTOMATIC AND MANUAL

You'll be happy to know that all digital cameras will focus their lenses automatically. SLR and some prosumer models also give you the option of focusing their lenses manually. FOCUSING MODES are designated as "AF" for AUTOFOCUS or AUTOMATIC FOCUS and "M" or "MF" for MANUAL FOCUS.

Autofocusing begins when you depress the shutter release button *halfway*. A small colored IN-FOCUS or CONFIRMATION LIGHT appears in or near the viewfinder or on the LCD screen to signal when the focus has locked onto the subject within the camera's AUTOFOCUS AREA (see below). Then you *fully* depress the shutter release button to make the exposure.

If the camera lens is *not* focused when you fully depress the shutter release button to make an exposure, the in-focus or confirmation light will blink and *the camera will not fire*. If that happens, release the shutter button and then partially press it down again in order to resume autofocusing on your subject.

SLR cameras offer two autofocusing modes. The standard mode described above is indicated by "S" on the camera and is often called the SINGLE, SINGLE SERVO, or ONE SHOT autofocus mode. The second mode is identified by "C" and is called the

8.1. Autofocusing is a wonderful feature of digital cameras, but it is not foolproof. This happy family in a hot tub would be disappointed if their picture had been out of focus. Study your camera manual to thoroughly understand the settings and controls for autofocus (and manual focus, if available).

CONTINUOUS or AL SERVO autofocus mode. Once you press the shutter release button halfway, this mode continuously focuses on a subject within the camera's autofocus area until you fully depress the shutter release to make the exposure.

Single, Single Servo, or One Shot autofocus is the normal choice for static subjects. Continuous or Al Servo autofocus is preferred for moving subjects, such as children or pets at play. This is the mode the pros use when shooting actions sports like soccer and basketball.

BE AWARE OF THE AUTOFOCUS AREA

All digital cameras have a small AUTOFOCUS AREA in the center of the viewfinder or LCD screen, usually designated by brackets

8.2. Cameras often superimpose crosshairs, a pair of brackets, or a box (as here) in the center of the LCD monitor and/or viewfinder to indicate the small area where the lens will automatically focus. Be certain that this autofocus area covers part of your main subject, such as the face of this statue at the Grand Palace in Bangkok, Thailand. If necessary, you can lock in the focus and then recompose the picture (see text).

or crosshairs. This serves like a gun sight to target your subject for the camera's automatic focusing system. To guarantee sharp focus, make certain that the autofocus area brackets or crosshairs cover some part of your main subject.

Be especially alert when photographing two people side by side. The background—instead of the people—will be in sharp focus if the autofocus brackets are positioned *between* their heads. If necessary, position one head within those brackets and then press the shutter release button halfway to set the autofocus and automatically lock the proper focus while you recompose the picture to include both people.

Unless you release pressure on the shutter button, the auto-focus setting stays locked until you fully press the shutter release button to shoot the picture.

Here's a tip when shooting close-ups of people's faces: the best place to focus is on their eyes. Do the same when photographing the faces of pets and other animals.

SLR and some prosumer cameras feature a separate AUTO-FOCUS (AF) LOCK BUTTON that you can press (instead of the shutter release button) to lock in the focus. On some models, this button also serves as a separate or simultaneous AUTO-EXPOSURE (AE) LOCK BUTTON (see page 160).

Because people are a favorite subject of photographers, some P&S and prosumer cameras have a feature called FACE DETEC-TION, FACE RECOGNITION, or FACE SENSING, which is designed to automatically find and focus on the faces of people in a picture.

8.3. Some cameras will automatically focus on faces, or only smiling faces, if that special feature is selected prior to shooting. Otherwise, always place the camera's autofocusing brackets or crosshairs on the eyes of your main subject.

A few models will fire only when your subjects smile. This technology is rather amazing, but it can be self-defeating if faces (or smiles) are not the main subject you want in sharp focus in your picture. Study the camera manual to learn how to turn this feature on and off, and to become aware of its limitations.

In addition to a small autofocus area in the center of the viewfinder, most SLR cameras offer MULTIPLE AUTOFOCUS AREAS scattered like a grid in the viewfinder. Wherever your main subject is located in the viewfinder, you can select the specific autofocus area that will cover the subject without having to re-aim the camera.

On some SLR cameras, you can also set these multiple auto-focusing areas to automatically track a moving subject so it will continually be in sharp focus before you fully press the shutter release to make an exposure. These settings are specific to each camera, so consult the instruction manual for details.

AVOID AUTOFOCUSING PROBLEMS

Autofocus mechanisms vary with the type of digital camera, and you should be aware of situations that may prevent the lens from focusing. Look in your camera manual for specific warnings, so you won't be surprised if your autofocus system fails to work.

For example, some cameras use a through-the-lens (TTL) PASSIVE AUTOFOCUS SYSTEM that works best when subjects have good contrast or straight edges. If your main subject is low in contrast and blends with the background, or is without any definable lines, this focusing system can go wrong.

Other cameras use an ACTIVE AUTOFOCUS SYSTEM that does not react to the light coming through the lens. Instead, it sends out pulses or beams of infrared light from a small window on the front of the camera, which then bounce back from the subject to the same window or to a second window. This feature can fail

when you're shooting through glass because the beam reflects off the glass instead of the subject on the other side of the glass. Also, take care that your finger or camera strap does not block the camera window; if it does, this autofocus system will not operate.

When the camera lens is unable to focus, a small colored light in or near the viewfinder, or a small colored dot or icon on the LCD screen, may blink as a warning. Also, you may hear the lens focusing mechanism go back and forth without stopping while it attempts to focus.

What can you do when autofocusing fails? Aim your camera at another object that is the same distance from the camera as the

8.4. Make certain the autofocus brackets or crosshairs of your camera cover the subject you want in sharp focus. Although it is the subject, the gull is out of focus in the first picture because the autofocus brackets were carelessly aimed at the water instead of the bird. The photographer corrected his mistake for the second picture; he focused on the gull, pressed the shutter release halfway to lock in that distance, and then recomposed the picture before fully pressing the release to make the exposure.

8.5. An AF (autofocus) "assist" feature can be activated in some cameras to enable autofocusing when your subjects are of low contrast or in dark surroundings. As shown on this SLR model, a light beam emits from the front of the camera (see arrow). The light reflects from your subject to help the camera calculate and automatically set the focusing distance.

troublesome subject, depress the shutter release button halfway to autofocus and lock that focusing distance, recompose the picture in your viewfinder or on the LCD screen, and then fully press the shutter release to make the exposure. Another option is to manually focus on your subject, if your camera permits.

Some cameras have an AUTOFOCUS (AF) ASSIST feature to make autofocusing possible in low-contrast or dim-light situations. An infrared or LED beam emitted by the camera or an external flash unit reflects off your subject to calculate and automatically set the focusing distance. The effective range of this AF ASSIST LAMP, BEAM, or ILLUMINATOR is limited and depends on the distance of your subject and the focal length of the camera lens.

KNOW THE MINIMUM FOCUSING DISTANCE OF YOUR CAMERA LENS

One thing you should know is the minimum focusing distance of the lens on your camera. If you are closer to your subject

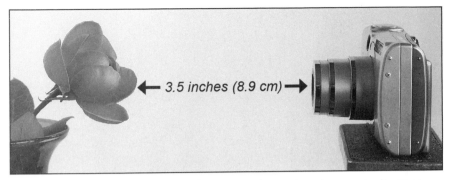

← 3.5 inches (8.9 cm) →

8.6. The minimum focusing distance of your camera's zoom lens changes according to its focal length setting; i.e., wide-angle or telephoto. It also varies when you select the macro mode for close-ups, which allows the camera to focus closer to your subject, as shown here. Read the text below, and consult your camera manual regarding specific minimum focusing distances. Note that the camera has been mounted on a tripod to maintain the proper focusing distance and hold the camera steady.

than that minimum focusing distance, your subject will be out of focus. As mentioned above, the camera will give you a visual warning in the viewfinder or on the LCD screen when the lens is unable to focus.

The exact minimum focusing distance will be stated in your camera or SLR lens manual. It varies according to the focal length of the lens and may be as much as several feet away from your subject. You can get the camera closer to your subject with the *wide-angle* setting on a zoom lens (or with a wide-angle lens) than you can with the *telephoto* setting on a zoom lens (or with a telephoto lens).

For close-up focusing that often allows your camera lens to be just inches from the subject, you should activate the MACRO MODE, which is a feature of all digital cameras with permanently attached zoom lenses. With SLR models, you can change to a MACRO LENS, which is discussed earlier in the book (see page 101) and also in the following chapter (see page 224).

The macro mode on P&S and prosumer cameras is typically

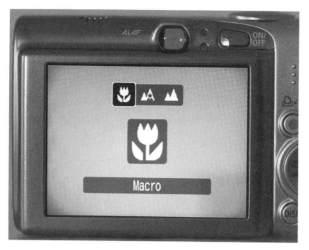

8.7. For close-up pictures, select the macro mode. This allows the camera lens to focus closer to a subject than normally and record it at a larger size. The macro mode is usually represented by a flower icon that resembles a tulip.

marked by a tuliplike flower icon and activated by pressing a button or switch. This changes the minimum focusing distance of the lens so you can bring your camera physically closer to your subject and thus photograph it at a larger size.

For example, say the camera has a normal autofocus range of 2 feet to infinity. By switching to the macro mode, the close-up autofocus range becomes 4 inches to 2 feet from your subject. Check your camera manual for the exact distances. And remember to turn the macro mode off after making close-up exposures so the camera returns to its normal autofocus range.

As you may recall from chapter 2, we recommend that you use your camera's OPTICAL VIEWFINDER (if available) instead of the LCD monitor to compose your pictures (see page 43). However, whenever you activate the macro mode to make close-up pictures, it is necessary to use the LCD monitor for more precise composition. Unlike optical viewfinders, which can suffer from PARALLAX ERROR at close range to a subject (see page 47), LCD screens show you exactly what the image sensor will record.

DEPTH OF FIELD CONCERNS

While discussing autofocus (AF) and manual focus (MF) modes for your camera, we want to remind you that what will appear in sharp focus in your picture not only depends on the point of focus but on DEPTH OF FIELD. Depth of field indicates the depth or shallowness of the picture's focus: how much of the picture will be in focus from the foreground to the background. This is determined by the point of focus, the focusing distance from the camera to your subject, the focal length of the lens, and the lens aperture (f/stop).

Depth of field in relation to lens apertures was described in chapter 4 (see page 92). In brief, the *smaller* the lens opening used to make an exposure (such as f/16 or f/22), the greater the

8.8. You can control a number of factors that determine depth of field, which is how much of the picture, from the foreground to the background, will be in sharp focus (see text). This row of bicycles in Norway shows extreme depth of field—everything appears in sharp focus.

8.9. Limiting the depth of field will focus attention on your main subject, as shown here at a Civil War reenactment on the Yorktown Battlefield in Virginia. By setting his zoom lens to telephoto and choosing a large lens opening (f/stop), the photographer made this bugler stand out in sharp focus from the background of other soldiers.

depth of field, which means more of the picture's depth will be in focus. By using a *larger* lens opening (such as f/2.8 or f/4), there will be less depth of field and only a limited amount of the picture's depth will be in focus.

When using the interchangeable lenses on SLR cameras, you can choose the f/stop and set the point of focus to control depth of field. Many SLR models also have a DEPTH OF FIELD PREVIEW BUTTON that you can press to visually check in the camera's viewfinder how deep an area of the picture will be in sharp focus.

On the other hand, most P&S cameras do not have a manual exposure mode that allows you to set the lens opening (f/stop). Nor do they have a manual focus mode that lets you manually adjust the point of focus.

However, as described in chapter 7 (see pages 155–58), P&S and prosumer cameras feature preset scene, picture, or shooting modes with algorithms for f/stop openings and points of focus that significantly affect a picture's depth of field. We recommend you study the camera manual for descriptions of exactly what exposure and focus settings are automatically made for each different scene, picture, or shooting mode. Then you can choose a specific mode, regardless of its name, that will produce the depth of field you desire in a picture.

For example, if you want great depth of field to help put everything in sharp focus, you might use the Landscape mode because it makes the exposure using a small lens opening (f/stop). Or if you want limited (said to be "shallow") depth of field so your subject stands out in sharp detail from the background, you might use the Portrait mode because it makes the exposure using a large (wide) lens opening.

SELF-TIMER MODE CAN PREVENT CAMERA SHAKE

Common to all digital cameras is a SELF-TIMER MODE, which trips the shutter after a certain time delay. That delay is typically 10 seconds before the exposure is made, but some cameras offer the choice of a shorter time delay, such as 2 seconds.

The traditional use of the self-timer is to allow the photographer to be in the picture instead of behind the camera. However, the self-timer is also useful for making hands-off time exposures. It helps prevent CAMERA SHAKE that can result in blurred images if your finger presses the shutter release just before a long exposure.

In any case, whenever you use the self-timer, the best way to keep the camera both steady and in position for precise composition is to mount it on a TRIPOD or use some other steady support, such as a BEANBAG (see pages 111 and 119).

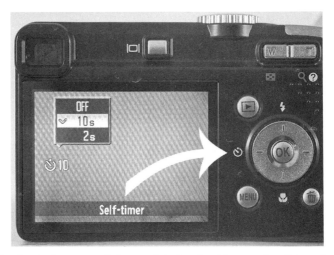

8.10. Pressing the four-way switch toward the icon for this camera's self-timer (see arrow) makes the self-timer menu appear on the LCD monitor. It allows you to select the time delay—either 10 seconds (chosen here) or 2 seconds—before the shutter is released to make an exposure.

A small LED (light-emitting diode) on the front of the camera flashes when the self-timer has been activated by fully pressing the shutter release. The LED then becomes a steady beam to signal you just before the shutter is released to make an exposure. A beep sound from the camera may also indicate when the exposure has been made.

SPECIAL EFFECTS MODE TO ALTER IMAGES

Some cameras offer a SPECIAL EFFECTS MODE, which also may be called a PHOTO EFFECTS MODE or a COLOR MODE or another name. This mode features a menu with two or more options to change the appearance of the full-color pictures that digital cameras normally produce. "Black-and-white" is the most popular choice, but some photographers prefer "sepia," a brownish tone that gives photos a vintage look.

8.11. Some cameras have a mode to create special effects, such as turning the color image to black-and-white (see arrow) before or after shooting the picture. The other choices shown on a scrolling menu at the bottom of this LCD screen include sepia tone (Se), the look of positive film (P), lighter (L) and darker (D) skin tones, vivid blue (B), and vivid green (G).

Depending on the camera, you may be able to choose the special effect *before* shooting the picture and/or *afterward* while looking at the picture on the LCD monitor in the playback mode.

A number of other effects may be offered, including subtle changes such as "lighter skin tone" and "darker skin tone." Or you may be able to select more pronounced changes to color images, such as overall "vivid color." And often there are specific one-color enhancements, such as "vivid blue" to enhance sky color, "vivid green" to enhance foliage, and "vivid red" to enhance sunsets. Whatever choices are available on your camera (if any), it's fun to try them out and see if you like the results.

> Read your camera manual to see if using the special effects mode will totally replace the usual full-color image or will create an *additional* image file with the change you choose, such as to black-and-white.

Keep in mind that color pictures can be altered later in similar ways by using image-editing software on your computer. That gives you the opportunity to see if you like a black-and-white or

sepia look, or other color variations, and still preserve the origi-
nal image file in its full colors in case your camera records only
the special effect you select.

ERASE MODE TO DELETE PICTURES

When you switch your camera to its playback (reviewing) mode
after shooting pictures, menus appear on the LCD monitor with
various modes and settings. A universal one is the ERASE MODE,
which enables you to delete single pictures or all of the images
stored on your memory card.

Whenever you select "erase" or "delete" on the erase menu,
you're asked to confirm that action by selecting "yes" or "no" in
order to avoid accidental erasures. Some cameras have a dedi-
cated ERASE BUTTON that is identified by a trash-can icon.

By the way, you can select specific images to PROTECT so they
cannot be erased accidentally in the camera unless you later
cancel the "protect" selection. When images that have been
protected are viewed on the camera's LCD screen, they are iden-
tified by an icon that usually resembles a door key. (Note that
if you format a memory card, all images on it will be erased—
including those you protected; see pages 64–65.)

The main reason photographers use the erase mode to delete
unwanted images is to free up space on the memory card so
additional pictures can be recorded. However, if you buy mem-
ory cards with high capacity, as we recommend, there is no
need to erase any pictures before downloading the images to
your computer and reviewing them more easily and critically on
its larger monitor.

Smart photographers also avoid erasing pictures in-camera
because it uses up battery power, especially when the LCD
screen is switched on for an extended time. However, if you

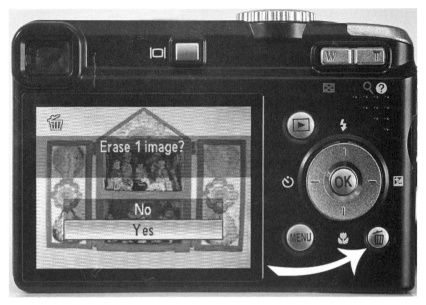

8.12. Pressing the erase button that's labeled with a trash-can icon (see arrow) activates an erase menu on this camera's LCD monitor. It asks you to confirm that you want to delete the picture from the memory card, which prevents you from erasing images accidentally.

are nearby an electrical outlet, you can plug in an AC adapter to power the camera instead of using its batteries for reviewing and erasing pictures.

MAGNIFY MODE TO SEE IMAGE DETAILS

Whenever you play back a picture on the camera's LCD monitor for review, you can activate a MAGNIFY MODE to enlarge portions of the image for closer inspection, especially to check for sharp focus or for blurred subjects caused by camera shake. Portions of the image can be increased in size at least two to four times, and even up to ten or sixteen times on some models.

On P&S and some prosumer cameras, to zoom in on the

8.13. To check the sharpness of any picture while in playback mode, you can activate the camera's magnify mode by pressing the telephoto end of the zoom lens control switch to enlarge the image on the LCD monitor. Pressing on the four-way switch will move the image up, down, left, or right to closely inspect any part of the picture (see text).

picture and increase the magnification you usually press or push the zoom lens control switch at its telephoto end (i.e., the "T" or one-tree icon). Since only a portion of the enlarged picture will show on the LCD screen, you press the appropriate arrows on the four-way switch to move the image left or right and up or down in order to view different sections of the picture. Press or push the zoom control switch at its wide-angle end (i.e., the "W" or three-tree icon) to return the picture to its full size.

The picture that appears on the LCD monitor when you activate your camera's playback mode is the most recent exposure you made. If you want to review an image that was recorded earlier, usually you press the left side of the four-way switch to click back through previous exposures one by one.

Don't forget: for the very closest inspection of any image, you must view it later on your computer monitor at 100 percent magnification, as we noted in chapter 2.

INDEX MODE TO VIEW MULTIPLE IMAGES

If you want to quickly scroll through all the pictures recorded on your memory card in order to find and review a specific image, use the INDEX MODE to view multiple images at one time. On P&S and some prosumer cameras, usually you press or push the zoom lens control switch at its wide-angle end to display several thumbnail-size images on the LCD monitor. Some cameras offer a choice of the number of pictures you want to appear at one time, such as four, nine, or sixteen.

To locate and highlight a specific picture in the group, press direction arrows on the four-way switch. The thumbnail image you select can then be viewed at full size by pressing or pushing the zoom control switch at its telephoto end.

8.14. Most cameras allow you to display multiple images on the LCD monitor, which makes it easier to review all the pictures on the memory card or find a specific image. You may have a choice to review four or nine (as with this camera) or sixteen thumbnail views at one time (see text).

CAMERA SOUND MODE

Digital cameras usually have a SOUND MODE that enables it to emit a beep or another noise to serve as a warning or to confirm certain camera operations. For example, the camera might beep to indicate that the autofocus has locked onto your subject, or it might make a sound like a camera shutter when an exposure is made.

Remember to turn the camera's sound mode off in museums, places of worship, and other locations where you do not want to draw attention to your presence or picture taking with these electronic sounds.

In addition to the various modes and settings discussed above, you'll find others described in the instruction manual for your camera and listed in its operational menus. Some we discuss much later in the book, including the "movie mode" (see page 421), while several others are described in the following chapter.

Special Shooting Techniques with Digital Cameras

S hoot, shoot, shoot. That's the freedom digital photography offers compared to film photography. The only cost to you is the onetime expense of memory cards to hold the images until you can download them to your computer or desktop printer. So fire away!

How do the pros get their prize-winning pictures? Often it's because they make dozens, if not hundreds, of exposures to capture the few images that are published in magazines or newspapers. Just watch a televised news event and you'll see what we mean: the constantly clicking cameras of the press sound like firing machine guns.

Some years ago when we were headed to Germany's Black Forest on assignment for *National Geographic*, we left the magazine's office with hundreds of rolls of 35mm film for the three-month shoot. Every week we'd airmail our exposed film back to Washington, D.C., for processing, and then wait until our editor called to tell us how the pictures turned out.

Be thankful for today's digital cameras because you can snap the shutter and instantly see the results. We urge you to experiment with all types of shooting techniques. As you learn more about how your camera works, you can make it work better for you.

This chapter will first describe some of the idiosyncrasies of digital cameras, and then shooting techniques that will both challenge and inspire you, such as making panoramic pictures.

BEWARE THE PROBLEM OF SHUTTER DELAY

Nothing is more disappointing than seeing a picture that is unintentionally blurred. Nine out of ten times it is because you moved the camera while the shutter was open. Keeping the camera steady during an exposure is more of a problem with digital cameras than with film cameras. That's because all digital cameras—except high-end single lens reflex (SLR) models—suffer from SHUTTER DELAY. Also known as SHUTTER LAG, this is the brief time delay between the moment you press the shutter release button and when the shutter actually opens to make the exposure. This lag occurs while the camera takes time to autofocus the lens and automatically set the exposure and white balance. Since your digital camera doesn't fire immediately and you inadvertently move the camera while waiting, or by pressing harder on the shutter release, the result is a blurred picture.

The shutter time lag is especially noticeable with P&S cameras—from one to two seconds. A longer delay—sometimes several seconds—occurs when the built-in flash is used, because the flash must charge up before each exposure.

Shutter delay is always irksome and may cause you to miss the best shot. That's especially true when you're trying to capture action, as at a soccer game or other sports event. You press the shutter release button just as a player kicks the ball, but by the time the shutter opens to make the picture, the ball is no longer in sight. Shooting in the CONTINUOUS MODE (see below) sometimes can be a solution to this problem.

Before you buy a camera, read reviews on the Internet to compare the shutter lag times of the various models you are

9.1. Shutter delay is an unavoidable problem in many digital cameras because the shutter doesn't fire immediately when you press the shutter release (see text). As a result, you might miss your best shot, as the photographer did here; he had intended to capture the soccer player at the very moment she kicked the ball. Also distracting is blurring of the image caused by camera movement; a faster shutter speed should have been used to freeze the action.

considering. Keep in mind that prosumer cameras have shorter lag times than P&S models, and professional SLR cameras have virtually no shutter delay at all. Before buying any camera, test the shutter time delay for yourself.

A frequent cause of fuzzy photos is jabbing the shutter release, which jars the camera. Always remember to arch your shooting finger and slowly press or squeeze down on the shutter release button.

To help you steady the camera, press it against the side of your face, not just the tip of your nose (assuming you're using a viewfinder instead of the LCD screen to compose the picture), and draw your elbows in against the sides of your chest to give the camera more support.

9.2. To conserve battery power, make certain your camera's power saving feature is turned on so that your camera will automatically "power down" (i.e., turn off) after a certain number of minutes without use (see your camera manual). Also, the LCD monitor can be set to turn off after a specific period of time when the camera is not being operated; here it is set for one minute.

If your camera has a significant shutter lag, you can shorten it somewhat by pressing the shutter release button *halfway* to preset the auto-exposure, autofocus, and white balance prior to the moment you anticipate making the exposure.

You also should be aware of two other time delays. The first is a delay of several seconds when you initially turn on the camera. This is known as a camera's POWER-ON TIME, START-UP TIME, or BOOT TIME. It is longest for P&S models with a retractable zoom lens that automatically extends from the camera when you switch the power on. If you anticipate making a picture, be certain the camera is turned on in advance or else you might miss the best moment to shoot.

Also, keep in mind that your camera will shut down automatically if it hasn't been used after several minutes. You'll recall that in order to save the batteries, most cameras have both a SLEEP MODE and a POWER SAVE or AUTO POWER OFF MODE (see page 71). These put the camera systems at rest, or shut them off, if the camera is idle for certain periods of time. You can press any button to wake the camera up but must use the power switch to turn back on a camera that has totally turned off.

Check the instruction manual to find out the exact number of minutes your camera can remain inactive before it will go to sleep (with its LCD monitor off but zoom lens still extended) or turn off completely (with its zoom lens retracted). On some models you can adjust those times.

Another time delay that can affect your shooting is a PROCESSING LAG that is indicated by a RECYCLE TIME. This is the amount of time required by the camera to electronically process and transfer an image recorded by the image sensor to the memory card where it is stored as an image file. As part of the processing procedure, the image makes an intermediate stop in the camera's INTERNAL MEMORY BUFFER while previous images are being written to the memory card.

This recycle time usually is of little concern. However, if the memory buffer fills up, it will momentarily lock the shutter release so you cannot make anymore pictures until the overflow of images in the buffer is written to the memory card. This can occur when you make multiple exposures, one right after the other. Test your camera to become familiar with its recycle time by shooting a number of pictures in quick order.

USING THE CONTINUOUS MODE
FOR RAPID-FIRE EXPOSURES

Making a quick series of exposures is referred to as CONTINUOUS SHOOTING or SEQUENTIAL SHOOTING. Cameras usually have a DRIVE MODE that gives you a choice of exposing either a single frame or several frames all at once.

The CONTINUOUS MODE, also called the BURST MODE or MULTIPLE EXPOSURE MODE, allows you to make more than a single exposure when you press the shutter release. As long as you hold your finger all the way down on the shutter release, the camera keeps firing. The continuous mode setting usually is indicated

9.3. To make a quick series of pictures, set the camera for continuous shooting. The camera will keep firing as long as you keep the shutter release button fully depressed. The continuous mode icon shows a stack of three frames instead of the one frame that represents the camera's single-shot mode (see arrow).

by an icon showing a stack of three frames. (Do not confuse this mode with the *continuous autofocus mode* described in the previous chapter or the *continuous numbering* preference for image files.)

Your camera manual will indicate how fast you can shoot in the continuous mode by a number of frames per second (fps). This FRAME RATE may be as slow as 1 fps for P&S cameras and as fast as 10 fps for professional SLR models.

The manual should also indicate the BURST RATE or BURST DEPTH. This is the total number of continuous shots you can make at one time before the internal memory buffer is temporarily filled and locks the shutter release to prevent additional exposures. Once the memory buffer has more room, the shutter release unlocks and you'll be able to resume shooting.

P&S models may be able to shoot only five frames in one burst, while professional SLRs can record dozens of frames in one go. The actual number of frames will vary according to the image file format, the resolution, and compression you choose (see page 133), the capacity of the memory card, and the condition of the camera's batteries.

The obvious reason to set a camera for continuous shooting is to capture fast or unpredictable actions that you might otherwise miss, whether it's a child blowing out birthday candles or race cars speeding around a track. Also, continuous shooting can sometimes offset the problems of shutter delay because you'll have a series of shots from which to choose the best instead of just a single exposure.

MAKING TIME EXPOSURES

Do you put your camera away when the sun goes down? It would be a shame to do that, because some wonderful photos can be made at night. Look for illuminated monuments, fountains, buildings, and bridges. Nocturnal street scenes after a rain offer intriguing reflections. Store window displays and colorful

9.4. Any subject with many lights, such as the Eiffel Tower in Paris, offers an excellent opportunity for a time exposure at night. To avoid camera shake that results in a blurry image, use a tripod and make a hands-off exposure by triggering the shutter with a cable release, the camera's self-timer, or a wireless remote control (see text).

signs may attract your photographer's eye as well. And always be ready for seasonal events, such as fireworks displays on the Fourth of July and outdoor holiday lights at Christmastime.

There are three major concerns when making time exposures with a digital camera: camera shake, exposure, and noise. You can prevent your camera from inadvertently moving during a long exposure by using a TRIPOD. That's the sure way to keep your pictures from being blurred. Tripods were discussed in detail in chapter 5; see pages 111–18 to review the tripod features that might work best for you.

Instead of triggering the shutter release with your finger, which might jar the camera even when it is on a tripod, you can activate the built-in SELF-TIMER (see page 177). Other ways to fire the camera without touching it are by using a CABLE RELEASE or a WIRELESS REMOTE CONTROL, both described earlier on pages 120 and 121.

If you are shooting with an SLR, there is another precaution to take against unwanted camera shake: activate the MIRROR LOCKUP. When you trip the shutter of an SLR, the mirror that reflects the image to the viewfinder flips out of the way so the light coming through the lens can reach the image sensor. This may cause slight camera movement—even on a tripod—unless you first lock up the mirror.

Consult the instruction manual to see if your SLR camera allows mirror lockup for long exposures; some lock up the mirror only for cleaning the image sensor. Also learn your camera's lockup procedure. On some SLR models, you first enable mirror lockup on a menu, then trigger the shutter release twice—first to lock up the mirror, and then to open the shutter to make the exposure. On other models, the mirror locks up first only when you use the self-timer.

If your camera (or an SLR lens) has an ANTISHAKE, SHAKE REDUCTION, or IMAGE STABILIZATION feature, should you activate it when making time exposures with your camera on a tripod?

9.5. To reduce camera vibration and maximize sharpness, especially for close-up photography, the mirror in some single lens reflex (SLR) cameras can be "locked up" prior to an exposure. When you press the shutter release on this SLR, the "mirror prerelease" (i.e., lockup) has been set to occur 2 seconds before the shutter opens.

Look for the answer in your camera (or SLR lens) instruction manual. Some advise not using the feature because the camera is being held steady by the tripod and the antishake mechanism may actually cause slight camera movement during a long exposure.

Our suggestion is to make the same picture with and without the antishake feature turned on, and compare the results later when you can view the images at their full size (100 percent) on a computer screen. Lens and camera antishake features were discussed in detail in chapter 4, beginning on page 87.

Time exposures are well named because they require longer than normal exposure times, which you already knew. But how do you know what shutter speed and f/stop settings to use to get ideal exposures at night? Fortunately, all digital cameras except the professional SLR models have preset SCENE, PICTURE, or SHOOTING MODES, which we described in chapter 7, beginning on page 155.

Engineers at the camera companies created algorithms to make what they consider the proper exposure, focus, white balance (and sometimes flash) settings for specific subjects and shooting situations. These have been given appropriate names and icons that you can select from camera menus or by turning a knob or dial.

9.6. Most point-and-shoot and prosumer cameras feature a Night setting in their selection of automatic scene, picture, or shooting modes. The icon for nighttime exposures (see arrow) has been chosen from the scene modes shown at the bottom of this menu on the camera's LCD monitor.

Among these modes are some that involve time exposures, such as Night Scene, Night Scene with Portrait, Fireworks, Candlelight, and Starry Sky. Not all cameras have these specific modes, but Night Scene is common to most.

Will the mode you use, such as Night Scene, produce well-exposed pictures? Try it and see how the recorded images look on your camera's LCD screen. If you don't like them, try the regular automatic (A) or program (P) exposure modes.

The result, however, may be overexposed pictures because the overall darkness of the night scene often fools the metering system into keeping the shutter open too long. Or your camera may not be able to open the shutter for a long enough time to register the night scene, which results in underexposed pictures. (When using the automatic or program mode for night shots, make sure the camera's built-in flash is turned off.)

If you still don't like the results with these automatic modes, try the camera's manual (M) exposure mode, if available. Experiment with the lens opening (f/stop) and shutter speed settings and review the results on the LCD screen to see if the expo-

9.7. Exposures can be tricky at night, even of the full moon. First try the camera's automatic or program exposure mode, as well as the Night Scene mode, if available (see text). An option on some cameras is manual exposure; vary the lens opening (f/stop) and/or shutter speed and then analyze the exposures on the LCD monitor. Remember to use a tripod, and keep shooting until the results please you.

sure is correct. Remember that using a wider lens opening and/or slowing down the shutter speed will let more light reach the image sensor, which is what you must do for most night exposures.

In many cases, your metering system will be sensitive enough to give an accurate exposure reading in the manual exposure mode. To make a nighttime reading, use the camera's SPOT METERING MODE. Aim the spot metering circle in your viewfinder or LCD screen at the brighter areas of the night scene. This prevents the darker areas from influencing the reading too much and causing overexposures.

As explained in the previous chapter, most SLRs can be set to very slow shutter speeds, even to 30 seconds. However, the maximum time the shutter can stay open on many point-and-shoot cameras is just 2 seconds. When longer exposure times are needed, you must set the exposure mode to B (bulb), if available. Then the shutter will stay open for the length of time that

you keep the shutter release fully depressed; see page 120 about using a CABLE RELEASE for that purpose.

If you are using an SLR for time exposures, there is a special precaution. During a long exposure, light might leak in through the viewfinder eyepiece while the mirror has flipped out of the way, and this may adversely affect the exposure. To block any extraneous light, many SLRs have a built-in EYEPIECE SHUT-TER with a lever to close it; others include a separate cap to slip over the eyepiece. Some photographers block such light during a long exposure simply by holding a hand in front of the eye-piece (without touching the camera).

Long exposures at night can create an unwanted effect in your digital pictures called NOISE. This appears as a grainy or blotchy pattern and/or color artifacts that degrade the overall appearance of your pictures. It is most apparent when the image sensor's sensitivity is set to a very high ISO, such as ISO 1600 or ISO 3200 (see pages 138–39).

That's the dilemma about noise and time exposures. The lowest ISO you can set on your camera, such as ISO 100, creates little or no noise. But at nighttime this low ISO requires a lon-ger exposure, which does cause noticeable noise. And if you set

9.8. To prevent light from leaking into an SLR camera through the viewfinder during long exposures, an eyepiece cap can be placed over it (as shown here). Or you can block the eyepiece opening with your hand.

the ISO to a higher number (such as ISO 400 or above) to allow a shorter exposure time, noise will again be evident.

To critically assess which approach causes the least amount of noise with your camera, put the camera on a tripod and shoot the same night scene in two ways: using a low ISO with a long exposure time and using a high ISO with a short exposure time.

Fortunately, many cameras have a NOISE REDUCTION feature that you can activate from a menu in order to lessen the problem. Image-editing software also can help reduce noise in your pictures later, but in both cases the sharpness of the images may be slightly decreased as well.

Experiment by shooting the same nighttime subject with and without your camera's noise reduction feature turned on. After you make this test, and the previous one (using a low ISO with a long exposure time and a high ISO with a short exposure time), download the images to your computer. Then compare all these images at full size on your computer monitor to see the effects of noise and how they might vary with different camera settings.

Read your camera manual carefully for cautions regarding long exposures and noise. For instance, because image sensors are electronic devices, they can heat up during long exposures and that higher temperature can increase noise.

PHOTOGRAPHING FIREWORKS

Fireworks are a challenging but rewarding nighttime subject. First, read the preceding section about time exposures to be aware of technical concerns that include camera shake, exposure readings and settings, and noise. Then try the following suggestions for making memorable fireworks photos with your digital camera.

Begin by mounting your camera vertically on a tripod and attaching a cable release to trigger the shutter. Bring extra

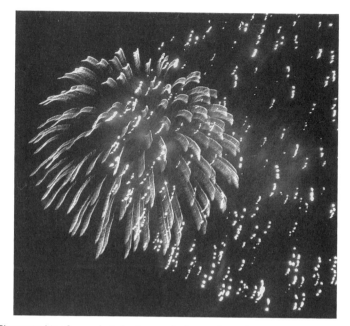

9.9. Photographing fireworks is fun but can be frustrating unless you prepare in advance (see text). Good timing and some luck also are required. This close-up of an explosion was caught during a 1/2-second exposure with the zoom lens of a point-and-shoot camera set at maximum telephoto.

memory cards, spare batteries, and a flashlight to help you see the settings you'll make on the camera.

The next step is to find a good camera angle that will give you a clear view of the fireworks. Start by checking the direction of the wind, if any, to make certain smoke from the fireworks will not blow your way and obliterate the display. Avoid bright lights that shine into your lens, and watch that people don't trip over the tripod legs.

Pick a spot that will allow you to shoot full-frame images of single explosions with your zoom lens at a telephoto setting and also be able to include several bursts in one exposure with the zoom lens at a wide-angle setting. To add extra interest,

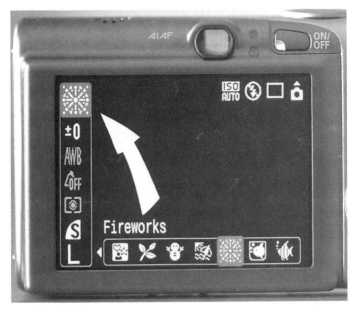

9.10. Some cameras have a scene, picture, or shooting mode that presets the exposure and focus for fireworks. An icon (see arrow) on this menu displayed on the LCD monitor of a point-and-shoot model indicates that the camera's Fireworks mode has been selected.

include trees, buildings, or people in overall views of fireworks high in the sky. If a body of water is nearby, add some fireworks reflections.

If your camera has an automatic scene, picture, or shooting mode specifically for fireworks, make a few test shots and review them on the camera's LCD screen to see how you like the results. Read your camera manual for any special advice regarding this mode.

If the pictures are overexposed or underexposed, switch the exposure mode to manual (M), if available, and try again. Here are the steps to take. Set the ISO to 100 and the lens aperture to f/11. (Change the lens opening to f/16 if your initial shots are overexposed or to f/8 if they are underexposed.) Instead of using

autofocus (AF), select the manual focus (MF) mode, if available, and set the lens focus to infinity (∞).

As for white balance (WB), setting it to Tungsten or Incandescent Bulb will produce the more natural colors of fireworks, which tend toward cooler blues and greens. If you prefer warmer red and orange results, set the white balance to Daylight or Flash. (If you shoot in a Raw format, you can readjust the white balance to your liking later with image-editing software.)

Most important is to be sure the shutter is open when the fireworks explode. Set the shutter to "B" (bulb), if available, so you can trigger the shutter open and then trigger it to close after any amount of time you wish. That way you can capture a single explosion or include several bursts in a picture.

Multiple bursts are often more impressive than a single firework display. Record them in succession with one time exposure, but block any extraneous light between the explosions by placing a card-size piece of black poster board, a dark hat, or even your hand just in front of the lens; be careful not to touch the camera.

If your camera has no "B" setting, set it to the longest shutter speed available, such as 15 or 30 seconds. This allows time to include several bursts or to record a single explosion and then cover the lens until the shutter closes. If you set shorter shutter speeds, such as 4 or 8 seconds, it is more difficult to get the timing right and be sure the shutter is open when the explosion occurs. Note that the maximum 2-second shutter speed on some P&S models may be too short a time to fully capture the streaks and patterns of fireworks.

Usually you can hear a thud when a firework is ignited and sent skyward. Follow its trajectory by watching the trail of the lighted fuse with your naked eye (not through the viewfinder or on the LCD screen). Trigger the shutter to open just before the firework explodes; as you'll discover, it's often hit or miss.

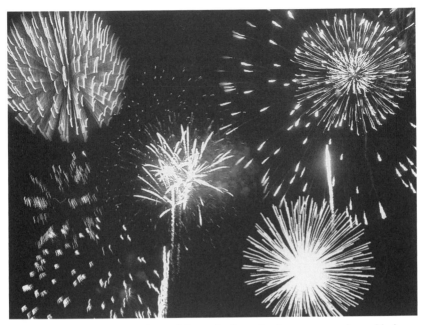

9.11. To capture one image of several fireworks, keep the shutter open and use a black card in front of the lens to keep light from reaching the image sensor between explosions (see text). In this photo, five explosions were briefly recorded at different times during a 30-second exposure.

Be aware of possible SHUTTER LAG that might delay the opening of the shutter after you press the cable release (see page 186). And there might be a time delay before you can make subsequent exposures because of a PROCESSING LAG (see page 189).

Fireworks shows are long enough for you to make plenty of test exposures and perfect your shutter timing before the grand finale, which usually offers the best opportunity for spectacular pyrotechnic photos. Be ready.

TIME-LAPSE PHOTOGRAPHY

As you probably know, TIME-LAPSE PHOTOGRAPHY doesn't refer to time exposures but rather to a series of exposures over a period

of time. Some digital cameras have menus with an INTERVAL TIMER setting so you can easily make time-lapse photos by setting the specific time interval between shots. Its icon is often three stacked pictures with a clock face on top.

To become familiar with time-lapse photography, select any subject that might make an intriguing sequence of images. One favorite is the opening of a flower blossom. Or capture the various positions and expressions of your baby while he or she is taking a nap. The setting sun with its vivid afterglow is another possibility.

Observe potential subjects in advance to become familiar with their actions. This will help you figure how often to make an exposure—such as every minute, every thirty minutes, or every hour—and also the total period of time needed for your time-lapse series.

Begin by mounting your camera on a tripod, then compose the picture, set the camera for auto-exposure and autofocus, and make a few test shots. Be sure the background is not distracting and that the lighting is uniform. For example, to avoid harsh shadows from the sun on a blossom, shade the flower with an umbrella. (Or bring the plant inside in a flower pot.) Also shade

9.12. For time-lapse photography, some cameras have settings for an interval timer to automatically make exposures at times you specify. This menu on an SLR model indicates that the timer is on and has been set to make a total of five exposures, once every ten hours; there was a 1-second delay before the shutter fired the first time.

your camera; never let direct sunlight shine directly into the lens or heat up the camera over time.

On the camera's time-lapse menu, set the time between exposures in minutes and/or hours, and start the sequence; the first picture will be made at the end of the time interval you've set. Until you turn the camera off to stop the time-lapse session, it will continue to make exposures at the set time unless your camera allows you to specify the total number of exposures, the memory card fills up, or the camera batteries become exhausted. (You can use an AC adapter to power the camera with electrical current and avoid any battery problems.)

In between shots, the camera will switch to its SLEEP MODE to conserve battery power by turning off the LCD and viewfinder displays and the metering system (and flash, if used). Many cameras let you select the amount of time the camera will wait after an exposure before going to sleep, such as 1, 2, 5, or 10 minutes; set the sleep mode to the lowest number so the camera will not waste batteries between time-lapse exposures.

Also check the length of time set for your camera's BATTERY SAVE or AUTO POWER OFF feature (see page 71). If necessary, disable that feature or readjust that time so your camera won't turn off completely during the time-lapse sequence.

Once you download the images to your computer, you can select a few frames that have the most impact and then print or display a panel with those pictures in sequence. Also, by using special software on your computer, all the frames can be combined into a brief TIME-LAPSE VIDEO. However, you will need a considerable number of images. For example, 240 images will be required to make a 10-second video clip at the normal rate of 24 frames per second. If the camera exposes one frame every minute, that time-lapse series of 240 photos will take four hours to complete.

9.13. Time-lapse photography captured these three images of a blooming orchid; they were selected from nine exposures made automatically over a period of nine days (see text).

CREATING PANORAMIC PICTURES

One of the most fascinating techniques to try with your digital camera is creating a photographic panorama. There are two basic steps to making a panorama: shooting a series of overlapping images from one position, then automatically stitching them together later with image-editing software on your computer. Note that a few cameras will do the stitching automatically in the camera as you shoot two or three overlapping pictures.

The good news is that stitching programs—such as Adobe Photoshop's Photomerge and Canon's PhotoStitch—do an impressive job of matching up a series of images and blending their tones and colors into a seamless panoramic picture. But this automatic computer process works best if you pay attention to certain guidelines when shooting the series of images that will be combined.

Photographers with film cameras rarely attempted to make panoramic pictures unless they had a special panorama camera. But creating panoramas has become popular with digital cameras because some have a PANORAMA MODE to help you. It may go by another name, such as STITCH ASSIST, which is the panorama mode on Canon cameras.

If your camera has a panorama feature, follow the specific shooting directions in its instruction manual. And use the panorama stitching program in the image-editing software on the CD that is packaged with your camera. Otherwise, try the procedures below.

First, we suggest that you use a tripod, and make sure its head is level. If not, when you pan from the first shot to the next, and so on, the edges of the overlapping images will not be parallel. A PAN HEAD works best to keep the camera level when panning because it is easily pivoted side to side with a handle (see illustration 9.17).

Fortunately, some panorama stitching programs are very sophisticated and will seamlessly align the images even when you hand hold the camera. Try shooting a panorama without a tripod to see if this works for you.

Most important to remember is to OVERLAP THE IMAGES by about 30 percent or more. This gives the software plenty of reference points that can be matched when stitching the panoramic picture together.

Do this by noting objects about one-third of the way into the picture and include them in the following frame so the same objects overlap. For example, if panning from left to right, find objects on the right-hand side of the first image to match up on the left-hand side of the second image, and so on for each frame you shoot.

Some SLR cameras have a menu setting for GRID LINES that imposes vertical and horizontal crosshatching in the viewfinder and/or on an LCD screen with a LIVE VIEW feature (see page 50). This can be used as a reference to help you overlap the frames; the grid will not be recorded in your pictures. A few point-and-

9.14. Creating panoramic pictures is rather easy to do with digital cameras, thanks to the special features for making panoramas found in many camera models and image-editing software programs. Stretched across two pages is a view of California's Dana Point Harbor that was stitched together from three exposures. See also illustration 9.18.

shoot models show target marks in the viewfinder to line up the overlapping images.

Use the manual (M) exposure mode, if available, so the exposure will be the same for each image you shoot. First, pan the

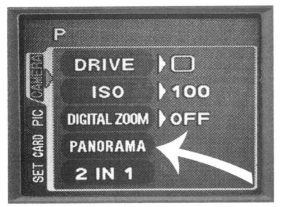

9.15. If your camera has a panorama mode, look for it on a menu on the LCD monitor (see arrow). Study the steps in your camera manual for shooting a panorama, and then practice the procedure so you'll be ready whenever a subject appears that is ideal for a panoramic picture.

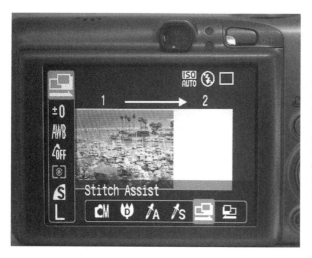

9.16. Some cameras help you align and overlap images when shooting a panorama. On this Canon LCD monitor, the "stitch assist" feature displays the first image next to the second image (not yet shot), and so on, as you pan the camera to shoot two or more images (see text).

camera to make exposure readings for each frame you plan to include, and then compare the readings to decide on the best overall exposure; some frames may have more shadows or highlights than others. Once you set the f/stop and shutter speed, do not change it while exposing the series of frames.

Use manual focus (MF), if available, and keep the same focusing distance for all the frames you shoot. Set the white balance (WB) to Daylight or another appropriate setting. Do not use automatic white balance (AWB) because the overall color of each image might change as you pan from one frame to the next frame.

After you've begun shooting the series of pictures, do not linger too long between frames, especially if there is changeable weather or lighting that can affect the white balance or exposure you've set.

Because of the inherent distortion, beware of using a wide-angle lens or the wide-angle setting on a zoom lens for panoramas. Also, wide-angle views may show some VIGNETTING with slightly darker corners and edges in each picture, which makes it difficult for the stitching software to create a panoramic image with uniform exposure.

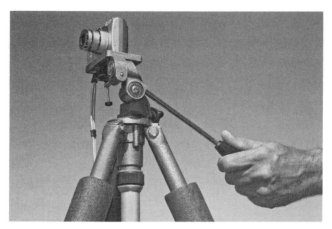

9.17. A pan head on your tripod makes it easy to keep the camera level as you pivot it left or right with a handle to make a series of shots for a panoramic picture that you stitch together later with computer software.

Whatever focal length you set on a zoom lens, take care not to change it during the series of shots because the frames will not match up perfectly for a panoramic picture.

You can pan the camera from the left or the right when making the exposures, but the computer stitching program may want to know in which direction you shot the series of pictures. Also workable is VERTICAL PANNING—going up from the bottom or down from the top—to create a tall panorama instead of a wide one.

We suggest that you shoot only three or four frames for your first panoramas; you can try more when you become familiar with both the shooting and the stitching procedures. The more frames you shoot, the wider the panorama will be, but bear in mind that the picture height of the final image will be reduced and also limited by the width of your printing paper or video display.

For the stitching software to work properly, you must keep the images in the order you shot them. Just before you start

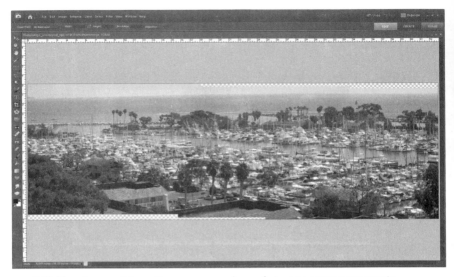

9.18. Many image-editing software programs have a feature to create a panoramic picture from two or more overlapping images. Three exposures of a harbor were automatically stitched into this panorama by the Photomerge feature of Adobe Photoshop, as described in the text. This picture was cropped at the top and bottom to eliminate staggered edges where the three images joined; see illustration 9.14 for the final panoramic result.

shooting any panoramic series, mark its beginning by exposing an extra frame with your hand or something else in front of the lens; do the same at the finish of the series to mark its end. That way you can easily locate the series of panorama pictures among all the image files recorded on your memory card.

After downloading the images to your computer, make your very wide or very tall picture come together by following the panorama stitching procedure found in many image-editing programs. For an example, working with Adobe Photoshop Elements 7, here's what you would do.

Under the program's **File** menu, click **New**, then click **Photomerge Panorama** in the fly-out menu. Click **Browse** to find and select the image files of all the pictures you shot, then

9.19. You can create a panorama by using image-editing software to crop an appropriate subject, such as this Alaska Railroad passenger train passing over a trestle in the wilderness (see box). It would have been impossible to shoot a panorama of the train in the usual multi-exposure manner because the subject was moving.

If you don't like taking all these steps to create a panoramic picture, there is an easy alternative: simply crop a single picture to a panoramic format. Remember to shoot the picture at the highest resolution your camera allows. That way there will still be sharp detail in the enlarged photo after you crop away much of the original image to make it a wide or tall panorama.

click **OK**, and watch the panoramic photo appear; it takes a minute or two for the program to align and blend the images.

Afterward, use the Crop tool to eliminate the unwanted checkerboard effects at the top, bottom, and sides of the panorama where the individual pictures joined. Finally, save this new panoramic image with its own file name and file extension by using the **Save As** command. Note: all aspects of image editing are discussed in chapter 14.

TAKING YOUR DIGITAL CAMERA UNDERWATER

You don't have to be a scuba diver to enjoy taking your digital camera underwater. Even skimming along the water's surface with swim goggles or a face mask and snorkel lets you capture some intriguing underwater images. And if you are not near an

ocean or lake, you can always make interesting shots in a swimming pool.

Whether you have a point-and-shoot, prosumer, or single lens reflex (SLR) camera, there is often an UNDERWATER HOUSING made for it. Housings for P&S and some prosumer models cost under $200, while those for SLRs are over $1,000.

Canon, Sony, Olympus, Pentax, Casio, and Panasonic supply housings for some of their own camera models. Housings to fit many camera brands, including Nikon, also are made by underwater camera and housing specialists, such as Ewa-Marine, Ikelite, Sea & Sea, SeaLife, Fantasea, Bonica, Aquapac, Aqua Tech, and Aquatica.

These waterproof housings are most often made of a hard polycarbonate plastic and have external controls that connect to

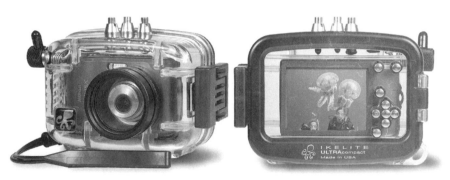

9.20–9.21. Underwater housings have controls on their watertight cases to operate the buttons and dials on the camera inside, whether a point-and-shoot model (above) or more complex SLR (right). These Ikelite housings are clear polycarbonate plastic that makes it easy to view the camera's LCD monitor (upper right) while you are underwater.

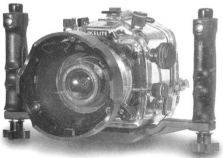

your camera's controls. There also are soft PVC (polyvinyl chloride) plastic housings that are flexible enough for you to directly adjust your camera's controls. Both types have a clear optical glass or plastic port for the camera lens to shoot through.

Manufacturers indicate the maximum WATER DEPTH to which a housing can go before a leak might occur that could ruin your camera. The flexible PVC housings are safe to depths of either 66 or 164 feet (20 or 50 meters), while the hard plastic housings vary in their depth limits from 100 to 300 feet (30.5 to 91.5 meters).

You should have little worry about the failure of an underwater housing due to water pressure, especially if you shoot at depths no greater than 25–60 feet (7.6–18.3 meters) where the most photogenic marine life is often found. Nevertheless, we recommend that you first test any housing you buy by taking it underwater *without your camera* to look for escaping air bubbles or leaks.

For occasional underwater photography, an alternative to using a housing is buying a regular point-and-shoot camera that is also WATERPROOF to a certain depth. For example, some Olympus Stylus SW models can be taken as deep as 33 feet (10 meters), while others are limited to 10 feet (3 meters) underwater.

As with cameras in underwater housings, a self-contained

9.22. A few point-and-shoot cameras are waterproof and can be taken to a limited depth for underwater photography in a swimming pool or when snorkeling. The Pentax model (left) is waterproof to 10 feet (3 meters), and the Olympus model (right) to 13 feet (3.9 meters.)

waterproof camera also is ideal for photographing in INCLEMENT WEATHER, because you never have to worry that rain or snow will damage it.

There are several things to know when photographing underwater. The deeper you go, the darker it gets. Also, as you descend, the colors of your subjects fade away and everything appears blue-green. Unless you stay near the surface and the sun is bright, you'll usually need an accessory EXTERNAL FLASH UNIT (or two) to record your subjects in their true colors.

Most BUILT-IN FLASH UNITS are too weak to do any good because the water quickly absorbs their limited light. Some are satisfactory if you use the macro mode and are very close to your subject. However, built-in flash also causes annoying BACKSCATTER, which is flash light reflected back into the camera lens by particles in the water. To avoid this problem, use a more powerful waterproof external flash unit (called a STROBE) that is extended by an adjustable arm above and to one side of the camera.

Experienced underwater photographers get very close to their subjects so the flash light has less distance to travel and there are fewer particles in the water between them and their

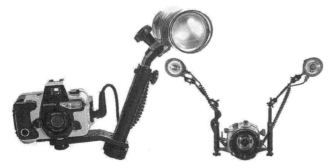

9.23. For the best underwater pictures, use a waterproof external flash unit or two; your camera's internal flash is too weak. Known as "strobes," these flash units are positioned on arms off camera to prevent unwanted reflections called backscatter (see text).

subjects. Set the camera's zoom lens at its wide-angle setting, or use a wide-angle lens on an SLR. Set the white balance (WB) to Flash if using flash or Daylight if using natural light.

Use the automatic (A) or program (P) exposure mode, and try the available focusing modes—autofocus (AF), manual focus (MF), and macro focus—to find what works best underwater with your camera. The instruction manuals for waterproof point-and-shoot models will give specific advice for underwater shooting.

P&S cameras that you can put into underwater housings may feature an automatic UNDERWATER MODE, which often is identified by a fish icon. Check the camera manual to learn exactly what this setting does. On some models it presets the white balance, while on others it presets the focusing distance or shutter speed and/or ISO. Avoid using the underwater mode if it is only designed to create an underwater effect by adding a blue cast to all images.

Use *both* hands to hold the camera steady when pressing the shutter button or lever; one-handed shooting almost always

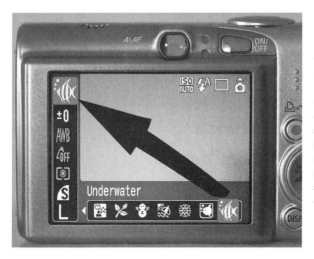

9.24. Some cameras with scene, picture, or shooting modes can be set for underwater shooting, usually designated by a fish icon (see arrow). A selection of scene modes is at the bottom of this menu on the camera's LCD monitor. Waterproof housings are available for many digital cameras (see text).

results in blurred pictures. Whenever you go into the water, remember to wear a wrist strap or neck strap in case you let go of your camera; most models and housings will sink instead of float to the surface if you drop them underwater.

When you are back above water and reviewing your shots on the camera's LCD screen, don't be discouraged if some of your aquatic subjects look dull or dark. Underwater photos can be greatly enhanced by making color and exposure adjustments with image-editing software on a computer; see chapter 14, beginning on page 324.

Photographing underwater can be exciting, but keep your movements slow and easy so you don't scare away the marine life or stir up sand and sediment that will cloud your pictures. Instead of chasing fish and other aquatic creatures, veteran underwater shooters often stay motionless and wait until their subjects come to them.

CAPTURING INFRARED IMAGES

Film photographers have long been intrigued with infrared photography, which requires black-and-white or color infrared film, a special infrared filter placed in front of the camera lens, and patience. Capturing infrared images has caught the fancy of digital photographers as well. You still need an infrared filter and patience to make infrared images with a digital camera, but you will be rewarded with some unique photographs.

Black-and-white infrared photos are especially startling because their tones are much different from normal black-and-white images. For example, grass and other greenery appears brilliant white instead of gray. Blue skies turn black, and people's faces have a ghostly look.

Although unseen by our eyes, INFRARED LIGHT is always present and will be recorded by image sensors. However, dig-

9.25. Although infrared photography is challenging, eye-catching pictures are the reward. The tones of your subjects turn out entirely different from what you see with the naked eye. This pampas grass was photographed against a blue sky through an infrared (IR) filter attached to the camera lens (see illustration 9.27).

ital cameras purposely block infrared light with an INFRARED (IR) BLOCKING FILTER, also called an INFRARED CUT-OFF FILTER, mounted in front of the sensor. The filter keeps the image sensor from being affected by infrared light that would otherwise alter the natural colors of your digital pictures.

In order to record infrared light with a digital camera, the built-in infrared blocking filter can be removed and replaced by an INFRARED FILTER. This filter will block almost all of the wavelengths of *visual* light but allow the wavelengths of infrared light to be recorded by the image sensor.

Among the companies that will do this for you is Life Pixel Digital Infrared Photography Conversion Services; the conversion costs $300–$500, depending on your camera. Or, if you are

brave enough to dismantle your own camera, there are do-it-yourself instructions on the company's Web site: www.lifepixel .com. It's important to note that once the conversion is made, your camera will no longer record normal, full-color pictures.

Because of the growing interest in infrared digital photography, the Sigma SD14 SLR camera has been designed for easier conversion by the photographer. You pop out a retaining ring that secures the infrared blocking filter and temporarily remove the filter. Then you place an infrared filter on the front of the camera lens to make infrared exposures. When you want to resume normal photography, just remove that filter from the lens and snap the infrared blocking filter and its retaining ring back inside the camera.

Another option is to buy an expensive digital camera already adapted for infrared photography, such as Fujifilm's FinePix IS-1 or its FinePix S3 Pro UVIR SLR, which are used primarily in law enforcement and scientific and medical fields.

If you'd like to make infrared pictures but don't want to buy or convert a camera only for infrared photography, you can try the following suggestions. Because every digital camera model varies in its reaction to infrared light, these are not specific directions.

First, we want to caution you that infrared photography requires experimentation—both when you shoot and later when using image-editing software—in order to produce the most spectacular images. If you are discouraged by your initial results, keep trying. (Or bypass the camera altogether and just use your computer, as described in the box on page 222.)

To use your digital camera for infrared photography without converting it, you first must test that some infrared light will reach your camera's image sensor and not be stopped completely by the built-in infrared blocking filter. (If infrared light is totally

9.26. To check if your digital camera is able to record infrared images, point a television remote control at the camera lens and press any button on the control to send an infrared beam to the image sensor. A white or purplish spot will appear on the LCD monitor if the beam passes through your camera's infrared blocking filter, which indicates that you can make infrared images.

blocked, you cannot record infrared images unless you convert your camera by removing that filter, as explained above.)

Make this test by pointing a television remote control at the front of the camera lens from a few inches away, press one of the control's buttons, and look for infrared light from the remote to appear as a white or purplish spot on the camera's LCD screen. If using an SLR camera without "live view," you must make an exposure while the remote control button is pressed, and then play back the image on the LCD screen to look for the white or purplish spot.

If you can see the spot, the next step is to buy an INFRA-RED FILTER to mount in front of your camera lens. As mentioned earlier, it will block almost all of the wavelengths of visual light but allow the wavelengths of infrared light (which are invisible to your eye) to be recorded by the image sensor.

The filters you can try are identified by the Wratten filter numbers 89B, 87, and 87C (listed in increasing order of opaqueness). One will work better than the others, depending on your

9.27. If your camera is capable of recording infrared images, an infrared (IR) filter, which appears black or almost black, must be attached to the front of the camera lens. A tripod is needed to keep the camera steady during the longer exposure time required by the filter (see text).

particular camera. (Don't bother with the red filters, numbers 25 and 29, commonly used with infrared films; they do not produce the same striking results when used on digital cameras.)

The three infrared filters recommended on the previous page appear almost black or entirely black when you try to look through them. That makes it impossible to compose your picture using an SLR's through-the-lens viewfinder, unless you do so before attaching the filter to the front of the camera lens. Also compose the picture in advance with non–SLR cameras that lack a viewfinder, because you won't be able to see much, if anything, on the LCD screen when the filter is in place.

To keep the camera in position when you compose the picture, use a tripod. A tripod also is necessary to hold the camera steady during the exposure time, which may be several seconds or more.

Before making an exposure with an SLR camera, close its viewfinder EYEPIECE SHUTTER or use the eyepiece cap (see page 196). This helps prevent stray visual light from reaching the image sensor and affecting the infrared image you want to record.

You have to test whether the auto-exposure and autofocus modes will work on your camera when the infrared filter is mounted in front of the lens. If not, switch to the manual exposure and focusing modes.

9.28. As these two images show, image-editing software can be used to give an infrared look (bottom photo) to an existing picture. Much of the green foliage has turned white and the blue sky has darkened in this view of a replica statue of Michelangelo's *David* in the courtyard of the Ringling Museum of Art in Sarasota, Florida. How this infrared effect was achieved is explained in the box on the next page.

For your initial infrared shooting, bracket the exposures to see what works best. As a starting point with manual exposure—outdoors on a sunny day, using an 89B filter, ISO 100, and an f/5.6 lens opening—make five exposures by bracketing the shutter speed at 1/4, 1/2, 1, 2, and 4 seconds. If using auto-exposure, bracket by adjusting the exposure compensation mode (see page 162).

Viewing the results on your camera's LCD monitor will be a disappointment, especially because they appear too dark. *Wait until you download all the infrared shots to your computer and adjust them with image-editing software before deciding if you have succeeded or failed.*

When you first open an infrared image on your computer screen, it often looks dark and monochromatic with a reddish tinge. Using image-editing software, convert the image to black-and-white to eliminate any color cast, increase the contrast and brightness of the picture, and use any of the program's other tools and commands to achieve the infrared look you like best.

Be sure to search "infrared photography" on the Internet for more advice and real-life experiences with particular camera models, infrared filters, and image-editing programs.

Want to make infrared photos the easy way? A number of image-editing software programs have a selection called "infrared" that you can click to instantly give any color digital image a black-and-white infrared look. The effect varies, depending on your subject. (See illustration 9.28.)

For example, using Adobe Photoshop Elements 7, open a regular (not infrared) image file, click **Enhance**, then **Convert to Black and White**. In the dialog box that appears, click **Infrared Effect** and adjust the **Contrast** slider until you like the result. Click **OK** and then save this new image with a new file name by using the **Save As** command. Read chapter 14 for details about using image-editing software.

MACRO MANIA: MAKING CLOSE-UP SHOTS

Close-up pictures are easy and exciting to make with digital cameras. Just look to nature for all sorts of intriguing subjects, such as colorful flower petals, patterns in a leaf, textures of tree bark, and morning dew on a spider web.

As mentioned earlier in the book, most P&S and prosumer models feature a MACRO MODE that adjusts the lens so that it can focus sharply on subjects very close to the camera.

As you probably know, the closer your camera can focus, the larger your subject will appear in the photo. Consult your camera manual to learn how close you can get to a subject when you select the macro mode. As you'll note, *the minimum focusing distance varies with the zoom lens focal length setting.* For example, one of our P&S cameras can get as close as 1.2 inches (3 cm) to a subject at the zoom's extreme wide-angle (W) setting, while

9.29. The macro mode was set on a point-and-shoot camera so that its zoom lens could focus very close to this hibiscus flower. When composing the picture, the photographer filled the LCD monitor with the flower in order to see detail in its petals.

9.30. Many cameras offer easy access to the macro mode for close-up photography; look at the four-way switch for a tulip flower (arrow) that is the traditional icon for the macro mode. When you press the switch at the tulip position, a menu appears on the camera's LCD monitor so you can quickly set the camera to macro, which enables the lens to automatically focus closer to your subject.

at its extreme telephoto (T) setting, the minimum focusing distance is 12 inches (30.5 cm).

For SLR cameras, there are special MACRO LENSES—or macro settings on regular lenses—that enable the camera to focus very close to subjects. Accessory attachments called EXTENSION TUBES and EXTENSION BELLOWS can be mounted between a macro lens and the SLR camera body to enlarge tiny subjects to greater than life size.

For occasional close-up work with an SLR, you can buy one or more CLOSE-UP LENSES that are of different strengths (diopters) and attach to the front of the camera lens to magnify small subjects. Close-up lenses also can be mounted on some P&S and prosumer cameras that have screw threads on the camera lens. Macro and close-up lenses and extension tubes and bellows were described in chapter 4, beginning on page 101.

Composing close-up pictures with an SLR is done with its THROUGH-THE-LENS VIEWFINDER or on the LCD MONITOR if the camera has a LIVE VIEW feature. With all other digital cameras,

9.31. Always use the camera's LCD monitor instead of an optical viewfinder when composing close-up pictures, as of this small Mexican handicraft. Otherwise, portions of your subject may not appear in the picture because of parallax error. However, if your camera has an electronic viewfinder, or if you have an SLR camera with "live view," you have a choice of using the LCD monitor or the viewfinder for precise close-up composition.

be sure to compose close-ups on the LCD monitor; avoid using an OPTICAL VIEWFINDER if the camera has one. Otherwise your subject will be off-center because of a problem called PARALLAX ERROR, which was described earlier.

On the other hand, you can compose close-ups accurately through an ELECTRONIC VIEWFINDER (EVF), which features a tiny LCD screen inside the viewfinder. However, it is much easier to see and compose close-up subjects by looking at the camera's larger LCD monitor. Detailed descriptions of camera viewfinders and parallax error appeared in chapter 2, beginning on page 46.

When shooting close up to a subject, the portion of the

subject area that will be in sharp focus is very limited. Because of this shallow depth of field, focus carefully on the most important part of your subject. If your camera has a manual focus (MF) mode, use it instead of autofocus (AF), which may get confused at very close range to your subject and keep trying to refocus.

Also, if your camera allows, use the aperture-priority (A or Av) or manual (M) exposure mode instead of automatic (A) or program (P). Set the lens aperture to its smallest opening, such as f/22, for the greatest depth of field (see page 92).

Don't worry about the lack of manual controls on P&S cameras; their autofocus and auto-exposure mechanisms do a remarkable job when making close-ups in the macro mode. Just keep making shots until the pictures please you.

Whenever you find a subject that's worthy of a close-up, you'll get the best results by mounting your camera on a TRI-POD. It helps you make the composition of the picture more precise and also maintains the focusing distance that is so critical in close-up photography.

A steady tripod also will prevent blurred images that result from camera movement. To further lessen the chance of jarring the camera, use a CABLE RELEASE or the camera's SELF-TIMER instead of pushing down on the shutter button to make the exposure. Tripods, cable releases, and self-timers were described in chapter 5, beginning on page 111.

Watch out for wind or even a breeze that might move some of your outdoor subjects, such as flowers. Any movement will be very evident in close-ups, especially when using a small lens opening that requires a slow shutter speed in order to make an accurate exposure.

Your camera's BUILT-IN FLASH will give a brief burst of bright light that may "stop" a moving subject, but beware of overexposure because the flash is so close. To reduce the amount of flash light, you can use the FLASH EXPOSURE COMPENSATION MODE that

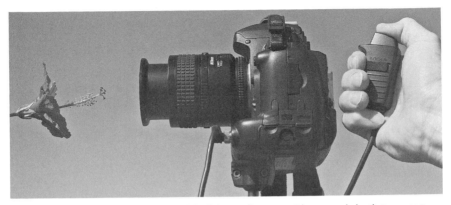

9.32. When making close-ups, as of this hibiscus flower, avoid camera shake that causes a blurry image by using a tripod and triggering the shutter with a cable release (right) or the camera's self-timer for a hands-off exposure.

is a feature of SLRs and some prosumer cameras. With other cameras, hold a layer or two of white handkerchief or facial tissue in front of the built-in flash to diminish and soften its harsh light output.

SLRs and some prosumer cameras allow the use of an accessory EXTERNAL FLASH UNIT, which can be held away from the camera to better control the direction and output of the flash light for close-ups. External flash units and methods for their use were described in chapter 3, beginning on page 80.

After making close-up pictures, remember to cancel the macro mode setting so the camera will again focus at normal shooting distances. Usually P&S and prosumer cameras will revert to the regular autofocus setting whenever you turn them off.

Creative Composition with Your Digital Camera

W hat's the secret to great photographs? It is COMPOSITION. Your photographic eye—not your camera—is what creates an outstanding picture.

The major thing for casual photographers to learn is that the person behind the camera, not the camera itself, determines how good a picture will be. Contrary to what you might believe, equipment really doesn't matter in photography.

As an example, at the annual convention of one of our professional journalism organizations, there is a "photographers' shootout" to see who makes the best pictures. One year, among all his fellow pros with expensive SLR cameras and all sorts of lenses, a friend armed himself with several simple onetime-use cameras, each with only a fixed focus, non-zoom lens. Guess who composed the pictures that were judged best of show?

Why do we always refer in this book to "making" instead of "taking" a photograph? Simply because cameras "take" pictures, but you "make" a photograph by composing it.

Remember, a great photograph is not a snapshot—you must decide exactly what you want in the picture.

You might not think of yourself as a born photographer, but you can train yourself to copy techniques that respected professional photographers use every day in pursuit of perfect pictures. In this chapter are some basic guidelines to composing pictures that will please you and everyone else who looks at your digital photographs.

EMPHASIZE YOUR SUBJECT

The first and foremost thing to consider when making any picture is its main subject, the CENTER OF INTEREST. In other words, what do you want viewers to see when they look at the picture?

10.1. How many pictures have you looked at and wondered what the photographer was trying to show you? This group shot of New Zealand's ubiquitous sheep is our not-so-subtle way of emphasizing one of the most important guidelines for great photography: always make certain that viewers can easily identify the main subject of your picture.

Ask yourself, "Will my subject be obvious to viewers?" What frequently happens is that you include other things—often inadvertently—that are distracting and draw viewers' eyes away from your subject. There's an easy way to eliminate many distracting elements before pressing the shutter release button: get closer to your subject.

GET CLOSER TO YOUR SUBJECT

Undoubtedly the most effective way to direct attention toward your main subject is to get close to it. That is simple to do: either move physically closer with your camera, or adjust the camera's zoom lens toward its telephoto (T) setting until your subject appears closer in the viewfinder or on the LCD monitor. The reason many pictures lack impact is that the main subject seems too far away. So move closer or zoom in to concentrate attention on your subject, and avoid including elements that are distracting. Make certain you see nothing in the viewfinder or on the LCD screen that you don't want in the final picture.

Yes, we know you can CROP a picture later with your computer to make a subject stand out (see page 323), but we believe it's more sensible to initially compose the best picture possible in the viewfinder or on the LCD monitor.

Sad to say, many photographers undergo a change in mind-set when they switch from film to digital photography. They think, "If a picture isn't perfect, I'll just fix it with my computer." Believe us, it is far easier, and a significant time-saver, to know what you're doing—and visualize the result—when you make an exposure with your digital camera. *There's no need to correct anything if you get it right the first time.* In other words, always pay close attention to composition.

10.2–10.3. An easy way to give more impact to your pictures is to fill up the camera's viewfinder or LCD monitor with your subjects. The first picture made after this baby's christening (left) unnecessarily shows the baby, parents, and godparents at full length, as well as the trees in the background. Fortunately, the photographer then turned the camera from vertical to horizontal and moved closer (below), which greatly improved the composition and focused viewer attention on the subjects' faces.

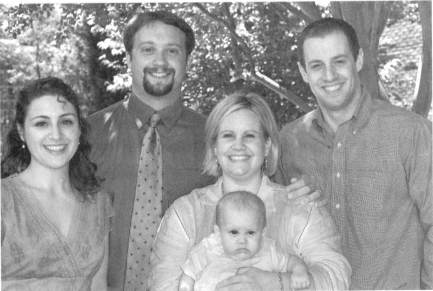

APPLY THE "RULE OF THIRDS"

It may surprise you to learn that the main subject—your center of interest—should not be in the center of the picture. Where should it be? The most valuable guideline for composing a picture successfully is to follow the simple RULE OF THIRDS. Professional photographers do this all the time.

Just imagine the viewfinder or an LCD screen divided into thirds with horizontal and vertical grid lines. Position your main subject along any of the four lines, or where two of the lines intersect. The subject should face toward the center of the picture, not away from it.

For full-frame portraits in a vertical format, the person's eyes should be located along the *upper* grid line. If the eyes are in the center of the picture, there will be empty space above the person's head.

10.4–10.5. When making a portrait, as of this man in Puerto Rico, don't center your subject (left). Get close and apply the "rule of thirds" (right) so the person's eyes align with an imaginary grid line marking the upper third of the picture (see text).

10.6. The horizon was positioned in the upper third of this picture to focus attention on the waterfront town of Charlotte Amalie and its two offshore islands in the United States Virgin Islands.

10.7. To emphasize these dramatic clouds above an island in the Caribbean, the photographer followed the "rule of thirds" and positioned the horizon in the lower third of this picture.

10.8. According to the "rule of thirds" for good composition, don't position the horizon in the middle of a scenic shot because it will divide the picture in half. There are exceptions, of course, such as this mirror reflection of the Canadian Rockies in the Vermilion Lakes in Banff National Park, Alberta.

Likewise, don't place the horizon in the middle of a scenic shot, which will divide the picture in half. Instead, if the foreground is the center of interest, as in a beach scene, locate the horizon along the *upper* grid line so that the foreground will occupy the lower two-thirds of the frame. Or, say a beautiful sky at sunset is your main subject; put the horizon along the *lower* grid line so the sky will occupy the upper two-thirds of the frame.

BEWARE THE BACKGROUND

When concentrating on your main subject, don't overlook the BACKGROUND. Far too many pictures are ruined because distracting elements behind your subject draw the attention of viewers away from your subject. Always watch out for cluttered or

10.9. Where's the person parasailing in this picture? She's obscured by the palm trees. The photographer should have waited until the parasail had risen higher in the sky above this resort in the Florida Keys. Always be careful that the background (or foreground) doesn't cause confusion or become a distraction in your photos.

busy backgrounds. Also look for objects in the FOREGROUND that might divert viewers' eyes from your subject.

To eliminate such distractions, change your camera angle or try selective focus (see below). Above all, you should avoid an all-too-common blunder: including a pole or a tree that seems to be growing from the top of a person's head.

TRY SELECTIVE FOCUS

Viewers look at subjects that are in sharp focus in a picture; they give little if any notice to areas of the image that are fuzzy. You can—and must—control whether everything in the photograph will be in sharp focus, as is desired in most landscape views, or

whether only a portion of your subject area will be in focus, as is desired in a portrait so the person will stand out from a blurred background.

This is called SELECTIVE FOCUS. It is especially effective in directing viewers' attention to your main subject, the most important part of the picture. For example, in making a full-frame portrait of a person's face, where should you focus? On the mouth, the nose, the ears? No, always focus on the eyes.

To control how much of your subject area will be in sharp focus, you should understand and employ DEPTH OF FIELD, which was discussed in chapter 4 (see page 92). As you'll recall, adjusting the lens aperture (f/stop) and the point of focus of the camera lens determines the depth of field. So does the lens focal length or zoom lens setting; i.e., wide angle or telephoto.

If you cannot manually set the lens aperture and focus of your

10.10. Setting a large lens opening (f/stop) on the camera limited the depth of field so that only the cute face of this koala is in sharp focus (see text). When making a portrait of an animal or a person, always focus on the eyes.

10.11. A small lens opening (f/stop) was set on the camera in order to get great depth of field in this picture so that both the sign and the church would be in sharp focus to make clear their humorous relationship.

camera, as is the case with most point-and-shoot cameras, use one of the scene, picture, or shooting modes that are specially designed to control the f/stop and focus according to your selection (see page 155). For example, the landscape mode sets a small lens opening and focuses at infinity in order to put everything in the picture in sharp focus. On the other hand, the portrait mode sets a large lens opening and limits the focus so only your subject will be in sharp focus and the background will be blurry.

CHANGE THE CAMERA ANGLE

When composing a picture and seeing an unwanted background or foreground, CHANGE YOUR CAMERA ANGLE to eliminate the

10.12–10.13. A simple way to improve a picture is to change the camera angle. This mother and son were sitting next to some the cherry tree blossoms in Washington, D.C., but the photographer was standing and inadvertently included the bicycle path in the background (left). Then he knelt down and moved closer to his subjects to make a much nicer composition (right).

problem. Move to your left or to your right, or shoot from a higher or a lower position.

Even when there is nothing disturbing in the background or foreground, changing your camera angle often produces a more eye-catching picture. Instead of shooting from your usual

10.14. The photographer shot from a low angle in a field of wheat to make the top of one stem and its kernels stand out from all the others.

10.15. By climbing to the top of the Leaning Tower of Pisa, Italy, the photographer had a high angle from which to make this eye-catching shot of the landmark's shadow.

standing position, sit or kneel down in order to be on the same level as your subject, such as a child or a dog. Or lie down so you are looking up at your subject.

Similarly, get higher than your usual standing position in order to be on the same level or to look down on your subject. Climb onto a chair or ladder, or shoot from the window of a tall building. Always look around to see if there is any camera angle that will make your pictures more memorable.

CHANGE THE CAMERA FORMAT

A simple way to differentiate your pictures from the norm is to TURN YOUR CAMERA FROM HORIZONTAL TO VERTICAL (in

10.16–10.17. When composing a picture in the viewfinder or on the LCD monitor, turn your camera from its usual horizontal orientation to see if a vertical format might be more appealing. With this osprey's wings outstretched while landing on a pole, horizontal framing was ideal for the picture above. However, for the portrait of another osprey (left), vertical framing was the better choice.

1. A simple way to improve the composition of many pictures is to put your subject *off center* by following the "rule of thirds." First imagine, on your camera's LCD monitor or in the viewfinder, a grid that divides the picture into thirds, both horizontally and vertically (see dashed lines). Then position your subject along one of those lines or where they intersect, as with the face of this cute puppy.

2. Always keep alert for unusual photo subjects and situations, and be ready to shoot. This family was walking to the beach in Southern California when they passed a building painted with this mural of a seaside scene and caught the photographer's attention.

3. If your camera doesn't automatically eliminate red-eye, you can do so with most image-editing software programs. Just outline with a box (see above) or place crosshairs on each eye with the computer's cursor, then click the mouse. This boy's right eye has already been fixed. For more about eliminating red-eye, see chapter 14.

4. Patterns and shapes can make eye-catching pictures. These crabs were for sale on Fisherman's Wharf in San Francisco, California.

5. One way to put motion in your "still" pictures is to use a slow shutter speed so the action of your subject will be blurred. The photographer shot from above to portray this twirling folkloric dancer in Mexico.

6. Be on the lookout for colors to capture with your camera, as the photographer did here while strolling along a street in Denmark.

7. Whether making portraits of people, pets, or wildlife, always focus on their eyes. Fill Flash was used to add a sparkle to the eye of this bald eagle in Alaska.

8. When photographing a tall subject in a vertical format, such as this obelisk in Luxor, Egypt, try composing it diagonally (corner to corner) in order to include more of the subject in the frame and attract attention to the picture.

9. Zoom lenses make it easy to compose pictures without moving physically closer to or farther from your subject. This inquisitive giraffe was among the wildlife encountered during a photo safari at Busch Gardens, an adventure park in Tampa, Florida.

10. Always use a fast shutter speed to shoot stop-action pictures. A setting of 1/250 second captured these young players during a soccer match in Bend, Oregon. The photographer prefocused on the ball and waited until the girls came running toward it before fully pressing the shutter release.

11. A macro lens or the camera's macro mode allows you to make close-up photos with ease, such as the inside of this California poppy that has opened to the bright sun.

12. Making automatic exposures indoors with natural light (no flash) can produce some pleasing results. This Buddha and worshippers were inside a temple in Sri Lanka.

13. A favorite subject of photographers, sunsets can have greater impact when you include more than just the sun in the picture. The golden light of the setting sun silhouettes this native Hawaiian and his outrigger canoe at the edge of a quiet lagoon on the Big Island.

Pictures of people can be much more interesting if your subjects are doing something instead of just looking at the camera.

14. This Huli wigman paints his face while looking into a piece of broken mirror prior to a village celebration in Papua New Guinea.

15. During a folk festival in the Black Forest, this German girl in a traditional hat of the region enjoys an ice cream cone.

16. There is no reason to put away your camera when the sun isn't shining. A rainy and misty day created the perfect mood for this scene with water-filled rowboats on a lake in Europe.

17. Always pay attention to *light*, which makes all the difference in photography. To add warmth to a cold winter scene in Yosemite National Park, the photographer waited until dusk when the lights went on inside the historic Ahwahnee Hotel.

18. Sometimes lens flare can be a photographer's friend instead of an enemy. Sunlight shining on the camera lens created this dramatic effect as a sheepherder led his flock through a field in Europe. For more about lens flare, see chapter 4.

19–20. After making digital pictures with your camera, image-editing software enables you to use your computer to improve your photos and also create entirely different images.

The kayaks and Ferris wheel at the Balboa Fun Zone in Southern California (above) became colorfully bizarre (left) by simply adjusting the software's Saturation control.

21. Using image-editing software, pro photographer Buddy Mays combined four digital pictures into this fantasy scene of a unicorn drinking from a lake. To do so, he created and assembled twenty-five "layers" into the final image. For more about using image-editing software, see chapter 14.

computerspeak, from landscape to portrait), and see if the composition of your picture appears more pleasing to your eye. Because digital cameras are designed to be held comfortably in a horizontal position, most images are shot in a horizontal format. While that is a natural format for landscapes and scenic vistas, there are times when the ideal format for your subject is vertical, as when shooting a person's portrait.

Also check if a photo's composition might have more impact by rotating the camera a little bit from a vertical position so that your subject will appear along an imaginary DIAGONAL line from one corner to the other of your viewfinder or LCD screen.

10.18. Composing tall subjects so they appear on the diagonal in the camera's viewfinder or on the LCD monitor attracts attention and adds variety to your photos. This statute of the Greek goddess Athena was photographed in her namesake city, Athens, Greece.

10.19. The highway serves as a leading line to guide viewers toward Cathedral and Bell rocks, the centers of interest in this photograph of "Red Rock Country" at Sedona, Arizona.

USE LEADING LINES

A common but effective way to direct viewers into or toward the subject of your picture is to use a LEADING LINE, such as a road, a fence, or a river. Also look for shapes and patterns, such as the shadows from a row of trees, which will guide viewers' eyes toward your center of interest.

FRAME YOUR SUBJECT

Finding a natural frame to position in the foreground of a picture is another technique for aiming the attention of viewers to your main subject. An overhanging tree branch, a doorway, or a

10.20. One way to direct attention to the main subject of a photograph is to include a natural frame. This gateway leads viewers toward a small mission church on the Laguna Indian Reservation near Albuquerque, New Mexico.

window—all are frequently used with great effect for this purpose. COMPOSE THE FRAME to surround the subject or to appear at the top or to one or both sides of the picture.

A bonus use for a natural frame is to block out a washed-out or distracting sky in scenic shots. The frame can be in focus or out of focus; just make sure it is an asset to the picture, not a distraction.

10.21. A common distraction in too many pictures is a tilted horizon, as evident in this shot off the west coast of Florida. The photographer was concentrating on his playful subjects and forgot to make certain the camera was level before pressing the shutter release.

LEVEL THE HORIZON

One mistake often made by snapshooters is easily avoided: always remember to keep the horizon level. It can be distracting when the earth's horizon appears tilted in pictures, so just before you press the shutter release, make sure the horizon is straight from side to side.

USE SIZE INDICATORS FOR SCALE

To help viewers get a sense of scale, particularly in scenic views, include something of a familiar size, such as a person, an animal, or a car. How big is that lake? A boat or a fisherman at the edge of a lake will give viewers an idea of its magnitude. Such SIZE INDICATORS also add some life to a static image and often make a picture more engaging.

10.22. To give viewers a sense of the massive scale of this Egyptian temple at Abu Simbel, the photographer included a tour guide in his white jallabia. Such size indicators often make pictures more interesting as well as more meaningful.

CAPTURE THE ACTION

When composing a picture, you should consider all of its elements, including ways to depict MOTION. Still pictures don't move, but you can convey a sense of action that will make them dynamic images. You can stop the action, blur the action, or do both in one shot.

STOP ACTION freezes your subject so it can be seen in detail despite being in motion when you pressed the shutter release.

As we describe in more detail below, there are several ways to do this: use a fast shutter speed, shoot at the peak of action, pan with your subject, or use flash.

To BLUR THE ACTION, use a slow shutter speed. Or blur a subject to create a feeling of motion by adjusting the focal length of a zoom lens during the exposure time. After shooting digital images, you also can use a computer's image-editing software to depict or enhance motion with the help of "blur" filters.

Stop-action photography is most easily accomplished by shooting at a FAST SHUTTER SPEED. If possible, set the camera's EXPOSURE MODE to M (for manual) or S or Tv (for shutter-priority) so you'll be able to manually select the shutter speed (see pages 149–50). SLR cameras have shutter speeds as fast as 1/8000 second, while most other digital cameras have a top speed of at least 1/1000 second.

> Because point-and-shoot cameras set exposures automatically, usually you are not able to adjust their shutter speeds manually. However, there may be a scene, picture, or shooting mode you can select, such as the sports mode, that causes the camera to shoot at a fast shutter speed (see page 155). Another option with P&S cameras is to set the ISO mode to a higher ISO number (see page 138), which often forces the auto-exposure setting to a faster shutter speed.

How fast must the shutter speed be in order to stop the action? It depends on the speed of the moving subject, the direction it is moving in relation to your camera, and the distance of the subject from your camera. You'll need a faster shutter speed for a subject closer to your camera than you do for a subject that is farther away.

Likewise, you'll need a faster shutter speed for a subject that is moving parallel or diagonally to the face of your camera than you do for a subject that is moving directly toward or away from you. Experiment by setting the shutter speed to at least 1/250

10.23. The shutter speed required to stop the action of your subjects depends on their speed, direction of movement, and distance from the camera. A speed of 1/250 second "froze" these bicyclists as they rode leisurely toward the camera; they appear close because the zoom lens was at a telephoto setting.

second and then increasing it to 1/500 or 1/1000 second, or faster, as may be required.

Another way to stop the motion of certain subjects is to press the shutter release at the PEAK OF ACTION, as, for example, with a basketball player at the apogee of a jump shot. Because the subject will be suspended in midair, you can shoot at nominal shutter speeds.

PANNING with a moving subject to show it in stop-action detail can make a dramatic picture because the background will be blurred and add to the sense of motion. The challenge is to choose a shutter speed that is not so fast that it freezes the background along with your subject. The shutter speed you choose depends on the speed of your subject. Use manual (M) exposure and try a range of shutter speeds, such as 1/125, 1/60, 1/30, 1/15, and 1/8 second.

If your camera allows, also use manual focus (MF) instead of

10.24. The photographer waited for the peak of action as this frisky colt rose on two legs while cavorting around his mother on a thoroughbred horse farm in Ocala, Florida.

automatic focus (AF) and prefocus on the spot your subject will pass.

Panning takes practice because you trip the shutter while following the moving subject in your viewfinder. (Panning and shooting while looking at an LCD screen is even more difficult.) Use the continuous shooting mode (see page 189) so that you can make more than one exposure (and have a better chance of success) as your subject goes past.

Position yourself in a comfortable stance so you can swing your upper body and camera around to easily keep the moving subject framed in your viewfinder. Make sure the camera stays level so the background won't appear tilted. *The trick you must learn is to continue panning even after pressing the shutter release.*

10.25. Panning with your subject gives a feeling of motion to still photographs, as of this moving carousel that appears slightly blurred while mother and daughter remain in sharp detail. Read in the text about techniques for successful panning, which takes practice.

Otherwise, you will unconsciously stop the camera before the shutter fires—and the panning effect will be lost.

If conditions are appropriate, firing a FLASH is another technique for making stop-action photos because its burst of bright light illuminates your subject for no more than 1/1000 second.

10.26. A flash stops this young woman in midair as she practices for the high kick competition at the World Eskimo-Indian Olympics in Alaska. She was performing very close to a wall, which caused shadows from the flash to show in the picture.

10.27. A slow shutter speed can give a feeling of motion and add extra interest to ordinary pictures. These energetic children were playing in the school gymnasium when the photographer made this eye-catching exposure at 1/8 second.

10.28. Zooming the camera lens *during an exposure* gives life to a static subject, such as this country highway in Utah. Unfortunately, not all digital cameras allow you to set a slow shutter speed or change the zoom lens focal length during that exposure time (see text).

The light from some external (not built-in) flash units is even as brief as 1/50,000 second. Reread our discussion in chapter 3 about using flash, beginning on page 72.

By using a slow shutter speed, you can purposely blur the action of your subject to give a picture the feeling of motion. Experiment with various speeds to find the one that has the most impact.

If you have a lifeless subject and want to impart a sense of action or movement, try adjusting your zoom lens *during* the exposure time. ZOOMING in or out creates streaks from a static subject and brings it alive. This requires a shutter speed that is slow enough to allow time for the focal length of the zoom lens to be changed. Use a tripod to hold the camera steady and in position for your composition.

This zooming motion technique works best with SLR cameras; digital models with a built-in zoom lens may not allow it to be adjusted toward the wide-angle (W) or telephoto (T) setting during an exposure.

PAY ATTENTION TO TIMING

Just because you've composed a picture and your camera is ready to shoot doesn't mean you should press the shutter release. It's important to wait for the best moment to make the exposure. In other words, *use good timing* in order for the picture to have the most interest and impact. For example, a child looking at his

10.29. Good timing by the photographer, not luck, captured this dog in midair as he caught a Frisbee during a canine disc-catching championship before fans that filled a stadium in Los Angeles, California.

birthday cake is a pleasant picture, but shooting when he blows out the candles makes a much more exciting photograph.

It pays to practice some patience. At tourist attractions, watch out for people who might stroll into the picture you've composed and ruin the shot; wait until they walk out of the frame before you shoot.

Take enough time to get the pictures you envision. If you're making portraits, don't press the shutter release until your subject has an expression you like. As you'll discover, children and pets are special challenges for a point-and-shoot digital camera, especially because of SHUTTER DELAY (see page 186). An option is to set the camera for CONTINUOUS SHOOTING, if available (see page 189).

The more you know about a subject and its habits, the better your pictures. Wouldn't you rather photograph a bird landing with food for newborn chicks than just get a shot of the bird sitting on its nest? Nature photographers know how difficult it is to make exciting photos of wildlife. They often spend days or weeks or even months in the field in order to get the best shots.

CONSIDER THE TIME OF DAY

The time of day you make a picture also has an impact on its outcome and an effect on viewers. Shadows, for example, can influence the composition of a picture and its mood. For scenic views, noontime is traditionally avoided because of harsh overhead sunlight. Landscape photographers generally prefer the directional light at dawn and at dusk; they concentrate their shooting during an hour or two just before and after sunrise and sunset.

Always consider whether the picture you are composing might look more interesting if shot at night, such as a city street scene showing bright and colorful lights from stores and passing cars.

10.30. Always consider the time of the day when your subjects might be the most photogenic. For many landscape photographers, dawn and dusk are ideal times to capture the many moods of Mother Nature. The descending sun casts a shadow that reveals the ripples of windblown sand on this dune in Death Valley National Park in California.

STUDY THE LIGHTING

"Writing with light" is the literal meaning of the word "photography." And as all experienced photographers know, you should always study the lighting of your subject in order to make the most eye-catching pictures.

There are many types of lighting, and depending on your subject, one type may be better for a picture than the others.

DIFFUSED LIGHTING is also called SOFT LIGHTING and is the type of lighting you have on an overcast day. Its opposite is

10.31. There is no reason to put your camera away at night. Some subjects are especially photogenic after dark, including this illuminated church with its mirror image in a reflecting pool in Vienna, Austria.

DIRECTIONAL LIGHTING, which is sometimes referred to as HARSH LIGHTING, such as you have on a bright, sunny day.

When the sun is behind you and shining directly on your subject, it is called FRONT LIGHTING or FLAT LIGHTING. This uniform illumination produces good detail, but your subject will have a "flat" appearance because there are no shadows to give depth to the picture. Also, bright light shining directly into the eyes of a portrait subject often causes the person to squint.

By moving to the left or right of your subject, front lighting becomes SIDE LIGHTING. This creates shadows on your subject that add depth and often more interest to a photograph. Side lighting is effective for making impressive portraits. If the shadows appear too dark on one side of the face, you can add FILL LIGHT with a flash or a reflector to lighten them.

10.32. An overcast day gives diffused, shadowless lighting to your subjects, such as these rolls of hay and an abandoned barn on a farm in Arkansas.

10.33. Directional lighting, such as the strong sunshine from the right side of this picture, helps the famous Neuschwanstein Castle stand out in the German countryside.

10.34. Front lighting is often unflattering and can cause your subjects to squint, unless they put on sunglasses, as did this vacationer in New England. As evident here, a distracting shadow of the photographer frequently appears in such pictures. See the text for better lighting options when photographing people.

10.35. The shadows on the right side of the boy's face indicate that side lighting was used for this very informal portrait.

10.36. Watch out for strong side lighting from the sun that can cause unwanted shadows on the faces of your subjects. To combat that problem and make this pleasant portrait of a hula dancer in Hawaii, the photographer's assistant held a reflector to add fill light that softened shadows on the right side of the girl's face.

When the sun or other main source of light is behind your subject and shining toward the camera, it is called BACKLIGHT-ING. This is a good way to keep people from squinting if you are making portraits in bright sunshine. Be careful when making an exposure reading so that you don't read the backlight rather than the subject and cause an underexposure; use spot metering if possible (see pages 158–59).

Of course, if you want to create a SILHOUETTE of your subject, make an exposure reading of the backlight to purposely underexpose the picture.

When the sun is overhead and shining straight down, it is referred to as TOP LIGHTING. This is not flattering light for pictures of people because there will be dark shadows in their eye sockets and elsewhere. However, you can save the day by using a flash for FILL LIGHT to lighten the shadows (see page 72).

10.37. Because of backlighting, this Bedouin girl has a pleasant expression instead of squinting her eyes in the harsh sunlight of the Negev Desert in Israel. The camera was set for spot metering to prevent the bright backlight from underexposing her face.

10.38. When the light is falling toward the camera and backlighting your subjects, you can underexpose in order to create silhouettes. These beachgoers were playing in the surf just before sunset at Newport Beach, California.

10.39. If bright overhead sunlight causes deep shadows on the eyes your subjects, use the camera's built-in flash or an external flash unit for fill light. In addition to eliminating those shadows, flash added a sparkle to the eyes of this beach boy at a Tahitian resort on Bora-Bora.

LOOK FOR COLOR

Be on the lookout for colors that might improve your photographs. Unless you purposely want a moody picture, try to include colors that will brighten up subjects when the weather is gloomy. For example, a red umbrella could be a colorful focal point on a rainy day. See some examples in the color photo section that follows page 240.

BE IMAGINATIVE

Following our guidelines for composition will give you some ideas for making better pictures, but remember that *there are no rules in photography.* Creative photographers use their imagination and try new techniques.

Experimenting with your digital camera is much of the fun

10.40. What are a photographer's best tools? Your eyes and your imagination! Keep them open and alert for picture possibilities. Neither a camera filter nor computer manipulation was needed for this intriguing photo; it is simply the reflection of two old brick buildings in the wavy glass windows of a modern office tower across the street.

of making pictures. And because there is no film to buy, there is no extra expense—so you can shoot as much as you wish. You'll also enjoy all the options for being creative by using your computer's image-editing software to alter the original look of your photographs, as we describe in chapter 14.

Moving Your Digital Images from Camera to Computer

Shooting digital pictures seems to be the easy part for many photographers. More challenging is working in an effective and efficient manner with the electronic image files you've created with your camera. To ensure order instead of chaos, we recommend that you mimic the pros, who develop systematic procedures they refer to as the DIGITAL WORKFLOW.

In this chapter and the following six chapters, we describe the orderly steps to take when downloading, organizing, storing, editing, printing, and sharing your digital image files.

YOUR DIGITAL WORKFLOW BEGINS WITH DOWNLOADING IMAGES

After you've captured digital pictures with your camera, what's the next step? Most photographers copy the image files stored on the camera's memory card to a personal computer. This is referred to as DOWNLOADING, IMPORTING, or TRANSFERRING pictures. There are several methods for doing this.

The easiest and fastest way is to remove the memory card from your camera and insert it into a MEMORY CARD READER, which is sometimes called a MEDIA CARD READER. Card readers are often

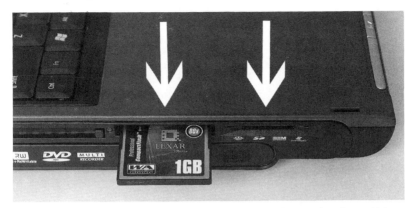

11.1. Many laptops and desktop computer towers feature built-in card readers, which offer fast and convenient downloading of pictures from your camera's memory card. The two slots (see arrows) on the side of this laptop accept five types of memory cards, including the CompactFlash (CF) card that is partially inserted.

built into laptop/notebook computers, the towers of desktop computers, and desktop photo printers. There are usually two to four slots that will accept different types of memory cards.

If your computer doesn't have built-in card readers, there are small accessory card readers that connect to the computer with a USB or FireWire cable. Two major makers of memory card readers are SanDisk and Lexar.

We recommend you buy a MULTI-CARD READER, especially if you have two or more cameras that use different types of memory cards or an SLR camera that accepts two different types of cards. Instead of a plug-in card reader, another option for laptop users is to insert a special card adapter or card reader into the computer's ExpressCard or PC Card slot.

The classic way to download images is to CONNECT A USB OR FIREWIRE CABLE between the camera and computer and transfer the files without removing the memory card from the camera. Some camera models come with a stand-alone CAMERA DOCK or CAMERA CRADLE that is connected to the computer through a USB cable.

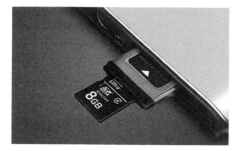

11.2. When a laptop computer does not have built-in slots for memory cards, you can buy a memory card adapter to fit into the computer's ExpressCard or PC Card slot.

You place the camera in its dock to download the images. These file-transfer methods are slower than using a memory card reader.

A quick and convenient option for downloading image files is to do so WIRELESSLY with radio signals or infrared light beams. However, both your camera and your computer must be equipped with built-in or external wireless transfer devices that use Wi-Fi, Bluetooth, or IrDA (infrared) technology to transmit and receive the image data without a connecting cable.

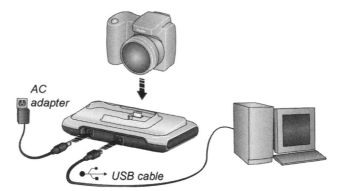

11.3. A common way to download pictures directly from your camera and its memory card is to plug one end of a USB cable into your camera or its camera dock (shown here) and the other end into your computer. To save your camera batteries, use an AC adapter (as this camera dock does) in order to provide power to the camera. (Illustration courtesy of Eastman Kodak Company.)

Don't be misled by terminology. When you "download," "import," or "transfer" image files from a memory card to your computer's hard drive, *the files are not removed from the card.* They remain on the memory card until you delete or erase those image files from the card. This is an important safety feature in case something goes wrong while the files are being electronically copied to your hard drive.

SELECTING A PROGRAM FOR DOWNLOADING IMAGES TO YOUR COMPUTER

Whatever method you use to download pictures to your computer, the process of transferring those image files requires computer software. This software is commonly an IMAGE-EDITING PROGRAM. In addition to importing image files from your camera and its memory card to your computer, image-editing programs enable you to organize, edit, print, and share your pictures.

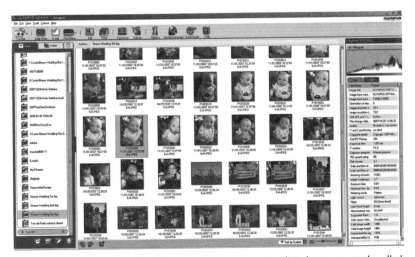

11.4. To enable you to download pictures to your computer, digital cameras are bundled with image-editing software designed for the specific camera brand, such as the Olympus Master program shown here. You also can use other free or purchased software programs to download pictures, as well as edit, print, and e-mail them.

You'll be happy to know that you can transfer digital images from your camera to your computer anytime you wish. There is no need to fill up the memory card before downloading its image files, whether one or one hundred or many more.

As we mentioned earlier, every camera manufacturer includes its own name-brand image-editing program on a CD that comes in the box with your camera. Some examples are Kodak Easy-Share, Olympus Master, and Canon ImageBrowser.

Also, there are many other image-editing programs available. Among our favorites are Google's PICASA, which you can download free from Google's Web site, and Adobe's popular PHOTOSHOP ELEMENTS.

In addition, two major operating systems—Microsoft's Windows Vista and Apple's Mac OS X—feature their own image-editing programs: Windows Live Photo Gallery and Apple's iPhoto.

Which image-editing program should you use for importing images to your computer? Any will do, but we suggest you get started by installing the image-editing software that is on the CD supplied with your camera.

TRANSFER OF DIGITAL IMAGE FILES TO YOUR COMPUTER VIA A USB OR FIREWIRE CABLE

If your computer or printer does not have built-in memory card readers, we suggest that, initially, you use the USB or FireWire (IEEE 1394) cable that was included in the box with your camera to download image files to your computer from the camera's memory card. Otherwise, you'll have to run out and buy a memory card reader in order to download the first pictures you

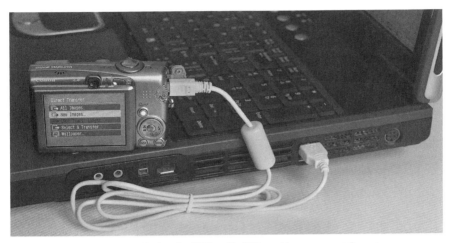

11.5. Every camera is supplied with a USB or FireWire cable to connect the camera directly with a computer to transfer image files from the memory card. An option is to remove the memory card from the camera and insert it into a card reader (see text beginning on page 269).

shoot. USB cables are most common; some SLR cameras use FireWire cables, and a few SLRs can use either type.

Begin by plugging the appropriate end of the cable directly into a USB or FireWire port on the computer. (To avoid hardware conflicts, do not plug the cable into a monitor, keyboard, hub, or an extension cable that is connected to the computer.) Then plug the other (smaller) end of the cable into the USB or FireWire port on the camera.

After your computer and camera are connected, turn on the camera. Check your camera's instruction manual to see if the camera must be set to its playback mode or if certain buttons must be pressed to activate the downloading procedure. An LED light on the camera usually starts blinking to indicate that downloading is in progress.

For the specific steps to take to transfer image files from your camera, carefully follow directions in your camera manual and/or

check the "Help" menus in your image-editing and operating system software for exact procedures. You may have several choices.

> Once you turn on the camera and press any appropriate camera buttons to begin importing the photos, keep your hands off the camera until its LED light stops blinking to indicate that the transfer of image files is complete. Also, to avoid accidentally corrupting the image files and ruining your pictures during their electronic transfer, do not run any other computer programs while downloading the image files to your computer.

In general, the images downloaded to your computer from your camera will first appear as thumbnail-size pictures on the monitor. You select all or some of those image files to save, and then copy, transfer, or import those files to a new folder or an existing folder on your computer's hard drive, as we describe in the following chapter. For reasons we soon explain on page 272, *do not check the box to automatically erase or delete the image files from the memory card after downloading.*

Be aware that it may take a while to transfer all the image files from your camera. The time required depends on the number

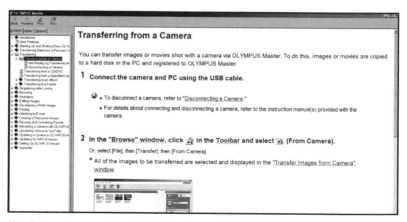

11.6. Be sure to consult the "Help" files in your particular image-editing program to find the steps for transferring images to your personal computer. Also read your camera manual for additional downloading directions.

of exposures you've made, the format of the image files (JPEG, TIFF, and/or Raw), and the processing speeds of the memory card and your computer.

We recommend that you use FRESH OR FRESHLY CHARGED BATTERIES or an AC ADAPTER to power the camera when downloading image files. That's because file data can be lost if the camera turns off for lack of power while the images are being transferred. For the same reason, check your camera instructions regarding its SLEEP MODE or POWER-SAVE MODE to make sure the camera will not suddenly shut down during downloading (see page 71).

TRANSFER OF DIGITAL IMAGE FILES TO YOUR COMPUTER WITH A CARD READER

Because a USB or FireWire connecting cable is supplied with your camera, it is convenient at first to use the cable to download

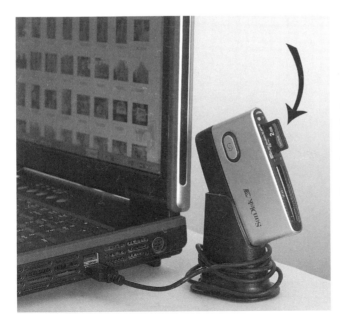

11.7. If your computer does not have a built-in card reader, you can buy an accessory reader that plugs into your computer. This multi-card reader has four slots that accept all types of memory cards, including Secure Digital (SD) cards (see arrow).

pictures directly from your camera to your computer. However, we recommend that you soon purchase a MEMORY CARD READER, because it can transfer pictures up to forty times faster than the camera-to-computer cable connection. Of course, this is unnecessary if your laptop computer, desktop computer tower, or desktop photo printer has built-in card readers.

If you purchase an accessory card reader that plugs into your computer, we repeat our earlier recommendation: buy a multi-card reader with several slots that accommodate different types of memory cards. If in the future you buy a digital camera that uses a different memory card than your current camera, that same multi-card reader can still be used to download your images.

Multi-card readers vary in the number of card formats they can handle; a few will read up to twenty-three different formats. (No wonder photographers wish there was just one standardized memory card for all cameras!) The basic formats are CF (Compact Flash), SD (Secure Digital), xD (xD-Picture Card), MS (Memory Stick), and MMC (MultiMediaCard). An early format, SM (SmartMedia), is no longer in general use.

Most card readers connect to a USB port on the computer. A few readers that are made exclusively for CompactFlash (CF) memory cards connect to a computer's FireWire port and allow quicker importing of image files.

By the way, accessory card readers are powered by the computers they are plugged into. Unlike cameras, they do not need power from batteries or an AC adapter in order to transfer image files from a memory card.

Be sure your camera is turned off before you remove a memory card. After it is removed, close the cover to the card slot to keep out dust. Handle the card carefully, and do not touch its metal contacts. Make certain you insert the card into the reader correctly; do not force it.

The specific steps for importing images from a memory card

11.8. A card reader connected to your computer will be indicated as one or more "removable disk" drives, which depends on the number of card slots the reader has. This computer drive menu shows four such disk drives (see arrows) that represent the multi-card reader in illustration 11.7. The drive highlighted by the darker box indicates that a memory card is in one of the card reader's four slots.

in a card reader will be found in the USER GUIDE that accompanies the card reader. Also, you can click **Help** in your image-editing program and operating system software for detailed downloading instructions.

When you connect an accessory card reader to your computer, the Windows, Macintosh, or other operating system will recognize the card reader as a "removable disk drive" and enable it to communicate with the computer. If you are using a multi-card reader with more than one slot, each slot will be indicated by a "removable disk drive" icon. The same is true for card readers built into computers or photo printers.

After you insert the camera's memory card into the appropriate slot, a blinking LED light on the reader will signal when the image files are downloading. Remember to insert and download only one card at a time.

Do not operate other computer programs until the card reader's LED stops blinking to indicate that the files have been transferred to the computer. Likewise, never remove the memory card from the card reader or unplug the reader from the computer until downloading is complete. If you fail to take these precautions, some image files may be corrupted, which means your pictures could be ruined during this electronic transfer process.

STEPS TO TAKE AFTER IMAGE FILES HAVE BEEN DOWNLOADED TO YOUR COMPUTER

As we mentioned earlier, image files are not removed from a memory card when they are downloaded, imported, or transferred to a computer's hard drive; they still remain on the card.

If the computer program asks whether you want the image files to be automatically erased or deleted from the memory card after downloading, *do not check that box*. Before eliminating any files from the card, first make certain all the files have been correctly transferred to the hard drive of your computer. If the images are not all there, or some appear corrupted because the electronic transfer was interrupted in some way, you will still have the image files on the memory card to import to your computer again.

Make your inspection by opening the file folder that holds the newly transferred pictures, and then review them either as a group of thumbnail photos or individually. To help you, most programs have a slider control so you can enlarge the size of the thumbnail pictures to see them in more detail. Also, you can double-click a thumbnail image with the computer mouse to make the photo fill much of the computer screen for even closer

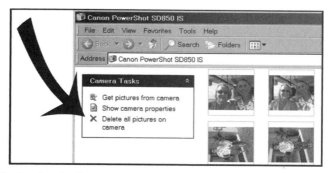

11.9. Whether downloading images to your computer from a memory card in your camera or in a card reader, *do not delete* the pictures from the card until you are certain they have been successfully transferred to the hard drive (see text).

viewing. Or review each picture in full-screen size by using the image-editing program's SLIDESHOW feature that displays every image in the folder, one after the other.

When you are certain that downloading has been completed successfully, you can UNPLUG THE CAMERA OR ACCESSORY CARD READER from the computer. However, pay attention to any instructions in the image-editing or operating system program for the proper procedure to follow when disconnecting a camera or card reader.

Once digital files are imported to your computer, we suggest that you immediately *delete all the bad pictures*. That includes out-of-focus images, accidentally blurred shots, and pictures with no meaning. Of course, the photos that remain may not be perfect, but you can improve them later with your image-editing software (see chapter 14).

By the way, pictures shot with your camera in a VERTICAL (PORTRAIT) FORMAT usually will appear as horizontal (landscape) images when downloaded. To return the images to their proper vertical orientation, you can click icons resembling curved arrows in order to ROTATE THE PICTURES clockwise or counterclockwise. Or wait until you organize the newly imported images, as described in the following chapter.

12

Organizing Your Digital Images So You Can Always Find Them

One of the most important things you can do is organize your digital image files. This will make it easy to find specific photos now and in the future. Even though your image files are usually kept in one place on your computer's hard drive, accessing them can be frustrating and time-consuming, unless they are organized.

Remember when you shot with a film camera and always seemed to be hunting in boxes or drawers for your negatives and slides? Avoid bad habits of the past by immediately organizing your electronic image files every time you download them from your camera to your computer. We consider this the most important step in your DIGITAL WORKFLOW.

CHOOSING A PROGRAM FOR FILE MANAGEMENT

Organizing your image files is formally known as FILE MAN-AGEMENT. Most photographers do this with an IMAGE-EDITING PROGRAM, which they also use to download, enhance, print, and share their pictures.

In the previous chapter about downloading images, we suggested that you initially use the image-editing software that

came on a CD in the box with your camera. However, we think you should try out other image-editing programs as well, because you may find one that is better suited for organizing your photos.

Start by searching the Internet for free image-editing software that you can install directly to your computer. Considered one of the best programs is Google's PICASA, which can be downloaded without charge by logging on to www.picasa .google.com. It currently is available for Windows Vista and XP users and for Mac computers with an OS X 10.4.9 or later operating system and Intel CPU (central processing unit).

Another basic program you might try is Adobe Photoshop Album Starter Edition, which you can download free at www .adobe.com/products/photoshop/family. In fact, as we mentioned earlier, the world's best-known image-editing program is ADOBE

12.1. Organizing your image files is essential, especially because you'll continue to shoot digital pictures year after year and save many of them on your computer's hard drive. Try a variety of image-editing programs to find the one you like best for keeping track of your photo files. In addition to the proprietary software that is supplied with your camera, free programs can be downloaded from the Internet, such as the Adobe Photoshop Album Starter Edition shown here.

PHOTOSHOP, which also can be purchased in a professional version known as CS (Creative Suite), as well as a baby-brother version named Elements that is popular with many amateur photographers. Adobe regularly upgrades these programs and gives them ascending version numbers, such as CS 4 and Elements 7.

Both Adobe image-editing programs include a stand-alone organizing feature, which is called Bridge in Photoshop CS, and Organizer in Photoshop Elements. For pros who shoot a great number of images, Adobe also has created a photo file management program called Lightroom; Apple has a competitive product called Aperture.

However, casual photographers will find there is no reason to invest in such software. That's because the Microsoft Windows or Apple Macintosh (Mac) operating system that probably runs your computer can be used to organize your image files. After all, your digital photos are just like all the other data files—a

12.2. Your computer's operating system, such as Microsoft Windows and Apple Mac OS, can be used to organize your digital image files. Shown here is Windows XP, in which downloaded images appear in a preestablished documents folder called "My Pictures." It holds alphabetized subfolders that you create with appropriate names to identify the images you put in them. Here those subfolders are displayed as "thumbnails," but you could choose to view them in an alphabetical "list."

series of zeros and ones—that are stored in folders and subfolders on your computer.

The most important step in organizing image files is to just *do it!* And do it now. Take the time to organize the photos already on your computer's hard drive, then it will be easy to continue to do so every time you download new images from your camera. (If you're too busy at the moment to deal with a backlog of pictures, at least start by organizing your next download of images.)

ORGANIZING YOUR DIGITAL PHOTOS IN FOLDERS

All image-editing programs will organize your digital image files, but not in the same manner or under the same headings. For example, the images may be organized under different headings, such as Folders, Albums, Collections, Groups, Events, People, Places, Categories, Tags, Keywords, or "Star" ratings.

Keep this in mind: FOLDERS are the basis for organizing all computer data files, including your image files.

When you open an image-editing program, the files often appear in what's called a "library" or "gallery." Usually you'll see a list of folders with the names of the image files they contain, and/or thumbnail photos of those images.

Some programs initially organize image files by the date they were shot or downloaded to the computer. Often you can view thumbnails of the images by clicking a heading called "timeline" or "calendar" and then selecting a certain year, month, and day, or a folder name.

> Whatever image-editing program you use, our advice is to start with its "Help" feature to find specific directions and tutorials for organizing your image files.

12.3. Like all computer files, image files are kept in folders that you name. When you open an image-editing program, such as Olympus Master shown here, you can access a list of the folders that hold your pictures (see left panel). After clicking a specific folder with your computer's cursor (see arrow), the folder opens to show thumbnail pictures (as here) or a list of the image files that the folder holds.

The way to organize image files is rather simple: you put them in FOLDERS and SUBFOLDERS. All of these folders are kept in a *master folder* that your computer's operating system has pre-established for photos. That folder is named "Pictures" in Windows Vista, "My Pictures" in Windows XP, and "Pictures" in Mac OS X.

Start organizing your digital photos by thinking hard about what subjects you most often photograph, and what would be the most logical way to locate those images in the future. Then create new folders with main headings, and subfolders with appropriate categories under them.

Let's say you are among the photographers who like to organize their pictures by EVENTS. You make new folders and name them Vacations, Holidays, Birthdays, School Sports, etc.

Under Vacations you might add subfolders labeled with destinations you visited, like Washington, D.C., Paris, etc. Or there might be broader vacation categories, like Europe and Asia, or times of the year, like Christmas and Summer. Those subfolders could have their own subfolders, such as Vacations > Europe > Italy or Vacations > Summer > Disneyland.

A Holidays folder also should have subfolders, such as Fourth of July, Thanksgiving, Christmas, and include the year of the event. A Birthdays folder might have subfolders with the names of each family member (such as Judy, Bill, Laura) along with the person's age or the year of celebration. A School Sports folder could have subfolders named for the sport (such as Soccer or Basketball), or they could be named for the family participant (such as Kathy or Rick).

Another option is to organize some of your pictures under a main FAMILY or PEOPLE folder, with subfolders named for each family member. Then under each person's name you create more subfolders with various categories, such as Birthdays, Graduation, Wedding, etc.

12.4. Find your image files easily by organizing them in many folders and subfolders. In this example, if you want to see the pictures of where and what you ate on a trip to Zurich, go down the folder "tree" by first clicking Travels, then Europe, then Switzerland, then Zurich, and finally Restaurants-Food (see arrow).

Some photographers prefer to keep track of their pictures by the DATES they were shot. They make a folder for each year and then subfolders for each month. However, we find a date-based cataloging system very frustrating when trying to find specific pictures. We prefer to add the shooting date to the names of the folders or the image files themselves, as described below.

Remember, you can always rename the folders and subfolders if you ever decide to change your system of organization.

NAMING YOUR IMAGE FILES WITH CARE

We must stress that you should carefully rename each image file to help identify it. That's because your camera generates the original FILE NAME, which is just letters and numbers, such as *P6160019.jpg* or *DSCF0212.jpg*. These names obviously give no clue as to the picture's subject. (After the period in the file name is the three-letter file extension that indicates the image file format, such as .jpg for JPEG and .tif for TIFF.)

By convention, the last four numbers indicate the ascending order in which the exposure was made and recorded to the camera's memory card. This is called the FILE NUMBER or FRAME NUMBER. When you set your camera's file numbering system to "continuous," the numbering automatically begins at 0001 with the very first picture you take with your camera and continues to 9999, when the file numbers will start over at 0001.

When renaming a file to help you identify the image, keep it brief but descriptive and include the file or frame number, such as *08MarysBirthday0019.jpg*. Fortunately, for images that you want to give the same name, such as *08MarysBirthday*, most organizing programs allow them all to be renamed at the same time as a "batch."

The original file number of the image recorded on the memory card usually can be carried over to the new file name, as in the

12.5. Many image-editing programs, like Canon's ZoomBrowser shown here, make it easy to rename image files individually or in a batch. After selecting the pictures you want to rename by changing the camera's original letter-and-number file names, type the new file name and indicate how to renumber the images in the order displayed. The original three-letter extension that designates the file format, such as .jpg, will be added automatically to the new name.

previous example. If not, a new series of consecutive file numbers can be automatically assigned to each image in the group.

These file numbers that follow the name enable you to identify a specific file, especially if there are several shots with the same name that look very similar. Also, as you note above, we like to precede each file name with the year the picture was shot, such as 08 or 09.

We do not include the month or day in the file name, unless we expect to photograph the same subject several times in the same year or the date is especially important.

For example, if we were doing a series of shots of the Golden Gate Bridge over several months, we would add two digits for the month, such as *0902GoldenGateBridge0136.jpg* for February 2009. And we would add two more digits for the day if we shot the bridge on different days in the same month, such as *090212GoldenGateBridge0152.jpg* for February 12, 2009.

There is a reason we usually don't include a specific date in the file name. That's because the exact date and time you made the exposure is recorded by your camera and embedded in the image file as METADATA. More specifically, it is called EXIF (EXCHANGE-ABLE IMAGE FILE FORMAT) DATA. You can view that information (and more) by clicking **EXIF Data**, **Properties**, **File Info**, **Details**, or another appropriate menu tab in your image-editing program when viewing any image file (see page 283).

When giving names to image files, you should try to follow some FILE-NAMING CONVENTIONS, which are part of the Universal Photographic Digital Imaging Guidelines (UPDIG). These file-naming "rules" were created to make sure that your image files can be accessed without problems when using current and future computer operating systems.

Specifically, you should limit the characters you use in file names to the alphabet from A to Z (both caps and lowercase), the numbers 0 to 9, the underscore (_), the hyphen (-), and

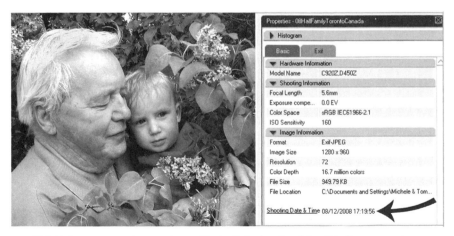

12.6. Unless you organize your image files by their shooting dates, it isn't necessary to include the date in the file name. That's because your camera automatically embeds the shooting date and time in the image file as metadata (see arrow), which can be viewed with your operating system or image-editing software.

one period (.). The period should *only* be used between the main file name and its three-letter file format extension, such as *08MarysBirthday0019.jpg*.

Avoid all other punctuation and symbols because some of them are part of the commands used by various operating systems, and they can create confusion and errors when included in image file names.

Also, *do not include blank spaces in file names* because they can cause problems when putting image files on the Web to share or show off your photography. Instead, we use a capital letter to delineate each word in the name, such as *GoldenGateBridge*.

Finally, keep the full file name to thirty-one characters or less, including the three-letter extension. For additional guidelines and more details, log on to www.updig.org.

ADDING METADATA TO HELP FIND YOUR PHOTOS

When organizing your image files by creating folders and subfolders and renaming the files, it is very helpful to add META-DATA. This is information you enter with your computer and is embedded in the image file to identify its content and help you locate the picture anytime in the future.

Windows for entering and viewing metadata will appear in your image-editing program when an image file is displayed and you click **Properties**, **File Info**, **Details**, or another appropriate menu tab. Some programs utilize common metadata formats known as IPTC DATA, developed by the International Press Telecommunications Council, and/or XMP DATA, the Extensible Metadata Platform developed by Adobe.

You can begin by typing a CAPTION or TITLE or DESCRIPTION of the picture. Then list general or specific KEYWORDS to identify noteworthy elements or aspects of the photo, such as "Butchart Gardens," "flowers," and "roses." Later, whenever you enter any

of those words in the "search" feature of your image-editing program, the picture (as well as other photos identified by the same words) will appear on your computer screen.

In addition to using keywords, some image-editing programs offer additional ways to TAG IMAGES so certain ones are easy to find. For instance, you might be able to use a STAR RATING to group images and mark your favorite photos with one to five stars. (Note, however, that those stars may not be recognized by other image-editing programs or by future versions of the same program you are currently using.)

If you expect to post your pictures on the Internet, there is other important metadata to add to those image files: your

12.7. Star ratings (see arrow) are among the ways you can tag your images in order to quickly find them with your image-editing program. Shown here is Photoshop Elements, which lets you assign one to five stars to any image. Use the stars to categorize your pictures (e.g., five stars = Family and Friends, four stars = Scenics, three stars = Events), or to rate their quality (five stars = Very Best, etc.), or indicate how you've used the images (e.g., one star = Prints, two stars = E-mail, three stars = Web site, four stars = Blog).

name, address, phone number, and other contact information. This will identify you as the photographer, as well as the owner of the image and its copyright.

As mentioned earlier, other metadata called EXIF or CAMERA DATA is automatically written to each image file. These are the camera settings used for the exposure and related details about the image that are recorded to the file when you press the shutter release. Included in the list are the file name, file size, image size (resolution), camera make and model, date and time the shot was made, focal length of lens used, if flash was fired or not, and the settings used for shutter speed, aperture, ISO, white balance, exposure mode, metering mode, and often much more information.

12.8. Camera data, also known as EXIF data, is embedded in each image file by your camera when you make an exposure (see text). This useful information about the exposure, including the f/stop and shutter speed, can be viewed by clicking menu listings called "Properties," "File Info," "Details," or the like. You may also find EXIF data by placing your computer's cursor on a thumbnail of the image in your image-editing program, as shown here with Olympus Master.

The information in this useful list serves as your personal SHOOTER'S NOTEBOOK for every picture you make. It is a convenient way to check why an image looks good (or bad) to you. Was the nice sparkle in your subject's eyes because the flash was used? Is the action blurred because the shutter speed was too slow? Is everything sharp from foreground to background because a small lens opening (f/stop) was used? Just check the EXIF information and you'll know.

The challenge for every photographer is to develop a personal file management system for your photos that you'll utilize whenever you add new images to your computer. Most of all, get in the habit of writing personal and picture metadata to your image files, which can be done rather quickly on a batch basis for similar pictures. You and your family will be glad you did, especially years later when your image files are opened and no one has to wonder who shot the picture, when or where it was taken, or what the photo is all about.

13

Preserving (Archiving) Your Digital Images for the Future

Thanks to the age of digital imaging, more people are shooting more pictures these days. However, they are making fewer prints to keep or share. In the almost-bygone era of photographic film, there were prints or slides to look at and keep in photo albums and slide trays, or in the proverbial shoe box. Today's pictures are just digital files and most often are viewed on the screens of computers and cell phones.

Unfortunately, the pictures you record electronically may suddenly disappear or be destroyed forever. If you only store them on your computer's hard drive, which is always susceptible to a "crash," your digital photos can be permanently erased. Or they can be destroyed in a few seconds by an electrical power surge or a lightning strike. They also can be ruined by physical calamities, as on an unfortunate day when you accidentally drop and break your laptop, or it is stolen.

For the long-term security of your images, especially to preserve memories for family and friends, your important digital images should be carefully ARCHIVED. Do this by copying your pictures digitally to an EXTERNAL HARD DRIVE, DVDS, or CDS, or an ONLINE BACKUP DATA STORAGE SERVICE.

Actually, the digital images you especially treasure should

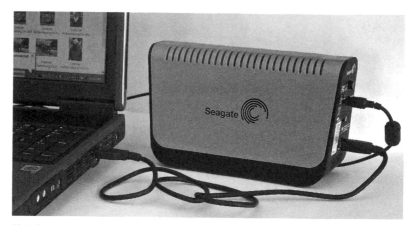

13.1. Connecting an external hard drive to your computer is a smart and convenient way to back up your valued image files. The model shown here holds 160 gigabytes (GB) of data and is much easier to handle than dozens of backup CDs or DVDs with an equivalent amount of photo files.

be copied *twice* for extra safety. You might archive them on an external hard drive, which makes a magnetic recording, as well as on DVDs or CDs, which preserve your pictures as optical recordings. Or you might copy them to two external hard drives. For the most security, back up your prized photo files on an external hard drive and also with an Internet backup data storage service.

> After you make the initial backup of all your existing photo files, get into the habit of backing up new files every time you download them to your computer.

Microsoft's Windows and Apple's Macintosh computer operating systems have BACKUP UTILITIES that can duplicate your image files and then restore them in case of accidental loss of the files on your hard drive. You choose a destination drive for the backup copies, such as a second hard drive in your computer, an

13.2. For peace of mind, you can back up your image files by using the "backup" utility of your computer's operating system, such as Microsoft Windows (shown here). You can do this manually at any time or automatically on a schedule you preset (see text).

external hard drive, or a disk drive in your computer in which you've placed a blank DVD or CD for recording.

An option is to set up a schedule that automatically backs up your most recent image files; you can set the frequency and time of day for your computer to perform the backup action. To back up files manually whenever you wish, simply "copy" them to the destination drive you choose. Consult your computer's "Help" menu for the specific steps to take to back up image files.

Archiving is worth the extra time and financial investment, if only for your peace of mind. If you are not already making copies of your photos for future generations to enjoy, start right now. Begin by organizing and backing up all the keepsake image files already on your computer, then make it a habit to back up new image files every time you download them from your camera.

BACKING UP YOUR DIGITAL PHOTO FILES
ON AN EXTERNAL HARD DRIVE

Rather than using a pile of CDs or DVDs to archive your photo files, we recommend you copy them to an EXTERNAL HARD

DRIVE, which is a self-contained device about the size of a hard-cover book. Not only is it easier and quicker to back up files on an external hard drive, it can hold many more image files in a smaller space.

For comparison, let's say you have an external hard drive that holds 500 GB (gigabytes) of data. Because a DVD typically holds 4.7 GB and a CD holds only 700 MB (megabytes), it would take about 106 DVDs or 714 CDs to store the same amount of image file data as on the 500 GB hard drive.

Transporting an external hard drive with those files is more convenient, too. If there was ever a fire or other disaster, you only have to grab the hard drive instead of big boxes of DVDs or CDs as you escape from your home or office.

External hard drives are self-standing devices with a wide choice of capacities: 80, 120, 160, 200, 250, 300, 320, 400, 500, 640, 650, and 750 GB (gigabytes) and 1, 1.5, and 2 TB (terabytes). Note: 1,024 GB equals 1 TB. As an indication of their cost, you can buy a 500 GB external hard drive for about $125. In general, the greater the drive's capacity, the more you'll pay.

Remember to buy for the future; it doesn't take much time

13.3. External hard drives are available in a variety of brands and physical sizes, as shown here. However, the most important consideration when buying an external drive for backing up your image files and other data is its capacity, which can vary from 80 gigabytes to 2 terabytes (see text).

to build up a big library of digital images. The number of digital pictures you shoot and the megabyte (MB) size of each image file determine the external hard drive capacity you'll need to keep backing up all your photos in the years to come. For a guideline, a 500 GB drive will hold about one hundred thousand pictures shot with a 5 or 6 MP (megapixel) camera.

Major manufacturers of external hard drives include Iomega, Western Digital, Maxtor, Seagate, LaCie, and CMS. Each company provides simple directions for connecting its drives to your computer.

Every external hard drive requires electrical power to operate, and a power supply cord is supplied with the device. Before you plug it in and turn on the hard drive, you must connect a cable between the drive and your computer. Make sure your computer has the proper connection port for the type(s) of cable supplied with the drive: USB, FireWire, and/or eSATA (External Serial Advanced Technology Attachment).

Once you properly connect an external hard drive and turn it on, the Windows or Mac operating system on your computer should automatically recognize it as a new disk drive, which is

13.4. When you connect an external hard drive to your computer, it will be recognized by your computer's operating system as a new disk drive, such as (G:), shown here for a Western Digital (WD) My Book external hard drive.

indicated by the external drive's brand name and/or an icon and a letter, such as (F:).

You can copy all the files just as they came from the camera's memory card, but it is more sensible to first review the photos and delete all blurred, out-of-focus, and other unwanted images. Then immediately organize them into appropriate folders, as described in the previous chapter (see page 277).

> We remind you once again: DO NOT WAIT. Get into the habit of backing up your pictures to an external hard drive as soon as you have downloaded them from the camera's memory card to your computer, deleted any bad images, and organized the remaining photo files into folders.

BACKING UP YOUR DIGITAL PHOTO FILES ON DVDS OR CDS

Before external hard drives became popular and less expensive to purchase, most photographers backed up their image files on optical discs, first on CDS (compact discs) and then on the next generation medium, DVDS (digital video/versatile discs). DVDs and CDs are still used to archive digital pictures today, but their drawbacks for long-term image storage are noted on the following few pages.

Most importantly, the life span of these plastic discs is unknown. Also, they must be handled carefully and stored properly to ensure the longest life. In addition, it can take a significant amount of time and effort to copy files to the discs and then catalog and physically store them.

If you do archive your digital photos on DVDs or CDs, here's some advice. First, *only buy quality discs to archive image files.* The more expensive discs are usually better made than bargain-priced discs, which means they—and the backup files you record on them—will last longer.

13.5. Take care when handling CDs and DVDs that hold backup copies of your image files. Always hold the discs by their edges, *not* by their surfaces as shown here.

Above all, use brand-name discs, not those with generic or store labels. Most DVDs and CDs are manufactured in Asia; look for discs made in Japan, where the quality control is considered better than in the other countries.

These high-tech discs are composed of thin layers of polycarbonate plastic, recording dye, and reflective silver or gold. On CDs there is also protective lacquer to resist scratching. When you "burn" a DVD or CD, digital data is recorded in the dye layer by a laser beam. It follows a groove (track) that spirals out from the inside hub to the outer edge of the disc.

The consensus of scientists is that discs with a gold reflective layer have a much greater life span than those with a silver reflective layer because gold is not susceptible to oxidation that can damage discs.

Keep in mind that claims of how many years a disc will last are determined solely by its maker; there are no industry standards for the longevity of a DVD or CD. You'll find a few DVD brands boasting a life span of one hundred years or more. In reality, the data on discs may last a few years or several decades. This depends not only on the quality of the discs but how carefully you handle and store them.

Recordable DVDs and CDs can be permanently damaged by prolonged exposure to light, high humidity, extremes of heat and cold, and by scratches or other physical abuse. Even air pollution can cause oxidation and thus damage to their reflective metal layers (except gold).

To extend the lifetime of discs and the digital image files you record on them, store the discs vertically and individually in opaque polypropylene plastic cases specifically designed for DVDs or CDs. Do not keep them in paper or plastic sleeves or album pages. Also, avoid stacking recorded discs together on the spindle in a so-called cakebox that's used for packaging blank discs in bulk.

Many people manhandle commercial CDs and DVDs with prerecorded music and movies, but the blank data DVDs or CDs on which you archive your digital pictures should be treated with more respect. Before and after recording images on them, hold the discs by their edges, not their surfaces. Blow away dust

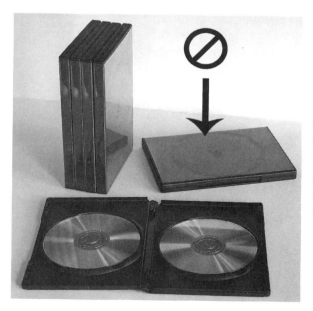

13.6. A safe way to protect CDs and DVDs with backup copies of your photos is in opaque polypropylene plastic cases like those shown here, which hold two discs. Store the cases upright; do not lay them flat.

with a can of compressed air rather than wiping off the surfaces. If you do wipe the disc, use a microfiber cleaning cloth (see page 107) and wipe from the center hub to the outer edges rather than in a circular motion around the disc.

Avoid using self-adhesive labels on DVDs and CDs. Such labels can come loose over time and foul up a computer's disk drive when you try to access your digital files. In addition, the adhesive itself may eventually have a detrimental effect on the disc's layers and ruin your images.

The safest way to label discs is with a felt-tipped pen specially made to mark on DVDs and CDs with ink that will not harm their layers of dye and reflective silver or gold. To avoid any problems, write only in the small clear area around the hub.

Keep the writing on a disc to a minimum. Mark the date when you completely filled the disc. Also, give it a consecutive number to help keep all your backup discs in order.

13.7. If you "burn" your photo files onto CDs or DVDs for long-term storage, do not write on those discs with anything other than the special felt-tipped pens designed for that purpose, like the Memorex pen shown here. These pens use nontoxic water-based inks instead of the smelly solvent-based inks common in regular felt-tipped pens. When you write, restrict yourself to a few words in the clear area at the disc's hub.

We suggest you keep an ongoing ARCHIVE DIRECTORY, where you list each disc by number and write down the names of folders on each disc to identify its contents. For a visual record, you can print CONTACT SHEETS with thumbnail photos of all the images on each disc (see page 366).

When buying blank discs for your photo archives, choose those labeled with an R (for "recordable"): CD–R, DVD–R, or DVD+R. Do not use those labeled with RW (for "read/write"): CD–RW, DVD–RW, or DVD+RW. That's because the data on RW discs can be overwritten, which means the image files you've archived might be accidentally erased or replaced by other files.

Be aware that DVD– and DVD+ are competing technologies, so make certain the DVD discs you buy are compatible with the disk drive in your computer. Fortunately, many modern drives are MULTI-DISK DRIVES that allow you to write (record) and read both types of DVDs (– and +), as well as CDs. If your computer only has a CD drive, you can buy an external DVD or multi-disk drive with a connecting cable that plugs into USB and/or FireWire ports on your computer.

Disc package labels feature several important numbers, including the DISC CAPACITY, which is usually 4.7 GB (gigabytes) for a DVD and 700 MB (megabytes) for a CD. Obviously a DVD is a better choice for archiving images because it would require about seven CDs to hold the same amount of data.

You'll note that some DVDs are described as "double sided" and/or "double layered." This indicates that they have two to four recording layers that increase their capacity to 8.5, 9.4, or 17 GB. However, to ensure the archival quality of your photos, we recommend using only the more standard DVDs, which are single sided and single layered, with a capacity of 4.7 GB.

Disc package labels show another number, such as 24x for

13.8. If you back up your image files to discs instead of an external hard drive, make sure any new computer you buy has a disk drive that will record DVDs. That's because a DVD will hold many more pictures than a CD, which means you'll use fewer discs and need less space to store them.

DVDs and 52x for CDs, to indicate the fastest RECORDING SPEED at which the disc can record data. In reality, the maximum recording speeds shown on disc package labels are not important. That's because *you should record at a slow—not fast—speed* to avoid any errors during the recording session that might corrupt the image files being written to the disc.

Experts suggest setting your disk drive's WRITE SPEED to only 4x when recording image files to a DVD. This means that 5.4 MB of data per second are "burned" to the disc, which will take about fourteen minutes to fill to its 4.7 GB capacity. (The full range of write speeds is 1x, 2x, 4x, 8x, 16x, 24x, 32x, 40x, 48x, and 52x, but most disk drives and disc recording programs do not offer all of these choices.)

Your computer's recording software and disk drive hardware may also incorporate DEFECT MANAGEMENT and DATA VERIFI-CATION PROCEDURES that require additional minutes to ensure

13.9. If you back up your image files on discs, make sure they have R (for "recordable") on the label. Those labeled RW (for "read/write") can be overwritten, which means your photo files may be accidentally replaced by other data. Unless your computer has a multi-disk drive, also check whether you must use DVD+ or DVD– discs. The label also will tell you the disc capacity (GB or MB) and write speed (x); disregard the number of minutes, which is for audio recordings.

that the copies of your images are free of errors. Remember that these are precious pictures you want to preserve, so it is worth the extra time. Also, it is always better to err on the side of caution rather than convenience, so do not run any other programs on your computer while copying image files from a hard drive to a DVD or CD.

And do not forget to open the files on the DVD or CD after you record them to make certain the photos are copied correctly and have not been corrupted in some manner. You want to discover any errors now, and not to find weeks or months or years later that some image files are missing or cannot be opened.

(By the way, another number you'll see on disc packaging is unrelated to archiving image files; that number indicates the maximum amount of audio playback time: 120 minutes for DVDs and 80 minutes for CDs.)

To copy image files to a DVD or CD, you must first become

familiar with your computer's DISK DRIVE(S) and DISC RECORDING SOFTWARE. Windows and Mac operating systems both include programs to write data files to DVDs and CDs, and usually you'll find a second disc recording software program installed on your computer. If you don't like using either one, additional BURNING SOFTWARE, as it is commonly known, can be downloaded from the Internet, usually with a free trial period so you can check how well it works for you.

Whatever program you choose for copying your image files to discs, be sure to set the RECORDING SPEED OF THE DRIVE, such as 4x for a DVD; do not use a default speed setting that says "fastest" or "maximum." Also enable the program's DATA VERIFICATION FEATURE that checks whether your image files have been written correctly to a disc.

Although DVD–Rs, DVD+Rs, and CD-Rs are known as "write-once" discs, you should enable the recording program's

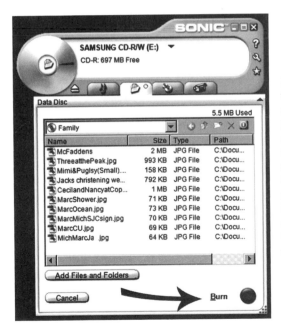

13.10. Become familiar with your computer's disc recording software, like the program shown here. After making three important settings (see text), drag-and-drop your chosen image files and folders to the program, then click Burn (see arrow) or a similar command to start recording the photos onto a CD or DVD.

setting that allows MULTIPLE RECORDING SESSIONS ON THE SAME DISC. That way you can copy image files at different times until the disc has reached its capacity. Otherwise, you are limited to a single recording session regardless of the amount of data copied to the disc, and that can be a great waste of disc space.

Whenever you put a disc in your computer's disk drive and open the recording program, the total FREE SPACE on the disc should be shown. With a blank disc, this may be a bit more or less than the 4.7 GB (DVD) or 700 MB (CD) capacities indicated on the disc packaging.

To copy image files from your computer's hard drive onto a disc, generally you drag-and-drop those files (or the folders holding them) into a window of the recording program. When you do this, the size of each file (or folder) is subtracted from the free space to indicate how much room remains on the disc.

If your image files in the folders exceed the disc's capacity, you'll be instructed to remove some of the folders or their files from the window before starting the recording session. Some programs allow you to exceed a disc's capacity and then insert a second disc into the disk drive to record all of the remaining folders and image files you've dragged to the window.

BE EXTRA SAFE: STORE A SET OF YOUR BACKUP PHOTO FILES OFF-SITE

Okay, you've made backup files of your digital photo files and stored them on an external hard drive and/or DVDs or CDs. Where do you keep those copies? Most probably at home. But what happens if there is a fire, flood, earthquake, hurricane, or other natural or man-made disaster? Will your photos be ruined and gone forever?

You can add another layer of protection to your valued digital pictures by storing an additional set of images on an external hard

drive or discs that are kept in a sanctuary away from home, such as your place of employment or the house of a family member or close friend. However, there are some drawbacks to this idea. You must invest more money, time, and trouble to make, transport, and then regularly update the off-site copy of your pictures.

A more convenient solution is to transmit your keepsake digital images via the Internet to an ONLINE BACKUP DATA STORAGE SERVICE. As long as the company remains in business, your images will be safe and always accessible.

A number of online storage services have emerged in recent years to handle the growing demands of individuals and small businesses for off-site data backup. Make a search on the Internet for "digital pictures storage services" or "backup services" to find one that best fits your needs. For a sample, log on to www.carbonite.com, click on "How It Works," and view the brief tutorial. Also, check out www.mozy.com.

You download the storage service's software to your computer, with instructions on how to designate the folders and files you want to back up and how and when to send them via the Internet to the service's Web site.

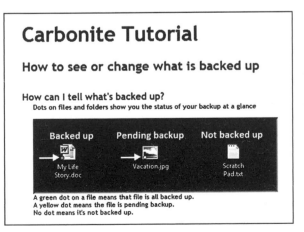

Carbonite Tutorial

How to see or change what is backed up

How can I tell what's backed up?
Dots on files and folders show you the status of your backup at a glance

Backed up	Pending backup	Not backed up
My Life Story.doc	Vacation.jpg	Scratch Pad.txt

A green dot on a file means that file is all backed up.
A yellow dot means the file is pending backup.
No dot means it's not backed up.

13.11. Get extra protection for your precious pictures by using an online backup service that stores data from your computer. Search Web sites, such as www.carbonite.com shown here, for details about saving your digital images files off-site.

Also given are the steps you need to take to RESTORE (copy back) those digital images to your hard drive, if, for example, some photo files have been accidentally erased from your computer or it has crashed and all your data has been lost. (Backup services usually make two or more copies of your image, so if one of its storage drives fails, your pictures will still be safe.)

If your image files are large in size and number, it can take considerable time—even days—to upload all your photos to the storage service's Web site. Some services' software allows the data transmission to be done "in the background" so you can use your computer for other tasks while the files are being uploaded.

After the initial upload of your images, new photos can be uploaded on a random or scheduled basis as you shoot them. Using online storage services is more efficient when you have a high-speed connection to the Internet, especially if you need to download some of the stored image files back to your computer.

Many storage services offer a free trial period, then charge a monthly or annual fee. This often is based on a certain gigabyte (GB) amount of storage space reserved for your files. A few companies, like Carbonite and Mozy, offer *unlimited* backup storage for a fixed price. If the long-term cost of preserving images online is a consideration for your budget, you may want to store only your most cherished pictures.

You'll read about ONLINE PHOTO SERVICES in chapter 16 and also about PHOTO-SHARING WEB SITES in chapter 17, both of which offer storage for digital photo files on the Internet. However, file storage is secondary to their primary business of making prints and personal gift items featuring photos from your image files.

Many of those Web sites offer free storage of your photo files. Others charge an account or membership fee, and there may be a limit to the storage space: a maximum number of mega-

bytes or gigabytes or photos you are allowed to store. Also, be aware that your files may be deleted if you do not log in to your account or order prints or other photo products within a certain time period.

If archival storage is your goal, avoid any online photo service or photo-sharing Web site that does not promise to keep all your image files stored forever—or at least for as long as you pay a monthly or annual fee for a specific or an unlimited amount of storage space.

> Don't forget that there is a low-tech way to preserve your most special digital images: print them, and then safely store those prints. If your original image files are somehow destroyed, you can always scan those keepsake prints and have new digital image files to work with. Read about printing and long-term preservation of digital photo prints in chapter 15. Ways to scan photo prints, film negatives, and slides are discussed in chapter 18.

BE WISE: RECOPY YOUR IMAGES TO THE NEXT GENERATION OF ARCHIVAL STORAGE

Whenever the next generation of storage media supersedes the devices and backup techniques in current use, it is important to remember to RECOPY YOUR PHOTO IMAGE FILES. For instance, with the ongoing innovations in computer technology, you can almost bet that CDs and DVDs will fall by the wayside in the future. Just think about FLOPPY DISKS, the once popular storage medium that has been phased out and probably will disappear entirely, along with the computer drives required for recording and playing floppy disks.

So keep in mind that the photos you've backed up on DVDs or CDs may not always be accessible from those discs. When the next high-tech advancement for storing data files comes into

vogue, be sure to use it to recopy and keep all the files you want to last your lifetime and even longer.

CONVERT YOUR CAMERA'S RAW IMAGES TO THE DIGITAL NEGATIVE (DNG) FORMAT NOW

If you shoot Raw images with your digital camera, a concern about future access to those files is more immediate. As explained earlier (see page 131), many camera manufacturers have created their own software programs that are required to process their respective Raw files. This can lead to trouble in the future if that proprietary software is no longer supported by the camera maker and you are unable to open your Raw files with current image-editing programs. Fortunately, there is a way to avoid the trouble and trauma that might cause.

To preserve your Raw image files so they will be readable anytime in the future, convert them to a NONPROPRIETARY RAW FORMAT, DNG, which is an abbreviation for DIGITAL NEGATIVE. It was developed by Adobe, creator of Photoshop, the world's most popular image-editing software. Because of the confusion and technical conflicts caused by dozens of different Raw formats, Adobe decided there should be a universal Raw file format that could be easily opened and read by Photoshop and other image-editing software programs.

When a Raw file from your camera is converted and saved in the DNG format (with the file extension .dng), also preserved is the CAMERA METADATA (EXIF) that notes the date and time the picture was made and the settings you used (see page 285). In addition, you have the option of embedding (preserving) the camera's original proprietary raw data in the same DNG file.

Log on to www.adobe.com for more information and free downloads of Adobe's DNG CONVERTER and CAMERA RAW applications, which are available for Windows and Macintosh operat-

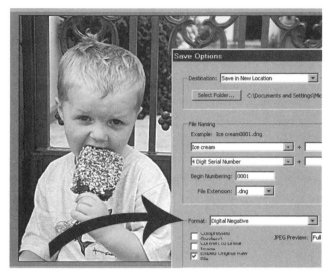

13.12. If you shoot in a Raw file format, the image files usually are proprietary; that is, in a format peculiar to your camera's manufacturer. To make certain you can access those files anytime in the future, save them in the Digital Negative (DNG) format, which can also embed the original Raw file (see text).

ing systems. Always check the Adobe Web site before you buy a new camera that shoots in Raw to make sure its Raw file format is supported for conversion to the Digital Negative format. And be sure to download an updated version of the DNG converter, if needed.

Editing and Improving Your
Photos with Computer Software

One of the great joys of digital photography is being able to enhance your pictures by using a computer and IMAGE-EDITING SOFTWARE, which also is referred to as PHOTO-EDITING SOFTWARE. The favorite program of photographers and graphic artists is ADOBE PHOTOSHOP. It is offered in both amateur and advanced versions that are respectively named Photoshop Elements and Photoshop CS (for Creative Suite).

Just like Google, another computer-age phenomenon, Photoshop has become part of our everyday language, even being adopted for use as a verb as well as being a proper noun. "I can always Photoshop it!" is a frequent exclamation of photographers who find something wrong with a picture and plan to fix it.

The image editing you do could be as simple as cropping a picture to improve its composition or getting rid of spots caused by dust on an SLR camera's image sensor. It could be to replace an unattractive gray sky with a beautiful blue sky. The change could be more dramatic, such as turning a person's frown into a smile or even eliminating a person from the middle of a group shot.

Because of Photoshop and similar image-editing programs, DOCTORED PHOTOS have become commonplace on the Internet and in the press. Composite photographs are used on the covers of

14.1–14.2. Image-editing software makes it possible to improve digital pictures after you shoot them, as shown by these images of a bull elk bugling for a mate during the rutting season in Alberta, Canada. Two distracting cows and elk droppings on the grass were removed in ten minutes by using the Clone and Healing Brush tools in the computer program Photoshop (see text).

publications to improve sales appeal. Tabloids, for example, some-times paste the head of a famous person onto a more attractive or better-dressed body.

A tip-off to readers that the photo is not direct from the cam-era is a credit line that identifies the picture as a "Photo Illustra-tion." However, many publications are not honest enough to indicate when a photo has been created from two or more digi-tal images.

Whether you like it or not, there is no longer any truth to the old adage that "a picture never lies." In fact, for many computer-savvy folks, the excitement of digital photography is IMAGE MANIPULATION; they most enjoy creating an entirely different picture from several original images.

14.3. Image-editing software allows your imagination to run wild. To create this whimsical picture, professional photographer Buddy Mays added four more images to a saguaro cactus he photographed in the bright Arizona desert. Using Photoshop, he made "layers" with separate pictures of the mouth of a friend, his daughter's sunglasses, and two cactus buds for the ears, and then positioned them on the cactus (see illustration 14.34).

THE DIGITAL DARKROOM:
CHOOSING AN IMAGE-EDITING PROGRAM

The place where you enhance digital images, or create entirely new images, is often referred to as the DIGITAL DARKROOM, which is simply a computer with image-editing software installed.

Image-editing programs vary considerably in their features. BASIC PROGRAMS enable you to make simple changes, including rotating, straightening, and cropping images, which we describe later in this chapter (see page 318). However, you'll need one of the ADVANCED PROGRAMS to make many of the changes mentioned in our examples at the very beginning of this chapter, such as turning a person's frown into a smile.

Before buying a particular program, we suggest that you start with the *free* image-editing software on the CD that was included in the box with your camera. It is a good introduction to the intriguing world of image editing and may serve all your needs. Examples of these programs are Kodak EasyShare, Olympus Master, and Canon ImageBrowser.

Another option is to use the image-editing features of photo programs that are included with the current major computer operating systems: Windows Live Photo Gallery, which is a feature of Microsoft's Windows Vista (and can be download free for Windows XP), or iPhoto, which is part of Apple's Mac OS X.

Or try the excellent and user-friendly image-editing software from Google called Picasa, which you can download without charge from the Internet at www.picasa.google.com. This currently works with Windows Vista and XP and with Mac computers using an OS X 10.4.9 or later operating system and Intel CPU (central processing unit).

Also free is a very basic program, Adobe's Photoshop Album Starter Edition, which you can download from www.adobe.com.

14.4. Image-editing software programs, like this one called Picasa, enable you to organize, improve, print, and share your digital pictures. Most programs will display your image files as thumbnail photos so they are easy to select.

If you become more involved with enhancing and manip-ulating digital images, you should try the exceptional Adobe Photoshop Elements program, which costs under $100. In the

Regardless of the image-editing program you install on your computer, be sure to do the following:

1. download the program's important "Getting Started" information that usually is available as a PDF file, which you should print out for refer-ence by using Adobe's Acrobat Reader;

2. become familiar with the program's "Help" menu, as well as ONLINE SUPPORT provided by the software manufacturer, which is where to find other how-to information and answers to any questions that arise as you use the program;

3. always DOWNLOAD UPDATES in order to take advantage of ongoing improvements to the software; and

4. read the "Read Me" file that often accompanies a downloaded program to find out about any idiosyncrasies or problems with certain aspects of the software.

future, you might want to advance to the professional Adobe Photoshop CS version, which sells for about $650. You can download either program from Adobe for a free trial. If you decide to buy either edition of Photoshop, be sure to get the most recent version, Elements 7 or CS4 (as of 2009).

In addition to Photoshop, there are several other advanced programs, including Corel's Paint Shop Pro Photo and Photo-Impact, ACDSee Photo Manager (amateur and pro), Apple's Aperture, and Ulead Photo Express.

MAKE SURE YOUR COMPUTER IS READY FOR IMAGE EDITING

Image-editing software, especially the professional programs, can take up considerable space on your computer's hard drive and challenge it to keep up to speed with every alteration you make to a photo. You'll become frustrated if your computer takes too much time to process and save each change you make to an image file. This happens most often when working with large (many megabyte) files, which usually are TIFF and Raw files.

Whenever you install new image-editing software from a CD or download it from the Internet to your computer, first check the software's list of SYSTEM REQUIREMENTS to see if your computer will operate the program efficiently.

For optimal performance when editing digital photo files, your computer should have plenty of RAM (random access memory), which is where digital data resides temporarily before being saved and written to the hard drive. And the hard drive itself should have considerable capacity in order to store all your digital photo files.

Just be aware that if your computer seems to operate in a slow manner when you are working on image files, you may want to upgrade the computer's processor, hard drive, RAM, video

14.5. Be certain your computer system is up to par, in terms of capacity and memory, for working on individual photos with your image-editing software (see text). Otherwise, there may be a prolonged processing time for each editing step you take, which can make the procedure frustrating instead of fun.

card, and/or other components to speed things up and make image editing more enjoyable.

PRESS THE "DELETE" KEY TO IMPROVE YOUR PHOTOGRAPHY

As we stressed in an earlier chapter, the first step when editing your images is to delete all the bad photos. In fact, do this immediately after downloading them from your camera to your computer. That way they won't take up space on the hard drive and clutter up your photo file folders with unwanted pictures.

Discarding your bad photos is a simple way to become a better photographer in the eyes of all your friends. They are thankful when you show off only your best work, not every photo you shoot.

14.6. When downloading new pictures to your computer, always get rid of the bad ones, such as blurred photos like this unflattering image. Locate and learn how to use the "delete" command(s) in your image-editing program, which may be on a menu and/or represented by an X icon (arrows).

Bad photos are those that are out of focus, blurred by accidental camera movement, don't have any meaning, or that you just don't like for any other reason.

BE CERTAIN TO USE "SAVE AS" WHEN MAKING A COPY OF ANY ORIGINAL IMAGE

Before making any changes to an original image file that you have downloaded from your camera to your computer—and intend to keep—take these two important steps: *(1) protect the original image by making a copy of it, and (2) give that copy a different name.*

Why? Because if anything goes wrong when you're enhancing or manipulating the copy image with your image-editing software, you'll still have the original file and can start over by

making another copy to work on. Otherwise, the original picture will be lost forever.

Copying is simple and quick with most any image-editing program. First, open the image on the computer screen by double-clicking its thumbnail picture or file name. Click **File** in the main menu, then **Save As**.

If you click **Save**, you only end up with the same original file; no duplicate copy will be made. So we repeat: click **Save As** when making a copy of the original image.

When you click **Save As**, a dialog box appears so you can give the copy a new file name that's different from the file name of the original image.

To easily name and recognize an exact copy, just add a code number or letter or word to the end of the original file name, such as "1" or "A" or "copy" or "dup." Add this before the three-letter file extension. For example: *08MarysBirthday_1 .jpg*, or *08MarysBirthday0019_A.jpg*, or *08MarysBirthday0019 _copy.jpg*.

Note that some image-editing programs offer a shortcut to making a copy of an image file.

14.7. Prior to editing any image, first make a copy of the picture by using the "save as" command (see arrow) in order to protect the original file (see text). If you make any mistakes, you can start over by making another copy of the original picture to work on.

Under **File** in the main menu, you might find **Save a Copy**, **Make a Copy**, **Duplicate**, or something similar. If you click that command, it will make a copy of the image and indicate it is a copy by automatically adding a number or word to the original file name, such as "1" or "(2)," or "copy."

Also, note that when you **Save As**, the dialog box that opens gives you an opportunity to save the file in a different file format, such as a TIFF (.tif) instead of a JPEG (.jpg). There are reasons you might want to do this, as we'll explain later in this chapter (see page 341).

LEARNING ABOUT IMAGE-EDITING SOFTWARE PROGRAMS

Do all these instructions about copying original images seem confusing? Our purpose is to emphasize that *you should preserve original image files and only make changes on copies of the files.*

What changes can you make to a digital image? Just peruse any image-editing software, especially cutting-edge programs like Photoshop, and the possibilities appear both endless and intriguing. How can you resist turning a portrait of your pet dog or cat into a watercolor masterpiece? Especially if you only need to click **File > Open > Filter > Artistic > Watercolor** and enjoy the result.

> The remainder of this chapter will give you an introduction to the basic and advanced features of image-editing programs. For step-by-step instructions, there are dozens of how-to books. Search the Internet for an up-to-date manual that explains how to use your particular image-editing software in detail.

Also check your software maker's Web site for helpful TUTO-RIALS, some of which are video presentations. In addition, you

14.8–14.9. You'll enjoy experimenting with image-editing software to see how you can alter the looks of your photographs. A filter called Photocopy in Photoshop Elements was applied to this picture of a collie to instantly create a "sketch" of the dog; Detail and Darkness slider controls were then adjusted to refine the image. See also illustrations 14.30–33.

can download detailed USER GUIDES and get personal help from CUSTOMER SERVICE. And there are ONLINE DISCUSSION FORUMS where you can ask questions and relate your experiences with image-editing techniques and problems.

Some things are common to image-editing programs, whether designed for amateur or professional photographers. As described in two preceding chapters, they enable you to DOWN-LOAD image files from your camera (see page 262), and then OR-GANIZE those files in some manner (see page 274). And, as we'll discuss in following chapters, they also make it possible to PRINT your photos (see page 362) as well as SHARE them over the Internet (see page 406).

14.10. Templates for making greeting cards and other artistic creations with your photos are features of many image-editing programs. A Type tool enables you to add words, and a Move tool lets you place the words and photos wherever you wish.

Image-editing programs enable you to show off your photography in many eye-catching ways, such as producing a panorama picture from several images (see page 205). They also make it easy to put together slideshows (see page 415) and short videos (see page 421), both of which can be accompanied by music. Other things you can create are greeting cards, photo collages, online photo galleries, and flipbooks that animate a series of still pictures.

Image-editing programs provide a choice of templates, frames, backgrounds, layouts, and themes that will give your photo projects a professional look. Most programs also offer direct access to online services that can print books with your photos and also put your pictures on dozens of items, such as calendars, postage stamps, and coffee cups (see page 395).

Most important of all, with image-editing software you can ENHANCE YOUR PICTURES so they'll look exactly as you wish. In

addition, you can even create photos that have little resemblance to the original digital images.

SIMPLE CHANGES TO MAKE FIRST TO DIGITAL IMAGES

A fact of life for photographers is that it will take some time before you become familiar with the various MENUS and COMMANDS in your image-editing software program. Begin by reviewing the program's main menu, which usually appears at the top of your computer screen.

Browse through the headings, such as these in Picasa: File, Edit, View, Folder, Picture, Create, Tools, and Help. Click each tab to see its drop-down menu and get acquainted with the various commands.

More menus will appear whenever you select a specific image file to work on, which you do by doubling-clicking its thumbnail picture or file name. In Picasa 3, those menu headings are Basic Fixes (with nine options), Tuning (with five options), and Effects (with twelve options).

Whatever image-editing program you are using, here are a few SIMPLE CHANGES to consider making when you initially open any image file on the computer screen.

First, you may have to ROTATE THE IMAGE. If a vertical shot appears horizontal on the screen, click the command to **Rotate** it 90° one way or the other. Often there are two buttons, with arrows curved in opposite directions, to rotate the image either clockwise or counterclockwise.

Once the image is oriented correctly, *make sure the picture fills the monitor screen so it is easy to see and work on.* Some programs do this when you double-click a thumbnail photo of the image. With other programs, click the **Full Screen** or **Fit on Screen** command or icon. Or you can use the **Zoom** control or tool to adjust

14.11–14.12. If a vertical picture appears horizontal on your computer screen, the first thing to do is "rotate" the image. Click the menu commands or buttons (see circles) that will turn the photo 90° counterclockwise or 90° clockwise (as with this statue of movie star John Wayne in California).

14.13. To better evaluate an image, visually enlarge the picture to its full size on your computer screen by using the Zoom tool or command in your image-editing program. You can zoom to 100 percent magnification to see more detail in any part of the picture.

the magnification of the image. (Note that the actual *file size* of the image will not change, only the size at which you view it.)

The next thing to do is *straighten the image*, if necessary. This is especially important for scenic and even people shots where the horizon is evident and should be level. As we cautioned in our chapter about composition, most viewers are distracted when the world appears tilted in your pictures. Crooked pictures are all too common when you compose with the camera's LCD screen instead of the viewfinder because it is more difficult to hold the camera level.

Some image-editing programs feature a **Straighten** command that superimposes a grid over the picture to help in leveling your subject. With other programs, you use the computer's cursor to draw a line to automatically align the main

14.14. To straighten the distracting tilted horizon in this picture, a grid was superimposed over the image to help the photographer realign the horizon at the Arkansas National Wildlife Refuge in Texas. See also illustration 14.15.

subject, or you "custom" rotate the image by degrees until the subject is level.

Afterward, you have to crop (see page 323) the now-tilted corners of the original picture that would otherwise stick out; some programs will do this automatically.

Here we must point out an important and much-used command in all image-editing programs: **Undo**, which is found under **Edit** in the main menu or on the screen next to a preview of the image that you have changed. By clicking **Undo**, the picture reverts to what it looked like just before the change was made. Some programs have a similar command called **Cancel**, which may be represented by an icon, such as a circle with a diagonal line drawn through it.

14.15. After rotating the image in illustration 14.14 until the horizon appeared level, the photographer used the Crop tool to trim off the now-crooked corners of the original picture. Rotate, Straighten, and Crop are basic image-editing features that make it easy to improve your pictures. See also illustration 14.17.

14.16. A command you'll often use is "undo" (see arrow), which cancels the alteration you have just made to a picture. If you then decide you liked the alteration after all, you can click the "redo" command and restore the change (see text).

For example, in the case of straightening, if your subject doesn't appear level after the initial change you made, just click **Undo** (or **Cancel**) and start all over. By the way, a companion command, **Redo**, will bring back the change you just undid.

Note that some programs let you undo several changes in the reverse of the order you made them; others let you undo only the most recent change.

After you make a change to an image and decide you want to keep it, you should **Save** the file. But also keep in mind that once you save a file, you cannot undo or redo any previous changes. Of course, you can continue making changes to a file you've just saved, and then undo and redo any of those subsequent changes until you decide to save the file again.

The last simple change to make after initially opening a photo file is to *crop the image*, if desired. As you may recall from

14.17. A basic way to improve a photograph is to "crop" it, which eliminates unwanted parts of the picture. This couple and their dog were separated from distracting surroundings by using the computer's mouse to draw a free-form "crop box" around them (see text). Some image-editing programs let you select crop boxes that are preset to specific photo paper sizes for making prints.

our chapter about composition, we believe you should compose pictures carefully at the time you shoot them, whether using your camera's viewfinder or LCD screen. However, once you see an image on the bigger screen of your computer monitor, often you'll notice distractions in the picture that you want to eliminate.

Image-editing programs have a **Crop** command or tool that you use to get rid of any elements that draw attention away from your main subject. In general, after you choose a starting point on the image, you move the cursor to create a free-form "crop box" around the portion of the picture you want to preserve.

With some programs, a proportional crop box appears on the picture and you adjust each side of the box by dragging it in or out and up or down with the cursor. Other programs will automatically adjust the crop box proportionally to a specific print

size that you select, such as 8 × 10 inches (20.3 × 25.4 cm). The crop box can be moved to different positions on the image with the **Hand** tool that you control like the cursor by left-clicking on the mouse.

Once you like how the picture looks when cropped, click **OK**, **Apply**, or an approval icon, such as a check mark, and the unwanted portions of the image outside the crop box will be eliminated.

If you change your mind, click **Undo** or **Cancel** and the full picture will reappear so you can crop it differently. When you are finally satisfied, click **Save** and the cropped image will permanently replace the image you were working on.

Or click **Save As** and give the cropped image a different file name so that the full image you were working on will be preserved under its original file name. Then, if you wish, you'll be able to crop the full image again in a different way, such as making a vertical composition from a picture that is in a horizontal format.

OTHER BASIC FIXES TO ENHANCE YOUR PICTURES

In addition to the rotate, straighten, and crop features described above, all image-editing programs offer some other common fixes for photo files, especially in regard to exposure, color, and sharpness. EXPOSURE ADJUSTMENTS can be made to contrast, brightness, shadows, and highlights, while COLOR ADJUSTMENTS can be made to color temperature, tint, hue, and saturation. SHARPENING ADJUSTMENTS are best done to the image after all other improvements have been made.

All programs enable you to make these adjustments to the *overall* picture. With advanced programs, you also can limit adjustments to *specific areas* of the picture you select.

There are usually several ways to make overall exposure and

14.18. Many image-editing programs have one-click commands that automatically make overall or individual improvements to a picture (see text). The menu shown here offers Auto Smart Fix, Auto Levels, Auto Contrast, Auto Color Correction, Auto Sharpness, and Auto Red-Eye Fix. Once you see the changes that are made to the image, you can click Undo or Cancel if you don't like the result.

color adjustments to a picture. Basic image-editing programs offer an easy way to start: an INSTANT FIX or SMART FIX button that makes automatic exposure and color adjustments all at once. The changes are made according to algorithms designed by the editing program's engineers, and you may not like the results. Try this one-click button anyway, then **Undo** or **Cancel** that action if you are unhappy with the outcome.

An easy alternative for making overall changes to a picture is to try individual automatic adjustments one at a time. They are usually called AUTO COLOR, AUTO CONTRAST, and AUTO LEVELS. Click **Help** in your image-editing program to find out about the specific changes that will be made to an image by each type of auto adjustment, which can vary with different software.

If the one-click auto-adjustment buttons don't improve a picture to your liking, you need to make individual exposure and color adjustments manually. Most often this is done with SLIDER

A common automatic adjustment is AUTO RED-EYE FIX, which eliminates the annoying red spots in the eyes of some subjects. This occurs when bright light from your camera's built-in flash passes through wide-open pupils and illuminates the red retina at the back of the eyes.

With some programs, you just click the cursor on each red eye to get rid of that color; others require you to draw a box with the cursor around each red eye and then click the box. This neat feature makes it unnecessary to use the battery-wasting RED-EYE REDUCTION flash setting on your camera (see page 74).

CONTROLS that you move with the cursor to make very precise changes to the overall image.

Slowly move the slider back and forth and look closely at the picture to watch the subtle changes. If necessary, check a **Preview** box to see those changes being made on a duplicate picture that will appear adjacent to the original image for comparison. Some programs also feature boxes where you can see—or set,

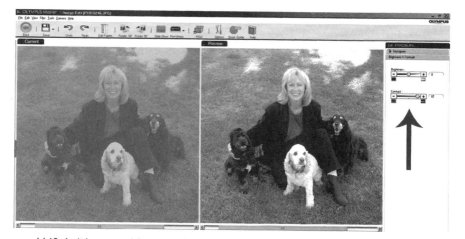

14.19. A slider control (see arrow) was adjusted to increase the "contrast" of the original image seen on the left (see text). A "preview" of the improved image appears on the right in this Olympus Master image-editing program.

if you wish—the actual percentage of change or a number that represents the amount of change.

The types of changes you can make vary with the image-editing program. A good place to start is ADJUSTING EXPOSURE, which gives you an opportunity to change the lighting in your picture. For example, the Photoshop Elements program offers four basic controls for making exposure adjustments: Shadows, Highlights, Brightness, and Contrast.

If there are dark shadows you don't like, move the SHADOWS slider to add more light, which will give some detail to those shadows. This control does not affect the highlights or midtones of the picture.

Or, if highlights are so bright they appear washed out, such as a foreground overexposed by flash, move the HIGHLIGHTS slider to reduce the light and give detail to those highlighted areas. This control does not affect the shadows or midtones of the picture.

To adjust the overall brightness, move the BRIGHTNESS slider until you like the result. Do the same with the CONTRAST slider to change the overall contrast of a photo.

Remember, after you click **OK** or **Apply** to any change, you can **Undo** or **Cancel** the result and make a different adjustment, if desired, prior to saving the image.

Once exposure adjustments are made to a picture, consider ADJUSTING THE COLOR by using some basic controls: Color Temperature, Hue, and Saturation.

To change the tone of colors in a photo, adjust the COLOR TEMPERATURE slider to make them look warmer (more red) or cooler (more blue). This control can help correct inappropriate colors that result when your camera's WHITE BALANCE was improperly set.

For example, if the person you shot indoors appears with off-color skin tones because of household tungsten bulbs or

14.20. The colors in your pictures can be adjusted on your computer screen until you like the way they look. Use the slider controls (see arrow) for different color adjustments that are called Color Temperature, Color Balance, Saturation, Hue, Tint, and other names in various image-editing programs.

fluorescent lights, use the color temperature control to make the skin color look more natural.

To change an overall color cast in a picture, use the HUE slider. And to make the colors in a picture more vivid or less intense (muted), move the SATURATION slider to the right or left. Slight adjustments with these sliders can make significant changes to the colors, so expect surreal results if you move either slider to its limits.

Some image-editing programs, including Photoshop Elements, enable you to make exposure adjustments by selecting a feature called LEVELS. This displays a dialog box with a HISTO-GRAM that is a graphic representation of an image's tonal range; i.e., its shadows, midtones, and highlights. Using the cursor, you move sliders to change the tones in the picture to your liking, as well as to control brightness and contrast. The changes will be evident in the picture as you move the sliders. Red, green, and/

14.21. You can lighten shadows, darken highlights, and also adjust midtones in a picture with the "levels" adjustment controls found in some image-editing programs, like Canon's ZoomBrowser shown here. This is done by moving black, gray, and white triangular sliders (see arrow) under the histogram (see text).

or blue color channels can be similarly adjusted to change color casts in an image.

Also, you may be able to make fine adjustments to an image with a feature called CURVES. This displays a dialog box with a straight diagonal line that curves as you move the cursor or sliders to change the color and tones of an image.

In addition to the adjustments described above, image-editing programs offer numerous other ways to enhance your photographs. As we suggested earlier, try out all the features in your specific software to see how they might improve your pictures.

For example, Photoshop Elements and Photoshop CS programs have a SPOT-HEALING BRUSH tool that easily eliminates small flaws in your pictures, such as facial blemishes in a portrait. After selecting this tool and the size of the brush, which is represented by a circle, you move the mouse to place the circle over the unwanted blemish, left-click the mouse, and the spot disappears. Apple's iPhoto will do the same thing with its RETOUCH tool.

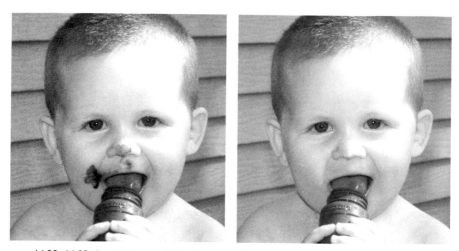

14.22–14.23. A mischievous child with a messy face makes a memorable picture for the family album. Of course, if you want to change his appearance, you can clean up the face with image-editing software, as shown in the matching image. With the Clone tool, you literally stamp existing parts of the picture over the parts you want to cover up. This requires small incremental steps, and patience.

For best results whenever you are going to work on a small portion of a picture, such as facial blemishes or red-eye, be sure to use the Zoom tool or control to zoom in (+) to see the photo's actual pixels at full (100 percent) size. In Photoshop, you also can click **View**, then **Actual Pixels** to see the image at its full file size. This will give you a detailed look at what you want to fix, and you can closely analyze the results before you click **OK** or **Apply** to confirm the editing action.

APPLYING SPECIAL EFFECTS TO YOUR PHOTOS

Whether basic or advanced, many image-editing programs allow you to MANIPULATE PICTURES in some surprising ways. The choices most often are found under menu headings named **Filter** or **Effects**.

A common alteration is to convert your full-color digital

14.24. Among the filters or effects available in most image-editing programs are those that convert a color picture to black-and-white. Converting a color image to sepia tone is another effect you can select, as shown in this Picasa dialog box.

picture to BLACK-AND-WHITE, which is sometimes labeled as MONOCHROME or GRAYSCALE. Also, if you move the Saturation slider all the way to the left, it will desaturate (remove) all the color and turn the image into a black-and-white photo.

Some programs give you greater control of the shades of gray in a black-and-white image. They let you simulate the effects of putting colored filters of various intensities in front of a camera lens, as photographers often do when shooting with black-and-white film.

Instead of changing a full-color photo to a black-and-white image, a popular option is to click SEPIA TONE, which will give the picture the reddish-brown look of a vintage photograph.

Or, if you want to improve a scenic shot by turning a dull sky into a blue sky, choose the GRADUATED TINT filter, like that offered in Picasa (but not all programs). You select the **Color** and adjust

its **Shade**, then use the cursor to position the effect appropriate to the skyline, and **Feather** it with a slider until the blue sky blends naturally in your picture. To improve a sunset shot, try the same thing but select a red or orange color instead of blue.

Be sure to try out all the creative effects that are available in your image-editing program. For instance, in Picasa you'll also find a SOFT FOCUS effect, which lets you select a circular portion of the picture to keep in sharp focus while putting everything surrounding it into soft focus. That makes your sharply focused subject stand out from the rest of the picture.

Similarly, in Picasa there is a FOCAL B&W effect that keeps a circular area you designate in full color while changing the area surrounding it to a black-and-white image.

By the way, you may see advertisements in photo magazines or on Web sites about PLUG-INS, which are third-party programs that create effects that may not be included in your image-editing

14.25. Soft Focus (see arrow) is one of twelve creative effects you can try in the Picasa image-editing program. Click it after you use the computer cursor to designate a portion of the picture to remain in sharp focus, and the surrounding area will appear out of focus. This directs attention to your main subject, like this smiling hostess who greets visitors at the welcome center in Natchez, Mississippi.

program. If you want to modify your images in the manners described in a plug-in ad, first inquire if the plug-in is compatible with your image-editing program before ordering the software.

MORE OPTIONS WITH ADVANCED IMAGE-EDITING PROGRAMS

With advanced image-editing programs, there seems to be almost no limit to the number of ways you can manipulate a photograph. For example, when you click **Filter** in the main menu of Photoshop Elements or Photoshop CS, you find a choice of more than one hundred effects, and each effect has dozens of variations (see illustration 14.26).

One helpful filter is Correct Camera Distortion. This can be used to lighten dark corners in a picture that resulted because of VIGNETTING, which is caused sometimes by a wide-angle lens

14.26. Photos can be manipulated in countless ways with image-editing programs. Clicking the Filter tab in the main menu of Photoshop Elements brings drop-down and fly-out menus with all sorts of effects. For example, clicking the Artistic tab gives you fifteen choices, from Colored Pencil to Watercolor. See also illustrations 14.8–14.9 and 14.30–14.33.

14.27–14.28. The historic inner city of Delft in the Netherlands is distorted in the top photo because of "keystoning," which causes vertical subjects to tilt inward. This occurs when you aim the camera upward, especially with a wide-angle lens or wide-angle zoom setting. The bottom photo shows how such camera distortion can be corrected with perspective controls found in some image-editing software programs (see text).

or wide-angle zoom lens setting (see page 208). You also can straighten the vertical or horizontal lines in photos caused by a tilted camera, as with tall buildings that appear to lean toward the center of the picture, which is called KEYSTONING. A grid can be superimposed on the image to help you set things straight.

Another very useful filter is Reduce Noise. This helps rid the image of an unwanted grainy pattern or color artifacts that most often result from shooting in low light, using a long exposure, or setting a high ISO (see page 140).

To manipulate images in precise ways, the better image-editing programs offer a wide variety of TOOLS. For example, Photoshop Elements has forty tools in addition to the four—Straighten, Crop,

14.29. To write messages on pictures you send to family and friends, use an image-editing program that has a Type tool. The Type tool (the T in the white circle) is one of many tool icons that appear in this on-screen toolbox menu (left) in Photoshop Elements (see text).

Red-Eye Removal, and Spot-Healing Brush—we've already described.

Other tools include Eraser, Blur, Clone Stamp, Cookie Cutter, Smudge, and Smoothing Brush. Often you can guess from their names the specific uses for the tools, but consult **Help** for step-by-step instructions on how to alter an image with each tool. The Type tool, for instance, enables you to write text on an image in horizontal and vertical directions.

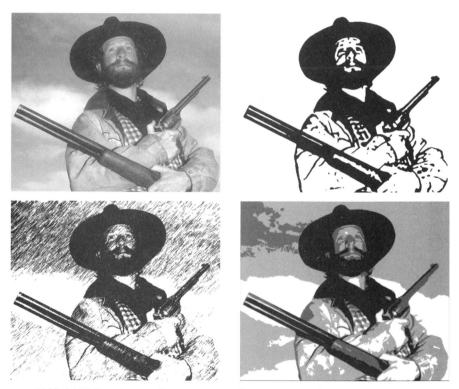

14.30–14.33. Some image-editing programs will create special effects when certain filters are applied to your images. Photoshop's Filter Gallery features more than one hundred effects, including the three shown here. This gunfighter, who performs for visitors in Jackson Hole, Wyoming, takes on an artistic persona with filter effects that are named Stamp (upper right), Graphic Pen (lower left), and Cutout (lower right). See also illustrations 14.8–14.9.

Film photographers may recognize two tools that are named for techniques used in photographic darkrooms: Dodge, which lightens a selected area, and Burn, which darkens a selected area. Tools like the Selection Brush, Elliptical Marquee, Magnetic Lasso, and Magic Wand help you select areas of the image to work on instead of the overall picture.

Whenever you are doing extensive modifications to an image, it is best to use "layers," a feature of some of the advanced image-editing programs. The layers feature allows you to make changes without permanently modifying the image you are working on until you merge or "flatten" those layers and save the file.

Every change you make is done on a separate layer, which you can imagine to be a sheet of glass. These transparent sheets are stacked on top of each other to create the whole altered image. However, you can always go back to any layer—or all of them—and easily make changes again until you're happy with the final result.

Of course, if not using layers, you can "undo" a change, as we described earlier. But that is troublesome and time-consuming if the unwanted change was followed by three or four other changes; you'd have to undo all those changes first, fix the earlier change, then make all the subsequent changes again. By using layers, you can make a change on any layer without disturbing or having to redo any of the changes on other layers.

For example, if you added text to an image on the second of five layers and later decided to change the color or size of the type, you could go back to that text layer and easily make the change. Using layers may seem quite daunting at first, but as the procedures become familiar, you'll be motivated to continue making modifications until the final image looks exactly as you wish.

14.34. A feature called "layers" is found in some image-editing programs, including Photoshop, as shown here with this grinning girl who is anticipating a gift from the tooth fairy. Layers enable you to make any number of individual adjustments to an image, and then change any of those alterations without having to start from the beginning (see text). The Layers palette (right) shows that three layers have been added to the background layer that is the main image (see arrow); many options are offered in the drop-down Layers menu (left).

FINAL STEPS IN EDITING IMAGES: RESIZING AND SHARPENING

Once all your enhancements and other alterations have been made to an image, there are two more things to do with image-editing software that greatly affect the final appearance of the picture. You should RESIZE and then SHARPEN the image according to how you intend to use it. The settings you choose depend on whether you intend to make a print of the image or display the picture on a computer screen.

If you are making a print, you need to adjust the image size so it will fit the print size you want, such as 4 × 6 or 8 × 10 inches

(10.2 × 15.2 or 20.3 × 25.4 cm). And if you send the image in an e-mail or put it on a Web page, you need to downsize the picture so it can be seen it its entirety on any computer screen. (As you probably know from experience, some people e-mail pictures that overflow your screen because they didn't bother to resize them.)

> Fortunately, all basic image-editing programs feature simple functions that *automatically* and appropriately resize and sharpen an image for printing or e-mailing or Web display. We explain those functions later, in chapters 15, 16, and 17.

However, if you are using an advanced image-editing program, there are several steps required to manually resize and sharpen an image. The steps vary according to the specific software; consult the **Help** menu for directions.

In general, when you manually RESIZE AN IMAGE, you first need to set its RESOLUTION. This determines the amount of detail that will be seen in the picture, which depends on the number of PIXELS PER INCH (ppi) you select. The more pixels per inch, the higher the resolution, which means the greater the detail.

What's important to remember is that high resolution is not needed for photos to be viewed in e-mails or displayed on Web sites; for these the usual resolution setting is 72 ppi. On the other hand, when making large prints, the resolution should be set much higher, up to 300 ppi.

Changing the resolution will change the picture's width and height (the DOCUMENT SIZE), and vice versa. If you want to keep the same resolution but change the picture size, you can RESAMPLE THE IMAGE. This adjusts the number of pixels per inch in the picture (its PIXEL DIMENSIONS), which simultaneously adjusts the picture's width and height proportionally.

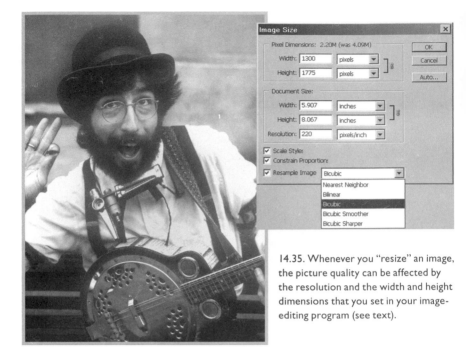

14.35. Whenever you "resize" an image, the picture quality can be affected by the resolution and the width and height dimensions that you set in your image-editing program (see text).

Unfortunately, resampling can degrade the detail and sharpness of a picture because the image is INTERPOLATED by the software, which means some pixels are discarded whenever you downsize it, and some new pixels are added whenever you upsize it.

To preserve the highest image quality when resampling, you select the best interpolation method, which is normally **Bicubic**. (Note that the Photoshop programs offer these two refinements: **Bicubic Smoother** to use when upsizing an image, as for printing enlargements, and **Bicubic Sharper** to use when downsizing an image, as for e-mail.)

At this point you can SHARPEN THE IMAGE, although this is often unnecessary for use in e-mails. Click **Auto Sharpen** and see if you like the results. Or adjust the sharpness manually with sliders for more control. One caution: beware of oversharpening, because it can create unwanted ARTIFACTS in the image (see page 140).

14.36. As the final step in image editing, you should "sharpen" the picture. In some programs, like Olympus Master shown here, you move one or more slider controls (see arrow) to adjust the degree of sharpness. By clicking Preview, you can watch the changes that will take place on the original image. Be careful not to oversharpen, which can degrade a picture rather than improve it (see text).

Of course, as the final step after a picture is resized and sharpened to your satisfaction, click **Save As** to save that image with a different file name. This keeps the original image file intact so you'll be able to resize and sharpen it later for some other purpose.

CHANGING THE IMAGE FILE FORMAT
WHEN SAVING AN IMAGE

Whenever you save an image using the "save as" command, you have an opportunity to change its IMAGE FILE FORMAT. Why would you want to do that? There are several reasons, especially in regard to JPEG files, but first you need to know a little more about file formats.

As we described in chapter 6, initially you select and set a file format on your camera prior to making an exposure (see page 129). The most common file format is JPEG (.jpg), but many camera models also offer TIFF (.tif) and/or a Raw file format (which usually is the proprietary format of the camera maker and carries its own three-letter file extension).

Photographs that you intend to include in e-mails, display on the Internet, or print in small sizes are usually shot as JPEGs. On the other hand, most professional photographers prefer to shoot all their photos in a Raw file format or as TIFFs.

That's because JPEG files suffer from LOSSY COMPRESSION, which means they lose some of their pixels *each time they are saved* as JPEGs after being altered with image-editing software. If repeatedly saved while being worked on, the quality of the

14.37–14.38. Degradation of images in the JPEG file format isn't normally as noticeable as in this comparison photo (right), but it does occur because of a characteristic known as "lossy compression" (see text). Every time a JPEG file is edited and then saved, lossy compression eliminates some pixels, especially if you save it at "low" image quality (see also illustration 14.39). To make this extreme example, the snowboarder's picture was opened, edited (by very slight resizing), and then saved at low quality a total of seventeen times.

original JPEG picture is degraded, especially because lossy compression can cause undesirable artifacts in the image.

TIFF files, on the other hand, utilize LOSSLESS COMPRESSION, which does *not* degrade the quality of a picture; none of their pixels are eliminated and no artifacts are created whenever they are saved. For those reasons, if you plan to make many alterations to an important JPEG, first make a copy and save it as a TIFF, and then work on the TIFF file instead—which is what the pros do. Note that when a copy of a JPEG file is saved as a TIFF file, the file extension will change from .jpg to .tif.

> You should be aware that basic image-editing programs may only work with JPEG and TIFF formats; they may not support Raw or other file formats mentioned below.

Regarding Raw files downloaded from your camera: after they are converted by the image-editing software that accompanied your new camera (or by Adobe's Camera Raw conversion software for Photoshop), we recommend Raw files be saved in the DNG (Digital Negative or .dng) file format, as described earlier on page 304. This preserves your Raw file images in a more universal open-source archival format so that they can always be opened, especially years in the future when your camera's Raw file format may be obsolete.

After saving Raw files as DNG files for posterity, you can copy and save a DNG file as a TIFF file when you want to work on it with image-editing software. If using Adobe Photoshop, an option is to save working copies of your DNG files (or JPEG or TIFF files downloaded from the camera) in the Photoshop Document file format, PSD, which has the file extension .psd.

Eventually, after you make all the changes you want, the picture in its final form should again be saved as either a JPEG or

a TIFF file. That's because those two types of file formats are recognized by most graphics programs that computers use in order to electronically display or print digital photos.

As explained earlier, JPEG is the file format choice if you plan to make small prints, such as 4 × 6 inches (10.2 × 15.2 cm), or display the pictures on a computer or TV screen. And TIFF is the file format choice if you plan to publish the image, as in a magazine, or make large prints.

Always remember that most Web browsers and e-mail applications will not display TIFF images; use JPEG images in your e-mails and for Web pages, including blogs.

When you save an image in the JPEG file format, a dialog box labeled IMAGE QUALITY or COMPRESSION usually appears on your computer screen. Here you have the opportunity to compress the JPEG file to reduce its size. In addition to saving space on your hard drive, a smaller image file takes less time to send via the Internet in an e-mail or to a Web page.

As you might expect, when an image file is reduced in size (compressed), the quality of the image also is reduced. In reality, this matters very little if the picture is displayed on the Web. But it matters a lot if you are going to make a large print; an *uncompressed* file will produce the best image quality.

Depending on your program, you set the image quality of a JPEG file by choosing a general description, such as Low, Medium, High, or Maximum. Or you select a specific number, usually on a scale from 0 to 12 or 0 to 100; the higher the number, the less compression, which means the better the image quality.

As a guideline, for pictures you send in e-mails or post to a Web page, a Medium quality setting is more than adequate. For

14.39. When saving pictures in the JPEG image file format, you set the "image quality" (also called "compression"). Select Maximum or the highest number (see arrow) for the best quality (see text).

making large prints from JPEG files, the Maximum (12 or 100) setting will give the best results.

Note that some advanced programs, such as Photoshop, have a **Save for Web** choice that opens a single dialog box to let you both resize the image and select the image quality (compression). It shows a side-by-side photo comparison with the original image, indicates the new file size in kilobytes, and estimates the number of seconds it will take to send that smaller compressed image over the Internet at a specific connection speed.

A major function of any image-editing program is to enable you to make your own photographic prints using a desktop printer, which we discuss in detail in the next chapter.

15

Printing Your Digital Photos at Home

Most people with computers also have a desktop printer, which makes it convenient for making prints of digital photos at home. Any printer will do, but one advertised as a PHOTO PRINTER or PHOTO-QUALITY PRINTER will produce better-looking prints. Likewise, you should use "photo" papers so your prints will have the appearance of traditional photographs. And your choice of inks for printing photos is important, too.

In this chapter, we first discuss printers, papers, and inks for making your own photo-realistic prints. Next, we describe the steps you should take with image-editing software to prepare a digital image for printing, and after making a print, how to analyze and improve it. Finally, we explain archival methods for mounting and framing prints so your photographs will continue to give enjoyment to yourself and others for a long time.

THREE TYPES OF DESKTOP PRINTERS FOR MAKING PHOTO PRINTS

There are three types of DESKTOP PRINTERS for making photo prints in your home or office. Most common are inkjet printers, but there are also dye-sublimation printers and laser printers.

Today's standard desktop printers are INKJET PRINTERS. As the name implies, they shoot jets of colored and black ink through tiny nozzles onto the print paper. This creates minute dots of ink that combine to form photolike images. The ink is contained in replaceable cartridges mounted in a PRINT HEAD that quickly passes over the paper one line at a time to create the image.

Some inkjet printers are designed especially for making photo prints, as may be indicated by the model name, such as HP's Photosmart and Epson's Stylus Photo printers. At least be sure that any model you buy is described as a "photo-quality" or "photo-realistic" printer. Even "all-in-one" models that serve multiple functions (printer, scanner, copier, and sometimes fax machine) can create good-looking pictures.

15.1. Inkjet printers are the most common type for printing photos. There is no need for a computer when making prints with this HP Photosmart model; it has card reader slots that accept memory cards and a USB port for direct connection to your camera (see arrow). The printer also includes some image-editing features and a small LCD preview screen. You can use this all-in-one machine as a scanner and copier as well.

Before purchasing any desktop photo printer, go online and use a search engine such as Google or Yahoo! Search to check the printer's technical specifications and read reviews about its features and any faults when producing photo prints.

DYE–SUBLIMATION PRINTERS also are popular for making photo prints, particularly those of snapshot size, 4 × 6 inches (10.2 × 15.2 cm). These are commonly called DYE–SUB PRINTERS, and occasionally referred to as THERMAL DYE TRANSFER PRINTERS. Heat from the print head causes color dyes on a long ribbon of film to vaporize and be absorbed by special photo paper to create the image.

On close inspection, dye-sub images have the continuous-tone appearance of traditional chemically processed photographs. This is why many photographers consider dye-sub photo images superior to those composed of tiny dots by inkjet printers. How-

15.2. Portable dye-sublimation printers are convenient for making long-lasting snapshot-size photos. This Sony model produces borderless 4 × 6 inch prints when connected directly to your camera or when a memory card is put into a card reader slot on the printer (see arrow). Any improvements you make with the built-in image-editing software can be previewed on its large LCD screen. See also illustration 15.6.

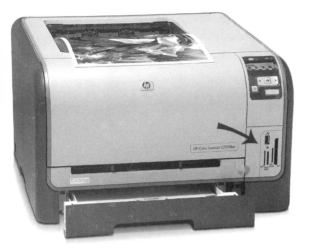

15.3. For various reasons, color laser printers are not as popular as inkjet printers for printing photographs (see text). Like the two other types of printers previously described, this HP model has card reader slots for the memory card from your camera so you can make prints without using a computer (see arrow).

ever, thanks to ongoing innovations in inkjet printer technology, inkjet prints are no longer second cousins to dye-sub prints. Dye-sub prints are especially resistant to fading and to smearing by water, but improvements in inkjet inks and papers have reduced dye-sub's advantage over some inkjet prints.

Another type of printer for making color photo prints is the LASER PRINTER, which uses powdered pigments called toners that are thermostatically fused to the print paper to create images. Although the photo prints can be of high quality, few casual photographers are attracted to laser printers because of their higher cost, bulkier size, and the minimal choice of models compared with inkjet printers.

PRINTER COSTS, BRANDS, SIZES, AND SPEEDS

Despite their complex technology, inkjet printers are surprisingly low in price; you can buy a good photo-quality printer for between $100 and $200. Manufacturers are said to underprice their printers because they know you will have to continually purchase paper and ink, and that's where their profits are.

As you might expect, every printer manufacturer always recommends you buy its own brand of inks and papers in order for the printer to make the best possible prints. In fact, most caution that the printer could be damaged by off-brand, third-party ink cartridges, and the printer's limited warranty may be voided if you use them.

Photographers who want to make the best prints possible usually buy inks with the same brand name as their printers. However, they are less loyal to the same name brand of photo papers because there is a wide choice of exceptional photo papers available from many reputable manufacturers.

Best-selling brands of good photo-quality inkjet printers include HP, Epson, Canon, Lexmark, and Dell; popular dye-sub snapshot printers are made by Canon, Epson, HP, Kodak, Sony, and Olympus.

When shopping for a printer, your first consideration should be the maximum size of the paper it can print. Most models of inkjet printers accommodate standard letter-size (8.5 × 11 inch; 21.6 × 27.9 cm) and smaller papers.

Others are considered "snapshot printers" because they are made specifically for 4 × 6 inch (10.2 × 15.2 cm) snapshot-size photo paper. Some of these printers also will make prints in other small sizes, such as 3.5 × 5, 5 × 7, and 6 × 8 inches (8.9 × 12.7, 12.7 × 17.8, and 15.2 × 20.3 cm).

And there are bigger desktop inkjet printers that serious amateurs and professional photographers prefer because specific models accept larger-size photo papers, such as 11 × 17, 13 × 19, or 17 × 22 inches (27.9 × 43.2, 33 × 48.3, or 43.2 × 55.9 cm).

In addition to giving the maximum print size, advertisements for printers usually indicate the PRINTER SPEED. This is expressed in PAGES PER MINUTE (ppm). Separate page-per-minute figures are given for printing text and for printing photos, which take more time. If you are comparing printers as to their photo-printing

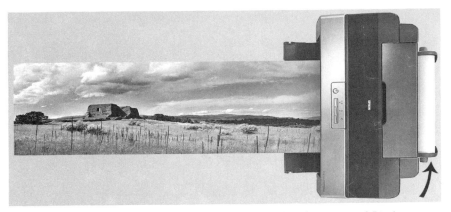

15.4. Some printers accept photo papers that are wider than the maximum 8.5 inches common to most inkjet printers. This Epson model can handle paper up to 13 inches wide, either in sheets or on a long roll (see arrow) for panoramic prints, as shown here in an overhead view.

speeds, be certain to compare speeds for the same photo size and the same medium (color or black-and-white).

The PRINT QUALITY you set prior to printing a photo also affects the printer speed (see page 370). In reality, it usually takes longer to print a photo than the manufacturer's printer speed figures indicate. A test of ten inkjet printers showed that printing times for an 8 × 10 inch (20.3 × 25.4 cm) color photo ranged from two to fourteen minutes—most averaged about four minutes.

Which brand and model of printer produces the best print quality? It's really a personal judgment. What matters most is how good the finished photographs look to you. Two of the things that greatly affect the appearance of a photo print are printer inks and print papers, which we discuss below.

ALL ABOUT INKS FOR PRINTERS

After you buy an INKJET PRINTER, you must install a major printing component, the INK CARTRIDGES that contain liquid

dyes or pigments. Most printers come with "starter" cartridges with small quantities of ink that will run out soon after you begin using them. Become familiar with the ink cartridges your printer requires, and buy a set of replacement cartridges to have on hand.

> For the best photo printing and print longevity, buy the brand-name ink cartridges indicated in the instruction manual by the printer's manufacturer. That's because those OEM (original equipment manufacturer) inks have been formulated by the company to work with their specific printers and photo papers.

The major makers of desktop printers—HP, Epson, Canon, and Lexmark—have their own inks. You may be tempted to save money by buying store-brand, third-party or refill ink, but these are generic types of ink poured into cartridges of different sizes to fit various printers. The results when printing pictures can be disappointing and a waste of your time and print paper.

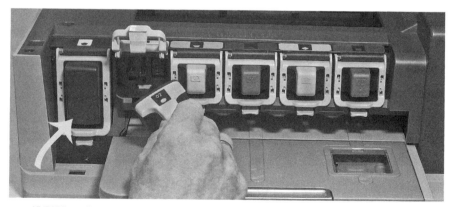

15.5 When changing ink cartridges in an inkjet printer, use the name-brand inks of your printer's manufacturer in order to make the best possible photo prints (see text). This HP printer has five color-coded cartridges with colored inks: yellow (being changed here), light cyan, cyan, light magenta, and magenta. A larger cartridge (see arrow) holds black ink.

One problem is that generic inks are more likely to clog the print head nozzles and cause streaks and untrue colors in the print.

Even if you initially like the look of a photo printed with off-brand inks, the PERMANENCE OF THE IMAGE is much less certain than if made with inks from the printer's manufacturer; some photos fade after a few months. For independent comparisons of specific printer inks (as well as of photo papers), log on to www .wilhelm-research.com.

Take note that most inks for inkjet printers are dye based. However, some inkjet printers use pigment-based inks, which increase the permanence of prints because they show a greater resistance to fading, ozone pollutants, water, and humidity. Pigment-based inks are sometimes referred to as "archival inks" for that reason. In reality, whether you print with dye- or pigment-based inks, a photo's longevity depends largely on the print paper you use (see paper discussion starting on page 355).

Some inkjet printers use only two ink cartridges, one with three colors of ink and the other with black ink. A few use one cartridge containing all the inks. Other printers feature four individual cartridges to hold three colors as well as black ink. An advantage of individual color cartridges over a single tricolor cartridge is that individual cartridges can be replaced separately when one color runs out before the others.

The basic colors that create a full-color photo print are cyan, magenta, and yellow, plus black, which are abbreviated with the initials CMYK. K stands for black so it won't be confused with one of the primary colors, blue, which is abbreviated B (as in RGB for red, green, and blue).

To make the colors even more realistic in photo prints, many inkjet manufacturers have added two additional ink cartridges,

light cyan and light magenta. As a result, six-ink printers are especially popular with serious amateurs who make their own prints.

In fact, there are even eight-, ten-, and twelve-ink printers that professional photographers use to produce exhibition-quality prints for clients and art galleries. Some of these printers feature additional colors, such as red and green. And there may be variations of black ink, too—such as dark gray, light gray, and matte black—which help create more impressive black-and-white prints.

When purchasing ink cartridges, take note of the VOLUME OF INK they hold, which is measured in milliliters (ml). You'll save money by buying cartridges with large capacities (if available) and by buying combination packs that have two cartridges of the same ink or a full set of the color and black ink cartridges required by your printer.

Make sure you buy ink cartridges that are specified for your particular printer by its manufacturer; there are no universal cartridges that fit all printer models. Each type of cartridge is identified by the manufacturer's number and the color of ink in it. Its package lists the printer models the cartridge was designed to fit. Also, check the "install by" or "use by" date on the cartridge packaging to make sure you are buying fresh ink.

Take care when installing ink cartridges in your printer. Damage can easily occur to the ink nozzles or electrical contacts in the PRINT HEAD or the printer mechanism. Follow the exact installation directions in the printer's instruction manual; do not depend on your intuition.

Some printers require you to align the print head every time you install a new ink cartridge. Otherwise the colors will be off-register in your print, and you'll be wasting ink and paper. All printers enable you to make a test print to check and reset the print head alignment.

If you use a DYE-SUB SNAPSHOT PRINTER, remember that its pigment-based inks are on a long ribbon of film that is the width

Ink ribbon for 40 prints 2 x 20 sheets of print paper

15.6. Color inks for dye-sub snapshot printers are supplied in a dry state on a plastic ribbon in a cartridge (see text). The cartridge comes packaged with compatible photo paper, as illustrated here for a Sony Print Pack that will make forty 4 × 6 inch (10 × 15 cm) prints. (Illustration courtesy of Sony Corporation.)

of the paper. This dry ink roll is in a cartridge and comes packaged with the special photo paper that is required; the paper may be supplied as separate sheets or on a roll with perforations to separate the individual photos after printing.

ALL ABOUT PAPERS FOR PRINTERS

Many novice digital photographers pay little attention to the wide choice of papers available for their inkjet printers. Most are concerned only with the PAPER SURFACE, which indicates the print's finish and texture. Their preference is usually for smooth glossy papers, which give the bright shiny look of traditional snapshot photos.

But the surface is only one of several characteristics of print papers to consider. Other aspects include the base material, weight, thickness, brightness, opacity, and whether the paper is designed for use with dye-based or pigment-based inks, or both. Another consideration is whether the photo paper is designed to be printed on only one side or on both sides.

Fortunately, many retailers have sample books with swatches of print papers from various manufacturers so you can see and feel the differences in papers. Some also sell sample packs with

15.7. When shopping for photo papers, you'll find various brands that include names of well-known companies like those on the paper packages shown here. Make sure to buy the right type, size, and number of sheets you want. Also study the package for the paper's characteristics; as you see here, "glossy" paper is described in different ways by its manufacturers.

only a few sheets of paper, which makes it economical for you to try out a paper before investing in a larger quantity.

Popular BRANDS OF PHOTO PAPERS carry the familiar names of printer manufacturers, such as Epson, HP, and Kodak, but there are at least three dozen other brand-name papers. Among them are Hahnemühle, Moab, Ilford, Lumijet, Oriental, Media-Street, Mitsubishi, Inkpress, Bergger, Pictorico, and Arches, all of which are known for their high-quality print papers. Office store brands do not have the same reputation and usually are avoided by serious photographers.

Some papers are advertised as ARCHIVAL PAPERS because of supposed long-term life, which ranges up to two hundred years according to some manufacturers. While there are no international standards for archival permanence of photographic images, one company respected for independent longevity tests on print papers and printer inks is Wilhelm Imaging Research; log on to www.wilhelm-research.com to view its reports.

The two basic surfaces of photo papers are termed glossy and matte. They come in many variations, such as smooth, nontex-

HP Professional Satin Photo Paper
Papel HP satinado fotográfico profesional / HP Professional Fotopapier seidenmatt
Papier photo satiné HP professionnel / Carta fotografica HP professionale satinata
Papel HP Professional para fotografía, acetinado / HP 프루페셔널 새틴 포토용지
HP プロフェッショナル半光沢フォト用紙 / HP 专业丝光相纸

Inkjet **25** Sheets hojas / feuilles Blatt / fogli 預購 / 매수 枚 / folhas

Satin
Satinado / Satin
Seidenmatt / Satinata
絹光沢 / 새틴
半光沢 / Acetinado

13 × 19"
330 × 483mm

300 g/m² 11.4 mil

15.8. The characteristics of a photo paper are listed on this paper package. According to its label, this inkjet photo paper comes in a twenty-five-sheet pack, has a satin surface, measures 13 × 19 inches (330 × 483 mm), has a weight of 300 grams per square meter (g/m²), and a thickness of 11.4 mils (see text).

tured GLOSSY PAPERS that their manufacturers may describe as ultra glossy, premium glossy, supreme gloss, high gloss, semi-gloss, or luster.

MATTE PAPERS do not have the shiny and highly reflective surfaces of glossy papers, and many are textured rather than smooth. Some matte papers are called "fine art" papers and have surfaces that are described variously as silk, velvet, satin, pearl, canvas, or watercolor.

The PAPER BASE usually varies according to the basic print surface. Glossy papers most often are of a resin-coated (RC) polyethylene plastic base, while matte papers are usually made of cotton rag, wood cellulose, and other natural fibers. Fiber-based papers are preferred for most fine art photographs.

Photo paper packages usually display several numbers to indicate other characteristics of the paper, including its weight and thickness, which relate to the paper's strength and durability. PAPER WEIGHT is expressed as grams per square meter (gsm or g/m²). Weights can range from about 100 to over 300 gsm.

PAPER THICKNESS (or CALIPER) is measured in thousandths of an inch, expressed as mils. Thickness can range from about 5 to 27 mils or more.

Two other numbers that may appear on packages of paper are measurements of brightness and opacity. PAPER BRIGHTNESS

indicates the amount of light reflected by the paper, as expressed by a number in the range from about 83 to 104; the higher the number, the more brilliant the paper, and therefore the more vivid the colors in a photo should appear.

PAPER OPACITY indicates how impervious the paper backing is to light passing through it, as expressed in a percentage that ranges from about 83 to 99 percent; the higher the number, the less light can pass through. This is especially important for papers designed for printing on both sides. Otherwise, the image on the opposite side of the paper might show through.

You should be aware that there are SPECIALTY PRINT PAPERS for displaying your photos in novel ways. For example, sheets of self-adhesive paper are ideal for making photo stickers or labels. Some are microperforated so you can easily separate them from the paper backing after printing. Other papers have a magnetic backing so pictures will adhere to metal surfaces. You'll also find precreased photo papers that fold in half to make greeting cards or party invitations. And there are iron-on transfer papers for putting your pictures on T-shirts and other cloth items.

Photo papers come in several SIZES to fit desktop printers that accept papers of various maximum widths, as described earlier

15.9. Consider using specialty print papers when you want to display your photos in different ways (see text). As an example, you can buy greeting card photo paper, such as the package shown here that includes forty sheets of thick card stock and envelopes for mailing.

in this chapter. Most common is letter-size paper that measures 8.5 × 11 inches (21.6 × 27.9 cm). Some printers are designed to use rolls of photo paper as well as individual sheets; an automatic paper cutter slices each printed photo from the roll.

Take note that the paper sizes used in this book are those familiar to American and Canadian readers; paper in other parts of the world has different dimensions and identities. For example, the international letter size is known as A4 and its measurements are 8.27 × 11.69 inches, which is slightly narrower and longer than letter-size paper in the United States and Canada.

As you'll soon discover, photo papers can be costly. When making 5 × 7 inch (12.7 × 17.8 cm) or smaller prints, you'll save paper and money by buying letter-size (8.5 × 11 inch; 21.6 × 27.9 cm) paper and using the "picture package" feature of your image-editing software to automatically fit two or more photos on the same sheet of paper (see page 365).

Once you find a photo paper that you like for the majority of your printing needs, it is more economical to purchase a box of one hundred or more sheets instead of packages with smaller quantities.

Be sure to follow the manufacturer's instructions for careful handling of the paper. Keep paper in its original packaging to avoid dust and inadvertent damage. Hold photo paper at its edges to prevent fingerprints or marks on the surface. After printing, allow the paper to dry thoroughly, especially before stacking prints together, putting them in albums, or framing them. Some fiber-based papers require hours or days to dry instead of the few minutes needed for resin-coated (RC) papers.

Papers vary greatly in their resistance to water; test a printed piece of paper by dragging wet fingers over the image. Both before and after printing, keep photo papers away from high humidity and extreme heat. Light and air pollution, especially

ozone, can be harmful as well. Proper mounting and framing will prolong the life of important pictures (see page 378).

GETTING CONNECTED TO A PRINTER

In order to make a print, you give commands to a printer using software in your computer. But first you must make a connection between those two hardware devices.

Most computers are connected directly to a printer with a USB or PARALLEL CABLE that plugs into the respective USB or parallel ports on both devices. To avoid printer malfunctions with a USB cable, be sure it is plugged into the computer itself, not into a hub with multiple ports.

Some computers and printers can be connected WIRELESSLY if both have built-in wireless capabilities, or if you set up an optional wireless network between the two devices.

Whether wireless or not, your computer and printer must be plugged into electrical power, unless they can be operated with BATTERIES. At present, only a few small snapshot printers can be used with optional battery packs, and they can be teamed up

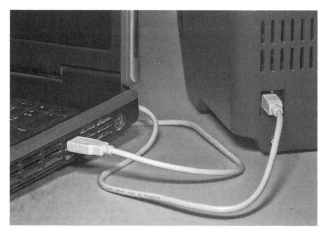

15.10. The most common way to directly connect a printer to any computer is with a USB cable, as shown here. Wireless connections are often more convenient because no cable is required, but both devices must be enabled for wireless communication (see text).

with battery-powered laptop computers for complete portabil-
ity and printing in the field.

An increasing number of inkjet and dye-sub printers feature
MEMORY CARD SLOTS so you can *bypass a computer entirely and print
directly from the card.* Of course, check that your type of memory
card will fit into the printer before buying it; most printers have
multiple slots. Also, if you prefer to make prints without going
through a computer, look for a printer with a large built-in LCD
monitor and image-editing features so you can preview and fix
up the pictures before printing them.

Another option with some printers is to connect directly to
your camera with a USB cable and print from the memory card
in that manner. Both camera and printer must have a feature
called PICTBRIDGE that allows communication between them via
the USB cable.

A few printers incorporate a CAMERA DOCK in which you

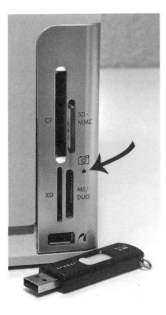

15.11. Card reader slots on some desktop photo
printers enable you to make prints directly from
your memory card without being connected to
a computer. This inkjet printer has five slots that
accept CompactFlash (CF), Secure Digital(SD)/
MultiMediaCard (MMC), xD-Picture cards (XD),
and Memory Sticks (MS/DUO), plus a USB port
for a flash drive (on table) or a connecting cable to
an external hard drive. On this model, a "photo
light" (see arrow) flashes when a memory card or
storage drive is being accessed by the printer; it is
a warning not to remove the card or drive until the
flashing stops because the file data might become
corrupted.

place the camera and avoid the need for a connecting cable to access the memory card.

Others allow you to plug in a MEMORY CARD READER to the printer's USB port so you can print directly from a memory card that has been removed from the camera.

In addition, there are printers with Wi-Fi, Bluetooth, or IrDA (infrared) technology that allow you to make WIRELESS CONNECTIONS with wireless-enabled cameras in order to print directly from a memory card.

SETTING THE PRINTER TO MAKE PRINTS OF YOUR PHOTOS

If you use your computer to operate your printer, a PRINTER DRIVER must be installed on the computer so the two devices can communicate. Windows and Mac operating systems include drivers for many printers and will automatically establish a data link between computer and printer when they are initially connected with a cable or wirelessly.

If your computer does not automatically recognize your printer by indicating "New Hardware Found" when you first connect the two devices, you need to download the software with a printer driver that is on the CD that came in the box with your printer. Insert the CD into a disk drive on your computer and follow instructions that appear on the computer screen.

Also included on the CD is an electronic copy of the printer's INSTRUCTION MANUAL, which you should install on your computer for easy reference. If you misplaced the CD, the printer driver software and the instruction manual can be downloaded from the Internet by logging on to the printer manufacturer's Web site and indicating the model number of your printer.

Note: a printer that allows you to print directly from memory cards does not need the printer driver to do so, but install the

software anyway in case you later want to operate the printer through your computer.

> Most printers that can print photos from a memory card without being connected to a computer have built-in software to make basic improvements to an image. They will do this automatically, or you can manually adjust brightness, contrast, color saturation, and sharpness. You can crop the image, too. Take note that no changes are made to the actual image files on the memory card; any adjustments you make affect only the pictures you print.

After the printer is successfully connected to your computer, select the image file that you want to print. Review the previous chapter about what you can do with your image-editing software program to improve your pictures before printing them.

After you have selected and improved an image you want to print, you must choose settings for the layout of the picture on the photo paper, and for the actions of the printer, such as the number of prints to make. Click your image-editing program's **Print Icon**, which resembles a printer, or click **Print** in the **File** menu.

The PRINT DIALOG BOX that appears on your computer screen will vary according to your image-editing program. Some basic programs, like Picasa and Windows Live Photo Gallery, try to make printing very easy and require you to choose only a few settings. More advanced image-editing programs, like Adobe's Photoshop Elements and Apple's iPhoto, offer more options that give you greater control. *For explanations of the settings in your particular program, and the specific printing steps to take, use the program's "Help" feature.*

All programs ask you to choose a LAYOUT for the pictures you want to print on a single sheet of paper, and they show you a PREVIEW of how the print will look on letter-size (8.5 × 11 inch; 21.6 × 27.9 cm) paper. The main choices are to print an

15.12. In many image-editing programs, a layout page appears when you select an image file to print. You'll also see a preview of the picture as it will look on a standard 8.5 × 11 inch (letter-size) sheet of photo paper. Shown here is the Layout/Preview step made with a Photo Printing Wizard that guides you through the simple printing procedure in the Windows Live Photo Gallery program.

"individual photo" or a "picture package" with multiple photos. Some programs also let you print a CONTACT SHEET that shows thumbnail-size photos of all the image files you select.

When printing an INDIVIDUAL PHOTO, you can select a standard photo PRINT SIZE, such as 8 × 10, 5 × 7, or 4 × 6 inches (20.3 × 25.4, 12.7 × 17.8, or 102 × 15.2 cm), or choose **Custom Size** and set your own print dimensions. If selecting a small print size, you can have it printed as a single image or as many times as it will fit on the sheet of paper.

If the individual image you want to print is horizontal, some image-editing programs will automatically position it in the LANDSCAPE orientation so it prints properly on the paper; like-

15.13. The aspect ratio of the image you want to print may not be the same as the size of the print you want to make. Some image-editing programs, like Picasa shown here, have a one-click control to automatically *crop* the image to fit the print size (see right arrow and right photo). Another one-click control automatically *shrinks* the image so it fits the print size without being cropped, which may increase the borders (see left arrow and left photo). The print size selected here is 8 × 10 inches on standard 8.5 × 11 inch photo paper.

wise, a vertical image should appear in its proper PORTRAIT orientation. If not, you must reset the orientation of the image. In many programs, click **Page Setup** to make this change.

Because the ASPECT RATIO of the image file (see page 55) and the print size you choose may not match, you have a choice of cropping parts of the image that fall outside the print's dimensions or including all of the image within those print dimensions. Alternately select and deselect the **Crop to Fit** box to see in the Preview window how the picture will change. You also can crop an image to fit a particular size of paper by using your image-editing software (see page 323).

Choosing a PICTURE PACKAGE is an economical way to save photo paper when making prints smaller than 8 × 10 inches (20.3 × 25.4 cm). For example, on a letter-size (8.5 × 11 inch;

15.14. A "picture package" option in some image-editing programs enables you to print more than one picture on a sheet of photo paper, and in different sizes. The drop-down Layout menu (see arrow) on the Print Photo page in Photoshop Elements 7 offers many combinations, such as the one chosen here: one 5 × 7 inch and four 2.5 × 3.5 inch prints on a sheet of 8.5 × 11 inch (letter-size) paper. A frame called Classic Oval was selected for this photo from two dozen frame designs that are available when you print a package of pictures.

21.6 × 27.9 cm) sheet you can print two 5 × 7 inch (12.7 × 17.8 cm) or twenty 2 × 2 inch (5.1 × 5.1 cm) pictures, plus all sorts of combinations of other print sizes, among them: 4 × 6, 4 × 5, 3.5 × 5, 2.5 × 3.25, 2.5 × 3.5, and 2 × 2.5 inches (10.2 × 15.2, 10.2 × 12.7, 8.9 × 12.7, 6.4 × 8.3, 6.4 × 8.9, and 5.1 × 6.4 cm). The same image will be repeated in all of the pictures, although some programs allow you to use different images in the same package.

If you want a printed reference for some of your image files, make a CONTACT SHEET, which is sometimes called a PROOF SHEET or an INDEX PRINT. Your program may allow you to select the number of columns of thumbnail-size photos to be printed on an 8.5 × 11 inch (21.6 × 27.9 cm) sheet of photo paper, which determines the size and number of images per page. Other programs print a fixed size and specific number of thumbnails. You

15.15. Most image-editing programs enable you to print what is called a contact sheet, proof sheet, or index print that shows a number of image files on one sheet of photo paper for easy reference. You can set the number of rows and columns, which determines the size and total number of thumbnail prints per sheet (see arrow). The file name can be included under each image to identify the pictures.

also may be able to choose whether or not to print the file name, shooting date, and/or a caption under each image.

The **Print** dialog box in some image-editing programs includes settings you need to make in regard to the printer itself. If your computer has print driver software installed for more than one printer, you must select the name of the printer you intend to use and make sure it is connected to your computer. Then click printer **Preferences**, **Properties**, **Setup** (or something similar) to open a dialog box for the document you're going to print.

Although the dialog box varies for each brand of printer, it is where you set the paper type, paper size, print quality, and print color. Paper is sometimes referred to as "media."

It is especially critical to set the correct PAPER TYPE or MEDIA

TYPE when printing photos. This determines the amount and pattern of ink sprayed on the specific paper; matte papers absorb more ink than glossy papers. Unless instructions packed with your photo paper advise otherwise, never leave the paper type or media type set at **Plain Paper**, which is usually every printer's default setting.

The drop-down list of paper/media types in the dialog box varies with the brand and model of your printer; the list often features papers that are the same brand as the printer. Also, check instructions packed with the photo paper for the paper/media type to set according to various brands and models of printers. And you can consult the printer's instruction manual for more details about the proper paper/media type to set for the paper you are using.

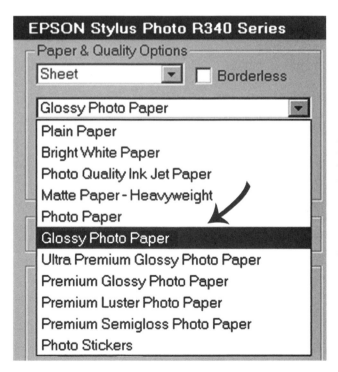

15.16. When you are ready to make prints, one step is setting the *type* of the photo paper you will be printing on. This drop-down menu for an Epson printer shows a partial list of paper types. Chosen here (see arrow) is Glossy Photo Paper, a popular type of photo paper.

Be certain to set the PAPER SIZE so the paper you are printing will be fed properly into the printer, and the print head will operate accurately. The default setting is usually letter-size (8.5 × 11 inches), unless you are using a snapshot photo printer that can only use smaller sizes of paper. Depending on the printer, the drop-down list of paper sizes may be limited or lengthy; some lists include both U.S./Canada and international sizes. Note: do not confuse Paper Size with the Print Size settings made earlier in the layout (see page 364).

A BORDERLESS PRINT setting is featured in some printer programs, which means the picture will extend to all four edges of the paper and there will be no border around the image. Some sizes of paper do not allow borderless printing; the program will warn you if you select an unusable size.

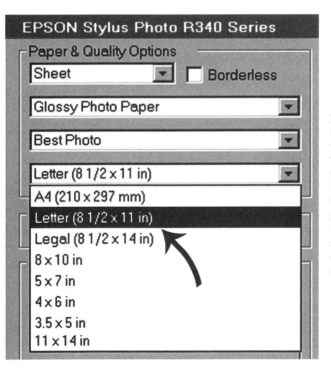

15.17. Another step when you are ready to make prints is setting the size of the photo paper you will be printing on. A partial list of paper sizes is shown on this drop-down menu for an Epson printer. Chosen here (see arrow) is Letter, a standard photo paper size measuring 8.5 × 11 inches.

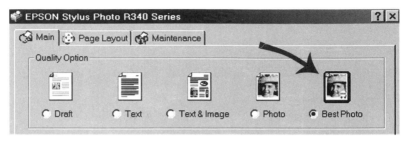

15.18. Don't overlook the settings for *print quality* when you are printing pictures. Choose one of the "photo" settings, which vary with the printer and the type of photo paper you are using. This Epson printer offers three choices: Text & Image, Photo, and Best Photo, which has been chosen here (see arrow).

An important setting to make is PRINT QUALITY. The choices vary with the printer and the paper type or media type you set, so always set the paper/media type *first* (see pages 367–68). For the highest print quality, set **Best** or **Best Photo** instead of **Normal** or **Photo**. At the highest-quality setting, the PRINTER RESOLUTION is increased and produces finer detail in the photographs (see page 378). To accomplish this, the PRINTER SPEED slows down, but that is of little consequence to photographers who want the best print quality.

Don't forget to set the PRINT COLOR, which is either **Color** or **Black-and-White** (sometimes termed **Monochrome**). Some programs also have a **Sepia** setting. And there may be **Advanced** settings so you can adjust a print's brightness, contrast, and color saturation (to make them muted or more vivid). Some offer grayscale adjustments so you can change the tones of black-and-white images.

Be sure to set the number of COPIES you want to print. We recommend that you initially print only one copy so you can carefully study it to see if any changes to the image, layout, or printer settings need to be made before making additional prints.

When all the print settings are made, LOAD THE PAPER PROPERLY in your printer. Remember that inkjet photo papers are

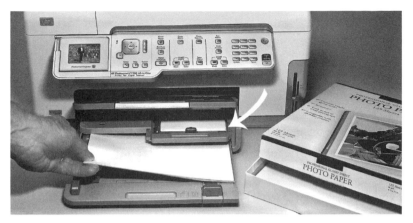

15.19. When loading a printer with photo paper, make sure the print surface is oriented correctly; with this HP model, that surface is placed facedown in the paper tray. This printer also has a special tray for 4 × 6 inch (snapshot-size) photo paper (see arrow).

coated for printing on one or both sides. Unless you are printing on a double-sided paper, *make certain the coated side for printing is placed correctly in your printer.*

Also, do not load too many sheets of paper into the printer at one time, especially heavyweight papers. Your printer's instruction manual will advise the maximum number of sheets allowed for specific types of papers.

Some image-editing and printer programs have settings for COLOR MANAGEMENT, which help ensure that the colors shown on your computer monitor and in the photo prints made by your printer will look as close as possible to those recorded by your digital camera. These settings involve technical matters such as monitor calibration, color gamuts, color spaces, and color profiles, which are especially of concern to professional photographers.

If there are color management settings in your software programs, leave them alone, or use the "Help" feature to find out about changes you might make to those settings if you are unhappy with the image colors in your prints or on your computer screen.

ANALYZING PRINTS AND MAKING IMPROVEMENTS

Once a finished picture comes out of the printer and the inks have dried, take time to analyze it. First, however, consider the VIEWING LIGHT you are using to evaluate the image. Keep in mind that the colors of your photographs will look different when viewed under natural (window) light, incandescent bulbs, or fluorescent lighting.

Be on the alert for obvious TECHNICAL PROBLEMS, such as light lines (called banding), faint colors, missing colors, or colors that don't seem true to your subject. Often the cause is an ink cartridge that has run out; some printers automatically stop when this occurs, others continue printing.

Another common cause for poorly printed photos is that a nozzle in the print head becomes clogged and the ink sprays intermittently or not at all. Check the printer's instruction manual to find out how to clean the print head and other procedures for printer maintenance. Whenever you have a printing problem, always look first in the manual's TROUBLESHOOTING section for possible causes and solutions.

PRINT QUALITY should be a major concern when analyzing a printed photograph. It is very disconcerting when your subjects lack fine detail and appear blurry or grainy. This is especially noticeable in enlargements that are 8 × 10 inches (20.3 × 25.4 cm) or larger but rarely evident with snapshots of 4 × 6 inches (10.2 × 15.2 cm) or smaller.

These problems occur because the resolution of the image is too low for the size of the print you've made; there are not enough pixels to produce the best-looking photograph. This is the main reason we recommend that you set your digital camera to shoot at its highest resolution if your ever expect to make large prints.

The other thing you must do to ensure the best print quality

15.20–15.21. A picture that is shot or saved at a low resolution may look okay when printed at a small size, as was the photo on the left. However, print quality often suffers when the same image is enlarged to a greater print size, as evident with the portion shown in the photo on the right.

is RESIZE THE IMAGE so it will fit the size of the photo you want to print. Image-editing programs often do this *automatically* when you select a standard or custom print size.

For example, to automatically resize an image using Adobe Photoshop Elements 7, after an image file has been opened and appears on the computer screen, click **Print** in the drop-down **File** menu. In the **Print** dialog box, under **Print Size**, click **Actual Size** and choose from a drop-down menu of standard print sizes.

The more advanced image-editing programs allow you to RESIZE IMAGES MANUALLY, which gives you the most control for producing prints of the highest quality but requires a number of steps. Following is the procedure to follow to *manually* resize an image with Photoshop Elements.

This may seem complicated, especially when doing it for the first time, and that is why casual photographers often choose the easier option and let the image-editing program automatically resize their pictures for printing.

Using Photoshop Elements, after you **Open** an image file on the computer screen, click **Image** in the main menu, then click **Resize**, and finally click **Image Size**, which brings up the **Image Size** dialog box (see illustration 15.22).

Here you'll see **Pixel Dimensions**, which indicates the total number of pixels in the image file. Below it, **Document Size** shows you the size the image will print at the **Resolution** indicated. The program defaults to a resolution setting of 180 pixels per inch (ppi). You recall that the more pixels per inch, the higher the resolution, which means the greater the detail in a photo.

Although 72 ppi is an adequate resolution for pictures to be sent in e-mails or viewed in Web pages on a computer screen,

15.22. Image-editing programs will automatically resize an image to fit the print size you select. You also can resize an image *manually* with some programs, including Photoshop Elements shown here. This Image Size dialog box shows the initial pixel and physical dimensions of your image and its resolution, which you can change for the best picture quality when printing (see text). Also see illustration 15.23.

pictures that are printed require a higher resolution in order to show fine detail. The ideal resolution for printing is considered to be 300 ppi, and this is the setting you should put in the **Resolution** box. Before you do so, make sure the **Resample Image** box is unchecked.

After you enter 300 pixels/inch, notice that the **Width** and **Height** dimensions under **Document Size** have changed to show the maximum size print that can be made at the ideal resolution of 300 ppi. If those dimensions are too small or too large for the size print you want to make, enter either the desired width *or* height; the other dimension is linked and will change proportionally, as will the resolution. If the dimensions of the image are not the same as the print size you desire, you'll have to crop the image accordingly (see page 323).

If the resulting resolution is 200 ppi or higher, you may be satisfied with the print quality that results, depending on the size of the print you make and your viewing distance from the print. Make a test print and be the judge; sometimes even a print with a resolution of 150 ppi will be acceptable to your eyes.

An option that may seem to produce better results is to keep the resolution at 300 ppi and then resample the image, which changes the "pixel dimension" and thus the size of the image. First, check the **Resample Image** box, and make sure the **Scale Styles** and **Constrain Proportions** boxes also are checked.

Be aware that resampling an image may degrade the detail and sharpness of a picture because the image is INTERPOLATED. This means the image-editing program adds some new pixels when you upsize the image or discards some pixels when you downsize it.

To preserve the best image quality when resampling, you select the best interpolation method, which is normally **Bicubic** rather than **Nearest Neighbor** or **Bilinear**. However, Photoshop offers two refinements: **Bicubic Smoother,** when

Image Size

Learn more about: Image Size

OK

Cancel

Help

Pixel Dimensions: 9.46M (was 22.9M)

Width: 1575 pixels

Height: 2100 pixels

Document Size:

Width: 5.25 inches

Height: 7 inches

Resolution: 300 pixels/inch

☑ Scale St**y**les

☑ **C**onstrain Proportions

☑ Resample **I**mage: Bicubic

Nearest Neighbor

Bilinear

Bicubic

Bicubic Smoother

Bicubic Sharper

15.23. When adjusting image size with Photoshop Elements (see illustration 15.22), the initial pixel and physical dimensions are changed when you reset the resolution; 300 pixels per inch (ppi) is considered ideal for the best picture quality when printing. If the resulting document (image) size is not the size you want for a print, check the Resample Image box and change image width and height. In the drop-down box, also select the best interpolation method, which often is Bicubic (see text).

upsizing an image, and **Bicubic Sharper,** when downsizing an image. Choose the setting appropriate to your image file from the drop-down menu opposite **Resample Image**.

Now you can enter the desired width *or* height. The corresponding dimension of the print will automatically change, but the resolution you previously set at 300 ppi will remain the same.

After you click **OK**, there's another step you can take before printing: SHARPENING THE IMAGE. *Be sure you are viewing the image at 100 percent on the computer screen*; click **View** in the main menu, then click **Actual Pixels**.

To see if sharpening will improve the picture after you've

15.24. Before printing a picture, try sharpening the image to see if that improves its appearance. In addition to autosharpening, some image-editing programs offer manual sharpening by moving slider controls, as shown here with Photoshop Elements (see arrows). When checking or adjusting sharpness, view the image at 100 percent magnification for close inspection. And be careful not to oversharpen, which can degrade an image instead of improve it.

resized it, click **Enhance** in the main menu, then click **Auto Sharpen** and see if you like the results. For more precise sharpening control, click **Adjust Sharpness** instead, which opens a dialog box with manual controls and shows a preview as you make sharpening adjustments. Beware of oversharpening; it can cause unwanted artifacts in the image.

After an image is resized and sharpened to your satisfaction, be certain to click **Save As** and give the file a *different* name. That way it is easy to find the file again later to make additional prints, and the original image file will still remain with all its original pixels. (If you just click **Save**, the original image will be permanently changed if you have resized or sharpened it.)

As to a different file name when you **Save As**, we add "P" to the original file name (before the three-letter file extension) to indicate the file is resized for printing. We also add the print size, such as "P810" to designate an 8 × 10 inch print.

Do not confuse image resolution (discussed previously) with PRINTER RESO-LUTION. The resolution of an inkjet printer is indicated by DOTS PER INCH, abbreviated dpi, which tells you how many dots of ink will be printed in a horizontal line one inch long.

Although many other factors affect print quality, the more dots per inch, the smaller they will be and potentially the better the picture will look. That's because it is more difficult for our eyes to see the edges of smaller dots, so the image they create looks more like a traditional con-tinuous-tone photograph.

The maximum resolutions of modern letter-size and larger inkjet print-ers are 1200, 1440, 2400, or 2880 dpi, and all produce high-quality photo prints. Because they only make small-size prints, snapshot photo printers have a resolution of 300, 600, or 720 dpi.

Please note that if a printer's resolution is represented by two numbers, such as 4800 × 1200, the *smaller* number represents its *true* resolution; disregard the larger number of the pair when comparing printer resolu-tions, because that number represents resolution that has been digitally enhanced to create a greater number of dots per inch.

MOUNTING AND FRAMING PRINTS FOR LONGER LIFE

After you spend the time, effort, and money to print some of your treasured photographs, be sure you mount and frame the prints properly in order to prolong their lives. Like other art-works, digital prints need protection from ultraviolet light, moisture, heat, and air pollution.

To frame a photograph you need a mount board, the print, a window mat, protective glass, and the frame itself. The MOUNT BOARD gives support to your print and helps prevent it from wrinkling. The WINDOW MAT separates the print from the PRO-TECTIVE GLASS so it won't become stuck to the glass over time. The mat also provides a wide border to set your image off from the surrounding frame.

Be sure to use "archival" mount boards and window mats,

15.25. Here's a simple and safe archival method for mounting photographs prior to displaying them in a wood or metal frame behind glass. Fold small strips of acid-free paper into triangles to hold the corners of the print, then secure them to the mount board with acid-free linen tape (see left photo). Afterward, a window mat that has been hinged to the top of the mount board with the same type of tape is lowered into position to cover the taped corners and make a frame around the print (see right photo).

which are free of chemical impurities that might cause print papers to stain or image colors to fade. Window glass or clear acrylic material like Plexiglas will protect the print from physical damage, dust, and especially the harmful ultraviolet (UV) light rays that can fade your photographs. When sealed in a frame, prints are kept safer from ozone and other atmospheric contaminants as well.

Take care when mounting a print to the mount board. Avoid ordinary glues, white paste, rubber cement, and cellophane or masking tapes, all of which may eventually bleed through the print paper and damage the image. Some spray adhesives have been specially formulated for mounting photos, but DRY MOUNTING TISSUE is the choice of professional framers.

Easiest to use is the pressure-sensitive, self-sticking type of adhesive tissue, rather than the heat-activated type that works best with a dry-mounting press. You cut a sheet of the self-sticking tissue to the size of your print, remove its protective backing, and press the tissue in place, first on the back of the print and then to the mount board.

Window mats come with precut openings to fit standard photo sizes, or you can cut your own custom-size windows with a mat cutter. Mats are available in a variety of colors, although basic white, black, gray, or beige mats work well with most photographs and do not distract from the image.

Frames are available in a great variety of wood and metal moldings. You'll find frames and mounting materials at frame shops, art supply stores, and some camera stores. A respected mail-order source for frames, mount boards, mats, and related supplies is Light Impressions in Brea, California. To learn more about the wide variety of products for protecting and displaying your photographic prints, log on to www.lightimpressionsdirect.com.

16

Using Local and Online Photo Services to Print Your Digital Pictures

A nyone who wants to enjoy all the benefits of digital photography should be familiar with desktop photo printers and printing, which were discussed in the previous chapter. However, if you'd rather not bother making prints yourself, there are numerous PHOTO CENTERS that will do the work. In many cases, this can be more convenient, faster, and less costly than making your own prints at home.

Photo printing is available in hundreds of local camera and imaging stores, as well as in camera chain stores like Ritz, Wolf, and Kits that are located throughout the United States.

In addition, thousands of photo centers are found in nationwide stores, including Target, Wal-Mart, Kmart, Sears, Costco, Sam's Club, Walgreens, CVS, and Rite Aid. Also convenient are FedEx Office Print Centers across the country.

Many photo centers offer three types of printing services: kiosk, over the counter, and online. By searching the Web, you'll find a number of photo centers that specialize in online service, such as Snapfish, Kodak EasyShare Gallery, Shutterfly, York Photo, winkflash, and PhotoWorks.

INSTANT PRINTS FROM STAND-ALONE PHOTO KIOSKS

When you are away from your home desktop printer, the quickest way to get prints of your digital images is to use a stand-alone PHOTO KIOSK. Within a few minutes of inserting a memory card, CD, DVD, or USB flash drive with your image files, the kiosk will deliver a finished print. The only delay is when other photographers are lined up in front of you to use the kiosk.

On average, the cost of a print at a photo kiosk is the same, or less, than the cost for ink and paper to make the same-size print on your desktop printer. For the least-expensive prints, use a photo center with over-the-counter or online service, which we describe later in this chapter.

This is actually a do-it-yourself operation because you use the kiosk's touch screen to choose the image(s) to print; you also can

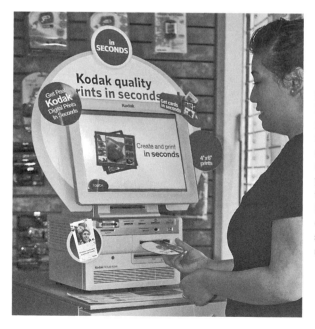

16.1. A variety of stores feature stand-alone photo kiosks, like this Kodak machine, that enable you to make photo prints instantly. After inserting a memory card, CD, or flash drive with your image files, you use a touch screen to choose the images to print, crop them, or make other improvements, and select print sizes and the number of copies (see text).

rotate, crop, remove red-eye, correct colors, adjust contrast and brightness, select the print size, and specify glossy or matte paper finish as well as the number of prints and whether you want a black-and-white or sepia-tone print instead of a full-color print.

Photo kiosks are creations of Kodak, Fujifilm, HP, Sony, and other digital imaging companies, and they vary in their features. For instance, using Wi-Fi, Bluetooth, or IrDA (infrared) technology, some photo kiosks will let you TRANSFER IMAGES WIRELESSLY from your digital camera, camera phone, PDA (personal digital assistant), or laptop computer. And some allow you to apply frames to your pictures, print without borders, and/or add text to the photos.

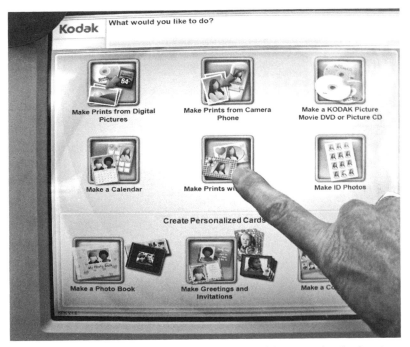

16.2. The touch screen on a photo kiosk offers a variety of choices, such as "make prints with borders," as shown here. Each selection you make gives step-by-step instructions and an opportunity to change your mind when shown a preview of your alterations to the image. Before any prints and charges are made, you can confirm or cancel your order.

There is a choice of standard photo sizes, such as 4 × 6 , 5 × 7, 6 × 8, and 8 × 10 inches (10.2 × 15.2, 12.7 × 17.8, 15.2 × 20.3, and 20.3 × 25.4 cm). Usually, you can select a PICTURE PACK-AGE with different photo sizes in order to print more than one picture on the standard 8.5 × 11 inch (21.6 × 27.9 cm) print paper.

Concealed inside the self-contained photo kiosk is a computer and one or more inkjet or dye-sublimation printers. After you use the touch screen to give the computer your printing instructions, the printer goes to work.

Just like your computer and printer at home, the kiosk's components are susceptible to glitches and printing errors. If you don't like the results, show the photo(s) to a store attendant for a credit, or otherwise you will be charged for every sheet of photo print paper delivered at the kiosk.

If you have trouble printing, ask if there are parameters for image files being printed in a particular photo kiosk. For instance, some will only print JPEG (.jpg) images, not TIFF (.tif) or other file formats.

To save time at a kiosk, download the images from your camera's memory card to your computer at home and PRE-EDIT THE IMAGES. Use your image-editing program to select, rotate, crop, fix red-eye, and make any corrections to color and exposure in advance. Then copy those improved pictures to a USB flash drive or a CD to use at the photo kiosk.

Some kiosks have a FLATBED SCANNER so you can digitally copy photo prints in order to make extra prints. This is a very welcome feature when a digital image file has been erased or a film negative has been misplaced and you only have an existing print.

You'll find specialized photo kiosks, such as Kodak's MOVIE KIOSKS, which make a slideshow of your digital pictures accompanied by music and puts it all on a DVD. This is an easy and

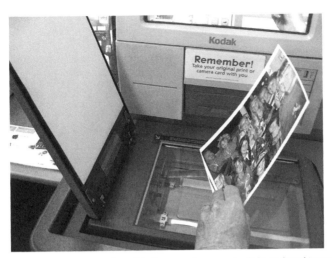

16.3. You can make prints at a photo kiosk even when you don't have digital images on a memory card, CD, flash drive, or camera phone. Just place an existing print facedown on the glass platen of a flatbed scanner and follow instructions on the touch screen.

novel way to show off a collection of your pictures from a vacation or wedding or other special event.

You select up to sixty shots from a camera memory card, USB flash drive, or CD, arrange thumbnail photos of those images in any order on the kiosk touch screen, and choose a prerecorded song. The kiosk's computer gives the show motion and a professional look by randomly making in and out zooms and left and right pans of the pictures. In five minutes, the DVD is delivered to you in a protective case that includes a print with thumbnail photos of all the images on the disc.

A photo kiosk may also be able to MAKE A CD of the images you select. This is especially useful when you're on vacation and fill up your camera's memory card. By making an on-the-spot CD at a photo kiosk, you preserve all the images from the card and then can erase the card to immediately use it again.

OVER-THE-COUNTER PRINTS IN ONE HOUR

Most photo centers also have COUNTERTOP TOUCH-SCREEN STA-TIONS that help you get prints on the spot in about an hour. As with the "instant print" stand-alone photo kiosks described above, you first insert a camera memory card, USB flash drive, CD, or DVD with your images. Next you select and improve the images on the touch screen, then choose the photo size; glossy, matte, or luster paper; and the number of prints.

However, instead of the few minutes it takes for a photo kiosk to make and deliver prints, your order is electronically transmitted to an adjacent PHOTO MINILAB that produces the prints in an hour or so. This is done digitally on CHEMICALLY PROCESSED PHOTOGRAPHIC PAPER that traditionally has been used to make prints from film negatives.

As a result, the so-called one-hour prints should have a longer life span than prints made by inkjet or dye-sublimation printers

16.4. Countless stores have photo centers that feature do-it-yourself kiosks for making prints. Most stores also have trained personnel who will offer assistance or do the printing for you.

in stand-alone photo kiosks or by your desktop printer at home. These minilab production prints are more resistant to fading from light and to damage by moisture and air pollution.

Trained staff at the minilabs will assist if you have questions or trouble while transferring and improving images and ordering prints at the countertop touch-screen station. Another option at some photo centers is to drop off your camera's memory card, USB flash drive, CD, or DVD with your images, indicate on the order envelope the size and number of prints you want, and let a staff technician do the rest (except make individual improvements to your images).

The choice of photo sizes is more extensive than at a photo kiosk. You can order prints at standard sizes such as 3.5 × 5, 4 × 6, 5 × 7, 8 × 10, and 8 × 12 inches (8.9 × 12.7, 10.2 × 15.2, 12.7 × 17.8, 20.3 × 25.4, and 20.3 × 30.5 cm), plus enlargements

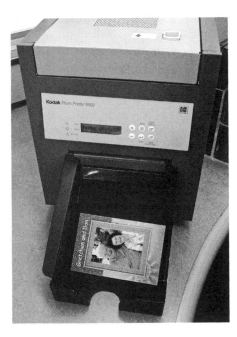

16.5. At photo kiosks, prints like this snapshot size are delivered instantly by photo printers. Or you can opt for later delivery by behind-the-counter machines run by photo center personnel. On-the-spot prints usually cost more than prints delivered in an hour or overnight.

of 11 × 14 and 12 × 18 inches (27.9 × 35.6 and 30.5 × 45.7 cm). Wallet-size prints also can be ordered.

Some countertop touch-screen stations are dedicated to making only the most popular snapshot-size (4 × 6 inch; 10.2 × 15.2 cm) prints. Prints of this size cost from about ten to thirty cents at photo centers; some minilabs reduce the per-print price if you opt for overnight service instead of picking up the prints in one hour.

> If you plan to have most of your digital prints made by a minilab at a neighborhood photo center, try out several to see which one produces prints with the best quality and gives good customer service. If you don't like the look of your prints, photo center personnel should be willing to remake them without charge—unless the problems are your fault, such as underexposed images that resulted in dark prints.

Prints should look similar to the image files displayed as pictures of the same size on your computer screen. However, your monitor might not be calibrated to show photos at their ideal brightness, contrast, and color. Also, the settings in your image-editing software may be wrong for the minilab's printing requirements.

When printing important pictures, especially enlargements for framing, ask the lab personnel about the specific settings to make in your image-editing program that will give the best results with the printing equipment they use. It's always best to crop and improve the image on your own computer, as well as set the print size and make sure its resolution is adequate to make a photo-realistic print (see page 373).

Because most minilab printing machines have algorithms to make automatic improvements to digital images, indicate "do not autocorrect" on the touch screen or order envelope so that no changes will be made to images you have pre-edited on your own computer.

Also, if you select the standard photo sizes offered by the

16.6. Using the photo kiosk touch screen, you can improve a picture before printing it by zooming in or out to enlarge or reduce the size of your subject, and then move around a "crop box" (see arrow) until you like the composition.

minilab, be aware that part of the image may be automatically cropped if the image file's ASPECT RATIO does not match the paper size). For example, all digital cameras (except full-frame SLR models) produce image files with an aspect ratio of 4:3. However, 4 × 6 inch (10.2 × 15.2 cm) prints and 8 × 12 inch (20.3 × 30.5 cm) prints have aspect ratios of 3:2.

16.7. One of the creative choices on touch screens at photo kiosks is adding a print border to frame the picture. You'll see a preview of various border designs in both horizontal (landscape) and vertical (portrait) formats, as shown here.

As a result, a portion of the image will be cropped from the top and/or bottom of a horizontal picture (or one or both sides of a vertical picture) when printed. If you want the entire picture printed, you must uncheck the crop box on the touch screen or write "do not crop" on the order envelope, which will result in borders on two sides of the picture.

Some touch screens will show you previews of how the picture would look uncropped and cropped. You may be able to move the image around on the screen to designate the specific portion(s) of the picture to crop.

Many of the over-the-counter one-hour photo centers will also make prints from digital image files you upload to them via the Internet. If one is located in your neighborhood, you can visit the store later that same day to pick up the prints you ordered.

PRINTS AND GIFTS GALORE FROM ONLINE PHOTO SERVICES

Digital photo printmaking has become a multibillion-dollar business. Growing annually in popularity are ONLINE PHOTO SERVICES that will make prints and photo items from digital image files you transmit to them via the Internet. The pictures and items you order are mailed to you or shipped by FedEx, UPS, or other delivery companies. Some online services let you pick up your prints at local cooperating photo centers.

A number of the online photo services originated as mail-order photofinishing companies that made prints from rolls of film, negatives, and slides that customers sent them. As you might expect, nowadays the majority of their business is devoted to digital imaging rather than film photography.

In addition, most of the online photo services offer free PHOTO SHARING, which allows you to store and display your photos

16.8. Search the Internet to learn about and compare online photo services offered by various companies, such as Snapfish shown here. In addition to making prints from your image files, most offer image-editing tools, ways to share and store your pictures, and an array of gift items that can be personalized with your photos.

online so they can be easily seen and enjoyed by family members and friends, and sometimes the general public. The online company's motive for photo sharing is to sell prints and photo products to the people who view your pictures. Search the Web to find "online photo services." Among the most prominent are those we listed earlier in this chapter on page 381.

Also, the image-editing software program you use in your computer may provide direct links to several online photo services. For example, with Picasa, when you click on **Create** in the main menu, then click on **Order Prints and Products**, more than a dozen online companies are listed. Even Microsoft's Windows and Apple's Macintosh operating systems have links to online photo services.

The first step to using any of the online services is establishing an account with your name, e-mail address, and a password. Then you can upload image files to your account according to directions from the online service. The image files will appear as

16.9. When uploading image files from your computer to an online photo service, you first place the pictures in albums that you create, such as this Picasa Web Album named Colonial Williamsburg. Photos in the albums can then be captioned, rearranged, moved or copied to another album, deleted, shared privately or publicly, and printed.

thumbnail photos, which you can organize into named categories called ALBUMS to help you keep track of the pictures. From those albums you select the images you want to have printed and those you want to share on the Internet.

To make an order, you indicate the print size, print finish, the number of prints, shipping address and delivery method, and type of credit card payment. Note that in the case of some services, the software for registering, uploading images, and ordering prints is not compatible with Macintosh (Mac) operating systems.

Most photo services explain everything in detail on their Web sites. Some feature "live chat" so you can ask questions and get answers online. For a good overview, log on to www .snapfish.com/howitworks and click on **take the tour**. To read step-by-step details for using Snapfish, click on **More Info** and/ or **online help**.

One consideration is the time it takes to upload your images to an online photo service's Web site; a high-speed connection

to your Internet provider speeds up the process. Although the images can be e-mailed, it is faster and more convenient to use the special software the service provides to upload your images as a group to its Web site.

Take note that when you upload image files to an online photo service, the image files also remain on your computer's hard drive.

By the way, some services allow you to send them a memory card, USB flash drive, CD, or DVD with your pictures instead of uploading the image files online.

Each service gives guidelines for the IMAGE FILE FORMAT required (usually JPEG), and the IMAGE RESOLUTION (file size in pixels) required for various print sizes. If the resolution of an image file is not adequate for the size of the photo you are ordering online, a warning will appear that the print will be of low quality unless you switch to a smaller print size.

Most services make prints in any of the various standard photo sizes, such as those listed on page 394. They also make enlargements, including a popular 20×30 inch (50.8×76.2 cm) poster size.

Before uploading any image files to an online photo service, make all improvements to the pictures with your own image-editing software. Most services offer editing tools to rotate, crop, fix red-eye, and correct colors and exposure, but usually it is easier and faster to use your computer's image-editing program in advance of uploading the images.

Some online photo services will store and display an unlimited number of images, either without charge or for an annual fee. Beware if the service requires you to order prints or photo products within a certain time period: if you don't order prints or products for a while, your images may be removed from its Web site.

Order Prints & Enlargements	Share & Organize	Create Cards & Calendars	Build Photo Books	Design Photo Gifts

Description

3.5x5 borderless print glossy	11X14 borderless print matte
3.5x5 borderless print matte	11x14 print with white borders glossy
3.5x5 print with white borders glossy	11x14 print with white borders matte
4x6 borderless Glossy print	12x18 borderless print glossy
4x6 borderless print matte	12x18 borderless print matte
4x6 Bordered Glossy print	12x18 print with white borders glossy
4x6 print with white borders matte	12x18 print with white borders matte
5x7 Borderless Glossy Print	16x20 borderless print glossy
5x7 borderless print matte	16x20 borderless print matte
5x7 Bordered Glossy Print	16x24 borderless print glossy
5x7 print with white borders matte	16x24 borderless print matte
5x7 Print with Decorative Boarders	18x24 borderless print glossy
Wallet Prints 4-up on 5x7 glossy	18x24 borderless print matte
Wallet Prints 4-up on 5x7 matte	20x24 borderless print glossy
Wallet Prints 8-up on 8x10 glossy	20x24 borderless print matte
Wallet Prints 8-up on 8x10 matte	20x30 borderless print glossy
8x10 Borderless Glossy Print	20x30 borderless print matte
8x10 borderless print matte	24x30 borderless print glossy
8x10 Bordered Glossy Print	24x30 borderless print matte
8x10 print with white borders matte	24x36 borderless print glossy
8x10 Print with Decorative Boarders	24x36 borderless print matte
8x12 borderless print glossy	30x40 borderless print glossy
8x12 borderless print matte	30x40 borderless print matte
8x12 print with white borders glossy	
8x12 print with white borders matte	
11X14 borderless print, glossy	

16.10. Online photos services offer a wide range of standard and large print sizes, as shown in this list from LifePics, a nationwide network of local camera, drug, grocery, and office supply stores where your prints can be picked up after ordering them via the Internet. Prints are offered in sixteen sizes, with or without white borders, and in glossy and matte finishes.

By the way, we do not recommend using online photo services for backup or archival storage of your digital images; ONLINE BACKUP DATA STORAGE SERVICES are best for that purpose (see page 301).

Online photo printing is a very competitive business, so shop around to find the service that produces high-quality prints that please you. PRINT PRICES are especially reasonable for the most popular photo size, 4 × 6 inches (10.2 × 15.2 cm); they range from ten to twenty cents. However, the price does not necessarily indicate print quality.

Many services will offer ten to twenty FREE PRINTS when you first register with them, and that is a simple way to sample their work. We suggest uploading the same images to two or three services and then making side-by-side comparisons for print quality when you receive all the photos.

In addition to comparing the print quality and prices at different companies, be certain to check *handling and shipping charges*, which can vary considerably. Also look for a *quick turnaround time* for processing your order, which should be within twenty-four hours. And always make sure there is a *satisfaction guarantee* that your order will be reprinted or your money refunded if you are not happy with the prints.

All online photo services offer a variety of PHOTO GIFT ITEMS that can be printed with your digital images. Favorites are calendars, greeting cards, posters, coffee mugs, aprons, coasters, mouse pads, stickers, puzzles, T-shirts, tote bags, and postage stamps (with first-class postage). Less-common items that also can be printed with your photos include pet bowls, golf towels, clocks, candy tins, and even boxer shorts.

16.11. Your pictures can be printed on all sorts of photo gift items when you upload image files from your computer to online photo services (see text). Shown here are a ceramic coffee mug, a jigsaw puzzle with its tin container, and a computer mouse pad.

Among the most impressive and popular products to feature your pictures are professional-looking PHOTO BOOKS, which make unique gifts for your family and friends. Imagine your own hardbound book of photographs displayed on a coffee table.

Using the online photo service's software, you choose the book size and number of pages, select photos from your digital files, pick a page layout and backgrounds, type any captions, and preview the result.

Common book sizes are 12 × 12, 8.5 × 11, 8 × 8, and 5 × 7 inches (30.5 × 30.5, 21.6 × 27.9, 20.3 × 20.3, and 12.7 × 17.8 cm) and smaller. You may get to choose either a hardcover or softcover and different cover materials and textures. The mini-

16.12. You'll be proud to show off your pictures in a photo book, which is easily made with the help of online photo services, such as MyPublisher.com shown here. After selecting and uploading image files to its Web site, you lay out the book using a choice of page templates, cover styles, and caption options provided by the service. Softcover or hardcover copies of your printed and bound photo book are shipped to you within a few days.

mum number of pages is often twenty (ten sheets with photos on front and back), but you can add more.

Unless you are using only small-size photos on every page, make certain your digital image files have high resolution so the pictures won't appear blurry and pixelated (show jagged lines) if enlarged to full-page size.

Once you place the order and pay for it by credit card, the book will be printed and bound in two to three days and then shipped to you. The cost of a twenty-page book can be as low as $20–$25. Because they are easy and rather inexpensive to create, it's no wonder that personal photo books have become a big hit with many photographers.

17

Sharing and Showing Off
Your Digital Photos

Thanks to digital imaging, today's photographs are more likely to be shown and shared electronically than as traditional prints. In this chapter you'll learn about e-mailing photos, as well as sending them in instant messages, and displaying them on photo-sharing Web sites, in digital picture frames, and on television screens, iPods, and other video players. We'll also discuss how to put a series of pictures into a slideshow that will grab the interest of your viewers.

E-MAILING YOUR DIGITAL PHOTOS

Sending photos to family and friends in e-mails via the Internet has become a popular way to share digital pictures and show off your abilities as a photographer. It costs nothing and is far more spontaneous than making prints and mailing them in an envelope.

Image files are usually sent in e-mails as FILE ATTACHMENTS in the JPEG (.jpg) file format. To speed up transmission time over the Internet, you should limit each e-mail to only a few image files and make sure each file is not very big.

Undoubtedly you have received an e-mail with a picture that

is too large for your computer screen. In order to view the entire photo, you had to scroll left and right and up and down. That's because the image was not resized and its pixel dimensions (picture width × height) were too big for the screen.

> Before sending a picture in an e-mail, the most important thing to do is RESIZE THE IMAGE so it is small enough for the entire image to be seen on any computer screen.

We repeat: whenever you intend to send e-mail with an image file, keep in mind that no one likes to view a picture that overflows the screen, so always resize your photos to a smaller scale that is appropriate for e-mail.

Another problem with e-mailing a photo at its full and original size is that it can take longer to transmit to the recipient, depending on the speed of your connections to the Internet. If either one or both of you have a slow dial-up telephone connection, rather

17.1. Don't be guilty of sending e-mails with photos that overflow your recipient's computer screen; no one likes to scroll back and forth and up and down in order to see the complete picture. Large images, such as the one shown here, should first be resized to smaller dimensions with image-editing software (see text and also illustration 17.2).

than the faster broadband cable or DSL connection, a large image file can take several minutes instead of only a few seconds to send and to be received.

Also, some Internet service providers limit the size of their e-mailboxes to only a few megabytes. That means large photo files can quickly fill up that space and cause subsequent e-mails to be rejected until the recipient empties his or her mailbox. As a result, if you send big file attachments, your pictures may never be seen.

Fortunately, all basic IMAGE-EDITING PROGRAMS offer a simple e-mail function that automatically resizes the image you select, or lets you choose an appropriate size, and then creates a file attachment with the photo to send in the e-mail.

In general, after you select the image file you want to send, you click an **E-mail** button or icon in the main menu. A dialog box opens that gives you a choice of picture sizes. There may be only a basic size description, such as Small, Medium, and Large. Or the box may show a choice of PIXEL DIMENSIONS (horizontal width × height) for the image; usually the choices are 640 × 480, 800 × 600, and 1024 × 768, but there may be even smaller (320 × 240) and larger (1280 × 960) sizes as well.

Note that in some programs, the size choices are indicated only by a single number, which is the longer side of the pixel dimensions: 320, 640, 800, 1024, or 1280.

Which size is best for sending a picture in e-mail? We suggest you choose **Small** or **Medium**, or the pixel dimensions of 640 × 480 or 800 × 600, so that the entire photo can be viewed on any computer screen.

> To see how your pictures will look on a computer screen when received, send yourself several test e-mails with the same photos at different image sizes; send a horizontal picture and a vertical picture. This will help you pick a specific image size to use when sending pictures in your e-mails.

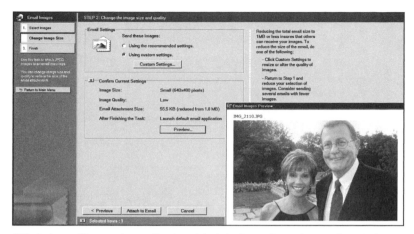

17.2. An image file sent via e-mail at its original size is usually too large to fit entirely on a computer screen, as seen in illustration 17.1. Using the e-mail feature of Canon's ZoomBrowser image-editing program, as shown here, the same photo was resized to 640 × 480 pixels so the full picture could be viewed all at once in an e-mail (see text).

Once you resize the image and continue to the next step, an e-mail **Message** box opens and shows that the resized image file has been automatically attached; the file name and the FILE SIZE in kilobytes (KB) appear in the **Attach** or **Attachments** box in the message heading. As a guideline, make sure resized images are less than 100 KB (they will be at 640 × 480 or 800 × 600 pixels).

Some image-editing programs also automatically insert text in the **Subject** box and add some promotional text to the message box, such as: "These pictures were sent with Picasa, from Google." You can delete the promo info and insert your own subject line and message before sending the e-mail.

When your e-mail is received, it will list the attached file and probably show a copy of the photo in the message box, depending on your recipient's e-mail program. If no picture is present, the recipient must click the attached file name to automatically open a feature in the computer's Windows or Macintosh operating system, or another software program, that will display the photo.

17.3. When a picture is sent as an attachment in an e-mail (see arrow), some e-mail programs will include the photo with the written message, as shown here. With other e-mail programs, you have to open the attachment in order to view the photo.

In addition to resizing the photo, the easy e-mail function of basic image-editing programs has algorithms that automatically set the RESOLUTION OF THE IMAGE for the fastest transmission over the Internet relative to the image size, and also SHARPEN THE IMAGE so it displays on the computer screen with the most clarity. The common resolution setting for photos being e-mailed is 72 ppi.

Keep in mind that when a resized photo is sent via e-mail as a file attachment, *the image file remains on your hard drive* with no changes to the original image size, resolution, or sharpness.

When resizing an image for e-mail, another choice usually offered is the **Original** size, which means the full image file will be sent. The ORIGINAL SIZE OF AN IMAGE depends on the number of megapixels recorded by your camera and whether you have cropped the image. For instance, a 6 MP (megapixel)

camera could produce an uncropped image with pixel dimensions of 3000 × 2000.

By comparing those original dimensions with the 640 × 480 or 800 × 600 pixel sizes we suggest using for photos sent in e-mails, it should be obvious why original images from most digital cameras need to be made *smaller* so they can be seen in their entirety on any size computer screen.

However, what if you are e-mailing a photo to someone who wants to MAKE A PRINT of the picture instead of just viewing it on a screen? In that case, you should attach the image file in its original size because the larger the file, the better the print quality will be.

If an image file sent in an e-mail is to be printed or kept, the recipient must save it to his or her computer's hard drive before the e-mail is deleted. This is done by clicking the file attachment

17.4. When a picture is received in an e-mail as an attachment (see arrow), you can click the image file name with your computer mouse to open a dialog box and save the image file to a folder, as shown here. Another option is to click the picture itself, if it appears in the e-mail, in order to open the Save Picture dialog box (see text).

name, or the photo itself if it appears on the screen, and then saving the attached picture in a folder with a file name that identifies the image.

Click on the **Help** feature of your computer operating system or image-editing program for specific advice about e-mailing pictures, including how to send more than one image file in the same e-mail.

If you want more control of the images you send, there is an alternative to using the mostly automatic e-mail function of basic image-editing programs that we described previously. With advanced image-editing programs, you can *manually* resize, set the resolution, and sharpen pictures to send in e-mails, as discussed in chapter 14 (see page 338).

SENDING PHOTOS IN INSTANT MESSAGES

In addition to e-mailing pictures, another way to share your digital photos directly with family and friends is through INSTANT MESSAGING (IM) via the Internet. Unlike e-mail, this is real-time communication between you and one or more persons who are online at the same moment and can directly respond to any message, including one that displays your photos. As the instant messaging name infers, your photos are transferred and received instantaneously.

AOL Instant Messenger (AIM), Yahoo! Messenger, Google Talk, and Windows Live Messenger are among the better known instant-messaging programs.

An instant-messaging (IM) program can be installed on your computer by downloading it free from the program's Web site or may already be part of your operating system. Next you create what is often referred to as a "friends list" or a "buddies list," which contains the e-mail addresses of the people with whom you want to share instant messages. Afterward, whenever you

17.5. With an IM (instant messaging) program, such as Google Talk shown here, you can send pictures to family and friends in real time while they are at their computers. Once you are chatting online, you click on image files or drag-and-drop them to your open chat window and then click the command to "send" the photos. Instant messaging seems more interesting when pictures are part of your online chat.

click on the icon for your IM program, your list of contacts appears with an indication of all those who are currently online with their computers.

To share photos, first you click on or drag-and-drop image files stored on your computer into the IM program window. Then you select the online recipients from your contact list, click a **Send** button, and your friends will instantly be notified that there is a message from you. When they click on the message, they'll see your photos on their computer screens, and you can chat back and forth about the pictures by typing on your keyboard.

SHARING YOUR PHOTOS ON
THE WORLD WIDE WEB

Although ONLINE PHOTO SERVICES (described in the previous chapter) allow you to share your digital pictures with others, there are more popular ways to show off your photos to family and friends or to a much larger audience. You can display them on PHOTO-SHARING WEB SITES such as Flickr and Photobucket, or on SOCIAL NETWORKING WEB SITES such as MySpace and Facebook, or in a BLOG, which is a personal journal you share via the Internet. Not surprisingly, photo-sharing Web sites are favored by photographers because it is easy to show off as many pictures as you wish.

In general, prior to uploading the images you want to share, you must first register at the photo-sharing Web site with your name, e-mail address, and a password. Also, you should initially download the special "uploading" software that makes it simple and relatively fast to copy any number of your images to the Web site all at one time.

Next, you browse the image file folders on your computer and select the photos to share. They are copied to new or existing ALBUMS that you create in order to categorize the pictures. The albums should have descriptive titles, such as "Shelly's Birthday," "Our Florida Vacation," and "Carrie and Shawn's Wedding." Once the photos are uploaded, you can move or copy them to other albums and reorganize them if desired.

Before you can share the photos, you must create a list with

Always remember that the Internet connects you to a global community, and anyone who views your pictures might copy them for personal or public use. If you don't want your photos to be shared with strangers, don't put them on the World Wide Web.

17.6. A blog is just one of the ways to share your photos with family and friends via the Internet (see text). Shown here is the personal journal of a friend who was making a trip around the world. In this entry, he posted photos of wild animals he saw on a safari in South Africa.

the e-mail addresses of your family, friends, and other contacts. The addresses automatically go into an address book when you first type them, so they will be easy to insert whenever you want to share other photos in the future.

You should know that the pictures you want to share are not actually sent in e-mails. (Photos that are e-mailed can take considerable time to send and to receive, and too many images or large files might jam up your recipients' mailboxes.) Instead, you e-mail an *invitation* to view your pictures, which recipients can view by clicking on a link to the photo-sharing Web site.

When family members or friends click on the link to an online photo service, a Web page appears with a personal message from you and thumbnail pictures from the album you've selected to share. Recipients can click on any image to enlarge it on the screen, or they can activate a slideshow that automatically presents large views of every picture in the order you have prearranged.

Your guests may be asked to register before they can view

your photos. And usually there are ads on the page explaining how to order prints or gift items that feature your photos.

Some photo-sharing Web sites are more community minded than commercially minded. One of the best known is FLICKR, an offshoot of the famed Web portal Yahoo! Flickr is a place to go when you want to share your photos with more than just family and friends.

You can designate each photo you upload as **Public**, for all Flickr members and others to enjoy, or as **Private** so it can be seen only by the members you designate as **Family** and/or **Friends**.

Joining Flickr is easy and free. You can upload up to 100 MB worth of photos every month and display as many as two hundred of your most recently uploaded pictures. Photographers who become addicted to Flickr can pay $25 a year for a "pro

17.7. Flickr is one of the most popular Web sites for sharing pictures on the Internet with people you designate: family, friends, and/or the general public. Once you sign up for free membership, you can upload image files to Flickr (see arrow) directly from your computer or mobile phone (see text).

account" that allows unlimited uploads and unlimited photos to be displayed.

Whenever you upload a photo, you are urged to add written TAGS, titles, and descriptions that identify the content of the image. Tags are KEYWORDS that help you and other members find specific images or a general category of pictures; just type one or several tags in the **Search** box and photos that have been labeled with any or all of those keywords will be displayed.

Flickr also is a good place to find thousands of **Groups** that display photos of your special interests, whatever they may be. Type a subject in the "Find a group" **Search** box, and you're bound to discover photos related to it, whether slimy snails, kickboxers, or unicycles. The heading for each group lists how many members, the number of photos posted, any discussions, and when the group was created.

Anyone who is registered at Flickr can join a group or start his or her own group, even if it is just to share the photos of your

17.8. The Internet offers opportunities to share your pictures with other photographers who have an interest in your favorite subjects. In the example shown here, hummingbird photography is one of the "groups" you can join on the Flickr Web site, www.flickr.com (see text).

wedding anniversary or a class reunion. You can keep a group **Private** so only those whom you invite can see the pictures posted there, or you can make it **Public** so that either those you invite or anyone can view the groups' photos.

SHOWING OFF YOUR PHOTOS IN A DIGITAL PICTURE FRAME

A very personal and novel way to display your pictures is in a DIGITAL PICTURE FRAME. This is an electronic device that can show off your photos on an LCD screen surrounded by a picture frame that stands on a table or hangs on a wall. Some frames can even be attached to refrigerators to replace a haphazard display of family snapshots. Many come with different frame or mat materials to fit the decor of your home or office.

Digital picture frames are made in a variety of sizes, which are determined by diagonal measurement of the rectangular LCD screen. Most common are 7-, 8-, and 10-inch (17.8, 20.3, and 25.4 cm) frames, but others range from 5.6 inches (14.2 cm) to 22 inches (55.9 cm).

The cost of a digital picture frame depends largely on the size of its LCD screen, plus special features, such as being able to connect wirelessly to your camera or computer to download images. Prices of the most common sizes are $100–$200. There are more than two dozen brands of digital pictures frames, including Kodak, Cevia, Philips, Coby, Westinghouse, Digital Spectrum, Pandigital, PhotoVu, Smartparts, and MediaStreet. Log on to www.digiframes.com to see the wide selection.

Comparing digital picture frames is difficult unless you view them with photos being displayed. They vary considerably in screen resolution, brightness, and viewing angles, all of which affect how sharp and vivid your pictures will appear. To review technical specifications before purchasing a frame, go online to

17.9. A popular way to show off photographs to family and friends is in a digital picture frame. The frame is actually an LCD screen that is available in various sizes and surrounded by frames of different styles (see text). This table or wall model features a remote control to manually change from one picture to the next or to display all the images as a slideshow.

the manufacturer's Web site and read the user's manual for the model that interests you.

Especially important is how image files can be downloaded to the frame. Most have slots to insert memory cards direct from your camera; check if the type of card in your camera can be used. Also, there should be ports for a USB flash drive and for a USB cable that connects to your computer for downloading images. Some frames allow images to be transferred wirelessly. Any Ceiva frame can be downloaded with pictures by connecting it to a telephone line to transmit images you first upload to the frame maker's Web site.

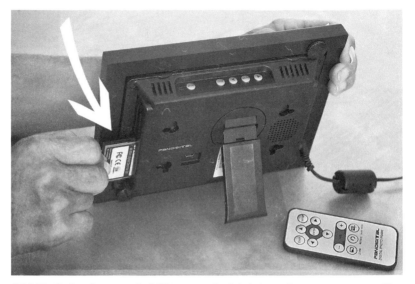

17.10. To display photos on the LCD screen of a digital picture frame, a memory card is inserted on the back side (see arrow). Buttons at the top of this frame control the display, or you can use a remote control (bottom right). A cord is attached to provide electrical power.

All digital picture frames display JPEG (.jpg) images and may also show other file formats, including video. A few will play audio files with music or sounds recorded by your camera. The size of the frame's internal memory will limit the number of photos and other files that can be stored; the more megabytes (MB) of memory, the better.

Be sure to check how photos will be displayed. Some frames rotate vertical images automatically to display them upright rather than horizontally; otherwise you'll have to rotate them in advance with your computer or camera, or use the REMOTE CONTROL that is supplied with some of the frames. Also, the image size may be automatically adjusted to fit the LCD screen, or you may have to resize large images in advance with your computer.

You can choose to show only a single image or to activate a SLIDESHOW FEATURE so pictures appear one after the other

according to a variable display time you set. Photos are shown in your prearranged order, though some frames have a "random order" option so the show will not be repetitious.

Although all digital picture frames require electrical power, a few include rechargeable batteries for short-term use away from a wall outlet. Some feature clock timers that turn the frames on and off at the times you choose.

DISPLAYING YOUR PHOTOS ON TELEVISION

Some photographers say that viewing photos displayed in a digital picture frame is like watching a miniature flat-screen TV. Another impressive way to share your pictures is to show them on a full-size television screen. And it's easy to do.

When the pictures are on the memory card in your camera, just connect the AUDIO/VIDEO (A/V) CABLE or VIDEO CABLE that came in the box with your camera. One end of the cable plugs into the A/V or video output socket on the camera. The yellow plug on the other end goes into a yellow video input socket on the television set. If it is an A/V cable, the third plug attaches to an audio input jack on the TV set so that you can hear any sound recorded by your camera (see also page 9).

Turn on the television to a "video" channel, then turn on your camera in its playback mode to see one of your pictures appear on the screen. Press the appropriate buttons on your camera to scroll through all your images as if you were reviewing them on the camera's LCD monitor.

To save battery power, the camera's LCD monitor will turn off automatically whenever the video or A/V cable is plugged into your camera. For a lengthy viewing session on a TV screen, connect the camera to an AC ADAPTER that's plugged into an electrical outlet for power.

Your camera may have a SLIDESHOW function that will

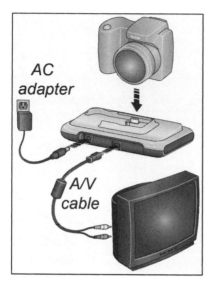

17.11. To show the pictures on your camera's memory card directly on a TV screen, plug one end of an audio/video (A/V) cable into your camera or its camera dock (shown here). The two plugs at the other end go into the appropriate video and audio sockets on the television set (see text). To save your camera batteries, use an AC adapter (as this camera dock does) in order to provide power to the camera. (Illustration courtesy of Eastman Kodak Company.)

automatically display one picture after another—check the camera's instruction manual. Each photo will remain on the screen for a few seconds; some cameras allow you to set the amount of time.

Activating the slideshow feature is an enjoyable way to share pictures you've just made at a party or family event. When going on vacation, don't forget to take along the video or A/V cable so you can connect to the TV set in your hotel or motel room and relive the day's activities.

Be aware that the quality of the images you see can vary according to the TV set. The resolution of most television screens is rather low, so your photos may not appear very sharp. To critically judge the quality of your pictures, view them at their full image size (100 percent) and resolution on your computer screen rather than on a TV screen or your camera's LCD monitor.

Another way to display your pictures on television is to copy them onto a CD or a DVD and put it into a DVD PLAYER connected to a TV set. Make certain the DVD player is capable of showing discs with images "burned" by your computer. The file

17.12. If you plan to show your pictures on a television screen by making a DVD or CD to put into a DVD player, remember to optimize the size of the image files for the best display. Some image-editing programs, such as Photoshop Elements 7 shown here, will automatically resize images to the pixel size you designate when making a slideshow (see below and also illustration 17.13).

format of all the images must be JPEG (.jpg). For a snazzy presentation, you can organize the pictures into a slideshow with background music.

LETTING YOUR PHOTOS STAR IN A SLIDESHOW

Whether you are showing off your pictures on a television screen or in a digital picture frame, they are more enjoyable to watch when you organize them into a SLIDESHOW instead of just displaying them randomly one at a time. The term originated with film photographers, who put their color slides in a projector to show larger images on a screen.

A slideshow is a wonderful way to give some life to static images. In fact, slideshows have become such a hit with viewers that image-editing programs enable you to create them in a few easy steps. Most photo-sharing Web sites also have a feature to assemble a slideshow from the photos you select from your albums.

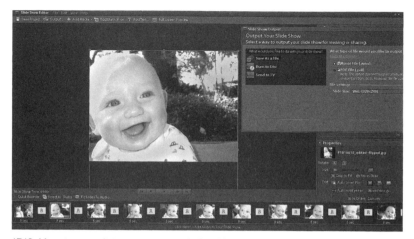

17.13. Many image-editing programs, including Photoshop Elements 7 shown here, make it easy to assemble impressive slideshows. You can save the show as a file to send in an e-mail, display on the Internet, show on a television set, or record to a CD or DVD for a lasting photographic memory.

Many slideshows are simply a group of pictures that automatically appear one after the other at an interval you select. Or you can advance each picture manually.

In fact, whenever you download new photos from your camera to a new folder on your computer, you can easily review them in full-screen size as a slideshow. Just click on the folder name or icon and then activate the **Slideshow** feature of your Windows or Mac operating system or your image-editing program. You can do the same to review pictures in any folder that is on your computer.

For fancier slideshows, use a software program that offers a choice of transitions, such as dissolving one image into another instead of making an abrupt change between pictures. Also, use zooming and panning techniques on your pictures to give the show a professional look. And you can add captions, music, narration, and other sounds to make a presentation that's even more impressive and entertaining.

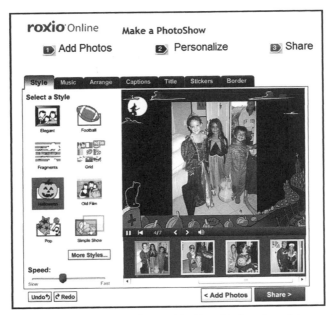

17.14. Try your hand at creating a professional-looking slideshow free of charge at www
.photoshow.com. After choosing the images to include, you select a presentation style
and background music, write titles and captions, add optional effects if desired, then
upload your show for family and friends to enjoy at the host Web site (see text).

Before buying any special software, try creating a free pro-
fessional-looking slideshow by logging on to www.photoshow
.com and clicking on "Make a PhotoShow." The slideshow you
put together with music, captions, and various transitions will
be saved to your own Web page at the PhotoShow Web site,
where your family and friends (and the public, if you permit)
can watch it at any time.

Another slideshow option is available with some image-
editing and organizing programs, including PICASA, which can
be downloaded free at www.picasa.google.com. After selecting
the photos you want to show, you create a "movie" that is saved as
a video file and can be e-mailed as a file attachment. Recipients
see your "moving" pictures by using MEDIA PLAYER SOFTWARE,

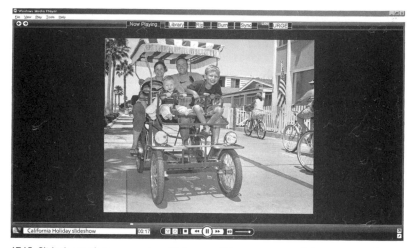

17.15. Slideshows that you create with image-editing programs and then save as video files can be viewed on your computer with media player software, such as the Windows Media Player shown here. When your video files are sent as attachments in e-mails, family and friends also can watch your slideshows on their computers' own media players, which can be downloaded from the Internet without charge (see text).

such as RealPlayer, Adobe Flash Player, Windows Media Player, or QuickTime Player, which are on many computers or can be downloaded free from www.real.com, www.adobe.com, www.microsoft.com, and www.apple.com.

Remember, when you select pictures for your show, those in a vertical format will appear smaller in order to fit the horizontal format of computer and television screens. In addition, there will be wide black borders on both sides of vertical images. For those reasons, some photographers crop vertical shots to a horizontal format or pick only horizontal photos for their shows.

Also, when putting together a slideshow, make sure it is interesting and not too long. Family members and friends probably will take the time to look at all your photographs, but the Web-browsing public will stop watching your slideshow as soon as they get bored.

To save a completed slideshow, copy (burn) it to a CD or

DVD by using the disk drive in your computer. Keep the CD or DVD for your future enjoyment or give copies to family and friends, who can view the show on their computers or use a DVD player to see it on a television screen.

Your slideshow also can be saved as an ADOBE PDF FILE and sent as an attachment in e-mails. Recipients view the pictures with the Adobe Reader software program, which is on most computers or can be downloaded free from www.adobe.com. Note, however, that only the photos will be shown and must be advanced manually by the viewer; any fancy transitions, zooms, pans, and music included in your slideshow will not be saved in PDF files.

Check your image-editing software's "Help" menu for instructions on how to create a slideshow or movie step by step. Some programs, such as Adobe Photoshop Elements, give you a choice of making a "simple" slideshow to save and view as a PDF file, or a "custom" show with all the bells and whistles to save and view as a video file.

Another option was described earlier, the remarkable Kodak MOVIE KIOSK that automatically assembles your pictures into a slideshow with dissolves, zooms, pans, and music, and then delivers the finished show to you on a DVD in about five minutes (see page 384).

EXHIBITING PHOTOS ON IPODS AND OTHER PORTABLE MEDIA PLAYERS

To show off pictures of your family, you can turn on your iPod or other PORTABLE MEDIA PLAYER instead of pulling out keepsake photos from your wallet. With large-capacity memories of up to 120 GB (gigabytes), these handheld players can store thousands of digital images to display on their small LCD screens. They also will show movie clips (videos) and play audio recorded by your camera (see chapter 18).

17.16. Portable media players let you share your photos with anyone at anytime and anywhere. Pictures are viewed on a 3.7-inch screen with this model, a Zune that has 80 GB (gigabytes) of storage space for digital files downloaded from your computer (see text).

Apple's iPod is the best-known brand, but there are many competitors, including Microsoft's Zune. Among the makers of portable media players are Epson, Samsung, SanDisk, Toshiba, Philips, Kodak, Archos, Creative, Cowon, iRiver, Coby, Dane-Elec, and Kingston.

A major consideration when buying a player to display photos and movie clips is the size of its LCD screen, which can range from 1.5 to 7 inches (measured diagonally). Go online to check the player's other technical specifications, including the hard drive or flash memory capacity, battery life, and whether image file formats in addition to JPEG (.jpg) can be displayed.

To download your image files, most players connect to your camera or computer through a USB cable. Some also have slots for memory cards that you remove from your camera to directly download images instead of doing so through a connecting cable.

18

Shooting Video Clips, Recording Sound, Using Camera Phones, and Scanning Photos

SHOOTING VIDEO CLIPS WITH YOUR DIGITAL CAMERA

First-time users of digital cameras often are surprised to find a shooting mode named "movie." It is indicated by an icon that resembles an old-time Hollywood motion picture camera. Although the MOVIE MODE is common to many models, all but a few SLR cameras are currently excluded from having this feature because of the nature of their viewing systems.

If your camera does have a movie mode, don't get the idea you can make a major film; that's a job for digital video cameras. Digital "still" cameras are capable of making VIDEO CLIPS, which usually are of short duration, depending on the capacity of the memory card. In addition, they may look somewhat jerky and grainy. However, your minimovies will be good enough to share with family and friends in e-mails or on social networking Web sites like Facebook and MySpace. You'll also enjoy watching them on a television screen.

Some cameras have a built-in microphone and will record audio at the same time you are making the video clip. Afterward, the moving images can be reviewed on your camera's

LCD screen and the audio can be heard on its built-in speaker (if available).

If you are not satisfied with the results, you can save sections of the video that you like, or delete the entire video clip and make another. As with single image files, the video/audio files can be downloaded to your computer for editing (with video-editing software) and sharing.

Video file formats are different from the file formats for single images. And you don't get a choice; your camera's manufacturer specifies the video format. Common formats are MPEG (for Moving Picture Experts Group) and AVI (for Audio Visual Interleave), which carry their respective file extensions .mpg and .avi.

Prior to shooting a video clip, you must select the IMAGE QUALITY, which affects the size and clarity of the image, as well as the recording time that will be available. Image quality is determined by two things: frame rate and resolution.

The FRAME RATE is how many frames per second (fps) will be recorded. For the best image quality, choose 30 fps, if available.

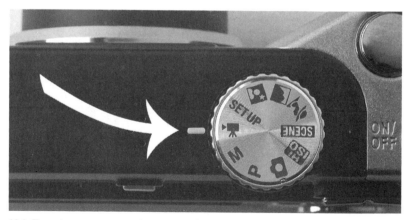

18.1. To activate your camera's movie mode, select the icon of an old-time Hollywood movie camera on the camera's mode dial (see arrow) or an LCD menu. You'll be able to make video clips, the lengths of which depend on the frame rate and image resolution you choose and the capacity of the camera's memory card (see text).

That means 30 pictures will be recorded every second, and this will give a smooth flow to your video.

The other common frame rate is 15 fps, which can result in jerky motion because every second only half the number of pictures is recorded than at 30 fps. The intermittent motion is especially obvious when there are fast-moving subjects, or you move the camera quickly while shooting.

Although 30 and 15 fps are considered standard frame rates in digital still cameras, your model may have rates of 10, 13, 19, 20, or 24 fps; select the highest rate available to get the best image quality.

The other thing you must choose is the IMAGE RESOLUTION, which may be called RECORDING PIXELS or IMAGE SIZE or SCREEN SIZE. The standard resolution and best size for top image quality is 640 × 480 pixels, sometimes identified as VGA (for Video Graphics Array). Two other choices offer lower quality and produce smaller image sizes: 320 × 240 pixels, also known as QVGA (for Quarter Video Graphics Array), and 160 × 120 pixels, occasionally identified as QQVGA (for Quarter QVGA).

18.2. When shooting in movie mode, you can avoid making video clips that look jerky by setting the frame rate to 30 frames per second (see arrow). This will record twice as many pictures per second as the slower frame rate of 15 fps (see text).

To make video clips with the utmost image quality, choose 30 fps and 640 × 480 pixels (if available on your camera). Names of the image quality settings for a specific frame rate and resolution vary with the camera make and model; consult your camera manual for details.

You should know the maximum RECORDING TIME available for your video clips, which is affected by the frame rate and resolution, the capacity of the MEMORY CARD you use, and whether the camera itself has a recording time limit. In general, the higher the frame rate and resolution you set, the shorter the video will be. On the other hand, the greater the memory card's megabyte (MB) or gigabyte (GB) capacity, the longer the video can be.

Actual recording times vary greatly from camera to camera; check the sample times listed in your camera manual. Our advice is to shoot at the highest image quality and use a high-capacity, high-speed memory card if it is compatible with your camera (see pages 62–63).

Once your camera's movie mode is properly set for recording,

18.3. For the best possible image quality when in movie mode, set the highest image resolution available, which is 640 × 480 pixels (see black arrow) in this camera. The LCD menu also indicates the recording time available (see white arrow); here it is 15 minutes, 27 seconds (see text).

you just press the SHUTTER RELEASE to start making the video. To stop recording anytime before the recording limit runs out, press the shutter button a second time. *You do not need to hold it down while recording.*

Also, be aware that images for your video clip are first written to the camera's INTERNAL MEMORY BUFFER and then downloaded to the memory card. If the buffer fills up before the data can be transferred to the memory card, your video recording may stop unexpectedly.

Depending on your camera, you can frame and follow your subjects by looking through the viewfinder or at the LCD monitor. The remaining recording time will appear in the viewfinder or on the LCD screen until it reaches zero. At that moment the recording automatically stops.

With many cameras, the auto-exposure, white balance, and autofocus functions will operate continuously while recording a video clip. On some models, the auto-exposure and white balance continue working while you shoot but the autofocus remains at the initial point of focus when you first press the shutter button to start recording.

PAY ATTENTION TO THE LIGHTING on your subject and avoid moving your camera from subjects in bright sunlight to subjects in shadow, or vice versa. Otherwise, there will be annoying underexposure or overexposure while the lens opening (lens aperture) adjusts. Your camera's built-in flash is of no use when shooting a video, so it is disabled when you select the movie mode.

While recording a video clip, you may be able to use the camera's DIGITAL ZOOM feature to make your subjects appear larger or smaller. However, image quality often suffers when using the digital zoom (see page 34). The better choices are to use the camera's OPTICAL ZOOM LENS, if allowed, or physically move closer or farther away from your subject, or change the subject size later with video-editing software in your computer.

If your camera features IMAGE STABILIZATION (see pages 87–88), it may be automatically disabled when the movie mode is selected. If not, some cameras overheat and automatically shut down when the image stabilizer is subjected to prolonged use while shooting a video. Look for such warnings in the camera manual, and turn the stabilizer off before it can cause an unwanted interruption.

You'll note that a tiny light flashes on the camera to indicate when the video images are being recorded to the memory card. After you've finished shooting, make sure the light has stopped blinking before you play back the video or try to record another clip.

When downloaded to your computer, video clips usually are converted automatically by your software to file formats that work with popular MULTIMEDIA PLAYERS, such as Apple's QuickTime Player (.mov) and Windows Media Player (.wmv). If these players do not already exist on your computer, they can be

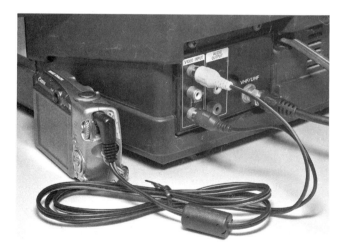

18.4. Digital cameras are supplied with a video cable or an audio/video (A/V) cable to connect the camera directly to a television set in order to display your pictures and listen to any sound you may have recorded. After inserting a single plug into the camera's video or A/V "out" socket, insert the other plugs into the TV's video and audio "in" sockets, as shown here.

downloaded without charge via the Internet from their respective creators at www.apple.com and www.microsoft.com.

To view your video clips on a television screen, use the two-plug VIDEO CABLE or the three-plug AUDIO/VISUAL (A/V) cable supplied with your camera to connect it directly to the TV set. One plug fits into the yellow VIDEO OUT port on the camera, while the yellow plug on the other end of the cable fits into the yellow VIDEO IN socket on the TV. If your camera records sound, put the white or black plug into the left (L) white AUDIO IN socket on the TV. Turn on the camera and TV, start the video playback, and enjoy the show.

RECORDING SOUND WITH YOUR DIGITAL CAMERA

As explained above, some digital cameras will record sound while you are shooting in the MOVIE MODE to make a video clip. Most of those cameras also allow you to make SOUND-ONLY RECORDINGS. This enables you to capture on-the-scene sounds or to make a brief narration to identify a picture after the image is recorded.

Depending on your camera, the RECORDING TIME per image may be limited to a few seconds, a minute, or longer. Stand-alone recordings that are not tied to a specific picture can last as long as it takes to fill up the memory card. The total recording time available and the amount of time remaining will be indicated on the camera's LCD monitor as you record.

Read your camera's instruction manual carefully for details about its AUDIO features and settings for recording and playing back sound. This is sometimes called the VOICE RECORDING MODE, VOICE MEMO MODE, or SOUND MEMO MODE. Do not confuse these audio settings with the SOUND MODE settings for the beeps and other noises your camera makes as warnings or to confirm operational actions you've taken (see page 184).

18.5. After shooting a picture, this camera allows you to make a brief sound recording to describe it. A menu superimposed over the image on the LCD monitor indicates (see arrow) the elapsed recording time (27 seconds) and total recording time available (60 seconds).

Cameras that will record sound in the movie mode have a tiny built-in MICROPHONE at the front to capture the audio as you follow the action. Its range for making intelligible recordings may be limited however, such as to 3 feet (1 meter) or so. SLR cameras capable of making sound memos have the microphone at the rear, where it can pick up the photographer's voice more clearly as he or she comments on the image being played back on the LCD monitor.

Be careful not to inadvertently cover the microphone with your fingers. Also, be aware that wind blowing on the microphone's opening in the camera body can cause distracting noise in the recording.

Many cameras that capture sound also have a tiny built-in SPEAKER that will play back what you have recorded. There may be settings to control the volume of the speaker. If your camera has no speaker, you can hear the recorded sounds when showing the pictures on your computer or a television screen. When you do, be sure the speakers are turned on and the volume level is adequate.

18.6. The microphone for cameras with a movie mode records through one or more small holes on the front of the camera; the speaker utilizes small holes at the side or rear of the camera.

Keep in mind that recording sound takes up space on your memory card and will reduce the number of images the card will hold. Your camera manual may have a comparison chart indicating the maximum number of images you can shoot with and without sound. Fortunately, audio recordings usually can be deleted and remade if you don't like the initial outcome.

When downloaded to your computer, audio files carry a different extension than image files, such as .wav, which represents the WAVE (for Waveform) audio file format. Audio files can be heard by using MULTIMEDIA PLAYER software on your computer. Free downloads of Windows Media Player and Apple's Quick-Time Player are available on the Internet from www.microsoft .com and www.apple.com, respectively.

USING CAMERA PHONES

Many of today's cellular (mobile) phones include an option for snapping pictures and are referred to as CAMERA PHONES. In fact, as camera phones become more common and the quality of their images increases, they are expected to become as popular for casual photography as regular point-and-shoot digital cameras.

If you are serious about getting quality photos from a camera phone, look for a model with high resolution capability, auto-focus, an optical zoom lens, built-in flash, and a large LCD screen

18.7. Many mobile phones include a camera, but some models have many of the features of regular point-and-shoot cameras. For example, Motorola teamed with Kodak to create this 5 megapixel (MP) camera phone with an autofocus lens, built-in flash, a removable memory card, and a 2.4-inch LCD screen to compose and review pictures.

to compose and review the images. For the most versatility, the camera phone should also have a slot that accepts a removable, high-capacity MEMORY CARD, which is also called a MEDIA CARD. As you might expect, top-end camera phones can be expensive and often cost more than regular non-SLR digital cameras.

In reality, camera phones today are mainly used for on-the-fly photography. The resulting snapshots are shared with family and friends, who view the pictures on their own mobile phones, in e-mails, and on social networking Web sites like Facebook and MySpace. Currently, very few photos from camera phones are ever printed as enlargements and then framed for more traditional display at home or in the office.

Whether or not the mobile phone is of average or very high quality, most often it is the carelessness of the user that creates the poor or mediocre photos that are all too common with camera phones. Here are five simple tips to instantly help you make better pictures with your phone.

18.8. Train yourself to hold your mobile phone very steady when making pictures; blurry images are all too common because of camera shake. Use both hands to hold the phone, and tuck your arms against your body. It also helps to lean against a solid support, such as the pole seen here. Read the text for other easy ways to get better pictures with your camera phone.

1. Most important is to *keep the camera phone steady.* Many models are small, lightweight, and awkward to hold for shooting. In order to prevent blurred pictures, use both hands and brace your arms against your body. For additional support, lean against something solid, such as a tree or a wall. SHUTTER DELAY is a common problem with camera phones, so remember to remain motionless until you are certain the shutter has opened and closed.

2. *Get close to your subjects.* Move closer physically, or adjust an optical zoom lens (if available) toward its telephoto (T) setting. Note that shooting close up at a wide-angle (W) setting can distort your subjects, which is particularly unflattering for people. Do not use a digital zoom function; it only enlarges the pixels in a picture, which degrades the image.

3. *Make sure your subject is in good light* in order for the picture to have the most detail. Beware of harsh sunlight that creates

dark shadows and high contrast in phone photos. If available, use the built-in light or flash—even in daylight—to give more clarity to your subject. Or, when indoors, turn on more lights if you can. Try to avoid backlighted subjects, unless you want them to turn out as silhouettes.

4. *Keep the lens clean.* Most lenses are protected only by a see-through plastic or glass cover, which can quickly get dirty when carrying your camera phone in a pocket or purse. Also, the lens is quite small, so dust or finger smudges will be more evident in your pictures. Wipe the lens gently with a microfiber cleaning cloth designed for regular camera lenses or eyeglasses.

5. *Always shoot at the highest image quality.* The names of the image quality settings vary with the phone manufacturer. For example, the choices might be High, Medium, and Low or Super Fine, Fine, and Normal. Check your phone's user guide. Image files are automatically compressed to save space in the phone's internal memory or on a removable memory card— the higher the image quality you set, the less compression.

You'll also find settings for IMAGE RESOLUTION, which may be called IMAGE SIZE or PHOTO SIZE. We suggest you always select the highest resolution, especially if you expect to print your photos. The higher the resolution, the larger the picture will be displayed on a computer or television screen. Also, more detail will show in the image. A common high resolution/image size in many camera phones is 640 × 480 pixels, which is also termed VGA (for Video Graphics Array).

Do not confuse image resolution with the resolution of the IMAGE SENSOR in a camera phone, which is expressed in megapixels (MP). In camera phones, little attention is paid to image sensors and their maximum megapixels, but higher-end models range from 5 MP to as many as 10 MP.

18.9. Just as with any digital camera, you can set the image resolution on a camera phone. This is sometimes called "photo size," as on this phone, or "image size." The higher the resolution, the greater the number of pixels and thus the larger the image file (the picture). Set here is this camera phone's highest resolution (see arrow), which is VGA (640 × 480 pixels) and best if making prints. If only sending photos to other camera phones, the "mobile" setting of 128 × 120 pixels would be sufficient.

Most USER GUIDES for mobile phones have minimal information and instructions for the camera, but read carefully to learn as much as you can about its various features, as well as any limitations. For example, most camera phones can be set to shoot in black-and-white or old-time sepia tones rather than color.

Try out all the different settings by shooting practice photos, and then analyze the results. It is worth the time to become familiar with the camera operation so you won't be fumbling with the phone and pressing the wrong buttons when a photo opportunity suddenly appears.

Photos you make with a camera phone are automatically saved in the JPEG (.jpg) image file format (see page 129). They can be viewed on the phone's LCD screen as a group of thumbnail photos or as larger individual images. On the screen, you can select images to delete or to send to another mobile phone, a Web site, desktop printer, photo kiosk, or computer.

Camera phones with Bluetooth or IrDA (infrared) technology make it easy to download images to a wireless-enabled computer or printer, or to a PHOTO KIOSK that makes prints (see

18.10. Before shooting a picture with your camera phone, check the "image resolution" and "image quality" settings that appear on the screen (see arrow) to see if they are appropriate for your subject and purposes. Here the camera was set at its highest resolution, 640 × 480 pixels, and highest quality, SF (Super Fine), for this keepsake photo of a newborn baby.

page 382). Some phones have a port to plug in a cable that connects to your computer to download the image files. Of course, if your camera phone has a removable memory card, it can be inserted into a MEMORY CARD READER that is connected to your computer (see page 269).

However, you probably will be sending most images from your camera phone directly to another mobile phone or to a Web site or in e-mail. The fees to transmit image data from a camera phone can add up quickly. If you shoot and send many photos, we suggest you buy an unlimited MEDIA PACKAGE from your mobile phone service provider in order to save money.

If you are serious about making high-quality photos, go online to the Web site of your mobile phone service provider, or

As with any camera you use, remember to be respectful of your photographic subjects and situations. Don't take voyeuristic photos or use your camera phone in places where photography is prohibited, as in some museums, theaters, and concert halls.

others, to read descriptions of various camera phones. Then visit the phone provider's retail store to personally try out the camera features, shoot a few photos, and see if you like the results.

SCANNING PHOTO PRINTS
AND FILMS TO DIGITIZE THEM

Most everyone has albums and boxes of photographic prints, film negatives, and/or transparencies (slides) from the years prior to the advent of digital photography. If you want to make use of any of them as digital images for e-mailing, displaying on a computer or Web site, or printing, they must first be scanned in order to create digital image files.

18.11. You can create a digital image file from a photograph by placing the print facedown on the glass platen of a flatbed scanner (see text). Some models, like the three shown here, also enable you to scan 35mm film negatives and transparencies (slides). A holder that accepts a strip of four negative frames or three mounted slides is built into the lid of the scanner on the left. For higher quality scans of such small film images, a dedicated film scanner is preferred (see illustration 18.12).

Many photographers do this themselves by using a desktop SCANNER. There are single-purpose models and others that are part of "all-in-one" machines that serve as a scanner/printer/copier, and sometimes as a fax machine.

Most common are FLATBED SCANNERS, which resemble small photocopiers and act like digital cameras to record the pictures you scan as digital image files. You put a photo print facedown on a glass platen, and a moving bar of light reflects the image with mirrors to a lens that focuses it onto an image sensor. From there the digital data is transferred via a cable to your computer for processing by software and storage on the hard drive as an image file.

If the picture you want to scan is a negative or a slide, many flatbed scanners have a built-in or accessory device to hold the negative or transparency film and transmit light through it instead of reflecting light off it (as with a print). There are also more costly FILM SCANNERS that digitize only negatives and transparencies, not prints. These are the choice of serious amateurs and professional photographers who want higher quality scans of 35mm and other films.

There is a wide choice of scanners made by scanner specialists, such as Pacific Image, as well as by photo-product companies, including Canon, Epson, HP, and Nikon. Some models cost less than $100, but expect to pay more if you want high-quality results, especially when scanning slides or negatives.

Very important to consider when shopping for a scanner is its RESOLUTION, which affects the amount of fine detail you'll see in scanned pictures. High resolution is necessary when printing enlargements for display but less of a concern for pictures that you only intend to print in small snapshot size or show on computer monitors and television screens.

18.12. As the name implies, film scanners are designed to scan only film negatives and transparencies (slides), not photo prints. Many models, like this Nikon COOLSCAN, handle only 35mm film. You manually insert one mounted slide at a time into the front slot (see arrow) or use an optional adapter that will automatically feed up to fifty slides into the scanner.

Resolution is expressed in DOTS PER INCH (dpi), but don't confuse this with the dpi discussed earlier in regard to printers (see page 378). Using dots per inch is misleading because a scanner's dpi actually indicates the maximum number of PIXELS possible in a scanned image. Nevertheless, just remember that the greater the dpi, the greater the number of pixels. And the more pixels, the higher the resolution, and therefore the better the image quality.

To confuse the issue even more, there are two types of resolution often listed for flatbed scanners: optical and interpolated. OPTICAL RESOLUTION is the true resolution and the only one to consider when choosing a scanner. That's because the INTERPOLATED RESOLUTION, which is sometimes called ENHANCED RESOLUTION, includes extra pixels created by scanner software.

A flatbed scanner's optical resolution is expressed by a pair of numbers, such as 2400 × 4800 dpi. Pay no attention to the higher numbers listed for interpolated resolution. In addition, when comparing the optical resolutions of scanners, use only the smaller number of the pair, which is usually 1200, 2400, or 4800 dpi. (Sometimes only the smaller dpi number is listed instead of a pair of numbers.)

18.13. The "optical resolution" of a scanner (see text) is different from the "image resolution" you set before scanning a photograph. The software for an HP scanner shows these menus when you click the Resolution button (see arrow). This gives you a choice of resolutions for the digital image file that will be created when a photo is scanned.

Also note that the optical resolution of a film scanner is indicated by only a single number, which may be 3000, 3600, 4000, or 7200 dpi.

Scanner specifications list enough technical terms and numbers to overwhelm you. One is COLOR DEPTH (sometimes called BIT DEPTH), which indicates the scanner's ability to reproduce shades of colors. Another is DYNAMIC RANGE (sometimes called DENSITY RANGE or D-MAX), which indicates the range of gray tones a scanner can record.

However, only professional photographers seem concerned about such specifications. That's because scanners have improved so much since the early models that any scanner you buy today will adequately digitize your pictures for e-mails, Web display, and desktop printing.

You'll note that scanner specifications often list a SCAN SPEED, but be aware that the actual scanning time can vary greatly with the type and size of the film or print you are digitizing.

Before connecting a modern scanner to your computer with a USB or FireWire cable, you should download the software from the CD that is packed with the scanner; it includes a "driver" that establishes communication with the computer. *We urge you to read the instruction manual carefully before installing and using any scanner.*

Whether using a flatbed scanner or a film scanner, you should CLEAN THE PRINT OR FILM just prior to scanning it so that dust on its surface is not recorded. Also make sure that a flatbed scanner's glass platen is clean. Wipe dust away from large surfaces with a microfiber cleaning cloth like that typically used on camera lenses and eyeglasses. For negatives and slides, use so-called canned air, such as Dust-Off, which is compressed inert gas that will blow away any dust.

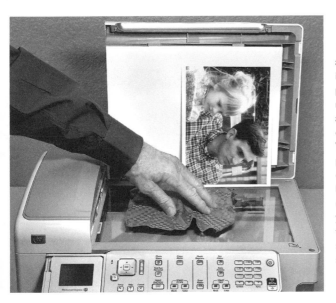

18.14. Before you scan a photograph by putting it facedown on the glass platen of your scanner, make certain the glass and the photo are free of dust and fingerprints. Very effective for this purpose is a microfiber cleaning cloth, which is being used here. If you neglect precleaning, later you'll spend much more time eliminating dust spots with image-editing software.

Some scanner software includes a feature you can select to electronically remove dust and scratches from the surfaces of films while scanning them. Or, after scanning, you can do the same thing to prints as well as to films with image-editing software. However, you'll save yourself much time and trouble by cleaning films and prints *prior* to scanning them.

Most scanner software and Windows and Macintosch computer operating systems offer two ways to scan: "automatic" and "custom." Selecting custom gives you better control and more choices, such as setting a specific IMAGE RESOLUTION. Adjustments can be made for contrast, brightness, color, and sharpness as well. You also can choose an appropriate file format (JPEG or TIFF), based on your intended use of the image (see page 132).

After your prints, negatives, or slides are scanned and their image files are saved on your hard drive, you can share and print those digitized photos just as you would with image files from your digital camera.

Among the many joys of our digital age is the discovery that there seems to be no limit to the world of photography. Pick up your digital camera and join in the fun.

Appendix A:
A Glossary of Digital
Photography Terms

Active Autofocus One of two types of autofocusing systems; uses pulses or beams of infrared light sent from a small window on the front of the camera, which bounce back from the subject to the same window or a second window; employs echo or triangulation technology. *See also Passive Autofocus.*

AE Abbreviation for "auto-exposure," the shortened term for "automatic exposure." *See also Auto-Exposure.*

AEB Abbreviation for "auto-exposure bracketing." *See Auto-Exposure Bracketing.*

AF Abbreviation for "autofocus." *See also Autofocus.*

AF Assist A feature built into a camera or its accessory flash unit to enable autofocusing in dim light; uses infrared or LED beams reflected off the subject; the distance of the subject and focal length of the lens determine the effective range of the AF assist; also called an AF Assist Lamp or Illuminator.

Algorithm In digital photography, a step-by-step procedure developed by engineers to carry out a specific task, such as setting a camera's automatic exposure or making an automatic adjustment to a picture with an image-editing program. *See also Image-Editing Software.*

Angle of View The subject area included by a lens, measured in degrees (°); also called Field of View.

Antishake A technology in cameras and lenses that combats the problem of blurry images due to inadvertent movement of the camera.

Aperture *See Lens Aperture.*

Aperture-Priority Exposure An automatic exposure setting where the

photographer first sets the desired lens aperture (f/stop), and then the camera automatically adjusts the shutter speed for a correct exposure; also an exposure mode indicated by A or Av (for "aperture value") on a camera dial or menu. *See also Manual Exposure, Program Exposure, and Shutter-Priority Exposure.*

Archival Storage Refers to safely preserving digital image files for use anytime in the future.

Articulating LCD Screen A movable LCD monitor that can be pivoted away from the camera body and/or tilted up and down for easier viewing in awkward situations; sometimes called a "twist-and-tilt" LCD. *See also LCD Monitor.*

Artifacts Unwanted visual defects in digital images; often appear as blotches of erratic color in areas of little detail when an image file is compressed too much; includes a defect called "noise." *See also Compression and Noise.*

Aspect Ratio In digital photography, the ratio of the width of a rectangular image to its height; common aspect ratios are 4:3, 3:2, and 16:9.

Auto-Exposure An exposure automatically set by the camera; based on the camera's built-in exposure meter reading and the autofocused distance to the subject; controls the settings for the lens aperture and shutter speed and sometimes the ISO, white balance, and built-in flash; commonly abbreviated AE. *See also ISO, Lens Aperture, Shutter Speed, and White Balance.*

Auto-Exposure Bracketing A feature of some cameras to ensure a proper exposure; automatically makes two or more exposures of the same scene at different f/stops or shutter speeds; commonly abbreviated AEB. *See also Bracketing.*

Auto-Exposure Lock A camera button or other locking device that "holds" the exposure until the subject is reframed in the viewfinder or on the LCD monitor and the shutter release button is fully pressed; on many models the auto-exposure is locked by pressing the shutter release button halfway; often combined with an Autofocus Lock. *See also Autofocus Lock.*

Auto-Exposure Mode Any of the camera modes that automatically set the exposure, such as aperture-priority, shutter-priority, or program mode. *See also Aperture-Priority Exposure, Program Exposure, and Shutter-Priority Exposure.*

Autoflash A built-in or accessory external flash unit that automatically determines flash exposures.

Autofocus Refers to a camera lens that focuses automatically; abbreviated AF. *See also Manual Focus.*

Autofocus Area The area marked by brackets or crosshairs in viewfinders and on LCD monitors that is covered by the autofocusing system; for sharp focus, the camera is aimed so the main subject is at least partially located within the autofocus area.

Autofocus Assist *See AF Assist.*

Autofocus Lock A button found on some cameras to lock in the focus on the main subject while recomposing the picture in the viewfinder or on the LCD monitor; on many models the autofocus can be locked by pressing the shutter release button halfway; often combined with an Auto-Exposure Lock. *See also Auto-Exposure Lock.*

Automatic Exposure Refers to any camera mode that determines and sets the exposure automatically; commonly abbreviated AE; also called Auto-Exposure. *See also Auto-Exposure Mode.*

Automatic White Balance A camera setting that automatically determines the white balance for a true-color exposure; abbreviated AWB. *See also White Balance.*

Av Abbreviation for "aperture value." *See Aperture-Priority Exposure.*

AWB Abbreviation for Automatic White Balance. *See Automatic White Balance.*

B Abbreviation for Bulb. *See Bulb.*

Background The area behind the picture's main subject or center of interest.

Backlighting A term used when the main source of illumination is behind the subject and shines in the direction of the camera; also called Backlight.

Backscatter An undesirable effect in underwater photography that occurs when light from a flash reflects off tiny particles in the water and records as fuzzy white spots in the image.

Backup Refers to making one or more duplicate copies of digital files in order to avoid the accidental loss of your pictures.

Ball Head A tripod head that makes it easy to adjust the camera in any position. *See also Pan Head.*

Beanbag A bag filled with Styrofoam pellets (or dried beans) used to cushion and support a camera in awkward locations and positions; simple substitute for a tripod.

Bit Depth *See Color Depth.*

Blog A Web site maintained by one or more individuals to provide

commentary and information about a particular subject, such as digital photography or any aspect of it.

Bluetooth A radio-wave communication system that allows wireless connections between various Bluetooth-enabled devices, including cameras, camera phones, computers, photo printers, and photo kiosks. *See also IrDA and Photo Kiosk.*

Boot Time The brief time it takes for a camera to become operational after its power is turned on; also called Power-On Time and Start-Up Time.

Bounce Light A term used when the flash or other main source of illumination is reflected off a surface (often a ceiling or wall) instead of being aimed at the subject directly; provides soft, indirect illumination.

Bracketing Making one or two more exposures—in addition to the one thought to be correct—in order to ensure a proper exposure; can be done by changing either the lens aperture (f/stop) or the exposure time (shutter speed). *See also Auto-Exposure Bracketing.*

Buffer *See Internal Memory Buffer.*

Bulb The shutter speed setting for a time exposure; the shutter release or cable release button must be kept depressed in order to hold the shutter open; indicated by B on a camera dial or menu.

Burn Refers to copying digital files onto a DVD or CD with computer software; also, a tool in some image-editing software used to darken selected areas of an image.

Burning Software *See Disc Recording Software.*

Burst Depth *See Burst Rate.*

Burst Mode *See Continuous Mode.*

Burst Rate The total number of continuous shots that can be made at one time before the internal memory buffer is temporarily filled with images; the shutter release temporarily locks to prevent additional exposures until those images are recorded onto the memory card; also called Burst Depth. *See also Continuous Mode and Internal Memory Buffer.*

Byte A basic unit of measurement used to express amounts of computer memory and digitized data in image files; 1,024, bytes equal a kilobyte (KB). *See also Gigabyte, Kilobyte, Megabyte, and Terabyte.*

Cable Release A push-button device that connects to the camera with a cable or wirelessly; enables the electronically controlled shutter to be tripped without physically pressing the camera's own shutter release; used for time exposures to prevent camera shake. *See also Camera Shake and Time Exposure.*

Camera Cradle *See Camera Dock.*

Camera Dock A cradle in which a compatible camera is placed to transfer image files from its memory card to a computer's hard drive or a desktop photo printer; also charges the camera's batteries when the dock's AC adapter is plugged into an electrical outlet; also called a Camera Cradle.

Camera Movement *See Camera Shake.*

Camera Phone A mobile phone that features a built-in digital camera.

Camera Raw A computer application for Photoshop image-editing programs that provides access to image files in a variety of Raw formats. *See also Photoshop and Raw.*

Camera Shake Any movement of the camera during exposure that causes an unexpected and unwanted blurred image; also called Camera Movement.

Catchlight An added sparkle in the eyes of a portrait subject; created by the reflection of a light source, such as a built-in or external flash unit.

CCD An abbreviation for Charge-Coupled Device, a type of image sensor in a digital camera or scanner. *See also Image Sensor.*

CD An abbreviation for "compact disc"; a small, thin plastic platter used to record and play back computer data, including image files; commonly holds 700 MB (megabytes) of data; being superseded by the DVD, which has a greater capacity. *See also Image File and Megabytes.*

Center of Interest The main subject of a photograph.

Center-Weighted Metering An exposure metering system in some cameras that reads the full subject area but is more sensitive to the central portion, as designated by a large circle in the viewfinder or on the LCD monitor. *See also Evaluative Metering and Spot Metering.*

Close-up A picture showing the subject in detail; made with the camera very close to the subject.

Close-up Lens An accessory lens attached in front of a camera lens to allow the camera to get closer to the subject to produce a larger subject image size. *See also Diopter and Macro Lens.*

CMOS An abbreviation for Complementary Metal-Oxide Semiconductor, a type of image sensor in some cameras. *See also Image Sensor.*

CMYK In photography, initials for three complementary colors that are produced when two primary colors are mixed: C = cyan (from blue and green), M = magenta (from red and blue), and Y = yellow (from green and red); plus K to represent black because B would be confused with blue, one of the primary colors represented by the initials RGB. *See also Primary Colors.*

Color Balance The ability of a camera to reproduce colors as the photographer sees them in real life; can be altered by adjusting the camera's white balance (WB) setting or by using filters on the camera lens; also settings in image-editing programs to adjust the color of images on a computer screen or in photo prints. *See also Color Management and White Balance.*

Color Depth Indicates the number of gradations of color that a flatbed scanner or a film scanner is capable of producing; the greater the number, the truer the reproduction of the original image; sometimes called Bit Depth because color depth is indicated by "bits" of data.

Color Management Refers to color balancing your computer monitor with your printer so that the colors of an image viewed on the computer screen will appear to be identical in the print; image-editing and printer software may include a color management program that automatically achieves this, but some pros prefer to manually calibrate the color balance of the monitor and the printer. *See also Color Balance.*

Color Temperature A scale of numbers used for measuring the color of light, which varies according to its temperature; expressed in units of measurement called kelvin, abbreviated K.

Compact Camera *See Point-and-Shoot Camera.*

Compact Disc *See CD.*

CompactFlash A type of memory card; most commonly used in professional single lens reflex cameras; abbreviated as CF card. *See also Memory Card, Memory Stick, MultiMediaCard, Secure Digital, and xD-Picture Card.*

Composition The arrangement of the subject or elements in a picture; carefully considered composition is the key to an effective photograph. *See also Rule of Thirds.*

Compression Reduces the size of an image file; saves storage space on a camera's memory card to allow more pictures to be taken; also saves storage space on the computer's hard drive and reduces the time required for sending (and receiving) images via the Internet; image quality can decrease when compression is increased.

Consumer Camera. *See Point-and-Shoot Camera.*

Contact Sheet A sheet of photo paper with a series of thumbnail-size images. *See also Photo Paper.*

Continuous Autofocus Mode An autofocus setting on some cameras; after the shutter release button is pressed halfway, it enables the lens to continue focusing until the shutter release is fully depressed to make an exposure; also called Al Servo autofocus mode. *See also Single Autofocus Mode.*

Continuous Mode A camera setting to continuously make exposures as long as the shutter release button is fully depressed; the number of images

exposed per second depends on the frame rate; also called Burst Mode and Multiple Exposure Mode. *See also Burst Rate and Frame Rate.*

Contrast The range of brightness of a subject; also, the range of density in a digital image.

Crop To eliminate unwanted parts of a picture; initial cropping is done with the camera by framing in the viewfinder or an LCD monitor only the subject area wanted in the picture; after an exposure is made, the image can be cropped with image-editing software on a computer.

Crop Factor A number supplied by camera manufacturers to compute the effective focal length of lenses used on their digital single lens reflex cameras (except for full-frame SLR models); the number varies according to the specific size of a camera's image sensor; also called the Focal Length Multiplier and Multiplier Factor. *See also Effective Focal Length.*

Curves A tool in Photoshop image-editing software to adjust the color and tones of an image; represented in a dialog box as a straight diagonal line that curves at points you select by moving the computer's cursor to change the color and/or tones. *See also Dialog Box and Photoshop.*

Dedicated External Flash Unit A flash unit that automatically activates or controls one or more flash features when attached to a compatible camera; among those features are flash synchronization, auto-exposure, zoom flash head, and ready light. *See also Flash Synchronization, Ready Light, and Zoom Flash Head.*

Default Settings Camera, computer, and software settings preset by the manufacturer; can be reset as desired by the user; also called Factory Default Settings.

Delete A camera or computer command to erase an image file or an action.

Density Range *See Dynamic Range.*

Depth of Field The area in a photograph that is in sharp focus; figured as the distance between the nearest and farthest objects in focus; varies according to the lens focal length, point of focus, and f/stop. *See also Point of Focus.*

Depth of Field Preview Device Stops down the aperture of a single lens reflex camera lens to a preselected f/stop so the photographer can visually check how much of the subject area will be in focus. *See also Depth of Field.*

Desaturate Computer command in image-editing software to remove color from a digital image; results in a black-and-white picture.

Desktop Printer A device for printing photos and documents in your home or office. *See also Inkjet Printers, Dye-Sublimation Printers, and Laser Printers.*

Dialog Box A software program window on a computer screen that is used to choose options or input information.

Diffused Lighting Nondirectional lighting that gives uniform illumination with lower contrast and less shadowing than directional lighting; also called Soft Lighting. *See also Bounce Lighting and Directional Lighting.*

Digicam A word that has been coined for digital cameras. *See also Digital Camera.*

Digital Camera Utilizes an image sensor instead of film to record the picture; identified by an LCD monitor on its back; saves images as individual digital image files for subsequent computer enhancement and use.

Digital Darkroom In general, a computer with image-editing software that enhances or creates entirely new images; the modern equivalent of a photographic darkroom used to process films and prints. *See also Image-Editing Software.*

Digital File A computer file containing digitized data, such as images and text.

Digital Film A nickname sometimes given to a memory card. *See also Memory Card.*

Digital Image An image composed of rows and columns of individual pixels; the more pixels, the higher the resolution, and therefore the better the photo quality of the image. *See also Pixel and Resolution.*

Digital Image File *See Image File.*

Digital Image File Format *See Image File Format.*

Digital Image Stabilization Electronically offsets camera shake to avoid blurred pictures; technically, a microchip processor in the camera cancels any incoming light rays recorded by the image sensor that do not match each other during the time of exposure. *See also Optical Image Stabilization and Picture Stabilization.*

Digital Imaging Creating images electronically, as with a digital camera; today's more popular alternative to shooting pictures on photographic film that requires chemical processing.

Digital Negative *See DNG.*

Digital Photo File *See Image File.*

Digital Photograph A photolike picture made up of pixels; can be displayed on a computer monitor or television screen or printed on photo-quality print paper or other material. *See also Pixel.*

Digital Workflow The various steps taken after capturing digital images with a camera; most often includes downloading the images files to a computer, then organizing, editing, enhancing, and storing them; optional steps are printing images and/or sharing them via the Internet.

Digital Zoom A setting on some cameras that electronically enlarges the center of an image produced by the camera's optical zoom lens; often disappointing because the enlarged image loses sharpness and clarity; considered

of little value by many photographers, who rely only on the optical zoom lens to increase the image size of their subjects. *See also Optical Zoom.*

Diopter An optical term used to indicate the strength or magnifying power of a close-up lens, which range from +1 to +10 diopters; also refers to adjustment control on some viewfinders for the photographer's eyesight. *See also Close-up Lens and Diopter Adjustment.*

Diopter Adjustment A manual control on the viewfinders of some cameras that adjusts the focus of the eyepiece to compensate for near- or farsightedness of the photographer; marked in plus (+) and minus (–) diopters.

Directional Lighting Direct lighting from a concentrated source, such as the sun or a studio light; gives higher contrast and deeper shadows than diffused lighting; sometimes referred to as Harsh Lighting. *See also Diffused Lighting and Bounce Lighting.*

Disc A word that in the computer world identifies an optical storage medium, such as a compact disc (CD). *See also Disk.*

Disc Recording Software A computer program used to copy image files and other data to a DVD or CD; sometimes called Burning Software.

Disk A word that in the computer world identifies a magnetic storage medium, such as a floppy disk. *See also Disc.*

Distortion Used to describe unnatural effects in pictures caused by optical characteristics of camera lenses, such as ill-proportioned buildings that can result when a wide-angle lens is tilted upward; can be corrected and/or created with some image-editing programs.

DNG Abbreviation for Digital Negative; a universal, nonproprietary Raw file format developed by Adobe Systems that can be opened and read by Photoshop and other image-editing software programs. *See also Photoshop.*

Dots Per Inch *See DPI.*

Download In general, to receive digital data on a local computer, such as when downloading digital images from your camera. *See also Upload.*

DPI Abbreviation for "dots per inch"; refers to the number of dots in a line one inch long; used to indicate the resolution of printers and scanners; the larger the dpi number, the higher the resolution, which means the better the quality of a digital image; in the case of scanners, often confused and interchanged with ppi (pixels per inch), which also is used to indicate print image resolution. *See also PPI and Resolution.*

Drag-and-Drop A convenient computer action in which the cursor is used to move images or other data from one location to another.

Drum Scanner An electronic scanning device used commercially to convert the image on a photographic print, negative, or transparency (slide) to a digital image; named for the spinning cylinder around which the

photographic work to be digitized is wrapped. *See also Film Scanner and Flatbed Scanner.*

Dry-Mounting Tissue An adhesive-coated, self-sticking or heat-sealing tissue used to mount a photograph to a mount board for durability.

DSLR Abbreviation for Digital Single Lens Reflex camera. *See also Single Lens Reflex Camera.*

DVD A small, thin plastic platter used to record and play back digital images, music, movies, text, and other data; commonly holds 4.7 GB (gigabytes) of data; appears identical to a CD, which it is superseding because of greater storage capacity; originally an abbreviation for "digital video disc," and then "digital versatile disc," and now stands alone as DVD. *See also Gigabytes.*

Dye-Sublimation Printer A printer used to produce digital prints that closely resemble traditional photographic prints; more expensive and less common than desktop inkjet printers except for models making only snapshot-size prints. *See also Inkjet Printer and Laser Printer.*

Dynamic Range Indicates how many distinct shades of gray a flatbed scanner or a film scanner can detect; sometimes referred to as Density Range (or D-max); based on a scale from 0.0 (whitest) to 4.0 (blackest); the higher the number, the greater the dynamic range, which means the more detail there will be in the brightest and darkest areas of the digital image. *See also Film Scanner and Flatbed Scanner.*

Effective Focal Length The operative focal length of a lens on any digital camera that is not a full-frame single lens reflex model; often expressed as the Equivalent 35mm Camera Focal Length or simply the 35mm Equivalent; can be determined by multiplying the actual focal length of the lens by a number that varies according to the specific size of a camera's image sensor; also applies when a camera lens is fitted with a lens converter, lens extender, extension tubes, or extension bellows. *See also Crop Factor, Full-Frame SLR Camera, and Lens Focal Length.*

Effective Pixels Maximum number of pixels an image sensor can actually record; the number is usually smaller than the camera's megapixel (MP) rating, which indicates the image sensor's total pixel count; sometimes termed Recording Pixels. *See also Megapixel and Pixel.*

Electronic Viewfinder A camera viewfinder that incorporates a tiny LCD screen; presents a less clear or sharp image to the eye than does an optical viewfinder; abbreviated as EVF. *See also Optical Viewfinder.*

Enhanced Resolution Indicates the interpolated resolution of a flatbed scanner; this is the often inferior software-enhanced resolution that electronically interpolates additional pixels that the scanner did not really

see; not to be confused with the optical resolution, which is a scanner's true resolution and indicated by the smaller of two numbers given for the resolution of the scanner; the larger number is always the enhanced (interpolated) resolution; also called Interpolated Resolution. *See also Pixel and Resolution.*

Equivalent 35mm Camera Focal Length *See Effective Focal Length and 35mm Equivalent.*

Erase A camera or computer command to delete an image file or an action.

EV Abbreviation for "exposure value." *See Exposure Value.*

Evaluative Metering An exposure metering system in some cameras that utilizes multiple light-reading zones of varied number, size, and location to calculate the best exposure for the full area seen in the viewfinder or on the LCD monitor; also called Multipattern, Multisegment, Multizone, and Matrix Metering. *See also Center-Weighted Metering and Spot Metering.*

EVF Abbreviation for "electronic viewfinder." *See Electronic Viewfinder.*

EXIF Abbreviation for Exchangeable Image File Format; information recorded with the image file about the camera settings when an exposure is made; also referred to as Camera Metadata. *See also Metadata.*

Exposure The amount of light acting on the camera's image sensor; exposure is controlled by the lens aperture (f/stop) and shutter speed of the camera.

Exposure Bracketing *See Auto-Exposure Bracketing and Bracketing.*

Exposure Compensation Camera settings to purposely overexpose (+) or underexpose (–) automatic exposures by an exposure value (EV) selected by the photographer. *See also Exposure Value.*

Exposure Lock *See Auto-Exposure Lock.*

Exposure Metering A system built into all cameras that reads the intensity of light emitted or reflected by a subject; once calibrated with an ISO setting, it indicates and/or automatically sets the lens aperture (f/stop) and shutter speed for a proper exposure.

Exposure Modes Various camera modes for setting an exposure: auto, program, shutter-priority, aperture-priority, and manual; also includes bulb (B) for time exposures. *See also Aperture-Priority Exposure, Auto-Exposure, Bulb, Manual Exposure, Program Exposure, and Shutter-Priority Exposure.*

Exposure Setting The lens aperture (f/stop) and shutter speed combination chosen automatically by the camera or manually by the photographer.

Exposure Value A system of numbers to indicate the amount of light that reaches the image sensor to make an exposure; abbreviated EV; correlates with settings made for exposure compensation and/or flash

exposure compensation. *See also Exposure Compensation and Flash Exposure Compensation.*

Extension Bellows A nonoptical, adjustable, accordionlike device used for making close-ups; attached between the camera lens and camera body to increase lens focal length and magnify the subject. *See also Extension Tubes.*

Extension Tubes Nonoptical, rigid metal or plastic tubes or rings of various lengths used for making close-ups; inserted between the camera lens and camera body to increase the lens focal length and magnify the subject; also called Extension Rings. *See also Extension Bellows.*

External Flash Unit A flash unit that is not built into the camera. *See also Dedicated External Flash Unit.*

External Hard Drive A stand-alone computer drive that magnetically records digital data; popular choice for long-term storage of image files because it has much greater capacity than a CD or DVD.

Eyepiece Shutter A manually activated device in the eyepiece of some single lens reflex cameras; used to prevent stray light from adversely affecting the camera's metering system while a time exposure is being made; may be a separate attachment to cover the eyepiece.

Face Detection An optional feature in some cameras that automatically finds and focuses on the faces of people composed in the viewfinder or on the LCD monitor; also called Face Recognition and Face Sensing.

Field of View *See Angle of View.*

File Extension A three-letter abbreviation for a digital file format; attached to the end of a file name and preceded by a period; .jpg and .tif are common image file extensions.

File Format *See Image File Format.*

Fill Flash Light from a flash unit used to augment the existing illumination or main flash unit; often used to lessen or eliminate shadows in a picture; also called Fill-in Flash.

Fill Light Light from any source used to augment the main illumination in order to brighten dark areas in a picture, such as shadows; also, an action in some image-editing programs to brighten dark areas of a photo.

Film Scanner A type of electronic scanning device used to convert the image on a photographic negative or transparency (slide) to a digital image that is saved as an image file on a computer's hard drive. *See also Drum Scanner and Flatbed Scanner.*

Filter A piece of colored or coated glass, plastic, or acetate placed in front of the camera lens that alters the light reaching the image sensor; in

an image-editing program, refers to a specific effect you can choose to change the look of an image.

FireWire A connecting cable used to transfer data, including image files, between some cameras, computers, printers, external hard drives, and other related devices; technically known as an IEEE 1394 cable; transmits data faster than a USB cable. *See also USB.*

Fixed Focal Length Refers to a lens with a single focal length; also called Single Focal Length; unlike a zoom lens, which has variable focal lengths. *See also Zoom Lens.*

Flare *See Lens Flare.*

Flash A very bright and brief source of artificial light used to illuminate subjects for photography; a flash unit with a gas-filled tube that produces a high-intensity flash of light of short duration; capable of giving repeated flashes; may be built into the camera or an accessory external flash unit.

Flash Drive *See USB Flash Drive.*

Flash Exposure Bracketing Making two or more flash exposures at different lens apertures (f/stops) to ensure a proper flash exposure. *See also Auto-Exposure Bracketing.*

Flash Exposure Compensation Camera settings that adjust the amount of light from the flash in relation to the existing light; an exposure value (EV) is selected to increase (+) or decrease (–) the flash illumination. *See also Exposure Value.*

Flash Memory Card *See Memory Card.*

Flash Mode Any of several flash modes that control the operation of a camera's built-in flash, such as autoflash, fill flash, red-eye reduction, slow sync, and no flash. *See also Autoflash, Fill Flash, Red-Eye Reduction, and Slow Sync.*

Flash Range The minimum and maximum distances that light from a flash unit will cover without overexposing or underexposing the picture.

Flash Synchronization Internal electrical and mechanical camera controls that ensure the shutter is fully open when the flash fires so that the flash-illuminated subject will be recorded by the image sensor.

Flatbed Scanner A type of electronic scanning device used to convert the image on an existing photographic print to a digital image that is saved as an image file on a computer's hard drive; smaller model is sometimes called a Photo Scanner. *See also Film Scanner, Photo Scanner, and Scanner.*

Flat Lighting *See Front Lighting.*

Focal Length *See Lens Focal Length.*

Focal Length Multiplier *See also Crop Factor and Effective Focal Length.*

Focus To adjust a lens so the light rays transmitted by it are sharply defined on the image sensor.

Focusing Mode A camera setting to control focus. *See also Autofocus, Manual Focus, and Macro Mode.*

Focus Lock *See Autofocus Lock.*

Foreground The area in front of the picture's main subject or center of interest.

Format Commonly refers to an image file format, such as JPEG or TIFF; also an action in the camera to prepare a memory card so it will work correctly with that specific camera; in order to eliminate all previous data, a memory card should be formatted instead of erased after its image files have been downloaded to a computer.

Four-Way Switch A round-shaped switch located on the back of most cameras that is touched at any of four points to cause an action; the action is indicated by an icon at the switch point or on a menu that appears on the LCD monitor when the switch is touched; also called a Controller and an Arrow Switch.

Frame A composition technique to position the camera so that the foreground objects in the picture form a natural frame at the top of, on the side of, or around the main subject; also refers to composing the picture within the viewfinder or on the LCD monitor.

Frame Rate Indicates in frames per second, abbreviated fps, the number of images that are recorded on the memory card when a camera is operated in the movie mode. *See also Movie Mode.*

Front Lighting A term used when the main source of illumination is coming from the direction of the camera and falling on the front of the subject; offers uniform illumination that is relatively shadowless, and thus lacks a feeling of depth; also called Flat Lighting.

f/Stop Used to control the amount of light transmitted by a lens; technically, a number that indicates what fraction the diameter of a lens opening is in regard to the focal length of the lens. *See also Lens Focal Length.*

Full-Frame SLR Camera A single lens reflex camera that has an image sensor the same size as a frame of 35mm film. *See also Single Lens Reflex Camera.*

GB *See Gigabyte.*

Gigabyte A unit of measurement that indicates the size of a digital file, and thus the amount of data it holds; abbreviated GB; equal to 1,024 megabytes (MB). *See also Byte, Kilobyte, Megabyte, and Terabyte.*

Graduated Neutral Density Filter A camera filter with a clear portion that gradually changes to a neutral density; used to alter the exposure of a

certain portion of the picture area; also a filter in some image-editing programs used to create the same effect. *See also Image-Editing Software.*

Graduated Tint Filter A camera filter with a clear portion that gradually changes to a specific color; used to alter the coloration of a certain portion of the picture area; also a filter in some image-editing programs used to create the same effect. *See also Image-Editing Software.*

Grayscale A term that is sometimes interchanged with the terms "black-and-white" and "monochrome"; indicates an image with a full range of gray tones from black to white; a setting on some cameras and in some image-editing programs to create a black-and-white image instead of a full-color image.

Grid Lines Crosshatched vertical and horizontal lines that form a grid superimposed in a camera viewfinder or on an LCD monitor to assist in composing a picture so that the subject appears straight or level; also a feature in some image-editing programs to help in the alignment of images.

GSM Abbreviation for "grams per square meter"; used to indicate the weight of photo papers; also abbreviated as g/m^2. *See also Photo Paper.*

Hard Drive A built-in computer drive that magnetically records digital data and stores it as digital files.

Harsh Lighting *See Directional Lighting.*

HDTV Abbreviation for "high-definition television."

High Contrast A term used when there is an extreme difference in brightness between the lightest and darkest parts of a subject or an image.

Highlight Detail Detail that is evident in the highlight (bright) areas of a picture. *See also Shadow Detail.*

Hi-Res Abbreviation for high resolution; sometimes written "hi-rez." *See High Resolution.*

High Resolution Refers to a digital image that appears sharper and has finer detail than an image with low resolution; the resolution of an image is indicated by a count of its pixels: the greater the number of pixels, the higher the resolution. *See also Low Resolution, Pixel, and Resolution.*

Histogram A graphic representation of an image's tonal range; i.e., its shadows, midtones, and highlights; displayed on some camera LCD monitors and by image-editing programs.

Hot Shoe A mount on the camera for shoe-mount external flash units; makes electrical connections between the flash and the camera's flash synchronization and shutter system; eliminates the need for a connecting flash cord.

Icon A graphic symbol found on cameras and their menus and in computer programs; represents a specific function or action.

IM Abbreviation for "instant messaging." *See Instant Messaging.*

Image-Editing Software Computer programs that allow enhancement of digital images after they have been captured by a camera or scanner and then stored on a hard drive.

Image File A computer file with a digital image; may be recorded and stored in different file formats; image composed of pixels; captured electronically by an image sensor in a camera or scanner; instantly available for viewing on a camera's LCD monitor; stored electronically in a camera on a small, removable and reusable memory card; can be downloaded to a computer's hard drive, or copied to a DVD, CD, or another digital recording device for subsequent use.

Image File Format A format created to encode digital data in a particular way in a file; various file formats exist for digital images, including JPEG and TIFF. *See also JPEG, TIFF, and Raw.*

Image Quality Affected by settings for resolution and compression made in the camera and in image-editing programs. *See also Compression and Resolution.*

Image Sensor A computer chip that electronically captures the light rays coming through the camera lens and creates a digital image; analogous to film in a film camera; two common types are CCD and CMOS sensors. *See also CCD and CMOS.*

Image Stabilization Refers to a lens or camera feature that counteracts camera movement to produce a sharp image instead of a blurred one; called Vibration Reduction by Nikon. *See also Camera Shake.*

Index Mode A camera setting that shows multiple recorded images on the LCD monitor; allows a quick review of pictures on the memory card.

Infinity The point or distance beyond which everything will be in focus; indicated by the infinity symbol (∞) on some camera lenses or menus.

In-Focus Indicator An audible beep and/or visual signal in the camera viewfinder or on the LCD monitor that indicates when the subject is in focus.

Infrared Blocking Filter A filter mounted in front of the image sensor to block infrared light that would otherwise alter the natural colors of images recorded on the memory card; also called an Infrared Cut-Off Filter.

Infrared Photography Records infrared radiation (heat intensity) as well as light intensity; requires removal and/or addition of filters in digital cameras; infrared images also can be simulated with image-editing software.

Ink Cartridge A replaceable cartridge inserted into a printer to provide the black and colored inks for printing images or other digital data onto print paper; cartridge must be compatible with the specific printer.

Inkjet Printer A popular type of desktop printer used to produce photo-quality prints; utilizes heat or electrical charges to vaporize colored inks that spray through tiny nozzles onto the print paper. *See also Dye-Sublimation Printer and Laser Printer.*

Instant Messaging A way to share digital photos via the Internet with one or more persons who are online at the same time; abbreviated IM.

Interchangeable Lenses Lenses that can be removed from a single lens reflex camera and replaced by other lenses. *See also Single Lens Reflex Camera.*

Internal Memory Buffer The camera's built-in memory where image data is briefly stored before being written to the camera's memory card; sometimes called a Buffer or Memory Buffer. *See also Memory Card.*

Interpolated Resolution *See Enhanced Resolution.*

Interpolation An electronic image-processing technique that increases the size of a digital image by duplicating existing pixels to create extra pixels that will enlarge a section of the original image. *See also Pixel.*

IPTC A common metadata format developed by the International Press Telecommunications Council; IPTC information added by the photographer is embedded in the image file to describe the photograph's content and ownership.

IrDA An infrared communication system for wirelessly transferring image files and other digital data between IrDA-enabled cameras and electronic devices such as computers, photo printers, and photo kiosks. *See also Bluetooth and Photo Kiosk.*

ISO Originally a system of numbers determined by the International Organization for Standardization to indicate the relative speeds of films; now adopted for use with digital cameras to indicate a change in the image sensor's effective sensitivity. *See also Image Sensor.*

JPEG An image file format that is common to all digital cameras; permits compression in varying amounts to reduce the size of the digital image file in order to take up less space on the memory card and to allow more exposures to be made; an abbreviation for the Joint Photographic Experts Group, a committee of the International Organization for Standardization that established the format. *See also Compression.*

KB *See Kilobyte.*

Kelvin A unit of measurement used to indicate the relative color temperatures of light sources; abbreviated K. *See also Color Temperature.*

Keystoning A type of unwanted image distortion; when the camera is tilted up, notably in architectural photography with wide-angle lenses, vertical parallel lines of the subject appear to converge at the top.

Keywords General or specific words that identify noteworthy elements or aspects of a photo; added as metadata to image files; a popular way to locate images on a computer or a Web site by using the "search" feature of software programs and Web sites. *See also Metadata and Tags.*

Kilobyte A unit of measurement that indicates the size of a digital file, and thus the amount of data it holds; abbreviated KB; equal to 1,024 bytes. *See also Byte, Megabyte, Gigabyte, and Terabyte.*

Landscape A term used to indicate the horizontal orientation of a rectangular picture. *See also Portrait.*

Laser Printer Currently the least popular printer for making photo prints, due to its technical superiority for text rather than images, higher cost, and fewer models. *See also Dye-Sublimation Printer and Inkjet Printer.*

Layers A feature of some image-editing programs; allows various changes to an image, each on its own layer, without permanently modifying the image until those layers are merged (i.e., "flattened") and saved as a file.

LCD Abbreviation for "liquid crystal display"; the type of small viewing screen on the back of a digital camera that displays a photographic image before and/or after the exposure is made; also electronic-powered information panels in some cameras, flash units, and exposure meters that present digital readouts to the photographer; also the most popular type of viewing screen on computer monitors.

LCD Monitor A viewing screen utilizing LCD (liquid crystal display) technology that can display digital images; found in small sizes on the backs of digital cameras and in larger sizes as desktop and laptop computer monitors; not to be confused with an LCD panel found on some cameras that displays information but not photographic images. *See also LCD.*

Leading Lines A composition technique using natural lines such as roads, fences, and rivers to direct attention to the center of interest in a photograph. *See also Composition.*

LED Abbreviation for "light-emitting diode"; tiny light(s) signaling or serving various functions in cameras and other photo equipment.

Lens Optical pieces of glass (or plastic) designed to focus rays of light to produce an image that is recorded by the camera's image sensor.

Lens Adapter A circular ring that attaches to the front of the camera lens in order to attach a filter or lens converter. *See also Filter and Lens Converter.*

Lens Aperture The adjustable lens opening that determines the amount of light allowed to pass through the lens; the relative size of the aperture is indicated by f/stop numbers. *See also f/Stop.*

Lens Cleaning Cloth A lint-free microfiber cloth designed to easily and safely clean lens optics.

Lens Converter An optical lens attachment fastened to the front of a camera's built-in zoom lens; used to decrease the lens focal length in the wide-angle position or to increase the lens focal length in the telephoto position; a number called the "focal length multiplier" indicates whether it is a wide-angle lens converter or a telephoto lens converter. *See also Focal Length Multiplier and Lens Focal Length.*

Lens Extender An optical accessory inserted between the body of a single lens reflex camera and the camera lens to increase the focal length of the lens, often to make it a more powerful telephoto; also called a Tele-Extender and a Tele-Converter. *See also Lens Focal Length.*

Lens Flare An often disturbing effect caused by light shining directly on the surface of the lens; reduces the contrast of the photographed subject.

Lens Focal Length Indicates the relative subject image size produced by a lens; the greater the focal length, the larger the image size; often measured in millimeters (mm): the larger the mm number, the greater the focal length; technically, focal length is the distance from the optical center of a lens to the point behind the lens where the light rays from an object at infinity are brought into focus. *See also Infinity.*

Lens Hood *See Lens Shade.*

Lens Opening *See Lens Aperture and f/Stop.*

Lens Shade A metal, plastic, or rubber extension in front of a lens used to shield the lens from direct rays of light or rain; also called a Lens Hood.

Levels A tool in some image-editing programs that utilizes a histogram to make precise adjustments to an image's tonal range, including shadows, midtones, and highlights; also can be used to change color casts in an image. *See also Histogram.*

Light-Emitting Diode *See LED.*

Lighting Usually refers to the type or direction of illumination falling on a subject.

Li-Ion Battery *See Lithium-Ion Battery.*

Liquid Crystal Display *See LCD.*

Lithium Battery A powerful, long-lasting replaceable battery; preferred over more common alkaline batteries for use in cameras and accessory flash units; not to be confused with rechargeable lithium-ion battery. *See also Lithium-Ion Battery and NiMH Battery.*

Lithium-Ion Battery A type of rechargeable battery used to power cameras and accessory flash units; often abbreviated as Li-Ion battery; runs twice as long as an NiMH (nickel–metal hydride) rechargeable battery; not to be confused with the replaceable lithium battery. *See also Lithium Battery and NiMH Battery.*

Live View A feature of some single lens reflex cameras that shows a preview of the picture on the camera's LCD monitor before an exposure is made and recorded by the image sensor (just as all point-and-shoot and prosumer cameras do).

Lo-Res Abbreviation for "low resolution." *See Low Resolution.*

Lossless Compression Describes a type of compression peculiar to certain image file formats (notably TIFF) that causes no artifacts or loss of pixels in an image when the file is saved. *See also Artifacts, Compression, and Lossy Compression.*

Lossy Compression Describes a type of compression peculiar to certain image file formats (notably JPEG) that causes a loss of pixels and some degradation in an image each time the file is saved. *See also Compression and Lossless Compression.*

Low Resolution Refers to a digital image that appears less sharp and has less fine detail than an image with high resolution; the resolution of an image is indicated by a count of its pixels—the fewer the number of pixels, the lower the resolution and therefore the poorer the image quality; sometimes abbreviated as Lo-Res. *See also High Resolution, Pixel, and Resolution.*

Macro Lens A lens primarily designed for close-up photography but capable of serving as a normal or telephoto lens as well; allows close lens-to-subject focusing without accessory equipment; called a Micro Lens by Nikon. *See also Close-up Lens.*

Macro Mode A setting on most point-and-shoot and prosumer cameras for close-up images; permits the lens to focus on a subject at very close range.

Magnify Mode Enlarges a small portion of a recorded image for closer inspection during playback on the camera's LCD monitor; the portion displayed and the level of magnification can be adjusted with camera controls.

Manual Exposure An exposure set manually by the photographer, who selects both the lens aperture (f/stop) and shutter speed; also an exposure mode indicated by M on a camera dial or menu. *See also Aperture-Priority Exposure, Program Exposure, and Shutter-Priority Exposure.*

Manual Focus A setting on some cameras allowing the lens to be focused manually; abbreviated MF. *See also Autofocus.*

MB *See Megabyte.*

Media Card *See Memory Card.*

Megabyte A unit of measurement that indicates the size of a digital file, and

thus the amount of data it holds; abbreviated MB; equal to 1,024 kilobytes (KB). *See also Byte, Kilobyte, Gigabyte, and Terabyte.*

Megapixel Abbreviated MP; a unit of measurement equal to 1,048,576 pixels; often used to indicate the maximum recording capacity of the camera's image sensor, such as 8 MP, or the size of a digital image. *See also Digital Image, Image Sensor, and Pixel.*

Memory Buffer *See Internal Memory Buffer.*

Memory Card A small, thin, reusable device that is inserted into a slot in a compatible camera to electronically record and temporarily store digital images; image files are transferred from the card to a computer, printer, or photo kiosk for subsequent use; sometimes called a Flash Memory Card or Media Card.

Memory Card Reader/Writer A small device that reads and writes to and from a computer the image files stored on a memory card.

Memory Stick A type of memory card; most commonly used in Sony-brand cameras; abbreviated as MS card. *See also CompactFlash, Memory Card, MultiMediaCard, Secure Digital, and xD-Picture Card.*

Metadata Information embedded in the image file automatically by the camera at the time of exposure or added later by using image-editing software. *See also EXIF and IPTC Data.*

MF Abbreviation for "manual focus." *See Manual Focus.*

Microfiber Cleaning Cloth *See Lens Cleaning Cloth.*

Mirror Lockup A manual control on some single lens reflex cameras that moves and holds the mirror that reflects the image to the viewfinder out of the way so the light coming through the lens can reach the image sensor; activated to prevent camera shake prior to a time exposure and for access to the image sensor for cleaning.

mm Abbreviation for "millimeter." *See also Lens Focal Length.*

Mobile Phone Worldwide term for "cell phone." *See also Camera Phone.*

Monochrome A term sometimes interchanged for "black-and-white" or "grayscale." *See also Grayscale.*

Movie Mode A setting on some cameras to record brief video clips. *See also Video File Format.*

MP *See Megapixels.*

MultiMediaCard A less popular type of memory card; abbreviated as MMC card. *See also CompactFlash, Memory Card, Memory Stick, Secure Digital, and xD-Picture Card.*

Multiple Exposure Mode *See Continuous Mode.*

Multiplier Factor *See Crop Factor and Effective Focal Length.*

Multizone Metering *See Evaluative Metering.*

Natural Light Existing light, usually sunlight, that is not supplemented with flash or other artificial light by the photographer; sometimes called Available Light, Ambient Light, or Existing Light.

Neutral Density Filter *See Graduated Neutral Density Filter.*

NiCd Battery A type of rechargeable battery occasionally used to power cameras and accessory flash units; abbreviated term for nickel cadmium, the battery's main components; now superseded in popularity and a longer life by NiMH (nickel–metal hydride) and Li-Ion (lithium-ion) rechargeable batteries. *See also Lithium Battery, Lithium-Ion Battery, and NiMH Battery.*

NiMH Battery A type of rechargeable battery used to power cameras and accessory flash units; abbreviated term for nickel and metal hydride, the battery's main components; runs 30 percent longer than NiCd (nickel-cadmium) batteries but half as long as Li-Ion (lithium-ion) batteries. *See also Lithium Battery, Lithium-Ion Battery, and NiCd Battery.*

Noise Refers to undesirable random patterns created electronically in a digital image; occurs most often with long exposures or when the camera's ISO is set to a higher number (faster speed); analogous to "grain" in film negatives, slides, or photographic prints. *See also ISO.*

Noise Reduction A feature found in some cameras and image-editing software to reduce noise. *See also Noise.*

OEM Abbreviation for "original equipment manufacturer."

Off-Camera Flash An external flash unit that is not mounted on the camera; avoids flat lighting; connection to the camera is made with a flash cord or wirelessly. *See also Front Lighting.*

Online Backup Data Storage Off-site facility for storing data, including digital images, that is accessed via the Internet.

Open Up the Lens To adjust the lens aperture to a wider f/stop. *See also Stop Down the Lens.*

Optical Image Stabilization An antishake feature of some cameras; involves numerous thousandths-of-a-second movements by either an optical element in the lens, or by the image sensor itself, in order to maintain the point of focus in the same spot on the image sensor despite any camera movement; abbreviated IS, or VR (Vibration Reduction) by Nikon. *See also Picture Stabilization.*

Optical Resolution Indicates the true resolution of a flatbed scanner; not to be confused with the software-enhanced resolution that electronically interpolates additional pixels that the scanner did not really see; optical resolution is indicated by the smaller of two numbers given for

the resolution of the scanner; the larger number is always the enhanced (interpolated) resolution. *See also Flatbed Scanner, Interpolation, Pixel, and Resolution.*

Optical Viewfinder An optical device in some cameras to view and compose the subject to be photographed; presents a clearer and sharper image to the eye than does an electronic viewfinder. *See also Electronic Viewfinder.*

Optical Zoom Refers to a camera's built-in optical zoom lens; not to be confused with a camera's digital zoom, which magnifies an image electronically. *See also Digital Zoom.*

Overexposure Excessive exposure that allows too much light to reach the image sensor and washes out details in the image. *See also Underexposure.*

Overexposure Indicator A feature in some cameras that causes very bright highlights in a picture to flash repeatedly during playback on the LCD monitor; a visual signal to the photographer to consider shooting again at a reduced exposure to avoid overexposed highlights.

P&S Abbreviation for "point-and-shoot." *See Point-and-Shoot Camera.*

Pan Head A tripod head that allows the camera to be moved from side to side while staying level; also has a tilt feature to move the camera up and down. *See also Ball Head and Tripod.*

Panning Describes the technique of following the action of a subject in the camera's viewfinder or on the LCD monitor and releasing the shutter while the camera is still moving; the result is a stop-action picture of the moving subject and a blurred background; gives a feeling of motion in a photograph.

Panorama Mode A camera setting to record two or more images in a series that can be "stitched" together with image-editing software into a panoramic format; called Stitch Assist mode by Canon.

Panoramic Format A technique to create an image with an extended range of view, commonly horizontal but may be vertical; produces a very wide or very tall picture from a series of overlapping images that are "stitched" with image-editing software.

Parallax Error A common problem when using the optical viewfinder of a point-and-shoot camera with a subject that is very close to the camera; the viewfinder sees the subject at a different angle from the camera lens; can be corrected by slightly changing the angle of the camera before making the exposure; can be avoided by using the camera's LCD monitor instead of the viewfinder to compose pictures of close-up subjects.

Passive Autofocus One of two types of autofocusing systems; uses the light reflected by the subject that passes through the camera lens; employs contrast detection technology. *See also Active Autofocus.*

PDF File An abbreviation for Portable Document Format, a file format developed by Adobe Systems; a popular way to send pictures, slideshows, video clips, and documents to other computers where they can be viewed with Adobe's Acrobat Reader software.

Pentaprism Optical glass or plastic in single lens reflex cameras that inverts the image produced by the camera lens and reflects it right-side up to the photographer looking through the camera's viewfinder.

Photofinishing Digital-imaging services offered by storefront and online companies, especially making photo prints and gifts.

Photography Literally means "writing with light."

Photography Mode *See Shooting Mode.*

Photo Kiosk A stand-alone or tabletop electronic device in retail stores for making photo prints or transferring image files to a DVD or CD from a memory card, flash drive, or camera phone; image editing and ordering is done on a touch screen.

Photo Paper Papers especially made to produce photo-quality digital images with inkjet, dye-sublimation, or laser printers; not to be confused with papers coated on one side with light-sensitive emulsion for making photographic prints that are processed in chemicals in a darkroom. *See also Dye-Sublimation Printer, Inkjet Printer, and Laser Printer.*

Photo Printer A generic term used to describe an inkjet, dye-sublimation, or laser printer that has been specifically designed to produce prints that closely resemble traditional photographic prints. *See also Dye-Sublimation Printer, Inkjet Printer, and Laser Printer.*

Photo Scanner A small flatbed scanner that converts snapshot-size photographs to digital image files. *See also Flatbed Scanner and Scanner.*

Photoshop Well-known image-editing software developed by Adobe Systems; available in amateur and professional versions named Photoshop Elements and Photoshop CS (Creative Suite). *See also Image-Editing Software.*

Photosites Light-sensitive diodes; tiny receptors on a camera's image sensor that represent pixels and create an image when struck by light focused through the camera lens. *See also Image Sensor and Pixels.*

PictBridge A built-in feature of some cameras and printers that enables direct printing from the camera; eliminates the intermediary step of downloading images to a computer.

Picture Element Compound term from which the word "pixel" was created. *See Pixel.*

Picture Package A command in some image-editing programs to print two or more copies of an image on one sheet of paper; can make copies

all one size or of different sizes; options are listed on a picture package menu.

Picture Stabilization A pseudo image stabilization feature of some point-and-shoot cameras; the camera's ISO is automatically increased in low light so that a faster shutter speed will be set to prevent blurring caused by camera shake. *See also Camera Shake, ISO, and Optical Image Stabilization.*

Pixel Acronym for "picture element"; the tiny electronic building blocks that create a digital image.

Pixel Dimensions A picture's width times its height, as measured by the number of pixels in one line horizontally and one line vertically; yields the total number of pixels in an image file. *See also Pixel.*

Pixels Per Inch *See PPI.*

Playback Mode A camera setting that turns on the LCD monitor to review images that have been recorded to the memory card. Also called Reviewing Mode. *See also Shooting Mode.*

Plug-in A small computer application that supplements a larger software program; enables special functions and effects within an image-editing program. *See also Image-Editing Software.*

Point-and-Shoot Camera A common term for a small automatic camera; abbreviated as P&S Camera; sometimes called a Compact Camera or a Consumer Camera. *See also Prosumer Camera and Single Lens Reflex Camera.*

Point of Focus The specific distance at which the camera lens is focused.

Polarizing Filter An adjustable filter placed in front of the camera lens; blocks certain light rays to diminish or eliminate glare or reflection from shiny surfaces (except unpainted metal); often used to reduce visual atmospheric haze and to darken blue skies and enhance white clouds.

Portable Media Player A small handheld electronic device that stores, displays, and plays digital media, including images, video, and audio (especially music); images are viewed on an LCD screen.

Portrait A term used to indicate the vertical orientation of a rectangular picture. *See also Landscape.*

PPI Abbreviation for "pixels per inch"; refers to the number of pixels in a line one inch long; frequently used to indicate print image resolution; the larger the ppi number, the higher the resolution; in the case of scanner resolution, often confused and interchanged with dpi (dots per inch), which also is used to indicate printer resolution. *See also DPI and Resolution.*

PPM Abbreviation for "pages per minute"; used to indicate the speed of a printer. *See also Printer Speed.*

Preflash A flash or brief series of flashes preceding the actual flash exposure in order to reduce red-eye. *See also Red-Eye.*

Primary Colors In photography, the three colors that combine to make white light: blue, green, and red.

Print A piece of photo paper with a photographic image. *See also Photo Paper.*

Printer An electronic and mechanical device for printing digital images and other documents. *See also Dye-Sublimation Printer, Inkjet Printer, and Laser Printer.*

Printer Driver Software that provides communication between computer and printer; ensures that digital data is compatible with a specific printer.

Printer Resolution For an inkjet printer, indicated by the number of dots of ink that will be printed in a horizontal line one inch long; stated as dots per inch (dpi). *See also DPI.*

Printer Speed Indicated by the number of pages printed per minute, abbreviated ppm; image files print slower (fewer pages per minute) than text documents.

Print Head In an inkjet printer, sprays droplets of ink through tiny nozzles onto photo paper; part of the ink cartridges in some inkjet models; in a dye-sublimation printer, heats color dyes so they vaporize and are absorbed by the photo paper.

Print Paper *See Photo Paper.*

Pro-Am Camera *See Prosumer Camera.*

Program Exposure A fully automatic exposure completely controlled by the camera; utilizes factory-programmed exposure combinations to set both the lens aperture (f/stop) and the shutter speed for a correct exposure; also an exposure mode indicated by P on a camera dial or menu. *See also Aperture-Priority Exposure, Manual Exposure, and Shutter-Priority Exposure.*

Prosumer Camera Designed for photographers who are more than amateurs (consumers) but not professionals; midway between a point-and-shoot camera and a single lens reflex camera; includes zoom lens reflex camera; also called Pro-Am Camera. *See also Point-and-Shoot Camera, Single Lens Reflex Camera, and Zoom Lens Reflex Camera.*

Quick Release A two-piece device fastened to the bottom of a camera and to the top of a tripod; enables fast attachment of camera to tripod and rapid removal.

RAM Acronym for "random access memory"; refers to the memory that temporarily stores data for processing, as in a digital camera or a computer.

Raw Indicates any file format that contains digital image data without in-camera processing; all alterations to the Raw image data are made with

image-editing software on a computer; usually a proprietary image file format with its file extension peculiar to each camera manufacturer. *See also File Extension and Image File Format.*

Ready Light A light on a camera or an accessory external flash unit that signals when the flash is fully recycled and ready to be fired.

Recording Mode *See Shooting Mode.*

Recording Speed The maximum speed at which a DVD or CD can record image files or other data. *See also Write Speed.*

Recycle Time The time required by the camera to electronically process and transfer an image recorded by the image sensor to the memory card; also, the time it takes for a flash unit to recharge to its full light output capacity after being fired and again be ready for use.

Red-Eye The undesirable effect that occurs when flash reaches and photographs the retina inside a subject's eyes; subjects appear with bright red eyes in the picture. *See also Red-Eye Reduction.*

Red-Eye Reduction A feature of some built-in flash and accessory external flash units to reduce red-eye by emitting a brief series of preflashes or a steady LED beam from the flash or camera prior to the actual flash, which causes the pupils of the eyes to constrict; also a feature in some cameras and most image-editing programs to eliminate red-eye after the flash exposure has been made. *See also LED, Preflash, and Red-Eye.*

Reproduction Ratio Used in close-up photography to indicate the size of a subject reproduced as a digital image in relation to the subject's actual size; when both sizes are the same the image is said to be life size and to have a reproduction ratio of one to one, expressed as 1:1.

Resize To change the size of an image with image-editing software by adjusting the number of pixels in the picture. *See also Pixel.*

Resolution The degree of detail in a digital image, particularly its sharpness and clarity; stated in general terms as high resolution or low resolution and in specific terms by the number of pixels per inch (ppi) or dots per inch (dpi); cited in technical specifications for cameras, scanners, computer monitors, printers, and television screens. *See also DPI, High Resolution, Low Resolution, Pixel, and PPI.*

RGB Abbreviation for "red, green, and blue," the primary colors.

Rule of Thirds A composition concept that places the main subject off center for a more appealing picture. *See also Composition.*

Scanner An input device that copies and digitizes into an image file any existing photo print, film negative, or transparency (slide); allows the use of digital image files of film-based photographs in the same ways as image files created by digital cameras; image files from a scanner are

saved on the hard drive of a computer; types of scanners include flat-bed, film, and drum. *See also Drum Scanner, Film Scanner, and Flatbed Scanner.*

Secure Digital A popular type of memory card; abbreviated as SD card. *See also CompactFlash, Memory Card, Memory Stick, MultiMediaCard, and xD-Picture Card.*

Self-Timer A camera mode that automatically releases the shutter to make an exposure after a preset number of seconds.

Sepia A reddish brown color tone that gives an antique look to photo-graphs; effect can be created in some cameras or with image-editing software after an exposure is made.

Shadow Detail Detail that is evident in the shadowed (dark) areas of a pic-ture; a consideration when making an exposure reading. *See also Highlight Detail.*

Sharpen Manual or automatic controls in image-editing software to improve the sharpness of an image.

Shooting Mode A camera setting to record images on the memory card; also called Recording Mode or Photography Mode. *See also Playback Mode.*

Shutter A device in the camera body that regulates the length of time that light reaches the image sensor to make an exposure. *See also Image Sensor.*

Shutter Delay The brief time lag between the moment the shutter release button is pressed and when the shutter actually opens to make the expo-sure; delay occurs while the camera autofocuses the lens and automati-cally sets the exposure; also called Shutter Lag.

Shutter Lag *See Shutter Delay.*

Shutter-Priority Exposure An automatic exposure where the photographer first sets the desired shutter speed, and then the camera automatically sets the lens aperture (f/stop) for a correct exposure; also an exposure mode indicated by S or Tv (for "time value") on a camera dial or menu. *See also Aperture-Priority Exposure, Manual Exposure, and Program Exposure.*

Shutter Release A button, lever, or other type of trigger on a camera that opens the shutter to make an exposure; allows the light coming through the camera lens to reach the image sensor. *See also Shutter.*

Shutter Speed Indicates the precise length of time that light reaches the image sensor to make an exposure; usually marked in fractions of a second.

Side Lighting A term used when the main source of illumination is at the side of the subject.

Silhouette A dark subject without detail that stands out from a very bright background; sometimes created when a subject is backlighted. *See also Backlighting.*

Single Autofocus Mode An autofocus setting on some cameras; after the shutter release button is pressed halfway, locks in the focus until the shutter release is fully depressed to make the exposure; also called Single Servo and One Shot autofocus mode. *See also Continuous Autofocus Mode.*

Single Lens Reflex Camera A camera featuring interchangeable lenses; also has a through-the-lens optical viewfinder showing the subject area that will be recorded by the image sensor; the most versatile type of digital camera; favored by professional photographers; most often referred to as an SLR or a DSLR camera. *See also Point-and-Shoot Camera and Prosumer Camera.*

Size Indicator Any object of a familiar size that is included in a picture to give a sense of scale.

Skylight Filter A clear camera filter that is often used to protect the camera lens from dust and scratches. *See also Ultraviolet (UV) Filter.*

Slideshow A series of images presented in a prearranged order; created with computer software for showing on computer monitors or television screens.

Slow Sync A feature of some cameras and autoflash units that sets slower-than-normal shutter speeds for flash synchronization so that natural light in the background will also be recorded by the image sensor; also called Slow Synchro and Nighttime Flash. *See also Flash Synchronization.*

SLR Abbreviation for "single lens reflex camera." *See Single Lens Reflex Camera.*

Smart Media A type of memory card used in early Olympus digital cameras; superseded by CompactFlash, Memory Stick, MultiMediaCard, Secure Digital, and xD-Picture cards; abbreviated as SM card.

Soft Lighting *See Diffused Lighting.*

Spot Metering An exposure metering system built into some cameras that reads only a very limited area, as designated by a small circle or brackets in the middle of the viewfinder or LCD monitor. *See also Center-Weighted Metering and Evaluative Metering.*

Stitch Assist *See Panorama Mode.*

Stop-Action The photographic effect of capturing a moving subject so that it can be seen clearly and in detail.

Stop Down the Lens To adjust the lens aperture to a smaller f/stop; sometimes stated as Close Down the Lens. *See also Open Up the Lens.*

Storage Card *See Memory Card.*

Straighten Manual and automatic controls in image-editing software to make the vertical or horizontal orientation of a subject in a picture appear natural instead of tilted.

Strobe A word sometimes used to describe an accessory electronic flash unit.

Subject Image The subject as recorded by the image sensor in a digital camera.

Subject Image Size The size of the subject as it appears on the camera's image sensor; determined in part by the focal length of the lens. *See also Lens Focal Length.*

Tags Personalized keywords attached as metadata to image files; used to identify images and locate them in the future. *See also Keywords and Metadata.*

TB *See Terabyte.*

Tele-Converter *See Lens Extender.*

Tele-Extender *See Lens Extender.*

Telephoto Lens A lens that has a greater focal length and a narrower angle of view than a wide-angle lens; produces a larger subject image than a wide-angle lens when both lenses are the same distance from the subject. *See also Angle of View and Lens Focal Length.*

Terabyte A unit of measurement that indicates the size of a digital file, and thus the amount of data it holds; abbreviated TB; equal to 1,024 gigabytes (GB). *See also Byte, Kilobyte, Megabyte, and Gigabyte*

35mm Camera A camera using 35mm film.

35mm Equivalent Given for a digital camera lens; indicates what the focal length would be for an equivalent lens on a 35mm film camera; helps photographers familiar with 35mm film cameras better understand the focal length of the equivalent digital camera lens; also called the Equivalent 35mm Camera Focal Length.

Through-the-Lens A term that indicates the camera's exposure metering system and optical viewing system work directly through the camera lens; common to single lens reflex cameras; often abbreviated TTL.

Thumbnail Refers to a photo that is very small in size; image files displayed as a group on a camera's LCD monitor or on a computer screen are often called thumbnails.

TIFF An acronym for Tagged Image File Format; an image file format that is available in some cameras; produces a larger image file with higher resolution and technically better image quality than the more common JPEG image file format. *See also Image File Format, JPEG, Raw, and Resolution.*

Time Exposure Usually an exposure longer than one second; may require setting the shutter speed control to B (Bulb) to keep the shutter open. *See also Bulb.*

Time-Lapse Photography A series of pictures of the same subject taken over a period of time without moving the camera.

Tools Controls used in image-editing software and other computer programs to perform specific functions or actions.

Top Lighting A term used when the main source of illumination is directed at the top of the subject.

Total Zoom The maximum zoom range of a camera; determined by multiplying the optical zoom range by the digital zoom range; a marketing ploy to claim a greater zoom range for a camera; creates a larger image but causes a reduction in image quality when optical and digital zooms are combined; also called Combined Zoom. *See also Digital Zoom and Optical Zoom.*

Tripod A three-legged device designed to give support and steadiness to the camera.

Tripod Head An adjustable device at the top of a tripod to which a camera or a large zoom or telephoto lens is attached. *See also Ball Head, Pan Head, and Quick Release*

Tripod Socket A screw-type socket in the base of a camera or on the barrel of some large zoom or telephoto lenses; used to attach the camera or lens to the tripod head.

TTL Abbreviation for "through-the-lens." *See Through-the-Lens.*

Tungsten Light Light from a household lightbulb or a halogen lamp; both have tungsten filaments that become incandescent when heated by an electrical current.

Tv Abbreviation for "time value." *See Shutter-priority Exposure.*

Ultraviolet (UV) Filter Helps eliminate the ultraviolet light to which image sensors are sensitive; improves images of skies by reducing (but not eliminating) atmospheric haze; often abbreviated as UV Filter; sometimes called a Haze Filter or a Skylight Filter.

Underexposure Insufficient exposure that produces dark images without detail. *See also Overexposure.*

Underwater Camera A waterproof camera specifically designed for underwater photography. *See also Underwater Camera Housing.*

Underwater Camera Housing A watertight housing designed to enclose and protect a camera for use underwater. *See also Underwater Camera.*

Underwater Mode Adjusts the shutter speed, ISO, white balance, and/or focusing distancing on some point-and-shoot cameras when put into an underwater camera housing for underwater photography.

UPDIG Abbreviation for Universal Photographic Digital Imaging Guidelines; establishes worldwide standards for digital imaging so that images can be uniformly accessed, transmitted, displayed, and embedded with

metadata when using current and future computer operating systems and other software. *See also Metadata.*

Upload In general, to send digital data from a local computer, such as when uploading your digital images to a Web site. *See also Download.*

USB Abbreviation for Universal Serial Bus; a common type of connecting cable used to transfer data, including image files, between cameras, computers, printers, external hard drives, and other related devices; transmits data slower than a FireWire cable. *See also FireWire.*

USB Flash Drive A finger-size portable device used for temporarily storing and transporting digital data, including image files; plugs into USB ports on computers and printers.

UV Abbreviation for "ultraviolet." *See Ultraviolet Filter.*

Variable Aperture Zoom Lens A zoom lens with a variable maximum lens aperture that changes in size as the lens focal length is changed; common to cameras with a built-in zoom lens. *See also Zoom Lens.*

Variable Maximum Aperture The maximum lens aperture (f/stop) that gets smaller in size on a variable aperture zoom lens as it is zoomed to a longer focal length; the maximum aperture may be reduced as much as one and a half f/stops or more. *See also Variable Aperture Zoom Lens.*

VGA A setting for the image resolution of video clips made in a digital camera's Movie Mode; abbreviation for "Video Graphics Array." *See also Movie Mode.*

Vibration Reduction *See Image Stabilization.*

Video File Format A file format for recording video clips in a digital camera's Movie Mode; common formats are MPEG and AVI. *See also Movie Mode.*

Viewfinder An optical or electronic device in some cameras that is used to view and compose the subject to be photographed. *See also Electronic Viewfinder and Optical Viewfinder.*

Viewing Angle The maximum angle at which a camera's LCD monitor, a computer's LCD screen, or a digital picture frame can be viewed without the displayed image losing contrast or color.

Vignetting An undesirable effect that darkens the edges of the image; often caused by a lens shade, lens adapter, or filter ring that extends too far in front of the camera lens; most common in wide-angle views.

Waterproof Camera A point-and-shoot camera that is impervious to moisture; ideal for use in inclement weather; may also be used underwater to a limited depth. *See also Underwater Camera.*

White Balance A control in digital cameras to correct the colors from different light sources so that subjects appear in the same colors in a photograph as they do in reality; can be set to automatic white balance (AWB) or

to a manual control to adjust for sunlight/daylight, cloudy/overcast, flash, incandescent/tungsten, or fluorescent light.

Wide-Angle Lens A lens that has a shorter focal length and a greater angle of view than a telephoto lens; produces a smaller subject image than a telephoto lens when both lenses are the same distance from the subject. *See also Angle of View and Lens Focal Length.*

Wireless Remote A small handheld electronic device that triggers the camera's shutter release from a limited distance; also called a Camera Remote.

Write Speed The speed at which a computer disk drive or external disk drive is set when writing ("burning") image files or other data to a DVD or CD.

xD *See xD-Picture Card.*

xD-Picture Card A type of memory card; most commonly used in Olympus and Fujifilm cameras; abbreviated as xD card. *See also CompactFlash, Memory Card, Memory Stick, MultiMediaCard, and Secure Digital.*

XMP Data A type of metadata automatically embedded in image files by some cameras; abbreviation for Extensible Metadata Platform. *See also Metadata.*

Zoom A control, command, or tool on cameras and in image-editing software to enlarge or reduce the size of a recorded image being viewed on the camera's LCD monitor or a computer screen. *See also Zoom Lens.*

Zoom Flash Head An accessory external flash unit with a reflector head that adjusts automatically or manually to provide the appropriate angle of illumination for wide-angle to telephoto lens focal lengths. *See also Angle of Illumination and Lens Focal Length.*

Zoom Lens A versatile lens that can quickly be adjusted to different focal lengths in order to vary the subject image size; built into the camera unless it is an interchangeable zoom lens for a single lens reflex camera. *See also Lens Focal Length and Subject Image Size.*

Zoom Lens Reflex Camera A camera with a built-in zoom lens that uses through-the-lens viewing and exposure metering systems common to single lens reflex cameras.

Appendix B:
Getting More Help—
Photography Web Sites

Listed below are the Web sites of photography-related companies and services mentioned in this book. Web addresses sometimes change, so if an address no longer reaches the company, enter its name in any Internet search engine. Also, some international companies have Web sites in several countries and languages. The majority of the following addresses are for U.S.-based Web sites using English; links at some sites will take you to other locations and languages.

ACDSee Photo Manager image-editing software
www.acdsee.com
Adobe Photoshop image-editing software, Camera Raw and DNG applications, Lightroom photo file management program, Adobe Reader for PDF files, Adobe Flash Player
www.adobe.com
AgfaPhoto cameras, printers, inks, printer papers, digital picture frames
www.agfaphoto.com
Apple Macintosh (Mac) OS X operating system software, iPhoto and Aperture image-editing software, QuickTime media player, iPod portable media players
www.apple.com
Aquapac underwater camera housings
www.aquapac.net
AquaTech underwater camera housings
www.aquatech.com.au

Aquatica underwater camera housings
 www.aquatica.ca
Arches printer papers
 www.arches-papers.com/en
Argus cameras
 www.arguscamera.com
B+W filters
 www.schneideroptics.com/filters
Benbo tripods
 www.patersonphotographic.com
Bergger printer papers
 www.bergger.com/us
Bonica underwater cameras
 www.bonicadive.com
Canon cameras, lenses, filters, scanners, printers, inks, printer papers
 www.usa.canon.com
Carbonite backup data storage
 www.carbonite.com
Casio cameras
 www.casio.com/products/cameras
Ceiva digital picture frames
 www.ceiva.com
CMS external hard drives
 www.cmsproducts.com
CNET camera and equipment reviews and news
 www.cnet.com
Coby digital picture frames and portable media players
 www.cobyusa.com
Cokin filters and lens converters
 www.cokin.com
Corel Paint Shop Pro Photo and PhotoImpact image-editing software
 www.corel.com
Cullmann tripods
 www.rtsphoto.com/html/cullmann.html
Dell printers
 www.dell.com
Digiframes.com digital picture frames
 www.digiframes.com
Digital Photography Review camera and equipment reviews and news
 www.dpreview.com

Digital Spectrum Solutions digital picture frames
 www.dsicentral.com
Domke camera bags
 www.tiffen.com
eneloop batteries
 www.sanyo.com
Epson printers, inks, printer papers, and portable media players
 www.epson.com
Ewa-Marine underwater camera housings
 www.ewa-marine.de
Fantasea underwater camera housings
 www.fantasea.com
Flickr photo-sharing Web site
 www.flickr.com
Fujifilm cameras
 www.fujifilm.com
Gitzo tripods
 www.gitzo.com
Google Internet search engine and Picasa image-editing software
 www.google.com
Hahnemühle printer papers
 www.hahnemuhle.com
Hasselblad cameras, lenses
 www.hasselbladusa.com
Heliopan filters
 www.heliopan.de
Hoya filters
 www.hoyafilter.com
HP (Hewlett-Packard) cameras, scanners, printers, inks, and printer papers
 www.hp.com
Ikelite underwater camera housings
 www.ikelite.com
Ilford printer papers
 www.ilford.com
Imaging Resource camera and equipment reviews and news
 www.imaging-resource.com
Inkpress printer papers
 www.inkpresspaper.com
Iomega external hard drives
 www.iomega.com

Kodak cameras, scanners, printers, printer papers, kiosk and online photo services, digital picture frames, and portable media players
www.kodak.com
LaCie external hard drives
www.lacie.com
Leica cameras and lenses
www.leica-camera.us
Lexar memory cards, card readers, and flash drives
www.lexar.com
Lexmark printers, inks
www.lexmark.com
Life Pixel Digital Infrared Photography Conversions Services
www.lifepixel.com
Light Impressions archival mount boards, mats, frames, and other supplies
www.lightimpressionsdirect.com
Lowepro camera bags
www.lowepro.com
Lumijet printer papers
www.hahnemuhle.com
Manfrotto tripods
www.manfrotto.com
Maxtor external hard drives
www.maxtor.com
MediaStreet printer papers and digital picture frames
www.mediastreet.com
Metz flash
www.metz.de/en/photo-electronics
Michele and Tom Grimm
www.tomgrimm.com
Microsoft Windows XP and Vista operating systems, Windows Live Photo Gallery image-editing program, Windows Media Player
www.microsoft.com
Mitsubishi printer papers
www.mitsubishiimaging.com
Moab printer papers
www.moabpaper.com
Mozy backup data storage
www.mozy.com
Nikon cameras, lenses, filters, and scanners
www.nikonusa.com

Olympus cameras, lenses, scanners, printers, and printer papers
www.olympusamerica.com
Oriental printer papers
www.orientalphotousa.com
Pacific Image film scanners
www.scanace.com
Panasonic cameras, printers
www.panasonic.com
Pandigital digital picture frames
www.pandigital.net
Pentax cameras and lenses
www.pentaxusa.com
Philips digital picture frames and portable media players
www.photoframe.philips.com
Photobucket photo-sharing Web site
www.photobucket.com
PhotoShow slideshow software
www.photoshow.com
PhotoVu digital picture frames
www.photovu.com
PhotoWorks online photo services
www.photoworks.com
Picasa image-editing software
www.picasa.google.com
Pictorico printer papers
www.pictorico.com
Polaroid cameras
www.polaroid.com
RealPlayer media player
www.real.com
Ricoh cameras
www.ricoh-usa.com
Ritz Camera online photo services
www.ritzpix.com
Rollei cameras
www.rollei.de
Samsung cameras and portable media players
www.samsungcamera.com
SanDisk memory cards, card readers, flash drives, and portable media players
www.sandisk.com

Sanyo cameras and eneloop batteries
www.sanyo.com
Seagate external hard drives
www.seagate.com
SeaLife underwater cameras
www.sealife-cameras.com
Sea & Sea underwater cameras and housings
www.seaandsea.com
Shutterfly online photo services
www.shutterfly.com
Sigma cameras and lenses
www.sigmaphoto.com
Slik tripods
www.slik.com
Smartparts digital picture frames
www.smartpartsproducts.com
Snapfish online photo services
www.snapfish.com
Sony cameras, lenses, and printers
www.sonystyle.com
Steve's DigiCams camera and equipment reviews and news
www.steves-digicams.com
Sunpak flash, tripods, and digital picture frames
www.sunpak.com
Tamrac camera bags
www.tamrac.com
Tamron lenses
www.tamron.com
Tenba camera bags
www.tenba.com
Tiffen filters
www.tiffen.com
Tokina lenses
www.tokinalens.com
Toshiba digital cameras and portable media players
www.toshiba.com
Ulead PhotoImpact and Photo Express image-editing software
www.ulead.com
Velbon tripods
www.velbon.co.uk

Vivitar cameras, lenses, flash, and tripods
 www.sakar.com
Western Digital external hard drives
 www.westerndigital.com
Westinghouse digital picture frames
 www.westinghousedigital.com
Wilhelm Imaging Research printer ink and paper longevity reports
 www.wilhelm-research.com
winkflash online photo services
 www.winkflash.com
Wolf Camera online photo services
 www.ritzpix.com
York Photo online photo services
 www.yorkphoto.com
Zeiss lenses
 www.zeiss.com

Index

(Page numbers set in **boldface** refer to illustrations.)